out
of
this
century

the informal

memoirs of peggy guggenheim

Martino Publishing
Mansfield Centre, CT
2015

Martino Publishing
P.O. Box 373,
Mansfield Centre, CT 06250 USA

ISBN 978-1-61427-778-1

© *2015 Martino Publishing*

Cover design by T. Matarazzo

Printed in the United States of America On 100% Acid-Free Paper

out
of
this
century

the informal

memoirs of peggy guggenheim

the dial press

1946

new york

Designed by Meyer Wagman

to

james johnson sweeney

Apropos of the dedication of this book the following telephone conversation occurred:

Peggy Guggenheim: Sweeney, I have something very embarrassing to ask you. Would you mind if I dedicated my memoirs to you?

James Johnson Sweeney: On the contrary, I would be flattered and delighted.

Peggy Guggenheim: I hope you will not live to regret it.

James Johnson Sweeney: I hope you mean I'll live but not regret it.

contents

part 1

chapter 1

gilt-edged childhood

I have no memory. I always say to my friends, "Don't tell me anything you don't want repeated. I just can't remember not to." Invariably I forget and I repeat everything.

In 1923 I began to write my memoirs. They began like this: "I come from two of the best Jewish families. One of my grandfathers was born in a stable like Jesus Christ or, rather, over a stable in Bavaria, and my other grandfather was a peddler." I don't seem to have gotten very far with this book. Maybe I had nothing to say, or possibly I was too young for the task which I had set myself. Now I feel I am ripe for it. By waiting too long I may forget everything I have somehow managed to remember.

If my grandfathers started life modestly they ended it sumptuously. My stable-born grandfather, Mr. Seligman, came to America in steerage, with forty dollars in his pocket and contracted smallpox on board ship. He began his fortune by being a roof shingler and later by making uniforms for the Union Army in the Civil War. Later he became a renowned banker and president of Temple Emanu-el. Socially he got way beyond

my other grandfather, Mr. Guggenheim the peddler, who was born in St. Gallen in German Switzerland. Mr. Guggenheim far surpassed Mr. Seligman in amassing an enormous fortune and buying up most of the copper mines of the world, but he never succeeded in attaining Mr. Seligman's social distinction. In fact, when my mother married Benjamin Guggenheim the Seligmans considered it a mésalliance. To explain that she was marrying into the well known smelting family, they sent a cable to their kin in Europe saying, "Florette engaged Guggenheim smelter." This became a great family joke, as the cable misread "Guggenheim smelt her."

By the time I was born the Seligmans and the Guggenheims were extremely rich. At least the Guggenheims were and the Seligmans hadn't done so badly. My grandfather, James Seligman, was a very modest man who refused to spend money on himself and underfed his trained nurse. He lived sparsely and gave everything to his children and grandchildren. He remembered all our birthdays and, although he did not die until ninety-three, he never failed to make out a check on these occasions. The checks were innumerable, as he had eleven children and fifteen grandchildren.

Most of his children were peculiar, if not mad. That was because of the bad inheritance they received from my grandmother. My grandfather finally had to leave her. She must have been objectionable. My mother told me that she could never invite young men to her home without a scene from her mother. My grandmother went around to shopkeepers and, as she leaned over the counter, asked them confidentially, "When do you think my husband last slept with me?"

My mother's brothers and sisters were very eccentric. One of my favorite aunts was an incurable soprano. If you happened to meet her on the corner of Fifth Avenue while waiting for a bus, she would open her mouth wide and sing scales trying to make you do as much. She wore her hat hanging off the back

of her head or tilted over one ear. A rose was always stuck in her hair. Long hatpins emerged dangerously, not from her hat, but from her hair. Her trailing dresses swept up the dust of the streets. She invariably wore a feather boa. She was an excellent cook and made beautiful tomato jelly. Whenever she wasn't at the piano, she could be found in the kitchen or reading the ticker-tape. She was an inveterate gambler. She had a strange complex about germs and was forever wiping her furniture with lysol. But she had such extraordinary charm that I really loved her. I cannot say her husband felt as much. After he had fought with her for over thirty years, he tried to kill her and one of her sons by hitting them with a golf club. Not succeeding, he rushed to the reservoir where he drowned himself with heavy weights tied to his feet.

Another aunt, who resembled an elephant more than a human being, at a late age in life conceived the idea that she had had a love affair with an apothecary. Although this was completely imaginary, she felt so much remorse that she became melancholic and had to be put in a nursing home.

My most attractive uncle was a very distinguished gentleman of the old school. Being separated from his wife who was as rich as he, he decided to live in great simplicity in two small rooms and spend all his money on fur coats which he gave away to girls. Almost any girl could have one for the asking. He wore the *Legion d'honneur* but would never tell us why he had been decorated.

Another uncle lived on charcoal which he had been eating for many years, and as a result his teeth were black. In a zinc-lined pocket he carried pieces of cracked ice which he sucked all the time. He drank whiskey before breakfast and ate almost no food. He gambled heavily, as did most of my aunts and uncles, and when he was without funds he threatened to commit suicide to get more money out of my grandfather. He had a mistress whom he concealed in his room. No one was allowed to visit

him until he finally shot himself, and then he could no longer keep the family out. At the funeral my grandfather greatly shocked his children by walking up the aisle with his dead son's mistress on his arm. They all said, "How can Pa do that?"

There was one miserly uncle who never spent a cent. He arrived in the middle of meals saying he didn't want a thing and then ate everything in sight. After dinner he put on a frightening act for his nieces. It was called "the snake." It terrified and delighted us. By placing lots of chairs together in a row and then wriggling along them on his stomach he really produced the illusion. The other two uncles were nearly normal. One of them spent all his time washing himself and the other one wrote plays that were never produced. The latter was a darling and my favorite.

My other grandfather, Meyer Guggenheim, lived happily with his cousin to whom he was married. They brought up an even larger, if less eccentric, family than the Seligmans. There were seven brothers and three sisters. They produced twenty-three grandchildren. When my grandmother died my grandfather was looked after by his cook. She must have been his mistress. I remember seeing her weep copious tears because my grandfather vomited. My one recollection of this gentleman is of his driving around New York in a sleigh with horses. He was unaccompanied and wore a coat with a sealskin collar and a cap to match. He died when I was very young.

I was born in New York City on East Sixty-ninth Street. I don't remember anything about this. My mother told me that while the nurse was filling her hot water bottle, I rushed into the world with my usual speed and screamed like a cat. I was preceded by one sister, Benita, who was almost three years older than I. She was the great love of my early life, in fact of my entire immature life. But maybe that has never ended.

We soon moved to a house on East Seventy-second Street near the entrance to the Park. Our neighbors were the Stillmans and

the Rockefellers. Opposite us lived President Grant's widow. My father remodeled this house and made it very elegant. Here my second sister Hazel was born when I was almost five. I was fiendishly jealous of her.

There is nothing about this house that does not still arouse my most poignant memories. In fact for years I dreamed about it. To enter our new domain you had to pass not one but two glass doors with a vestibule in between. Then you found yourself in a little marble entrance with a fountain. On the wall was a stuffed eagle with chains. My father had shot it himself, though it was a legal offense. He had done this in the Adirondacks, where we had a camp and went in the late summer.

Behind this hallway, which had a marble staircase, there was a door which led to the elevator. Three years ago when I returned to New York after an absence of many years, I went back to this house to visit an aunt who lived there. When we were in the elevator my daughter of sixteen, who was accompanying me, suddenly burst out with, "Mama, you lived in this house when you were a little girl?" I modestly replied "Yes," and to convince her added, "This is where Hazel was born." My daughter gave me a surprised look and concluded with this statement: "Mama, how you have come down in the world." From then on the butler, who was ushering us upstairs, looked upon me with suspicion and rarely admitted me to the house. However, my memories alone warranted my admission.

On the reception floor there was a high-ceilinged dining-room with panels and six indifferent tapestries. In the back was a little conservatory filled with plants. In the center of this floor was a reception room with a huge tapestry of Alexander the Great entering Rome in triumph. In front of it was a double-trayed tea table with a monstrous silver tea set. It was in this room that my mother gave a weekly tea party to the most boring ladies of the haute Jewish bourgeoisie, which I was forced reluctantly to attend.

In the front of the house was our Louis Seize parlor with huge mirrors, tapestries on the wall and tapestried furniture. On the floor was a bearskin rug which had an enormous red mouth and a red tongue. Sometimes the tongue broke loose, and, when it was detached, it had the most revolting appearance. The animal's teeth were forever being mended as they also came out. There was also a grand piano. One night I remember hiding under this piano and weeping in the dark. My father had banished me from the table because, at the tender age of seven, I had said to him, "Papa, you must have a mistress as you stay out so many nights."

The center of the house was surmounted by a glass dome that admitted the daylight. At night it was lit by a suspended lamp. Around this was a large circular winding staircase. It commenced on the reception floor and ended on the fourth floor where I lived. I recall the exact tune which my father had invented and which he whistled to lure me when he came home at night and ascended the stairs on foot. I adored my father and rushed to meet him.

The third floor belonged to my parents. In the front was a library with red velvet paneled walls and large glass bookcases that contained the classics. Here there was another fur rug, a tiger skin. On the walls were portraits of my four grandparents. This room, as well as every room in the house, had cream colored lace curtains at the windows.

It was in this room that I sat at a large Louis Quinze table with a glass top and was fed by a maid whose sole duty at that time was to see that I ate. I never had any appetite. When my tears were of no avail, I protested by vomiting and the feeding came to an end.

In the back of the house my mother had her room. It was preceded by a little alcove containing cupboards, which space she needed for her large wardrobe. The bedroom was covered with pink silk and had twin beds. The furniture was mahogany

with brass incrustations. On her bureau, which was much too high for her to use as a dressing-table, was a set of silver brushes and bottles. There was a long cheval glass, in front of which my mother sat to have her hair brushed by her French maid or by a special hairbrusher who came in for that purpose. This was the hour that I was allowed to play in my mother's room. Behind her room was my father's dressing-room.

Upstairs my sisters and I had a whole floor to ourselves until my grandfather Seligman came to live with us. My room was next to a steep and dark staircase that led up to the servants' quarters. It frightened me and I had nightmares about it.

I also have poignant memories of the servants' quarters which were less than adequate, and seemed to be distinctly in contrast to our elegant rooms. The men-servants' rooms were the worst of all. They were not on the top floor, which was bad enough: they were in the back of the house on queer little landings along the servants' back stairs. The kitchen was below the ground floor and, in consequence, very dark.

My mother gave many dinner parties and I remember on one of these occasions the nurse rushed downstairs to call my mother away from the table. She had heard a baby cry in the kitchen-maid's room and upon investigating the matter she had found the newly born infant hidden in a trunk, strangled in its own navel cord. The girl had come to our house only a few days before to take refuge. She had given birth alone and then murdered her illegitimate offspring. Our family doctor declared her insane to save her from prison.

My childhood was excessively unhappy: I have no pleasant memories of any kind. It seems to me now that it was one long protracted agony. When I was very young I had no friends. I didn't go to school until I was fifteen. Instead I studied under private tutors at home. There was one period when I took lessons with a girl called Dulcie Sulzberger. She had two brothers who fascinated me, one in particular, Marion.

My father insisted that his children be well-educated and saw to it that we acquired "good taste." He himself was keen on art and bought a lot of paintings. In Munich he had us painted by Lenbach but since I was only four at the time I do not remember anything about it now. My memory goes back only to Hazel's birth. Lenbach painted me in a Vandyck costume and, for some strange reason, gave me brown eyes instead of green, and red hair instead of chestnut. With Benita he was less fanciful. Perhaps because she was so beautiful, he portrayed her as she really was, with brown hair and brown eyes. I have two portraits, one of myself, and the other one of Benita and me, in which I appear with golden hair. These are the greatest treasures of my past.

The only toys I can remember are a rocking horse with an enormous rump and a doll's house containing bearskin rugs and beautiful crystal chandeliers. The doll's house must have left me with a fearful nostalgia, because for years I tried to reproduce it for my daughter. I spent months papering walls and buying objects to furnish her house. In fact I still can't resist buying toys. I immediately give them away to children but I must buy them for my own delight. I also remember a glass cabinet filled with tiny hand-carved ivory and silver furniture, which had an old-fashioned sculptured brass key. I kept the cabinet locked and allowed no one to touch my treasures.

My strongest memories are of Central Park. When I was very young my mother used to take me driving there in an electric brougham. There was a certain rock on the East Drive that resembled a panther about to spring. I called it "the cat," and whenever we passed it, I pretended to telephone to it to say hello or to warn it of our arrival. For a telephone I used the speaking tube of our brougham. Later I rode in the Park in a little foot-pedaled automobile. The Mall was the perfect place for this. In the rambles I climbed rocks all by myself, while my governess waited below. In the winter I was forced to

go ice skating, which caused me to suffer agonies. My ankles were too weak and my circulation much too bad. I shall never forget the excruciating pain I felt from the thawing of my toes, when returning from the lake I clung to a stove which was in a little cabin intended for skaters.

All this left me with such painful memories that I have carefully avoided the Park ever since. In fact I refused to visit it when I came back to New York a few years ago. However, one hot summer night Alfred Barr insisted on taking me there. I tried to find all the haunts of my childhood, but everything was changed. Only the rambles with its old castle remained, true to my childhood memories.

Not only was my childhood excessively lonely and sad, but it was also filled with torments. I once had a nurse who threatened to cut out my tongue if I dared to repeat to my mother the foul things she said to me. In desperation and fear I told my mother and the nurse was dismissed at once. Also I was not at all strong and my parents were perpetually fussing about my health. They imagined I had all sorts of illnesses and were forever taking me to doctors. At one period of my life, when I was about ten, they decided I had some intestinal disturbance and found a doctor who ordered me to have colonic irrigations. These were administered by Hazel's nurse and, as she was quite unqualified for her task, the result was catastrophic. I got an acute attack of appendicitis and was rushed off to the hospital at midnight and operated on. For days I was kept in ignorance of the operation, since they thought I was too young to be told. However, I did not believe their silly stories and insisted that my stomach had been cut open.

Soon after this, my sister Benita developed the whooping-cough and we had to be separated lest I catch it and cough open my newly healed, and let me add, enormous wound. My mother took a house in Lakewood, New Jersey, for herself and Benita, and I was sent to a hotel with a trained nurse.

Needless to say I passed a lonely winter and only occasionally
was I permitted to speak to Benita on the street and from a
great distance. My mother had several nieces who were mar-
riageable and she was perpetually giving house-parties for them
while she shut poor Benita up in a wing of the house. As a
result Benita became melancholic. I must have been very pre-
cocious and spoiled, since I was allowed to visit my mother and
entertain her visitors. I fell in love with one of them. His name
was Max Rossbach and he taught me to play pool.

Not long after this I had a bad accident while riding in
Central Park. As I passed under a bridge some boys on roller
skates overhead made such a noise that my horse bolted. My
lady riding teacher was as incapable as I of stopping the beast.
I lost my seat, fell to the ground and was dragged for quite a
distance. I could not disengage my foot from the stirrup and
my skirt caught on the pommel. Had I been riding astride this
never would have occurred. I not only hurt my foot but I
seriously injured my mouth. My jaw was broken in two places
and I lost a front tooth. A policeman, finding the tooth in the
mud, returned it to me in a letter, and the next day the dentist,
after disinfecting it, pushed it up into its original position.
This did not end my troubles. My jaw had to be set. During
the operation a great battle took place among the attending
surgeons. Finally, one of them triumphed over the other and
shook my poor jaw into shape. The vanquished dentist who
was called Buxbaum never got over this. He felt he had
superior rights over my mouth, as he had been straightening my
teeth for years. The only good that came out of all this was that
it put an end to the agonies I had been suffering in the process
of being beautified. Now that had to end. The first danger in-
curred was the possibility of being blood-poisoned. When that
passed, the only risk I ran was of getting hit in the mouth
and losing my tooth again before it was firmly implanted. In
those days my sole opponents were tennis balls, so that when I

played tennis I conceived the bright idea of tying a tea strainer in front of my mouth. Anyone seeing me must have thought I had hydrophobia. When it was all over my father received a bill for seven thousand five hundred dollars from the dentist who had never admitted his defeat. My father persuaded this gentleman reluctantly to accept two thousand.

In spite of all the trouble I went through to preserve the tooth, I knew it could not remain with me for more than ten years, after which time its root would be completely absorbed and the tooth would have to be replaced with a porcelain one. I was prophetic in gauging its life, may I say, almost to the day. After ten years I made an appointment to have it replaced before it fell out, which it did exactly two days before the dentist expected me.

One of my first great passions was for the actor William Gillette. I went to all his matineés and virtually screamed to warn him when I thought he was going to be shot by an enemy in the play *Secret Service*.

Benita was the only companion of my childhood and I therefore developed a great love for her. We were perpetually chaperoned by French governesses, but they were always changing, so that I can barely remember them. Hazel, being so much younger, had a nurse and lived a distinctly separate life. I don't remember my mother at all at this age.

When I was five or six my father began to have mistresses. A certain trained nurse lived in our house in order to massage my father's head since he suffered from neuralgia. According to my mother this nurse was the cause of all her troubles in life as she somehow influenced my father for the bad, without actually ever having been his mistress. It took my mother years to rid herself of the poisonous presence of this woman in our household, for my father depended on her so much for the massage. However, we finally got rid of her but it was too late. From then on my father had a whole series of mistresses. My

mother took it as a great offense that my aunts remained friendly with this nurse and had long feuds with them for befriending her. All this affected my childhood. I was perpetually being dragged into my parents' troubles and it made me precocious.

My father always called me Maggie, only much later did I become Peggy. He had beautiful jewelry made for us which he designed himself. In honor of my name, Marguerite, he once presented me with a little bracelet that looked like a daisy chain, made of pearls and diamonds. My mother received more substantial presents, among them a magnificent string of pearls.

I adored my father because he was fascinating and handsome, and because he loved me. But I suffered very much as he made my mother unhappy, and sometimes I fought with him over it. Every summer he took us to Europe. We went to Paris and to London where my mother visited hundreds of French and English Seligmans. We also went to fashionable watering-places. My mother was very mean about tipping and on one occasion I remember to my great embarrassment seeing all our luggage chalked with crosses. When we were leaving Trouville the hotel porters had marked them as a sign of warning to the porters of the next hotel, our future victims.

My father engaged a lady called Mrs. Hartman to teach us art. We brought her to Europe with us and it was her duty to make us cultured. She took us to the Louvre, the Carnavalet and to the Châteaux of the Loire. She taught us French history and also introduced us to Dickens, Thackeray, Scott and George Eliot. She also gave us a complete course in Wagner's operas. I am sure Mrs. Hartman did her best to stimulate our imaginations, but personally, at that time, I was more interested in other things. For one, I was infatuated with my father's friend, Rudi. He was a typical roué and I can't imagine now why he fascinated me. I was so much enamored of him that I wrote mad letters about my passion, in which I said my body was

nailed to the fire of the cross. When Rudi married one of my cousins whom my mother had brought to Europe with her, and whose unfortunate marriage I fear she and my father arranged, I wept bitter tears and felt completely let down. I complained, saying he had no right to trifle with the affections of two women at once. At this time I must have been about eleven.

Besides this exalted life which I seem to have led, I had a hobby for something much more material—I collected elegant little wax models and dressed them in the most fashionable of clothes, which I created and executed myself. This was inspired by the fact that we were summering in Trouville where all the ladies and the courtesans were so chic.

One day when I was having tea with Benita and my governess at Rumpelmeyer's in Paris, I found myself fascinated by a woman at the next table. I could not take my eyes off her. She seemed to react in the same way to us. Months later, after I had been tormenting my governess to tell me who my father's mistress was, she finally said, "You know her." Like a flash the face of the woman at Rumpelmeyer's came to my mind and when questioned my governess admitted I was right.

This woman was called the Marquise de Cerutti. She was neither pretty nor young. I never understood my father's infatuation for her. But she had the same agreeable quality (maybe sensuous) of the trained nurse. The Marquise was dark and resembled a monkey. She had ugly teeth which my mother used to refer to with contempt as "black." We met this woman everywhere in Paris. It was most awkward. One day at the dressmaker Lanvin, my mother, accompanied by Benita and me, walked into a room where the Marquise de Cerutti was seated. My mother rushed out of the room and we followed her. The Lanvin staff, with correct French understanding, gave us another *salle* to ourselves.

The Marquise, as we used to call her, or T.M., as my father referred to her for short, meaning The Marquise, wore the

most elegant clothes. She had one suit which was made entirely
of baby lamb fur. One day when we were taking our morning
walk in the Bois on the Avenue des Acacias, we met the Mar-
quise wearing this costume. My mother protested to my father
regarding his extravagance. To console her he gave her money
to have the same suit made for herself. Being a good business
woman she accepted the money but instead she invested it in
stocks and bonds.

The Marquise de Cerutti had been preceded by another lady.
This lady, whom I never saw, nearly succeeded in marrying
my father. In fact my mother had come to the point of divorc-
ing him. But the whole Guggenheim family came in groups and
individually, begging her to reconsider her decision. We had
streams of visitors all day long. Their one idea was to avoid
this catastrophe. Finally my mother gave in. I don't know when
the affair ended, but I do know that the disappointed mistress
received a large consolation prize and to this day part of my
income goes to her regularly, twice a year.

The Marquise de Cerutti did not last long and was followed
by a young blond singer. She was with my father when he was
drowned on the Titanic in 1912 and was among the survivors
brought back to New York.

In 1911 my father had more or less freed himself from us.
He had left his brothers' business and had his own in Paris.
This was a move he doubtless made to be able to live a freer
life, but its consequences were more far-reaching than he ever
realized. By leaving his brothers and starting his own business,
he forfeited his claims to an enormous fortune. He had an
apartment in Paris and was interested in or owned a concern
which built the elevators for the Eiffel Tower. In the spring of
1912 he was finally to return to us after an eight months
absence. He had a passage on some steamship which was can-
celled because of a strike of the stokers. By this mere accident

of fate he was to lose his life: he booked a place on the ill fated Titanic.

On April 14th, as people came out of the Metropolitan Opera House, they were greeted with shouts of "Extra!" announcing the dramatic sinking of this gigantic liner on her maiden voyage. In order to make a record trip for the White Star Line, Bruce Ismay, the president of the company, who was himself on board, and the captain, ignored the warning of icebergs and forged their way ahead completely disregarding the danger. The Titanic rushed to her doom. The first iceberg she encountered ripped her bottom open. Within an hour she sank, stern and bow going under together after a terrific explosion which split her in two. There were only enough life boats for a quarter of the people on board. Others who could swim were frozen in the icy water before Captain Rostrum of the S.S. Carpathia could come to their rescue. Seven hundred people were saved out of twenty-eight hundred. The world was shaken by this disaster. Everyone waited breathlessly for the Carpathia to dock to find out who were the lucky survivors. We wired Captain Rostrum to find out if my father was on his ship. He wired back, "No." For some reason I was told this while my mother was kept in ignorance until the last minute. Then two of my cousins went down to meet the survivors. They met my father's mistress.

With my father there died a lovely young Egyptian, Victor Giglio, who was his secretary. He had had a hard time in the past and was happy to have been engaged by my father, thinking his troubles were ended. I was attracted to this beautiful boy, but my father did not approve of my ardor. A steward of the Titanic, a survivor, came to see us to deliver a message from my father. He said that my father and his secretary had dressed in evening clothes to meet their death. They had wanted to die as gentlemen, which they certainly did, by gallantly giving their places to women and children.

My father's body was never recovered and was therefore not buried in Halifax with those that the sea washed up. Many other well known men were lost on the Titanic, among them Widener, J. B. Thayer, John Jacob Astor, Edgar Meyer, and Isadore Straus with his wife who refused to leave him. In those days, before the First World War and before the sinking of the Lusitania, the Titanic was considered a worldwide tragedy. Naturally there was an inquest, but the captain had committed suicide, or rather he had the decency to go down with his boat. From then on we avoided the White Star Line like the plague.

At the time of my father's death we were living in the St. Regis Hotel—we had rented our house to one of my aunts—where we had enormous apartments. In those days the St. Regis Hotel was the stronghold of the Guggenheim family. My uncle Daniel had a whole floor beneath us. Every Friday evening there was a family reunion, when my uncles would get together to talk business while my aunts retired to a corner to discuss clothes. Needless to say they had plenty to recount on this score, since they all went to the most expensive dressmakers in New York.

After my father's death I became religious. I attended the services in Temple Emanu-el regularly, and took great dramatic pleasure in standing up for the *Kaddish* (the service for the dead). My father's death affected me greatly. It took me months to get over the terrible nightmare of the Titanic, and years to get over the loss of my father. In a sense I really have never recovered as I suppose I have been searching for a father ever since.

When my father died, he left his business affairs in an awful muddle. Not only had he lost a vast fortune by discontinuing his partnership with his brothers, but the money he should have had, some eight million dollars, he had lost in Paris. The small amount that was left was tied up in stocks that were yielding no interest and were at such a low ebb that they could not be sold. However, my mother did not know this and we continued

living on the same scale. My uncles, the Guggenheims, very
gallantly advanced us any funds we needed, keeping us in
supreme ignorance. Finally my mother discovered the truth and
took drastic steps to end the false situation. To begin with she
started spending her own personal fortune. We moved to a
cheaper apartment with fewer servants. She sold her paintings,
her tapestries and her jewelry. She managed very well, and
although we were never poor, from that time on I had a com-
plex about no longer being a real Guggenheim. I felt like a
poor relative and suffered great humiliation thinking how
inferior I was to the rest of the family. My grandfather Seligman
died four years after my father, and then my mother inherited
a small fortune from him. We immediately reimbursed my
father's brothers. After seven years my uncles settled my father's
estate. They had finally put things into such shape that by
advancing their own money my sisters and I each inherited four
hundred and fifty thousand dollars and my mother slightly
more. Half of what I received was placed in trust and my uncles
insisted that I voluntarily do the same with the other half.

Of course we went into mourning. I felt important and
self-conscious in black. In the summer, to my great relief, I was
allowed to wear white. We went to Allenhurst on the Jersey
coast, which was the summer resort of most of the Jewish
families we knew. Not actually Allenhurst but the places next
to it, Deal Beach, Elberon and West End, were all built up with
the homes of the Jewish bourgeoisie. It was the ugliest place
in the world. Not one tree or bush grew on this barren coast.
The only flowers I remember were rambler roses, nasturtiums
and hydrangeas, and since then I have not been able to endure
them. My grandfather had a family mansion in West End, in
which all his children were born, including my mother, the
youngest. It was in this hideous Victorian house that my grand-
father, at the age of ninety-three, died during the last war.

My Guggenheim uncles all owned the most magnificent

houses on this coast. One uncle had an Alsatian wife and with her French taste they built a house which was an exact copy of the Petit Trianon at Versailles. Another uncle had a magnificent Italian Villa with marble Pompeian inner courts and beautiful grottoes and sunken gardens. Compared to these my grandfather Seligman's house was a modest affair. It was completely surrounded by two porches, one on each floor. The porches were covered with rocking chairs where the entire family sat and rocked all day. It was so ugly in its Victorian perfection that it was fascinating. The culminating point was the family portraits. My mother and her two sisters and five brothers had all been painted as children, in costumes of the period made of black velvet with white lace collars. In their hands they carried birds, Bibles or hoops. They looked so heavy-eyed in these portraits that they were unmistakably Semitic.

As most of this coast was inhabited by Jewish families, it became a sort of ghetto. In Allenhurst, which was anti-Semitic, there was a hotel opposite us that would not admit Jews. During the summer, to our great delight, it burned down while we stood watching. Every summer that we did not spend in Europe we spent on this horrible coast. We bathed in the Atlantic in the wild breakers and played tennis and rode horses. However, I much preferred Europe and the next year, 1913, we persuaded my mother to take us back.

When war broke out in 1914 we were again in England, visiting one of my mother's cousins, Sir Charles Seligman. I remember shocking him very much by my careless and extravagant appetite. He was worried about the lack of food that would result from the war, and I had asked for some more beef to finish up my mustard.

part 1

chapter 2

virginity

During my sixteenth summer I became conscious of sex. It was very upsetting and frightening. It began pleasantly when I fell in love with Freddy Singer, a nephew of the Singer Sewing Machine people. We were all living in a hotel in Ascot. His brother fell in love with Benita, so we had great fun dancing and playing tennis together. But after that I had a disagreeable fright about sex. I was visiting one of my Seligman grand-aunts in Kent. In her household was a young medical student from Munich, who was an American by birth and therefore not interned. I felt he wanted to seduce me and I think he was amused by my fear and played up to the role of seducer. I have never been so terrified in my life. Later when I met him in New York he resumed his role again, but this time he wanted to marry me. I convinced him to marry my cousin instead. She was my best friend and he seemed to be in love with both of us. I was then in school and my cousin was a mature woman fifteen years older than our suitor. The marriage was successful and they had lovely twin daughters.

During the war I finally was sent to school. It was a private
school on the West Side for young Jewish girls, and I would
walk there every day through Central Park since we lived in an
apartment on Fifth Avenue and Fifty-eighth Street. But after
a few weeks I developed whooping-cough and bronchitis, and
had to spend the winter in bed. I was lonely and neglected, as it
was the year of Benita's début, and my mother was very busy
with her. Somehow I managed to do all my homework alone
and kept up with the school course and passed all my exams.
I am not at all intellectual and it was a great effort. But I did
like reading, and I read constantly in those days. I read Ibsen,
Hardy, Turgenev, Chekhov, Oscar Wilde, Tolstoy, Strindberg,
Barrie, George Meredith and Bernard Shaw.

My second year at school was slightly more fortunate than my
first. I managed to attend regularly, with the exception of a
short period when I contracted the measles. We had a busy
winter preparing to produce *Little Women* as our graduation
play. Mrs. Quaife, our wonderful dramatic teacher, conceived
a life-long affection for me, introduced me to Browning's poems
and gave me the rôle of Amy in the play. When I left school
I renounced the idea of going to college. This was due to
Benita's influence. She talked me out of it, she said I had done
the same to her. For years I regretted it.

During my second school year I began to have a social life.
I organized a little dance club with my schoolmates and some
other girls. To cover the expenses of a monthly ball, we all con-
tributed money. We were permitted to invite one or two boys
to come and dance with us. We made a list of the desirable
young men in our Jewish circles and then I held a mock auction
sale and auctioned them off to the highest bidder, who then had
the privilege of inviting him. These parties were gay and really
not at all stuffy.

About the time I graduated from school I began a great
friendship with a beautiful girl called Fay Lewisohn. She

resembled Geraldine Farrar, which was most appropriate, as her home was the center of gatherings of the Metropolitan Opera Company. My feeling for Fay was much greater than hers for me and I now think that mine was unconsciously of the order of *Madchen in Uniform*. Maybe Fay suspected this. In any case she was interested in young men.

Fay's mother, Mrs. Adele Lewisohn, and her grandmother, Mrs. Randolph Guggenheimer, were charming hostesses. They entertained lavishly not only singers, but also all the intellectuals of New York. Unfortunately Fay and I were too young to take part. Or rather, Fay hated this as much as I hated being dragged into my mother's social life. They lived on Fifth Avenue in a house with a strange balcony on the top floor bearing stone figures of women resembling caryatids. Mrs. Lewisohn admired me, as I did her; and years later when I met her in Paris she told me how suitable a friend she had considered me for Fay and regretted that her daughter did not appreciate me as much as she did. She considered me a serious-minded girl compared with Fay who loved only pleasure.

During the summer of 1915 I received my first kiss. It was from a young man who took me out driving every night in my mother's car. He invariably borrowed our automobile to drive home afterwards and would bring it back every morning at seven on his way to the station, when he went to New York to his job. My mother disapproved of my suitor because he had no money. She controlled herself until the night when he kissed me for the first and last time. We were in the garage and as he leaned over me, by mistake he put his arm on the horn. This awoke my mother. She greeted us with a storm of abuse and screamed at us, "Does he think my car is a taxi?" Needless to say I never saw the young man again. My mother felt triumphant, but several years later Fate proved her, according to her standards, entirely in the wrong, as this young man fell heir to a million dollars.

After graduating from school I was rather at a loose end. I continued reading with my voracious appetite and studied courses in history, economics and Italian. I had one teacher called Lucile Kohn, who had a stronger influence over me than any other woman has ever had. In fact, because of her, my life took a completely new turn. It didn't happen suddenly; it was a gradual process. She had a passion for bettering the world. I became radical and finally emerged from the stifling atmosphere in which I had been raised. It took me a long time to liberate myself, and although it was not for several years that anything occurred, the seeds that she sowed sprouted, branching out in directions that even she never dreamed of. Her interests were entirely political and economic. She had complete faith in Woodrow Wilson. But when she was disappointed by his inability to carry through his program she joined the Labor movement. I did not follow her, being by then in Europe, but I sent her vast sums of money. Later she told me that I had altered her life, too, by sending her this money. She acquired an important standing in the Labor movement and has been working fervently for it since that time.

I had taken to riding again as soon as I was allowed to after my accident, but this time I took no chances. Not only did I have a male teacher but I also learned to ride astride. At fourteen I fell in love with my riding teacher. He was a fascinating Irishman who flirted with all of his pupils.

During the war I learned to knit. Once I started, I never stopped. I took my knitting everywhere with me, to the table, to concerts, even to bed. I became so adept I could make a sock in one day. I remember my Grandfather Seligman greatly disapproving of my speed, which he claimed made me spend too much money on wool. I fear his parsimoniousness surpassed his patriotism.

As we could not go to Europe during the war, my mother took us up to Canada one summer. We motored all the way.

During the entire trip I knitted and missed most of the beautiful scenery. However, I managed to look up occasionally and felt well recompensed for my sacrifice. In Canada we made great friends with the Canadian soldiers who were stationed near Quebec. Benita and our friend, Ethel Frank, and I had great fun with them. On the 'way home we were politely but firmly turned out of a hotel in Vermont for being Jewish. As the state law forbids hotel-keepers to refuse lodgings overnight, we were allowed to remain until morning and then we were informed that our rooms were rented. This gave me a new inferiority complex.

Later I went to a business school to learn stenography and typing. I thought I might get a war job. However, I was too stupid to keep up with the girls who were all of the working class and who made me feel like a rank outsider. I soon gave it up.

In 1916 I made my début. I gave a big afternoon Leap Year party in the Ritz Tent Room. From then on I went to many parties and was taken out in the evening by young men. I found this sort of life idiotic, though I was a good dancer and loved dancing. The whole thing seemed to me artificial and I never met anyone I could talk to seriously.

Eventually, we moved to 270 Park Avenue. My mother permitted me to choose furniture for my bedroom, and I was allowed to charge it to her. But unfortunately I disobeyed her and went shopping on the sacred Day of Atonement, the great Jewish holiday *Yom Kippur*. I had been expressly warned not to do this and I was heavily punished for my sin. As a result my mother refused to pay for the furniture. I was left stranded with this large debt which I had to take out of my allowance. Benita came to my rescue and supported me for weeks. Among many other things, I remember going for a beauty treatment to Elizabeth Arden's at Benita's expense.

Ever since my earliest childhood every day at twelve sharp

a sad old lady with a lisp called Mrs. Mack came to our house. She was a shopper and had a little book in which she would note any object that was required in our household. One day it was three yards of lace, a bottle of glue or six pairs of stockings. Another it might be a box of soap, sewing silk or a green feather for a hat. At Christmas time she was most occupied when she came with a much larger notebook and found out confidentially, in turn, what each of my sisters and I would like for presents from Mrs. Dan, Mrs. Sol, Mrs. Simon, Mrs. Murray, etc., as she called my Guggenheim aunts. Then she proceeded to the shops where she had charge accounts and received ten percent discount on her purchases. As she invariably bought everything wrong, most of her life was spent in exchanging things. When we shopped for ourselves we did much better and she benefited just the same because we charged everything to her.

In 1918 I took a war job. I sat at a desk and tried to help our newly-made officers buy uniforms and other things at reduced rates. I had to give advice and write out many cards of introduction. I shared this job with my friend, Ethel Frank, who had been my most intimate school companion. When she fell sick, I did all her work and mine, and the long hours proved too strenuous for me. I collapsed. It began by my not sleeping. Then I stopped eating. I got thinner and thinner and more and more nervous, I went to a psychologist and asked him if he thought I was losing my mind. He replied, "Are you sure you have a mind to lose?" Funny as his reply was, I think my question was quite legitimate. I used to pick up every match I found and stayed awake at night worrying about the houses that would burn because I had neglected to pick up some particular match. Let me add that all these had been lit, but I feared there might be one virgin among them. In despair my mother engaged Miss Holbrook, my dead grandfather's nurse, to look after me. She accompanied me everywhere. I wandered

around, revolving in my brain all the problems of Raskolnikov, thinking how much I resembled this hero of Dostoevsky's *Crime and Punishment*. Finally Miss Holbrook, by sheer force of will, made me think of other things. Little by little I became normal again. During this period I was engaged to a flying officer who was still in this country. I had several fiancés during the war as we were always entertaining soldiers and sailors.

In the spring of 1919 Benita married a young American aviator who had just come back from Italy. The whole thing was most unfortunate. Since 1914 she had been in love with a Russian baron she had met in Europe. For some reason or other, which I could never make out, this Russian, although he seemed to love her, never came to the point of actually proposing to her. During the war he was attached to his legation in Washington and we saw him often in New York.

However, in a moment of weak-mindedness, she married the flier because he threatened to commit suicide if she didn't. Peggy, our best friend, and I were witnesses at City Hall. As soon as the marriage was over we came back and told my mother. She was all for having it annulled, and Benita seemed to agree. But in the end she went off with the aviator on a honeymoon and they settled down together. To me he was completely unworthy of her. He was handsome in a flashy way, but superficial with no depths of passion. He was melodramatic. I was madly jealous and unhappy. I missed her presence in our house beyond words, and I was left alone with my mother, for Hazel was at boarding school. My mother's one idea was to sacrifice her life to her children and she had done nothing else since the death of my father. We wished that she had married again instead.

In the summer of 1919 I came into my fortune. I was an heiress and I was independent. My mother was greatly upset. She could no longer control me. The first thing I did was to make an extensive trip all over the United States. I invited my

brother-in-law's cousin to chaperon me. We went from Niagara Falls to Chicago and from there to Yellowstone Park, all through California, down to Mexico and up the coast to the Canadian Rockies. At that time Hollywood was just born. It was so small that it was almost non-existent. I had a cousin there who introduced me to some movie people. They all seemed quite mad. On the way home we visited the Grand Canyon. Then we returned to Chicago, where I was met by my aviator fiancé who had been demobilized. He introduced me to his family, who were all Chicagoans, but I did not make a hit. I complained too much about the provincialism of Chicago. As I was leaving on the Twentieth Century, he told me it was all off. I was very unhappy because I thought I was in love with him and was patiently waiting for him to make a fortune in, the loose-leaf paper business so that he could marry me. His name was Harold Wessel.

In the winter of 1920, being very bored, I could think of nothing better to do than have an operation performed on my nose to change its shape. It was ugly, but after the operation it was undoubtedly worse. I went to Cincinnati where there was a surgeon who specialized in these beauty operations. He made you choose a plaster model of the nose you preferred. He never was able to give me what I wanted, a nose "tip-tilted like a flower," something I had read about in Tennyson. During the operation (performed under local anaesthetic), when I was suffering the tortures of the damned, surrounded by five nurses in white masks, the doctor suddenly asked me to choose again. He could not do what he had planned. It was all so painful I told him to stop and leave things as they were. As a result of the operation my nose was painfully swollen for a long time and I didn't dare set foot in New York. I hid in the Middle West waiting for the swelling to go down. Every time it rained I knew it beforehand, because my nose became a sort of barometer and would swell up in bad weather. I went to French

Lick, Indiana, with a friend and gambled away nearly another thousand dollars, the operation having cost as much.

A short time later Margaret Anderson came to me and asked me if I would give her some money for the *Little Review*, and an introduction to one of my uncles. She said that if people believed in preventing wars the best possible thing to do was to subscribe to the arts. Being young and innocent, I hoped I had put off the next World War for several years by contributing five hundred dollars to the *Little Review*. I sent Margaret to my fur coat uncle and if she did not succeed in getting five hundred dollars out of him (I can't recall now) I trust at least that she got a fur coat.

If Lucile Kohn was responsible for my radical beliefs, my actual liberation came about quite differently from any manner she might have foreseen. One day when I was at my dentist's, I found him in a predicament. His nurse was ill and he was doing all his work alone. I offered to replace the nurse as best I could. He accepted my help, for which he paid me $2.35 a day. I opened the door and answered the telephone. I held instruments for him and boiled them. I also learned which of my acquaintances had false teeth. Of course I was recognized by the patients, who asked Dr. Scoby in great surprise if it wasn't Miss Guggenheim who admitted them into the office. All this soon came to an end when the real nurse returned.

I now felt in need of a job so I offered my services to my cousin, Harold Loeb. He had a little radical bookshop near Grand Central Station. I became a clerk and spent my afternoons on the balcony writing out checks and doing various boring jobs. I was only permitted downstairs at noon, when I had to replace the people who went to lunch, at which time I sold books. When I complained of my fate to Gilbert Cannan, who came often and sat for hours in the bookshop, he said to me, "Never mind, Lady Hamilton started out as a kitchen-maid."

Though I was only a clerk, I swept into the bookshop daily, highly perfumed, and wearing little pearls and a magnificent taupe coat. My mother disapproved of my working and came often to see what I was up to and to bring me rubbers if it was raining. This was embarrassing. My rich aunts also came and literally bought books by the yard to fill their bookcases. We had to bring out a tape measure to be sure the measurements coincided with their bookshelves.

In the bookshop I met many celebrities and writers and painters, among them Marsden Hartley and my future husband, Florenz Dale, Leon Fleischman and his wife Helen, who later married James Joyce's son.

Although I received no salary in the Sunwise Turn Book Shop, Harold Loeb and his partner, Mary Mowbray Clarke, allowed me a ten percent reduction on all the books I bought. In order to have the illusion of receiving a big salary, I bought many books of modern literature and read them all with my usual voracity.

The people I met in the Sunwise Turn fascinated me. They were so real, so alive, so human. All their values were different from mine. I loved Mary Mowbray Clarke. She became a sort of goddess for me. Eventually she sold the bookshop to Doubleday Doran, having bought out Harold Loeb long before.

Marsden Hartley impressed and terrified me. So did Gilbert Cannan. I was much less afraid of Florenz. He was about twenty-nine at this time, and to me he appeared like someone out of another world. He was the first man I knew who never wore a hat. His beautiful, streaky golden hair streamed all over as the wind caught it. I was shocked by his freedom but fascinated at the same time. He had lived all his life in France and he had a French accent and rolled his r's. He was like a wild creature. He never seemed to care what people thought. I felt when I walked down the street with him that he might suddenly fly away—he had so little connection with ordinary behavior.

The Fleischmans became my great friends. They practically
adopted me. I was so unhappy about Benita that I was delighted
to have a new home. I fell in love with Leon, who to me looked
like a Greek God, but Helen didn't mind. They were so free.

One day Leon took me to see Alfred Stieglitz. They put the
first abstract painting I had ever seen in my hands. It was
painted by Georgia O'Keefe. I turned it around four times
before I decided which way to look at it. They were delighted.
I didn't see Stieglitz again until last spring, twenty-five years
later, and when I talked to him I felt as though there had been
no interval. We took up where we left off.

Soon after I went to Europe. I didn't realize at the time that
I was going to remain there for twenty-one years, but that
wouldn't have stopped me. My mother went with me and she
brought my Aunt Irene Guggenheim's cousin, Valerie Dreyfus,
to help look after me. I was already too much of a handful
and my mother knew she couldn't keep up with me. As much
as I could, I dragged these two ladies all over Europe with my
usual speed and my usual enthusiasm. Soon my mother got
tired and handed me over to Valerie. *She* could keep up with
me. In fact she encouraged me. She was a wonderful guide, had
been everywhere before and was a very smart traveler. We went
to Holland, Belgium, Spain and Italy. With my mother we had
already been to Scotland, all over England and through the
Loire country.

In those days my desire for seeing everything was very much
in contrast to my lack of feeling for anything. That was born,
however, as a result of my other frenzy. I soon knew where
every painting in Europe could be found, and I managed to get
there, even if I had to spend hours going to a little country
town to see only one. I had as a great friend Armand Lowen-
gard, the nephew of Sir Joseph (later Lord) Duveen. He was a
fanatic about Italian painting. Seeing what a good subject
I was, he egged me on to study art. He told me that I would

never be able to understand Berenson's criticism. This remark
served its purpose. I immediately bought and digested seven
volumes of that great critic. After that I was forever going
around looking for Berenson's seven points. If I could find a
painting with tactile value I was thrilled. Armand had been
wounded in the war and was rather badly done in. My vitality
nearly killed him and though he was fascinated by me, in the
end he had to renounce me, as I was entirely too much for him.

I had another boy-friend, Pierre. He was a sort of cousin of
my mother's. I felt wicked because I kissed both him and
Armand on the same day. He wanted to marry me but I merely
wanted to have as many suitors as I could collect. Soon I wanted
more than that. I had a great friend, Fira Benenson, a Russian
girl. We lived in the Crillon Hotel in Paris and tried to outdo
each other in collecting proposals. We dressed in the most
elegant French fashions and I am sure we were idiotic.

I didn't see the Fleischmans again until I returned to America
for a brief visit in the spring to attend Hazel's wedding to
Siggy. I then persuaded the Fleischmans to come and live in
Paris. As they had a child and little money, Leon having re-
signed as a director of Boni and Liveright's publishing house,
it was all very complicated. But they came. It changed their life
as much as they had changed, and were still to change, mine.

Helen Fleischman was a friend of Florenz. She was having a
little affair with him into which Leon had pushed her. It excited
him. She told me that she wanted me to come to dinner with
Florenz and then she told Florenz not to pay too much attention
to me because Leon would be offended. I think Leon must have
been, as Florenz and I got quite friendly.

A few days later Florenz took me out for a walk. We went
to the tomb of the Unknown Soldier and then we walked along
the Seine. I was wearing an elegant costume trimmed with
kolinsky fur that I had designed for myself. He took me into a
bistro and asked me what I wanted. I asked for a porto flip

thinking I was in the kind of bar I was used to. In those days I led only the most expensive sort of life and had never set foot in an ordinary café and had no idea what to order.

At this time I was worried about my virginity. I was twenty-three and I found it burdensome. All my boy-friends were disposed to marry me, but they were so respectable they would not rape me. I had a collection of photographs of frescos I had seen at Pompeii. They depicted people making love in various positions, and of course I was very curious and wanted to try them all out myself. It soon occurred to me that I could make use of Florenz for this purpose.

Florenz lived with his mother and his sister Odile in a very bourgeois apartment near the Bois. When his father was not in a sanatorium having a *crise de nerfs*, he was living at home upsetting his entire family. Florenz's mother was an aristocratic New England lady. His father was a painter. He was of Breton ancestry, half French, half American. He had been neurasthenic for years and his family had no idea what to do about him. They had tried everything but he was the world's great incurable neurotic.

Florenz wanted to get away from home again. His mother gave him a small allowance of one hundred dollars a month and, considering her income was ten thousand dollars a year, she wasn't over-generous. But she preferred to spend it on her husband, whose capital had long since vanished paying doctor's bills. He had been in every sanatorium in Europe. Florenz might have taken a job but he didn't like working. He was a writer of considerable talent but as yet unknown.

He now told me he was about to take a little apartment, and I asked if I could pay half the rent and share it, hoping by this maneuver to get somewhere. He said yes, but soon changed his mind. The next time I saw him he told me he had taken a hotel room in the Rue de Verneuil on the left bank, in the Latin Quarter. He came to see me at the Plaza-Athénée Hôtel where

I was living and started to make love to me. When he pulled me towards him I acquiesced so quickly that he was surprised by my lack of resistance. However I told him that we could not do anything there as my mother might return at any moment. He said we would go to his hotel room sometime. I immediately rushed to put on my hat, and he took me to the Rue de Verneuil. I am sure he had not meant to. That was how I lost my virginity. It was as simple as that. I think Florenz had a pretty tough time because I demanded everything I had seen depicted in the Pompeian frescoes. I went home and dined with my mother and a friend gloating over my secret and wondering what they would think of it if they knew.

part 2

chapter 1

marriage

Florenz was considered the King of Bohemia. He knew all the American writers and painters and a lot of French ones too. In those days they met at the Café de la Rotonde in Montparnasse. But Florenz had a row with a waiter or the manager of that café and he made everybody move opposite to the Dôme. After that they never returned to the Rotonde. Florenz gave wonderful parties in his mother's apartment. The first one I went to was very wild. I took with me a bourgeois French playwright, and in order to make him feel at home in the midst of Bohemia, I sat on his lap most of the evening. Later I received a proposal (I can hardly say of marriage) from the girl who was to become the well known Robin of *Nightwood*. She got down on her knees in front of me. Strange things were happening everywhere. Florenz's father was at home and was very annoyed by the confusion the party caused. In desperation he retired to the toilet where he found two delicate young men weeping. He retired to another bathroom where he disturbed two giggling girls. He liked to be the center of attraction. If there was any-

thing going on he wanted to be the star himself. After he had made a scene he felt better. Even if no one else paid much attention to him, at least his wife must have.

I soon met two great friends of Florenz: Agnes Dew and Djuna Barnes. They had both been his mistresses. They were very beautiful women. They had the kind of nose I had gone all the way to Cincinnati for in vain. Agnes Dew was dark with a beautiful figure. She was tall and elegant and had soft eyes. Her widow's peak was her great attraction. She was the only person in Bohemia with any money and yet she was always broke because she lent it or gave it all away the minute it arrived from America. She was a war widow. She was waiting for some man called Norman to join her in Paris, but first he had to disentangle himself from his wife.

Djuna was quite different. She was already a well known writer. Leon had borrowed a hundred dollars from me to help pay her passage to Europe. Later she did journalistic jobs. She rushed around Europe interviewing famous people. She wrote articles about celebrities for which she received enormous prices. At this time she was not rich.

Helen Fleischman told me to give Djuna some underwear. A disagreeable scandal ensued as the underwear I gave was Kayser silk and it was darned. I had three distinct categories of underwear: the best, which I had decorated with real French lace and which I was saving for my trousseau; my second best that was new, but unadorned, and that which I sent to Djuna. After she complained, I sent her the second best sets. I went to visit her. She was sitting at the typewriter wearing the second best underwear. She looked handsome with her white skin, her magnificent red hair and her beautiful body. She was very much embarrassed to be caught wearing the underwear after all the rows that had been made. Anyhow I apologized about the first lot I had sent her, and she forgave me. When Helen gave Djuna presents she just opened her cupboards and said, "Help your-

self." I felt I should be less mean, so I gave Djuna my favorite russet cape and my favorite hat. It was adorned with a cock's tail feathers and when she wore it she looked like an Italian soldier.

One day I took Djuna to the Musée du Louvre and gave her a lecture on French art. I think she was bored. We met Agnes Dew there and all three of us went to lunch. All through the meal I could not talk to them. I had a lot of homework to prepare. In those days I was studying Russian because I did not like Fira Benenson to have secrets from me. All her friends were Russian and I felt left out of their conversations, so I decided to study their language.

When Florenz told Helen about our affair she took it very well. But Leon was furious. Anyhow that ended Florenz's affair with Helen and from then on he belonged to me. I decided really to go in for my love affair in a big way, so I convinced my mother to go on a little trip to Rome with one of her nieces. She left Valerie behind to chaperone me. Poor Valerie had no idea what was going on, but she took a room in the Hôtel Plaza-Athénée where I was living and tried to look after me. Florenz came nearly every day.

One day Florenz took me to the top of the Eiffel Tower and when we were gazing at Paris he asked me if I would like to marry him. I said "yes" at once. I thought it was a fine idea. As soon as he had asked me, he regretted it. In fact from then on he kept changing his mind. Every time I saw him look as though he were trying to swallow his Adam's apple, I knew he was regretting his proposal. He got more and more nervous about our future and one day he ran away to Rouen to think matters over. Florenz's mother, Mrs. Dale, insisted on sending Agnes Dew with him (she even paid her train fare), hoping that this would cause sufficient trouble to end the engagement. But when they got to Rouen they did nothing but fight, and soon Florenz wired that he still wanted to marry me.

As we were more or less engaged I decided to warn my mother. She came rushing back from Rome to stop the marriage. She thought she should get references of Florenz. She asked him who would give any. Florenz had a wide circle of acquaintances and at St. Moritz he had once met the King of Greece, so to tease my mother he gave the king's name. My mother carried a little notebook and inscribed names in it. She was quite puzzled and even asked me how she could communicate with the King of Greece. Of course no one thought that we should marry. Leon went to my mother and told her how much of a catastrophe it would be, and Marion, an old friend, the brother of Dulcie, begged me to give up the project. He said, "Do anything, come and live with me as a sister, but don't marry Florenz." Of course I did marry him. It was all the fault of a lawyer called Charlie Loeb. We went to him to find out how it could be done and before we knew it he got all the papers and posted the bans and drew up a *séparation des biens* to protect my rights.

After the bans were posted I began to think we might really marry, but suddenly Florenz decided to go to Capri with Odile and postpone the wedding. I was to return to New York where he would join me in May if we still felt like marrying. One afternoon when he was all packed he went to buy the tickets for his trip. My mother, Mrs. Dale and I sat in the Hôtel Plaza-Athénée, each with her private feelings about the future. Suddenly Florenz appeared in the doorway looking as pale as a ghost and said, "Peggy, will you marry me tomorrow?" Of course I said, "Yes." After that I was still not at all sure that Florenz would not run away, so I decided not to buy a dress for the wedding. I bought a hat instead.

The morning of the wedding Florenz's mother phoned me to say, "He's off." I thought she meant Florenz had run away. He hadn't. She merely meant that he was on his way to fetch me. We went in a tramcar to the Mairie of the Seizieme Ar-

rondissement at Avenue Henri-Martin where the ceremony was
to take place.

We had all invited lots of friends. There were four distinct
elements among the guests. First of all, Florenz had invited all
his Bohemian friends, but as he was rather ashamed of marry-
ing me, he had written them *petit bleu* notes briefly asking
them to be present, as though he were asking them to a party,
and he did not even mention who the bride was to be. My
mother invited all her French Seligman cousins who lived in
Paris and all her bourgeois friends. Florenz's mother invited
the American Colony of which she was herself a well known
hostess. I invited all my friends. They were very mixed at that
time. They were writers and painters, mostly from a very
respectable milieu, and of course there was Boris, my Russian
friend, who came to the wedding and wept because I wasn't
marrying him. Helen Fleischman was my witness and Florenz's
sister was his. My mother nearly cried because she was not
asked to sign the register, so we had to let her add her name
to the others. We made her provide lots of champagne and she
gave us a big party at the Plaza-Athénée after the ceremony.

When we had all drunk a lot of champagne and danced for
hours, someone suggested that Florenz take me away on a honey-
moon. We were going to Italy in three days but Florenz did not
seem to be in the slightest hurry about ending the wedding
party. He was tied up with his sister and hated leaving her.
He felt that his marriage in some way would break up his
relationship with her. To console him I said she could join
us in Capri, where we were going on our honeymoon. I then
asked my Russian teacher, Jacques Schiffrin, to come too, but
Florenz objected, and I had to disinvite him. Finally Betty
Humes, a friend of Florenz who was in the consulate service,
persuaded him to take his bride away. We went to a hotel on
the Rue de Rivoli and then to bed. We soon got up, however,
as we had invited many of our friends to come to a second

wedding party at the little Boeuf sur le Toit in the Rue Boissy
d'Anglas. On the way there we went to Prunier's and ate a lot
of oysters.

The next morning my doctor came to administer a *piqûre*,
as I was recovering from the flu. He was Proust's doctor and
had looked after him all that winter, when he was dying. He
now seemed elated by my marriage and told me I was entering
into a marvelous new life. I was surprised as I felt depressed
and said, "Do you really think so? I don't."

As soon as I found myself married, I felt extremely let down.
Then, for the first time, I had a moment to think about whether
or not I really desired the marriage. Up to the last minute
Florenz had been in such a state of uncertainty that I had been
kept in suspense and never questioned my own feelings. Now
that I had achieved what I thought so desirable, I no longer
valued it so much.

We went to have lunch with my mother. She was curious
about what she imagined was my introduction to love and I
was boastfully apologetic about the smell of lysol which I was
carrying around with me. My mother, thinking she would catch
me, asked, "How often did you use it?" I was disgusted with
her indiscretion and refused to answer her question. All the
waiters in the Plaza-Athénée looked at me as though they too
were curious.

Two days later we went off to Rome. My mother came to the
station with an emergency passport for me bearing my new
name, Marguerite Guggenheim Dale, in case I felt the need of
running away from Florenz, as I was now on his passport.

In Rome we looked up my cousin, Harold Loeb, who was
publishing *Broom Magazine* with Kitty Cannell. Harold was
shocked by Florenz's sockless feet in sandals. I wanted to retain
my independence so I looked up my former beaux in Rome,
and Florenz found some former girl-friends. I still felt distinctly

let down by my marriage and somehow thought it ought to be much more exciting.

Florenz chose an ideal place to take me for our honeymoon. He had lived in Capri before and while I had spent a few brief hours there with Valerie on one of our hasty trips, I had no idea what it was like. I had merely visited the Blue Grotto in a boat. Now we settled down and rented a villa on the Tiberius side of the island, very high up. As we walked down to the sea every day for our swim we found the climb back very trying in the heat. We swam at different beaches but our favorite one was the Piccola Marina. At the Grande Marina we rented little boats called sandolas which were manipulated with a double oar. First you used it on one side and then on the other. We rowed out to meet the steamboat that came from Naples every day. It was all exciting and new to me. I had never been in such a natural place and the beauty of this simple life delighted me.

Capri itself is like an enchanted island. Once you have come there it is very difficult to leave. Most of the inhabitants are *queer* but the beauty of the place and its marvelous setting in the blue Bay of Naples are too good to be true. It is a small rocky island that rises high out of the sea. Above is another town called Anacapri, and below are little fishing villages. The main town, Capri, is the center and has its intense social life on the piazza like all Italian towns. There was a café called Morgano's where one met and made friends. The walks around Capri are extremely beautiful and in parts the vegetation resembles the moors of Scotland.

There were no cars on the island and very few carriages. There was a funicular which took people up from the boat-landing to Capri. One's life depended more or less on the supplies brought over by the boat. For days one could be cut off from the mainland by the rough seas. One had absolutely no sense of responsibility, the whole atmosphere reminding one of an *opéra bouffe*. The following year I was to fathom the depths

of intrigue here and then I really got to know Capri much better. But that comes later.

We had many strange neighbors, our nearest one was a Swedish count who lived a mile further up our road on the way to the ruins of Tiberius's villa. The count, who was a descendant of Marie Antoinette's faithful lover Fersen, lived with a goatherd he had adopted. In order to hold him, he first had him educated, and then he taught him to smoke opium. They were a handsome young couple. Capri was full of such people.

There was one old lady who sold coral in the streets. She was reported to be the ex-mistress of the Queen of Sweden.

Krupp had built himself a magnificent villa here with his war profits. Mrs. Compton Mackenzie had a wonderful villa overlooking the rocks called the Faraglioni, while Mackenzie had built a little stone hut up in the heath at the very top. The year before I came, the Marchesa Casati roamed about the island with a leopard.

I soon found that I had married into a strange family. My mother-in-law was fussy but she was a fine woman of the old school. She was a D.A.R. and behaved like one. Even though she had not approved of the marriage, once it was accomplished she accepted me wholeheartedly. I think she really liked me, and she was the first person I ever met who admired my looks. I had been brought up to believe that I was ugly, because my sisters were great beauties. It had given me an inferiority complex. When Mrs. Dale met Benita and Hazel, she claimed that I was better-looking than either of them. Imagine how this surprised and pleased me. Mrs. Dale accepted me as a daughter-in-law, but she never permitted me to call her "Mother."

If Mrs. Dale accepted me, I cannot say the same for her daughter Odile. She was the thorn in my marriage. She adored her brother with a passion one could not fail to admire and which he reciprocated. (They gave one the feeling that they

were made for incest; and by not indulging in it they augmented their frustrated passion.) Everything was "my brother" with Odile. She did not relinquish one inch of him to me. She always made me feel that I had stepped by mistake into a room that had long since been occupied by another tenant, and that I should either hide in a corner or back out politely. She was a very strong character and I soon found her trying to run my household. My life was doubly complicated by the fact that she was excessively attractive, and was perpetually having love affairs. At first I was shocked, but later I outgrew my puritanical prejudices. Every time she had a new lover Florenz became wildly jealous and, as I was his whipping boy, I suffered very much from it all. Odile was three or four years older than I, and completely mature while I was a baby. That also put me at a disadvantage. She had a very beautiful mezzo-soprano voice and had been studying for years to be a singer. Odile had long blond hair the color of Florenz's. They looked exactly alike as they both had their mother's beaky Roman nose. But Odile was small.

As soon as we were settled in Capri, or rather after three weeks, Odile joined us. She did allow us to be alone for that short period. She brought with her an Italian friend called Elaine, which helped a lot, but when Florenz and Odile stalked together on the Piazza at the hour when everyone collected, I was made to feel non-existent.

I did not have any responsibilities in Capri because our house was run by four Italian sluts, who made love every night with soldiers in our garden. Teresina, the mother of an illegitimate baby, and her three little sisters looked after us. Their salary was minute and only two of them were paid, but they made up for it by cheating us outrageously when shopping and by taking home half of the food. In Italy this was more or less taken for granted by Americans, and when Elaine, as a good Italian woman, wanted to put a stop to it Florenz as a foreigner

would not hear of it. The sluts were charming. They sang Neapolitan songs for us all day long and they even brushed and combed my hair which was too long for me to cope with. They served good meals and we considered ourselves lucky to have them in our household.

Florenz was snobbish about my family. He did not like the Guggenheims, and was perpetually making fun of them. One day after my Aunt Rose had arrived at our house riding a mule, as she could not walk up the hill, he told me that it was extremly appropriate, since it appeared to be quite in keeping with the Old Testament. Another day he told me he would like to throw all my uncles over the cliff where Tiberius had killed his enemies. I was so offended I burst into tears.

In the late summer we left Capri for St. Moritz. We motored through Italy and stopped in Arezzo and San Sepolcro to see the Piero della Francesca frescoes. I enraged Florenz by looking for Berenson's seven points instead of enjoying the paintings for themselves. We went to Venice, Florence and Milan and finally ended up in a little train that zigzagged up to the Engadine.

I had never been to St. Moritz before and was much impressed by the social life there; not that we took much part in it. As a matter of fact we led a quiet family life with Mrs. Dale and Odile and a few friends of mine from England and New York who showed up. Florenz and I played a lot of tennis and we won a tournament. We played well together for he was very strong at the net and I backed him up. I accepted his directions and never let him down.

In the fall I went to New York to see Benita. I had planned this trip long before my marriage and nothing in the world could interfere with it. Florenz went off with Odile to the Basque country on a motor-bike that Benita had given him for a wedding present.

Benita had settled down with her husband and they seemed

quite happy. There was still terrible jealousy between him and
me, and Benita was like a rose between two thorns. Before I
left New York I signed a contract with a publisher who wanted
to publish a novel that Florenz had written long before.

After a short time I realized that I was going to have a baby.
I was quite sick but very happy, and I wired Florenz in order
to warn him. My beautiful aunt, Irene Guggenheim, took me
back to Europe with her in her stateroom, because I was so
sick and she wanted to look after me. I was in bed for the whole
trip. Florenz met us at Southampton, and we were very happy
to be together again.

We had to plan our future about the birth of our child. We
immediately called him Gawd Guggenheim Dale and decided
he must be born in London. We did not want him to be a
French citizen, which he would be if he were born in Paris.
Both Florenz and his father had been born there and the
third generation would be claimed by the French and forced
to do military service. Florenz had an American passport and
had served as a liaison officer in the American Army with the
heavy artillery in the last war.

Aunt Irene's daughter Eleanor, who had married the Earl
of Castlestewart, a psychoanalyst, took me to her doctor in
London. She had just had a baby and she was very pleased with
Dr. Hadley's care. He told me when to expect the birth of
Gawd and we decided to go back to France for the winter and
return to London in May.

We went down to Sussex to visit Eleanor and I remember
her husband telling me what an exciting life I was going to
have with Florenz, instead of the dull one Eleanor was leading
with him. I don't know why everyone thought my future was
to be so thrilling. It certainly was, but I wonder how they all
knew it before I did.

Florenz was a dynamic person. He had an amazing person-
ality and he was handsome. He had great charm which he was

forever turning on people successfully. He always made me feel inferior. I was inexperienced when I met him and I felt like an awful baby in his (what I considered at the time) sophisticated world. Florenz was always bursting with ideas. He had so many he never achieved them because he was forever rushing on to others. He just tossed them off the way most people toss off clichés. It was extraordinary. His vitality was fantastic. He could stay up three nights running. I could never do without my sleep, and when I lay in bed waiting for him to come home, knowing he was drunk and apt to be in trouble, I had no rest. He brought me into an entirely new world and taught me a completely new way of life. It was all thrilling, often too thrilling.

It is difficult to remember now how Florenz and I began fighting. We had one quarrel before we were married, in the Plaza-Athénée Hôtel, caused, I think, by something Valerie said. Florenz made a scene and stalked out in a fury. However, it never dawned on me that this was a sample of what I might expect perpetually in the future. Florenz was very violent and he liked to show off. He was an exhibitionist, so that most of his scenes were made in public. He also enjoyed breaking up everything in the house. He particularly liked throwing my shoes out of the window, breaking crockery and smashing mirrors and attacking chandeliers. Fights went on for hours, sometimes days, once even for two weeks. I should have fought back. He wanted me to, but all I did was weep. That annoyed him more than anything. When our fights worked up to a grand finale he would rub jam in my hair. But what I hated most was being knocked down in the streets, or having things thrown in restaurants. Once he held me down under water in the bathtub until I felt I was going to drown. I am sure I was very irritating, but Florenz was used to making scenes, and he had had Odile as an audience for years. She always reacted immediately if there was going to be a fight. She got nervous and

frightened, and that was what Florenz wanted. Someone should
have told him not to be such an ass. Djuna tried it once in
Weber's restaurant and it worked like magic. He immediately
renounced the grand act he was about to put on. As a result
of these displays of anger he got into an awful lot of trouble
with the public authorities and was often arrested. One of the
first big fights I can remember was in a theatre when we went
to Raymond Roussel's play, *Locus Solus*. Everybody was
hissing it and of course Florenz was for it. He made a demon-
stration and a royal battle followed, and being pregnant I did
not want to be involved. Florenz's opponents were numerous
and they got him down on the floor. The *Commissaire de Police*
was sent for and came to his rescue. Later he gave us his box
so that we might see the rest of the play in safety.

The next big fight I remember was in the Hôtel Lutétia. It
was brought on entirely by my lack of tact. I had resumed my
Russian lessons with Jacques Schiffrin, and I announced to
Florenz that I was in love with my teacher. Florenz picked up
an ink-pot and hurled it at the wall. It broke the telephone
and spattered the room with ink. The room had to be re-
papered. To remove the spots on the floor I found a miraculous
little deaf man who came every day for weeks. He squatted on
the floor bringing out from a bag an array of bottles which he
applied one by one until the spots completely vanished.
Schiffrin, in the meantime, borrowed money from me to pay
his printing bill. He was launching his *Editions de la Pléiade*
and ran short of funds. In return he gave me six hundred copies
of his first beautiful book, *La Dame de Pique*. I went to all
the book shops of Paris to dispose of my six hundred volumes. I
was not very successful as a saleswoman and soon Schiffrin, who
was well on the way to success, bought them back from me.

Because of my money I enjoyed a certain superiority over
Florenz and I used it in a dreadful way, by telling him it was
mine and he couldn't have it to dispose of freely. To revenge

himself he tried to increase my sense of inferiority. He told
me that I was fortunate to be accepted in Bohemia and that,
since all I had to offer was my money, I should lend it to the
brilliant people I met and whom I was allowed to frequent.

When we started living in Paris I was quite sick because of
my pregnancy, and I took some medicine every day. Bob Coates,
having no idea what was wrong with me, and as he himself
was suffering from some stomach disturbance, insisted on trying
my medicine. At that time he was a young writer living a
Bohemian life in Paris and he was one of our best friends.

Florenz loved big parties and we never missed a chance to
give one. He liked me to dress extravagantly and he took me to
Paul Poiret and made me buy elegant clothes, but my fast ad-
vancing waistline was not very attractive and I did not look
very chic in these wonderful costumes. Hazel joined us in Paris.
She was already divorced and that winter she married Milton
Waldman.

In the middle of the winter we went down to the Riviera.
We found a little villa at Le Trayas and rented it for two
months. One of my cousins in the automobile business sold me
an old second-hand Gaubron, whose cut-out was perpetually
open and it made a terrible noise. We hired a chauffeur and
Florenz learned to drive the car. Our life here was very simple.
We had only one maid, and we stayed in the villa most of the
time. But Florenz bathed in the sea all winter and went to the
markets to bring home food. Since I was ill I spent weeks
reading all of Dostoevsky. Of course we had our fights to pass
the time. What we fought about in Le Trayas and what took
up two weeks of our time before we finally signed a truce was
the fact that Bob Coates wanted to borrow $200 from Florenz
in order to go back to America. For some reason I took this
badly and would not let Florenz have the money. He had to
refuse it to Bob. Finally Odile came down to visit us, and we
ended our battle.

In March Benita came to Europe for she wanted to be with me for the birth of Gawd. When she discovered my Bohemian life, she was shocked and was much against it. Benita was extremely conventional and her husband made her more so. It was difficult for her to make a bridge between two such different ways of life.

At the end of April I went to London with Fira to look for a house. Florenz was to follow with the new car we had just bought, a Lorraine Dietrich. The Gaubron had collapsed. I looked as if Brancusi's egg had been superimposed on my slender person.

I rented a beautiful house with a garden in Kensington up on Camden Hill. We were very comfortable and there was plenty of room for guests and nurses when the moment arrived. Agnes Dew stayed with us for a while but left to join Norman when he finally came from America. Benita and her husband were living at the Ritz, with my mother. We did not want my mother to know when Gawd was expected. She fussed so much it was nerve-racking. We had managed to keep her in ignorance of his existence for a long time. Now she thought he was much younger than he was.

Actually, on the night of his birth, there was none of my family about. I had left Benita at seven o'clock in town and I was not feeling too well, but I came home to a dinner party Florenz and I were giving. Our guests were Agnes Dew and Norman, and Tommy Earpe and his wife, and an old friend of Florenz from his Oxford days and his wife, and Bob Mc-Almon. During the dinner we drank the health of someone under the table, meaning Gawd. Tommy Earpe, who had no suspicions, began looking for a dog. Soon after dinner the wife of Florenz's Oxford friend threw a pillow at me and that seemed to have an immediate effect. To my great embarrassment the waters broke and I retired upstairs. Agnes got hysterical and wanted to put me to bed. Florenz rushed off in the car with

Earpe to fetch the nurse. She had been actually engaged for that day, but was waiting to be called. When she arrived she took everything in hand and made me do the right things. All I can remember is the most dreadful pain that came in waves and that got worse and worse. Each time I felt as though I could not endure any more. Agnes sat on the steps with Florenz. Finally the nurse allowed him to go and fetch Doctor Hadley. When he arrived I was suffering the most excruciating pain. He asked me if I wanted an anesthetist and by then naturally I said "yes." I felt as though wild horses were dragging me apart, and I had come to the end of my strength. When the second gentleman in a top hat, who took ages to put on his white spats, arrived, my troubles ended but the doctor's didn't. The chloroform worked so well, that Gawd refused to budge and had to be taken by forceps. He arrived at eight in the morning just in time for breakfast, and Agnes and Florenz saw him before I did, for which I never forgave her. When I came to and was told I had a boy I felt embarrassed to think that I had harbored a male creature inside my being for so long.

Florenz phoned my mother. She thought it was a joke and she would not believe that she had a grandchild. We had fooled her so well that she did not appear until the evening, and then was completely surprised to learn that Gawd was really there. He was born on May 15th, the anniversary of Benita's wedding and the day after Mrs. Dale's birthday. We named him Michael Cedric Sindbad Dale. Agnes named him Cedric in honor of Cedric Morris, a great friend of hers, a painter. Sindbad (from the Arabian Nights) was Florenz's choice; mine was Michael. He was darling, but very ugly. He had a wrinkled little red face, a lot of black hair, enormous protruding ears, and heavenly feet and hands. The day-nurse was a sort of dragon, but the night-nurse was an angel. So we postponed all our fun until the night.

I nursed Sindbad for one month. After that I had no milk.

Nursing was painful and for some reason I was an unnatural mother and could never give my breast to my children without the assistance of a nurse. If the babies had had to depend on me they would have starved. Dr. Hadley made me stay in bed three weeks. I was bored and read George Moore and Henry James to amuse myself.

It was at this time that Peggy came to stay with us. I don't know what else to call her throughout this book, for she has changed her name so often. She first came into my life at school, but as she was one class ahead of me, I never knew her well. Then she married my cousin, Edwin Loeb. That didn't work, and Benita and I made her get a divorce. When she came to London she was just recovering from her divorce. She had not as yet got into any further trouble. Florenz loved her, and I was delighted as she was my oldest friend. She is hard to describe, because she is so elusive. If you ever pin her down to anything you find out the next day that she has told someone else the exact opposite of what she has told you. She sees around and into everything, and therefore has no *parti pris*; consequently we have always called her double-faced. But she is the only really intelligent woman I have ever met. She has the logical brain of a man. She looks like a Cheshire cat because she has an enormous mouth which is perpetually grinning. She is extremely stubborn. She seems to know what she wants in life, but she doesn't at all really know what is good for her. For some strange reason she has always had the wrong husband, and she has had three of them. As a mother she has been a great success, and has had lots of pleasure from her three children. However, at this stage she had no children. Peggy has never failed to appear at the crucial moments in my life. I felt all I have had to do was to bring out my Aladdin's lamp and Peggy would pop up and help me.

We all went back to Paris for the fourteenth of July as

Florenz always celebrated that festival by dancing in the streets
for three nights. I couldn't keep up with him.

After Paris we went to Villerville in Normandie and rented a
place for the summer. It was a hideous old house, with a bathtub
in the cellar; it greatly resembled my grandfather's house, but
this one had a beautiful garden with a studio where we all
painted, even I. Odile and Peggy were with us, and Mina Loy.
Louis Aragon, who was Odile's boy-friend at the time, came
for a visit. So did Harold Loeb and Kitty Cannell and Man
Ray and his remarkable hand-painted Kiki. One day James
Joyce and Nora walked in. They were looking for their daugh-
ter who was in a boarding-school somewhere on the coast.

Benita had gone back to America and I was unhappy without
her again. I watched the French Line steamships go out to sea
from Le Havre, past our house, and wished I were leaving too.

In the fall we went back to Capri. Peggy and Agnes and Odile
were with us. This time we stayed in a little hotel in the center
of town. My cousin Eleanor Castlestewart had found me a
nurse called Lilly, whom we had brought back to the continent
with us. She was so dark that she looked more like a foreigner
than an English girl. Men were always running after her. She
was completely innocent and unsophisticated and excited about
traveling. Lilly took good care of Sindbad as she had been
trained in a hospital, and she was naturally conscientious.

Soon after we were in Capri, Florenz got into trouble. He
was jealous of a new lover of Odile's. This little Italian, when-
ever he spent the night away from his wife, pretended he had
been to the Caccia or to shoot little birds up on the heath.
We used to tease Odile and ask her if she had been to the Caccia
when she spent the night with him. She did not like the fact
that Captain Patuni, as he was called, refused to be seen in
public with her. Because of his wife he had to hide Odile.
One night at dinner she complained bitterly about this and got
Florenz, who was drunk, all worked up. He rushed into a

private club where Captain Patuni was playing cards with
some men and threw all the cards he could seize into Captain
Patuni's face. A battle followed. A policeman had his thumb
broken. Florenz was put in chains and lay on a table waiting
to be carried off to jail. He had as an enemy the *sindaco* of
Capri, whom he had once mocked, and as a result this man
was his sworn enemy. Florenz was forced to spend ten days in
jail awaiting trial. He was in a damp cell, and we were told to
send him meals from the hotel. We also sent him wine and
whiskey and lots of books. He was guarded by a wonderful
jailer who had lost his job temporarily for allowing his prison-
ers out every night. When they were out they went on with
their profession and brought their booty back to jail. He was
reinstated but without salary.

This jailer accompanied the judge, who was blind, on his
walks to and from the courthouse. He told me that he had the
judge's consent for me to go to the prison to visit Florenz, but
that I should get the permission myself. I went to the judge
and fell on my knees, pleading my baby's ill health as an
excuse to talk to my husband. I even wept. The judge was
noncommittal, but soon after the jailer came to see me. He
told me to wear black and to come to a certain corner of the
road where a big black dog would be waiting for me and would
conduct me to the prison. I was terrified, and if Odile hadn't
forced me to go, I would certainly have backed out. When I got
to the prison, where I soon went every night, I fell asleep, ex-
hausted by my worries and my attempts to rescue Florenz.
Everyone on the island had a new scheme to free him. All the
schemes involved enormous bribes, and they seemed dangerous
and uncertain.

Finally Agnes found the solution. She was picked up by a
lawyer, Signor Tirelli, who had come from Rome for the day
and who thought she was Odile. Having heard about the
scandal he offered his services, which we accepted. Agnes went

with him to Rome to see the American Consul-General, who
was a great friend of the Dales, hoping he would help us, but
all he said referring to Florenz was, "That boy was always
crazy." Signor Tirelli was the lawyer of the American Con-
sulate. He was a clever old thing, and came over one day to
prepare the case, the date of the trial finally having been set.
He went around the island and collected enough witnesses to
prove that Florenz was drunk and had meant no harm. When
the trial came up on the tenth day, the barman of the Quis-
iana Hotel, where we had started out our evening, testified
that we had not only had eight cocktails, but that they were
gin, which in Italy is not usual, and that after dinner we had
drunk large quantities of Veuve Clicquot champagne. Captain
Patuni was called as a witness, but refused to appear. He was
forcibly brought by two soldiers and had nothing unpleasant
to say against Florenz. The policeman was bribed to be silent.
Florenz was released and we left Capri that day on Tirelli's
yacht for Amalfi. I insisted on this. Florenz did not like it,
but I made him go. Before leaving he stalked around the piazza
with Odile to show that he was not beaten. Tirelli charged us
the modest sum of one thousand dollars, the voyage on his yacht
thrown in. After that he charged us another five hundred to
have Florenz's name removed from the records of crime.

I was rather ashamed to think that my husband had been in
prison, and whenever the matter came up I tried to explain
quickly what the offense had been.

When we said goodbye to the jailer, who had become our
dear friend, we gave him a large tip. He immediately lost it or
said he had, and had to be given another. He told Florenz his
only desire in life would be to serve someone like him by
guarding his fortune. He said he would have liked to sit and
watch a large pile of money which should be placed on the
floor in a room, and which would be safe with him.

Amalfi was as beautiful as Capri, but in quite a different

way. It did not have the charm of an island. We took walks on the sloping countryside which was covered with vineyards. There were also several towns in this vicinity and we had to drive to get to them. One was a long way off and very high up. It was called Ravello and had a most beautiful twelfth-century building with cloisters covered in Virginia creeper. I wanted to buy the house, which was called Casa Rodolfo, but I could not produce the sum necessary because all my money was tied up in trust.

After Amalfi we decided to go to Egypt for the winter, but Odile and Peggy went back to Paris. Our dragoman took us everywhere, and saw to it that we bought everything. It wasn't difficult because Florenz and I were fascinated by the Souks of Cairo. We found wonderful earrings for virtually nothing, and bought dozens of them to take back to Paris, since Odile, Agnes and I were all frantic collectors. We also bought materials and Florenz had suits made with Egyptian cloths of all colors. He bought me perfumes, little coats and a cape from the Sudan, and he bought himself the oddest little rag dolls, beautiful Persian prints and a water pipe. We ate only in Arab restaurants where the chief food is lamb. There was one restaurant where we ate out-of-doors, but it was an ordeal, because during the meals, whole streams of beggars and vendors of food solicited us in turn. It would have been possible to buy our entire meal from these passers-by. The Arabs called me "Princess" to flatter me, thus hoping to get larger *bakshish*. I have never seen such shameless people. They were just like flies. One brushed them away merely to have them return the next minute.

We were admitted to the mosques, but not at the sacred hour of prayer when the male Arabs would squat in the courtyards around fountains washing their private parts and urinating before they turned their faces toward Mecca and the setting sun to invoke Mohamet.

We spent days in the Souks shopping and drinking Turkish coffee, the thickest and sweetest coffee in the world. It is served to you by all the shopkeepers if they have hopes of selling you something expensive. One could never buy anything immediately. Shopping in Cairo involved days and days of bargaining. It just had to be done in the traditional way, tiresome as it was.

In the evenings we went to the Arab quarter. This was considered low and incorrect for foreigners, especially for ladies. Florenz went everywhere he saw a sign, "out of bounds for British officers and soldiers." I remember a beautiful Nubian girl who did a *danse de ventre*. She so much resembled Hazel, in spite of being as black as could be, that I called her my sister. Florenz was fascinated by her and I decided to give him an evening off to be with her. At that time we were living in the desert in Mena House, next to the Pyramids of Gaza. One evening, when we had been shopping in Cairo, I left Florenz and went back alone to Mena House. Considering my sacrifice he might have been nicer to me. When he put me on the bus he purposely threw all my packages about or dropped them in order to embarrass me, for he was annoyed at having had to carry them all afternoon. He returned late that night, and by chance I followed him into the bathroom and saw that something was wrong. He had to admit the truth. Suddenly I was angry when I thought what I might have been exposed to, and refused to make love to him for days. He told me that the girl wore white underwear and had a very high bed. When he could not climb up to it she took him under the armpits and lifted him up like a doll.

The next day we went camping in the desert. This is not at all what it sounds like. Nothing could be more luxurious. It entails a complete caravan of camels and attendants, a cook and tents and furniture and food all being brought along. It was certainly worth it because it is the only way to see the desert.

The desert is a vast sea of sand which rolls in all directions and in all shapes. It is mountainous and sometimes rocky. Occasionally there is a mirage or an oasis and often you meet other caravans. Otherwise you would feel completely lost. Nothing is more uncomfortable than riding a camel. The jerking and swaying motions drive you mad and exhaust you. You can't rise in a trot or gallop. You just sit in agony. Later I took to riding donkeys instead, and that turned out to be marvelous fun. They have a wonderful little gait, almost better than that of a horse.

We decided to take a trip up the Nile and all the dragomen of Cairo began running after us trying to rent us a *dahabeah*. We were invited to the home of one dragoman in the desert where he gave us a sumptuous meal of thirteen courses. Finally in desperation we ran away to Luxor where we rented a modest boat that depended entirely on the whimsical moods of the Nile winds and on a crew of eight to pull us if necessary. When the winds failed the crew got out and walked on the shore and drew the boat along by ropes. Florenz and I became so impatient that often we got out and walked along the banks, waiting for the boat to catch up with us.

Geographically Egypt is a strange country. It depends entirely on the Nile for its existence; otherwise it would merely be desert. Egypt varies much in width. At its widest point it covers many miles (as in the Delta land) and at other places it shrinks to about one foot. Its cultivated land exists only where the Nile has watered it. Along the banks a system of irrigation is in continuous motion. The lovely singing noise of the revolving wheel that turns as a camel walks in circles to propel it, greets one at regular distances. Buckets of water are attached to this wheel, and as they come out of the Nile full they disgorge their contents into a trough which feeds the channels dug for irrigation. Sometimes there were no camels and human energy replaced them with a simple hand derrick.

All along the banks were little villages of mud huts. The women of the town would come down to the water's edge carrying pitchers on their heads to fetch the water. Florenz insisted on bathing in the Nile, in spite of the dangers of crocodiles and germs, and one day he frightened away a whole bevy of women who screamed as he emerged naked from the water.

The people of Egypt are mostly Arabs, and they are very poor. We tried to learn their language from the dragoman who came on the *dahabeah* with us but he spoke perfect English. He drank a bottle of whiskey a day. The captain was very handsome and I conceived a slight passion for him. He played Arab music for us on a tom-tom.

Once you get on the Nile, you must give up all sense of time, but I couldn't. I became so impatient that I almost went mad. Florenz spent hours below in a cabin writing a book. He had a Puritan conscience, and he was a writer. Sindbad and Lilly were left behind in the hotel in Assuan at the First Cataract. I got bored, and to amuse myself I bought a pregnant goat. I had hoped to see it give birth. However, it fooled me by choosing the one short hour I was absent, visiting some friends on a Cook's steamboat. The captain sent a sailor to fetch me, but it was too late. Soon after that the whole boat reeked of goat smells and we could not endure it. I gave it to the captain. We also had two sheep on board. They were affectionate and sat on our laps. Eventually we were supposed to eat them, since all our food consisted of mutton courses. Sometimes we had as many as five in one meal, all prepared in different fashion. But I could not bear to think of eating the sweet sheep, so we gave them to the captain, too.

We went right up to the Second Cataract of the Nile at Wadi Halfa. We thus saw all the best temples as well as the Valley of the Kings with its gigantic twin statues. It was just before Tutankhamen's tomb was opened. The strongest impressions I have of Egypt proper have nothing to do with the

Arabs and their civilization. What the Egyptians stood for was
something so cruel, so subtle and so dignified. The carvings of
the Egyptians on all the tombs were exquisite and the temples
so overwhelming in size that one felt like a midget. Some of the
temples were under water at this time because of the machin-
ations of the dam at Assaun. We went in a rowboat through the
courtyard of Kimombo Temple which was half under water
and we saw only the top half of the Phalaes Temple.

At Wadi Halfa we were entertained by the governor. It was
rare that people got that far on a *dahabeah* and he wanted to
honor us. The British ruling class are pretty awful in their
colonies. We did not relish this visit.

On the way back we picked up a steamboat and were tugged
part of the way. It was strange seeing Egypt fly past in the
moonlight instead of having it unroll itself like a slow-motion
film in the sunlight. It was also exciting to recognize all the
spots we had passed before.

When we left the boat after three or four weeks, the men
expected a tip. We didn't know what to give them. I suggested
a pound each, but they were not very pleased. Then we added
another pound to each and they were very happy and cheered
us. In those days I was very mean, and Florenz had a hard
time arranging things with my money as I always tried to inter-
fere. Finally he tipped the dragoman with his own money.
Much later I told Benita how badly I behaved to Florenz and
she wept for him.

When we got back to Cairo we left Sindbad and Lilly in
Mena House and went to Jerusalem. For the first time in my
life I felt ashamed to have married outside my faith. The
Jews of Jerusalem looked upon me askance. Palestine was a
young country in those days in spite of its extreme age. It was
in its infancy as it had just been given back to the Jews. It
didn't seem to be working any too well. There were terrible
fights among the Moslems, the Jews and the Christians. They

all wanted to own the key to the Holy Sepulchre. Jerusalem itself was little built up. Most of the activities were concentrated on farming. The only thing that really impressed us was the Wailing Wall. It mortified me to belong to my people. The nauseating sight of my compatriots publicly groaning and moaning and going into physical contortions was more than I could bear, and I was glad to leave the Jews again.

We returned by a different steamship line, disembarked at Genoa and from there we took a night train to Paris. As soon as we arrived I dispatched Florenz and Lilly and Sinbad, and decided to face the customs on my own. Everything we had bought in Cairo was concealed between my dresses in my Innovation trunk. It was very ingenious because not only were there innumerable Sudanese clothes for Odile, Agnes and me, but also an odd collection of embroidered tablecloths and pillow slips. The worst offense was the Turkish tobacco that we were bringing into France. This was not allowed. At the last minute Florenz ripped open an enormous rag doll that he had bought and filled it with about four hundred cigarettes. Nothing was found and I retired with my booty. When I got to the Hôtel Lutétia and began to unpack I could hardly believe my eyes. I felt as if I were a magician bringing things out of a hat. We gave a cocktail party every Sunday and showed our wonderful Arab treasures to our guests.

The rooms in the Lutétia were not big enough for us now that we had Sindbad, so we took an apartment on the Boulevard Saint-Germain for six months. It was Proustian and we did our best to make it cozy. We horrified the Viscomte de Cambon, our landlord, by buying rustic French furniture and installing it in the place of his *Louis Seize meubles,* which we hid in the backroom. We brought all of Florenz's library here and had all the books I had received as wedding presents from my family in America. When we moved from the apartment we caused a scandal on the Boulevard Saint-Germain by throw-

ing all our books out the window and catching them in sheets below in order to remove them.

We gave fantastic Bohemian parties in this flat. Florenz made me buy a cloth-of-gold evening dress at Poiret's. Now I was so thin again it suited me perfectly. I also wore a headdress made by a Russian lady who was Stravinsky's fiancée. It was a tight net gold band that made my skull look like Tutankhamen's. Man Ray photographed me in this costume with a long cigarette-holder in my mouth. It was sensational. In those days I never drank, and I was bored at these parties where everybody got tight. I hated people being sick in my house, and I especially hated people making love on my bed. Once a lady left her corsets behind and called for them later. After the guests would leave I went around, like my aunt, with a bottle of lysol. I was so afraid of getting a venereal disease.

To one of these parties I invited one of my mother's nieces who happened to be in Paris on her honeymoon with her second husband, after she had got rid of the roué whom I resented her marrying over my head at the age of eleven. When she arrived at this party she was fascinated by a couple of beautiful young men who were dancing closely, locked in each other's arms. I made her sit and guard the silver all evening, telling her that I had no idea who half of my guests were as Florenz picked up odd people in bars when he was tight, and invited them all to our house. We kept open house every Sunday evening. At another one of these parties, Kiki, Man Ray's mistress, hit him in the face and called him a dirty Jew. My mother was present and was outraged. She told Kiki what she thought of her.

My mother was much more conventional than I, and she was forever inviting Florenz and me to the Ritz to her parties. On the other hand, she seemed to enjoy our Bohemian parties as well. She had made great friends with Mrs. Dale and was dragged into the American Women's Club which was Mrs.

Dale's stronghold. My mother was probably at her best at this time, because she could at last have a life of her own. She was no longer tormented by my father's infidelities, and all her children were married. But she never actually relinquished her daughters. She used to phone me every morning and tell me it was cold or raining and that I should wear a warm coat or rubbers, as the case might be. This drove me frantic, but what I hated most of all were the conventional parties at the Ritz and being perpetually told that I led the wrong kind of life. Anyone who was not rich she referred to as a beggar, and any woman who had a lover she called N. G., meaning no good. She was greatly disappointed that I had not married a Jewish millionaire. Nevertheless, she liked Florenz because he flirted with her. She herself had had various proposals, which she turned down. One was from a Sicilian duke, who wrote to ask her to lend him a return ticket to America, at the same time lamenting the fact that although he would like to marry her he regretted that he was not rich enough "to keep her in her usual luxury stand." She was, I am afraid, a one-man woman and, after the bad luck she had encountered with my father, she put all her energies into making matches for other people.

She had a strange habit of repeating everything three times. Once when we were dining with her at the Ritz, Florenz tickled her leg under the table; her only comment to this was, "Shush, Peggy will see, Peggy will see, Peggy will see." Once when she went to a milliner to order a hat with a feather, she said, "I want a feather, feather, feather." She is reported to have received a hat that bore three feathers. In New York when finally at the age of fifty she learned to drive a car, she was stopped by a policeman in a one-way street for going against the traffic. Her reply, if inconsistent, was correct. She said, "I am only driving one way, one way, one way." She not only repeated everything three times, but she also always carried three coats with her which she was perpetually changing. In a heat wave

she wore two silver foxes and fanned herself to keep cool. She always carried three watches, one was a wristwatch, one she wore around her neck as a necklace, and the third one formed part of a lorgnon. The latter she could not use as she could see only with the lorgnon. Therefore it was impossible to benefit by this double arrangement. She was very generous to her children although she had a phobia about spending money. She gave me a fur coat or an automobile every year and was forever putting money in trust for me, but when it came to tipping everything went wrong, and one had to be perpetually on the lookout or be frightfully embarrassed. She was an inveterate gambler and very secretive about the size of her income.

During the course of this winter Agnes, who also wore a Poiret evening dress I had ordered for her, led a wild life. She usually ended up in bed in this dress with several people. One night she lost her key and she went home with Marcel Duchamp. That started what one might designate as the Hundred Year's War. The next morning she came to us for taxi fare to go home because she was scared to ask Marcel for more than ten francs. At that time she lived near the Eiffel Tower in a little apartment she had made beautiful with maps she pasted on the walls and with earrings hung as décor instead of paintings.

Marcel was much sought after. It was very difficult to attach him, and in any case he disapproved of the mad life Agnes led in the Boeuf sur le Toit with homosexuals. Her great friend was Moises who gave her credit in his nightclub, and as a result she spent fortunes there.

Marcel was a mysterious man. He hadn't painted since 1911, the days of the "Nude Descending a Staircase." That had made him famous. Now he only played chess, and was on the French chess team. He also bought and sold Brancusis. Marcel was a handsome Norman and looked like a crusader. Every woman in Paris wanted to sleep with him. His particular vice was

ugly mistresses. Agnes was really much too beautiful for him, but in the end she managed to get him anyhow. It took years, but that probably made it more exciting. He was forever coming and going. At one time he even married a hideous heiress to please Picabia. It was during a period when Agnes and he were not on speaking terms, but immediately after the wedding he went to find Agnes and they had a reconciliation. Marcel soon divorced his wife.

In the spring of 1924, the Comte de Beaumont organized and financed the *Soirées de Paris*. He rented the Cigale, a famous music-hall in Montmartre, and engaged all the best talent of Paris to write music, dance and paint scenery for him. Stravinsky and *Les Six* composed music, Lifar, Riabouchinska, Lopokova, Borovansky, Toumanova, Massine, Danilova and other famous stars danced. Picasso, Ernst, Picabia, Chirico and Miro did *décors* for him. It was all very exciting because the artists collaborated with the Comte de Beaumont instead of just accepting orders as was the case with the Russian Ballet.

This also was the beginning of the social aspect of the ballet. It became very chi-chi and between acts we went into the bar where we met all our friends. It was, incidentally, the last good ballet ever produced.

This was a pleasant change and quite an improvement on our usual routine of life. We generally spent every night in cafés in Montparnasse. If I were to add up the hours I have whiled away at the Café du Dôme, La Cupole, the Select, the Dingo and the Deux Magots (in the Saint-Germain quarter) and the Boeuf sur le Toit, I am sure it would amount to years.

There were not only ballets but plays. Cocteau wrote *Roméo et Juliette* and Tristan Tzara wrote *Le Mouchoir de Nuage*.

During the winter I got the idea of bobbing my hair. Odile and I were the only women left in our world with long hair. Florenz adored it that way, but I was awfully sick of the strug-

gles I had with brushing and combing it, and from the head-
aches it gave me. I must say it was beautiful. It was chestnut
colored and very long and wavy. One day I went and had it cut
off. When I came home I did not dare face Florenz. I tried to
hide my head under a hat. When he finally caught me he was so
furious he threw me under the dressing table. I conserved my
mane, but I could no longer consider it part of myself.

In the spring Benita and her husband came to Europe again.
She was more shocked than ever by our wild Bohemian parties.
Benita and her husband left for Italy and my mother and I
without Florenz joined them in Venice. I considered myself an
efficient guide, since this was my fourth visit to Venice, and I
knew where all the churches and paintings were. I did not yet
know Venice on foot, but I was soon to learn that, too. Florenz
had given me an inkling of the existence of another life in
Venice, when he had taken me for walks on a few of the best
known highways of communication that zigzagged around
Venice. But when we were there it was too hot to do much
walking and we had spent our few days bathing at the Lido. He
had initiated me in the use of the steamboat, called a *vaporetto*,
which replaced the tramcars of other cities. Before that, I had
traveled only in gondolas, like the idle rich and tourists, who
never really get to know Venice. The following fall I was to
learn every inch of my adored city for we were to live there
for three months. But that comes later.

When I left Benita I promised to spend the summer with
her in St. Moritz. Florenz was a faithful husband, but during
my absence in Venice he had had an affair with a beautiful
girl called Eileen. The affair ended as soon as I came back, but
nine months later I went with Florenz to see Eileen's baby.
We never knew if it was Florenz's, Eileen's husband's or Bob
McAlmon's.

One night Bob McAlmon, who was one of our best friends,
gave a big party in a restaurant in the Champs Elysées. He had

as guests Louise Bryant and her husband William Bullitt, who was later our Ambassador to France. We happened to be sitting at the next table, and Bob finding himself short of funds, asked us to cash a check so that he might pay his bill. I was annoyed that he should have left us out of this party, and told Florenz not to help Bob in any way. Florenz was furious with me and when we got back to Mrs. Dale's flat where we were staying at the time, we had a dreadful row. In the middle of it Odile, who was in the room next door, overheard us and came in to take Florenz's part. I told her it was none of her business and that she should keep out of married people's fights. Odile told me to leave the apartment and I was so upset I began rushing around the flat as I was, quite naked. Mrs. Dale took the situation in hand and said to me, "This is my apartment, not Odile's, and you are not going to leave." She really was always a good mother-in-law to me.

In the summer we set out for Karesee in the Austrian Tyrol. We drove there over the Stelvio, the highest pass over the Alps and which was used by the Italians for auto races. The road zigzags in hairpin bends up to eleven thousand feet. At every corner we had to stop and back-up our car and turn, for the chassis was much too long for this road which had been built for little racing cars. It was terrifying as we thought each time we might go over the side and drop into the valley below. Our engine couldn't stand the strain of going up in first gear and the water boiled over. We discovered a little mountain stream and carried water back in our bathing caps. When we got to Bolzano we only found one room. Odile was with us and Sindbad was to follow with Lilly, by train. We spent a miserable night, Florenz making scenes without end because I wanted to join Benita for the summer and he did not want to go to St. Moritz where we were to meet her, since she would not come to Karesee. Odile and I were exhausted by morning, but we continued our trip.

The Austrian Tyrol is the loveliest country in Europe. It doesn't frighten one like the Engadine. Its scenery is less imposing and much more acceptable. Florenz did a lot of rock-climbing with guides. He was good at this and had been brought up to walk on glaciers and climb the highest mountains of Europe. Mrs. Dale was one of the first women mountain-climbers of the Alps. Personally I hated even walking uphill and was terrified the only time that the Dales took me on a glacier, the Diavolezza, near St. Moritz. I thought we would fall into every crevasse, and we came pretty near being killed at one moment, but that, it seems, is part of the excitement required to spur people on to this unnatural sport. They claim that when they reach the top of a mountain some thousands of feet high and see the sun rise they are recompensed for all the hours of hard work and danger they have put into it. They certainly deserve their reward.

In the end Florenz gave in and took me to St. Moritz. I don't think he liked being with my family, but I was always with his. After St. Moritz we went to Lake Como with Benita and her husband and stayed at Tremezzo. Mrs. Dale and Odile were with us too. We swam in the lake, we played tennis and I tried to learn to play golf to keep up with the Dales. I was so bad that I felt I had killed my teacher as he soon died, and I gave up this sport forever. Benita and her husband taught us to play Mah Jong. It became a vice. In the evenings we danced.

By this time Sindbad could walk and talk, and he had become very beautiful. His black hair had turned into thick blond curls and he had quite a few teeth and wonderful rosy cheeks. I was quite mad about him, as were all the members of my family. Benita adored him too as she had no child of her own, having had many miscarriages. Florenz hadn't wanted a baby, but once Sindbad arrived he was crazy about him. He really wished to have a girl, so I promised him I would give him one. I said I would never stop until I had produced

one. So we tried to make a daughter. In the beginning we couldn't make anything. We were disappointed for three months. At that time Sindbad was eighteen months old.

Benita and her husband returned to America, and Florenz and I remained with his family in Tremezzo for the late summer. Even Mr. Dale was with us for a while, but he soon went back into a sanatorium.

We went down to Milan where Odile was to join an opera company. She was to sing in the provinces somewhere in Italy. Florenz and I left her to go to Venice where we settled down for three months. We took rooms in a depressing old-fashioned hotel on the Riva, which was modest in price. Up to then I had lived only in the more elegant hotels. Florenz had a workroom with a large stove. The smell that emerged from it was so disagreeable that he couldn't work. Finally we investigated and found it was packed with French letters. After the burning rubber was removed he was able to continue the novel he was writing.

Agnes was with us. She loved Italy and spent several months out of each year in an old castle at Anticoli, near Rome. She was almost a native by now, and felt great sympathy with the people. She conversed with everyone in rather good Italian. My Italian became more fluent after awhile. I had studied the language for years but it had never seemed real till I lived in Italy. Reading D'Annunzio's plays and novels in New York was most unreal.

Florenz found an old friend, Favore, in Venice. He was an Italian Jew, who looked like an El Greco, with his long face and black beard. His profession was to make false old masters, which were sold to the unsuspecting public. He gave up his job temporarily to help us buy the antique furniture with which I had decided to furnish our home. Not that we had a home, but I knew that if we bought the furniture we would eventually have one.

Shopping in Italy was almost as tiresome as shopping in Cairo. The question of bargaining was the all-important thing. It became dreadfully boring to have to go back to the same shop six or seven times in order to reduce the price asked to something normal. Favore discovered some wonderful objects that really should have been in museums. Then there was the added trouble of getting them out of Italy, since export of real antiques was prohibited by the government. We found a beautiful fifteenth-century oak buffet which required four men to carry. It looked Spanish as it had once been decorated with red velvet, and little bits of this remained around its metal incrustations. In an attic in Treviso, Favore discovered a beautiful thirteenth-century chest. It had wonderful carvings depicting a baptism and a woman fainting. Of course we bought it, and later I found its sister in the Victoria and Albert Museum in London. We found eleven three-legged oak chairs, all with different carvings. The astute shopkeeper told us that he could have a twelfth one made for us. After ordering it we found dozens of these chairs at many of the other antique dealers.

It was a lot of fun, but what I enjoyed most was getting acquainted with Venice on foot. Florenz had lived there as a child for his father had always gone there in the autumn to paint. Florenz knew every stone, every church, every painting in Venice; in fact he was its second Ruskin. He walked me all over this horseless and autoless city and I developed for it a lifelong passion. Everything in Venice is not only beautiful but surprising. It is very small, but so complicated because of the S-shaped Grand Canal that you are forever getting lost in its little streets. You always come out eventually on the Grand Canal, but not at all where you expect. Nothing is more tiring than these promenades, however, because they involve walking over endless bridges with steps.

The Piazza San Marco with its wonderful soap-bubble-domed Byzantine Cathedral and its seventeenth-century arcades is one

of the most beautiful squares in the world. It would be pleasant to walk there because there are no automobiles or horses, but the tourists are almost as objectionable. Sitting in cafés around the side or listening to music produced by a brass band in the evening is less dreary. What I really preferred were all the other piazzas that I discovered on my walks about the town. These are unknown to all but the Venetians, as tourists never get any further than the Piazza San Marco. However, every parish of Venice has its piazza.

It is unnecessary to go into the foul odors of Venice. They fade away or become unimportant compared with the over-whelming beauty of a city that still bears the architecture of ten centuries. Needless to say I wanted to buy a *palazzo*, but I was again handicapped by the foresight of my uncles who had made me put all my money in trust.

While we were in Venice, Lilly got pneumonia and I looked after Sindbad every day instead of on Thursdays, as was my habit. I got so tired carrying around this enormous child, who did not like crossing the bridges with all their steps, that I engaged a little maid to help me. To my great shame she turned out to be about fourteen years of age, and not much bigger than Sindbad, but I presume she was used to looking after a large family of younger brothers and sisters. We often used to take him to the Piazza where he sat and fed the pigeons.

In the winter, there were no tourists to feed the pigeons and they were virtually starving. We felt it incumbent on us to supplement the rations allowed them by the municipality of Venice. Every day at noon we arrived in the Piazza with our five kilo bags of grain. The flutterings of the hungry creatures were alarming, and the wind caused by their flight almost blew us away.

Because of Florenz's exhibitionism he dressed rather eccentri-cally. Besides never wearing a hat and having golden hair streaming over his face, he attracted attention in various other

ways. He wore white, azure blue, terracotta or beige overcoats. His shirts were made from the materials that were designed for entirely different purposes. They were of all colors, but what he liked best was to find an odd material, intended for drapes or furniture covering, at Liberty's in London. These gay, sometimes flowered patterns, he took to the most conservative shirtmakers on Halfmoon Street and insisted (to their surprise) on having them made into shirts. He wore sandals rather than shoes. His feet turned in like a pigeon's. I believe he had some kind of a shoe complex because every time he went into a shoe shop he became hysterical and made a scene which often ended by his rushing out without buying anything. His jackets and trousers were a rare assortment. He wore the most conspicuous trousers he could find. They too were of all colors. At one time he had a brown corduroy suit made by one of the smartest tailors in London, but later he preferred to wear ordinary French workingman's blue-velvet trousers that he found in the markets of Toulon. In addition, he had a large collection of weird ties.

In Venice Florenz got the silly idea that he wanted me to have a sable cap made for him to protect his ears from the cold while driving. I think it represented a symbol of power. I refused to gratify this very extravagant wish. Instead, after many fights, I had made to order for him an Italian officer's black cloth cape with a velvet collar. At first he did not like it, but soon he realized how handsome he looked in it with his beautiful blond hair, and from then on he favored it.

When the rainy season finally drove us out of Venice we went to Rapallo. There at least we had sun, but we paid for it. What a horrible dull little town it was! We met Ezra Pound there and joined his tennis club and played every day. Ezra was a good player, but he crowed like a rooster whenever he made a good stroke. Later when I met him in Paris and told him how much I hated his beloved Rapallo, he said, "Maybe

you have unpleasant personal memories of it." There was every
reason why I should have. Besides my being very bored there,
Florenz upset life considerably by terrible rows.

On New Year's Eve we attended a party in a private night-
club. Florenz got jealous of a man who asked me to dance,
and went over to his table and insulted him. A big fight en-
sued. I was taken by the shoulders and hurled against the
wall. I did not in the least relish this treatment because I was
pregnant again. In the end we were forcibly evicted from the
night-club and were looked at askance in the tennis club.

One night Florenz and I had a bad private fight. It started
by his calling Benita a bore, and to retaliate I said Odile was
a whore. This so infuriated Florenz that he smashed to pieces
a new tortoise-shell dressing-table set I had bought that very
day, after months of bargaining in the Italian fashion. He knew
just what this meant to me. I had a complex about toilet sets
ever since I had regarded with horror my mother's silver
brushes and combs. As a child I had spent all my savings on
collecting a set of twenty-three ivory pieces in Paris on the
Boulevard Haussmann to decorate my dressing-table. It was a
sort of fetish and I had had "Peggy" engraved on each piece.
Ever since I had gone to Italy with Valerie I had dreams of
acquiring a tortoise-shell set to replace this ivory one, which
had long since vanished.

Florenz's destruction of it was to me more than painful.
After he did it he dragged me down to the sea where, though
it was a cold night, he rushed in with all his clothes on. After
that he insisted on taking me to the cinema where he sat shiver-
ing in his wet clothes. No wonder Ezra thought my memories of
Rapallo may possibly have been unpleasant.

We motored along the coast and on our way to Paris we
found ourselves in an enchanting place called Le Canadel. It
was little known at that time and quite unexploited. It was
half way between St. Raphael and Toulon on the Côte des

Maures. There was a long unpeopled sand beach edged by a forest of pine trees. We stayed at a very dull *petit bourgeois* hotel, but down below was the café and inn of Mme. Octobon. It was primitive, but the food was delicious, and people drove there for meals from miles away. We decided to live in this part of the world and began to ask if there were any houses for sale. We were told there was one about a mile away. It was an inn called La Croix Fleurie, where Cocteau stayed every winter with Raymond Radiguez. It was just above the sea and had its own beach extending about a mile towards Cap Nègre. This beach was the first place the American troops landed in 1944, in their invasion of the south of France.

The house itself was not inviting but it was a nice little white plaster building in the Provençal style. It had a double exterior staircase ascending to a balcony which gave access to three spacious rooms. There were another three rooms and a bath in the back. Since this house was so small the owner had added a wing, which made the place not only possible but attractive. The wing consisted of one large room with a huge fireplace and three French windows that reached to the high ceiling and gave out on a lovely terrace with orange trees and palms, forty feet above the sea. There was a kitchen with a primitive coal stove and two other rooms and a toilet on the ground floor. There was neither telephone nor electric light. But there was plenty of sun and pine trees and the sea with a private beach. What more could one want? On the other side of the road there was a double garage with three servant's rooms. About three-quarters of an acre of land went with the house. It was uncultivated and was covered with pine trees to the left of the house, and in this tiny forest was a green wooden cabin.

We bought the house and immediately, as the French do, our landlord clinched the affair by producing the *notaire* from

Cogolin, who happened to be present, and we signed a promissory document.

However, when I got home and considered my rash act I regretted it. Not that I did not like the place, I loved it; but I realized how much too much we had offered to pay for it, not only offered but actually agreed in writing in the presence of a *notaire*. I consulted with Florenz, and we decided to go back and tell them that we had cabled to America for the money and that it was not forthcoming, as it was all in trust. We said we were going to New York in a few months, and that we would do our best to raise some funds. The landlord was so scared that he reduced the price by one third, which approached what he should have asked in the beginning, and in order to save his face he declared that, since we were not intending to use it as a hotel and were relinquishing those rights, we were entitled to a reduction. We thereby forfeited forever the privilege of calling our villa by the charming name of La Croix Fleurie and we found ourselves in the position of not being allowed ever to make a hotel on these premises or to sell them as such.

We were not to take possession of our new home until the summer. We expected the birth of our daughter in August, so we knew we would not live there until the fall. We now signed the real *acte de vente* at Cogolin, the official head of the *commune*, and celebrated with a bottle of champagne. Then we found some local builders, and Florenz ordered a little house to be built for him as a studio on the other side of the road.

After that we left for America, but not to raise the funds, because I did have just the amount necessary. I went, of course, to see Benita. At the last minute Florenz came with me, although he hadn't meant to. He was writing a novel, and did not want to do any more traveling.

We arrived in March, and Florenz chose as our residence

the Brevoort Hotel. Sindbad was a year and ten months old; he had a great success with everyone on the boat, the France. But not as much success as a wonderful conversationalist named Esther Murphy (later Mrs. Chester Arthur III), who held everyone spellbound for a week by her endless and fascinating talk. She seemed never to stop, and I wondered how anyone could know so much and sleep so little.

Mina Loy, who was not only a poetess and a painter, was always inventing something new by which she hoped to make her fortune. She had just created a new, or old, form of *papier collé*—flower cut-outs which she framed in beautiful old Louis Philippe frames she bought in the flea market. She asked me to take these to New York for her and sell them. Florenz gave them the wonderful title Jaded Blossoms. I arranged to have an exhibition in a decorator's on Madison Avenue. They were to take one-third commission, which is normal, but I provided all the clients. When it came to hanging them Florenz assisted us. He was so Bohemian and temperamental that the lady in charge of the shop wanted me to send him away, but when I explained that he was my husband she could not refuse his help. The exhibition was a great success, and I sold the Jaded Blossoms everywhere. Benita bought two which she offered to the Metropolitan Museum, but they were refused. I looked up all my old friends, hoping to sell them Jaded Blossoms. I became so obsessed by this that I went all over New York carrying them on my fast-growing stomach. My poor daughter was perpetually buried under them.

When I felt I had sold enough, Florenz and I began to look for a house for the summer. We had no idea as yet where Deirdre was to be born. We got more and more depressed at the prospect of a summer in America, and finally in desperation went back to France on the Aquitania, with my mother. We thought we had fooled her again about the date of the birth of our daughter, but one day she walked into the bath-

room when I was having a bath and informed me that surely
I had made a mistake.

In order to avoid giving another soldier to France we de-
cided to go to Switzerland just in case Deirdre turned out to
be a boy. So at the end of July we went to Ouchy on Lake
Geneva just below Lausanne. Mrs. Dale found us a doctor. As
her husband knew almost every neurologist and psychologist
in Switzerland this was easy. The doctor said Deirdre would be
born between the first and eighteenth of August. I decided not
to have chloroform this time, and a midwife was engaged to
look after me. She came on the first of August and we added
another room to our suite in the enormous Beau Rivage Hôtel.
The nurse turned out to be handsome. She resembled a Leo-
nardo da Vinci Madonna, and I was greatly attracted to her.
She became bored with nothing to do and every time she said
good-night, she begged me to give birth before dawn. After two
weeks I began to lose faith in ever giving birth again in my life.
There was a head-waiter in the hotel whose wife was also ex-
pecting a child, and every day we politely inquired about each
other's future prospects. On the seventeenth day of August
Florenz pulled a terrific scene in the dining room. I have no
idea now what it was all about, but I remember his throwing
a whole dish of beans in my lap and then later rushing around
in our apartment, throwing all the furniture about and break-
ing a chair. Maybe this stirred Deirdre because the next day I
began to feel queer. The midwife sent me on a long walk with
Florenz along the lake. It was extremely painful and we had to
stop every now and then when the birth pains became too
awful. Towards evening we took out Sindbad's cot and dressed
it up in curtains. That of course settled it for my mother. She
had the tact to pretend that she had not noticed it, but she sat
up all night with a paper upside down in her hands in an adjoin-
ing room with Odile. About ten o'clock we sent for the doctor.
This time Florenz was very happy for he was not banned from

the room, as he had been in England at the birth of Sindbad. In fact he was permitted to hold one of my legs. As the pains got more and more unendurable I regretted my decision not to take chloroform. When I felt the wild horses dragging me apart I begged for a few whiffs. The midwife had some ready and every time the pain started she held it to my face. All I remember is her saying to me, "Poussez, madame!" And in the end evidently I did not do my bit and just as they were about to take Deirdre with forceps she relented and came by herself at eleven-thirty.

The whole performance was so quiet that our neighbor in the hotel could not believe a baby had been born. I never screamed once. I held a handkerchief in my hand throughout the entire birth. In some strange way it must have given me a feeling of safety. When the pains got too bad I dug my nails into my palms hoping to vary the agony. I also clutched on to the railings of the brass bedstead.

This time I had made Lilly promise that no one would see my baby before I did. The minute she was born Lilly hid her and waited for me to come to before showing her. She was brought to me in a towel. Instead of being covered with blood as I had expected, Deirdre was covered with what seemed to be cold cream. She was all white. She looked exactly the way Sindbad had looked in every other respect. She had black hair and blue eyes. As she was a girl I knew then that I would never have another child. I had kept my promise to Florenz.

The after-birth pains lasted for days. On the eighth day I was put on a chaise longue and soon after I was allowed to get up. One day when the midwife was out and I was alone with Deirdre, she began to cry. I could hardly walk across the room to her and I felt as if all my insides would fall out. I nursed her for a month and then I couldn't any more. It happened this way.

Florenz and I decided we had endured Ouchy long enough and we wanted to go to our new home in the south of France.

Florenz started ahead in the car, and I went by train with the two babies, Lilly and the midwife. When we arrived in Lyons we were told we had three-quarters of an hour to wait. I rushed out with Lilly and Sindbad in order to get them some lunch. When we got back to the train it had left. Deirdre and the midwife and all the luggage had disappeared. I was quite frantic as I thought I would never see my baby again. The midwife had no idea where we were going and had never traveled before. Instead of losing my head, I had the presence of mind to go to the *chef de gare*. He immediately wired to the next station the train was to stop and asked that the midwife and Deirdre and the fifteen suitcases be taken off the train. Then Lilly and Sindbad and I were put on another train. We remained at the next station for only about two minutes, but just time enough to recover Deirdre, the nurse and the suitcases. As a result of the shock I lost my milk. Luckily we had some powdered milk with us, for Deirdre was already getting one bottle a day.

Our new home was in a place called Pramousquier. My mother always mispronounced it Promiscuous. It wasn't a village or a town. It merely possessed a railway-station and a few houses. A little train passed eight times a day, four going from St. Raphael to Toulon and four from Toulon to St. Raphael. It took about four hours to get to these destinations, so we naturally preferred our car. Once when there was a strike on this line Florenz suggested that I give the strikers a thousand dollars to keep them going. He preferred this to Lucile Kohn's causes, where a lot of my money went. As a result of my gift we were the only people who were served on the line during the strike, and we continued to receive ice and other packages. When the strike was won we were allowed to ride free on the railroad. We used this little train to go to the neighboring villages of Cavalière, where there was a small shop, and to Le Canadel where we drank Pernod at Mme Octobon's. How-

ever, most of my life was not spent on this little train, that looked like a toy and made a noise like an express, but was spent in a Citroën car chasing around the coast buying food. I raced this little train for many years, carefully avoiding it at the most dangerous crossings where people were often killed. Our house-painter had lost his son in this way. He was run down on his motor-bike. The painter received my condolences with tears at the same time, and in the true French manner he tried to sell me the motor-bike.

We had no electricity for years, and at first we had no telephone. We had an old ice-box and we received our ice by the train every morning. It was thrown off on the railway line, and often I had to chase to Cavalière where it got thrown off by mistake. The country was grassless, cowless, and therefore milkless. Our nearest real town was Le Lavandou. It had a post office from which the postman came on a bicycle every day. I am surprised he brought us our mail because we had a wild sheep dog who leaped on and bit anyone in a uniform. She had been left one day by Gabrielle Picabia. We found Lola tied to an orange tree, and although she was ferocious, we could not do other than accept her as a gift. Anyway, she was very sweet to everyone not in uniform. All my frustrated desires to witness a birth were satisfied finally by Lola, who gave birth on our couch in the sitting-room. She was completely unconscious of the fact that she was about to be a mother, and her surprise was touching. I forced her to accept and look after her babies. We kept three or four of them and they became ferocious. They rushed about the countryside with Lola, eating all the chickens. We were perpetually having to pay fines for chickens killed, and even once for those that might have been born. Later we had nine cats whose kittens the dogs sometimes ate at birth.

We had an Italian gardener called Joseph. With the help of Florenz he laid out beautiful gardens, but the dogs were for-

ever tearing them up, and Joseph wanted to be rid of them. In order to encourage us to give them away he used to collect all their *merde* every morning with a shovel and place it on the terrace around our breakfast table. We were puzzled for months wondering why the dogs chose this spot for their convenience until it finally occurred to me that Joseph had plotted this himself.

All our maids were Italian, and as a result our kitchen and larder were filthy. It is a miracle we did not all get poisoned from the rotting of food in the heat and the excessive filth. By degrees we made ourselves a comfortable existence, or rather Florenz did. We furnished our house with all the beautiful Venetian furniture, but Florenz insisted on buying some comfortable sofas and chairs. He rebuilt the house and made a lovely little library. After that he ordered a big studio over the garage for Odile. In the end we had four houses, for we had another one built on the extreme end of our property for Bob and Elsa Coates.

Pramousquier was a real home and it grew perpetually in every way. We really felt we belonged to the country. Florenz being almost French we were rooted there. By degrees more and more people came to visit us.

One of our first guests was Mina Loy who came with her daughters, Joella and Faby. Mina painted a fresco in her bedroom. She conceived lobsters and mermaids with sunshades tied to their tails. We had good food finally by engaging *cordon bleu* cooks in Paris and buying a whole set of copper pans to bribe one to stay with us. We had a wine-cellar and Florenz saw to it that it was well filled. However, in the early stages I remember one maid pouring all the wine left in bottles together. The only discrimination she had made was between red and white.

This winter we went up to Wengen to ski. Florenz loved this sport but I never dared to try it, my sense of balance being as

weak as my ankles. Since my painful experiences in my child-
hood I carefully avoided anything that I knew would be un-
pleasant. Naturally I got bored waiting all day alone in the
hotel with the babies. One day I took Sindbad out on a sled
and cracked a rib. I decided to go to Paris and leave Florenz
with Odile. I intended secretly to lead a wild life, and enjoy
my freedom of ten days.

I gave a big cocktail party in Florenz's studio. It was a dirty
old workshop in an *impass* or *cul de sac* but ideal for Bohemian
parties. This was the first party I had given without Florenz
in Bohemia, and I was very pleased with myself.

After this party I found what I wanted, but I was excessively
tight and was almost unconscious of it. When Florenz came
back he sensed at once that I had been up to something, but it
was so harmless that he need not have taken it so badly. The
night he arrived without any warning I was with my friend
Boris. That certainly was perfectly innocent, but Boris left
at once because Florenz was in a state of frenzy. He im-
mediately proceeded to give a demonstration in the Hôtel
Lutétia where I was living. He rushed around tearing up the
whole place and throwing all my clothes in the middle of the
room. My shoes went out the window. Then he tried to get
into the babies' room. Fortunately our new nurse, who had
just replaced Lilly, had locked herself in, and she did not
have the pleasure of seeing him in this state. Florenz then
found my hair which I had so carefully conserved in a drawer
and taking it with him, kissing it, he rushed out, only to return
in a few hours to begin the scene all over again.

This was not the end. It went on for days and it ended up
by producing an unknown husband for Odile. I admitted
to Florenz that I had been untrue to him, but I lied about
who it was. He suspected some nonexistent person who lived
on Avenue de la Bourdonnee. One night when we were having
dinner in a little bar in Montparnasse, Florenz, who was still

chafing over my infidelity, suddenly arose and hurled four bottles into the corner just over the heads of four Frenchmen who were peacefully eating their dinner. Naturally they took this very badly, and the police came and removed Florenz in a pushcart. I fainted on the bar, and when I came to, Florenz was in prison.

Odile, who was with us, suggested that we go and get Marcel Duchamp to help us out of our troubles. He told Odile immediately to get the four Frenchmen to withdraw their complaints. They all agreed except one, and another one fell in love with Odile, and later married her. He was a handsome Vendéen and although completely out of our world, belonging to an old French military family, he managed to enjoy himself in our midst. If he started off this way he certainly could stand anything.

Marcel and I wandered around Paris all night longing to go to bed together, but we did not consider it an appropriate moment to add to the general confusion.

The next morning I went to the police and escorted Florenz to the *Commissaire*. Florenz was covered in blood and wore no tie, and we were guarded on this walk through the streets by several policemen. It was very romantic. Then Florenz was freed and he thought his troubles were over, but they were not.

The fight continued, and one night when Florenz and I were still at it, he dragged me to the Gare de l'Est and said we were going to provins overnight. We sat in a double-decker train waiting for it to leave when he suddenly changed his mind and took me out. Then we walked in the streets and to my great surprise, offering me a glass of beer, he pushed me through an unknown door. To my amazement fifteen naked girls greeted us, begging us each to choose one of them as a partner. I was so surprised I chose the ugliest one. We sat and talked and Florenz's choice, who was quite pretty, told him she knew who he was. She had read about his goings-on in the paper and had

recognized him from the description. This was not my first admittance to a brothel. I had been to one in Venice, but this time the girl seemed to want to continue the friendship. I gave her my address. One day much later she appeared in a car at Pramousquier. She waited at the gate, uncertain as to whether I would admit her. She was on her yearly holiday with a girl-friend, and when I saw her with clothes on I did not immediately recognize her. Finally I invited her in and she bored us for an hour with a very commercial conversation and departed.

I think this must have been the year that the British coal-miners went on strike. I was greatly moved by their struggle and when the affair reached the point of becoming a national issue I decided to make a large donation. I cabled my bank in New York to sell the last ten thousand dollars of stock I had left from my grandfather's inheritance. This caused a lot of trouble, because my uncle who gave fur coats to girls disapproved and interfered. He asked the bank if I thought I were the Prince of Wales. I finally managed to get the money but just too late. By the time it reached England the strike was over. Florenz consoled me by saying, "Never mind. There will be just enough for every miner to have a glass of beer."

While I was in Paris Berenice Abbott had asked me to lend her five thousand francs to buy a camera. She said she wanted to start photography on her own. To pay me back she came to Pramousquier and took the most beautiful photographs of Sindbad and Deirdre and me. I certainly was well reimbursed.

About this time Mina Loy and I embarked on a great business venture. With her usual genius she had invented three new forms of lampshade. One was a globe of the world with a light inside it. One was a shade with boats whose sails were in relief. They were fixed on separately and gave the illusion of old schooners sailing in the wind. Her third invention was a double-cellophane shade with paper cut-outs in between, which cast

beautiful shadows. I had set her up in a shop on the Rue du Colisée, and she had a workshop next to Florenz's studio on the Avenue du Maine where she employed a lot of girls. I ran the shop and she and Joella, her daughter, ran the workshop. When I went to America I took with me fifty or so of these shades with strict instructions from Mina where not to sell them. I am afraid I disregarded her instructions for I had not paid much attention to them.

For the opening of the shop in the Rue du Colisée we allowed my mother to invite her *lingère* to exhibit some underwear at the same time, as we then thought to make some money; this upset Mina so much that she refused to be present at the *vernissage*. We also sold some hand-painted slippers made by Odile, and later we gave Florenz an exhibition of his paintings. They were very decorative, but quite childish. The best one was called "Women and Children." It portrayed factory women with their children at their breasts and horrible smug factory owners looking on smirking, with cigars in their mouths. Florenz had not been influenced by the Surrealists who came to Le Lavandou in summer in large bands, and wandered in and out of our house in their vague way with their artificial wives. André Masson and Gaston Louis Roux lived very near us and they were good friends of ours.

The lampshade shop was very successful, once I got rid of the underwear. Florenz's uncle was horrified when he heard that I worked there myself. He asked Mrs. Dale if I even accepted money. The Dales were very snobbish and had an awful shock when their cousin, a Rhinelander, married a negress in New York.

In the summer we took a trip to the Pyrenees and landed in Font Romeu at midnight. When we drove up to the door of the elegant hotel we surprised the *concierge* by handing out a package that contained a sleeping child, Sindbad. The *concierge* had hardly recovered from his shock when we fished on

the floor of the car and handed him a second one, Deirdre. We left Doris and the children here and drove on to Andorra, the smallest republic in the world. There we found the President raking in hay. It was as democratic a country as it was tiny. From there we went to Barcelona.

We spent hours walking on the Ramblas and hours fighting in our room. Every time we sat in a café a shoe-shine boy appeared and offered his services. The dust underfoot certainly warranted this operation being made every few minutes. The strange thing was that every time my shoes were cleaned they came out a different color; once they were silver, once rose, and once green. Wherever we looked we saw signs that read Gomez Ideales. On the way back we passed the monastery of Montserrat, but the road was so bad we did not dare ascend to its heights.

During the winter Florenz completed his novel, *Murder Murder*. It was a sort of satire of our life together and, although it was extremely funny, I took offense at several things he said about me. He was so upset that he seized the manuscript and burned it in the stove of his studio. That day Pauline Turkel was coming from Nice to type it. Florenz had to dictate a rough draft of it from memory. This time he was kinder to me.

We had a wonderful life in Pramousquier. We had perpetual sun and therefore needed no heat in the house. We merely burned a big log in the living-room in the evening. Florenz swam all the year round. I didn't. All one had to do was jump out of bed, slip on a bathing suit and run down to the beach. I spent hours there reading and sun-bathing. I usually got up at nine or ten, had breakfast on the terrace, then did my daily shopping for bread and ice or went milk hunting, or for whatever else was necessary. The shops delivered the rest of the food from Le Lavandou and Hyères. After that I went down to the beach. About two o'clock we ate lunch on another terrace, which was much cooler in summer as it was sheltered by trees

and built on an overhanging cliff that was swept by pleasant breezes. We always drank so much wine, even if it was only the wine of the countryside or Muscadet which came from Odile's future family estate, that in summer we took a siesta. We lunched out-of-doors all the year round.

In winter we ate on our large terrace overlooking the sea. It was covered with palm trees that blossomed in March, and with orange trees that gave forth the most delicious perfume in the early winter when the orange blossoms flowered. The whole countryside was covered with mimosa which abounded in our garden, and for months everything seemed to have turned yellow. Besides the pine trees the country was covered with olive and cork trees; in fact cork was the great industry of the south. There was a little factory back in the hills at a place called Collobrières. The corks were cut on a machine which one woman manipulated by hand, the process being nearly medieval. At Collobrières there was an inn where we enjoyed wonderful six-course meals for eight francs. Another place we drove to was the Forêt du Dom where wild boars were hunted. Here we had equally good meals of boar, for the same modest prices.

In the afternoon Florenz took us in large groups (consisting mostly of women) for a walk in the country. We had only two directions to walk in. One we named *du côtè de chez Swann* and the other *le côté de Guermantes*. There were several variations, however, and we went back into the country and over the hills. Sometimes Florenz went on longer walks right over the top of these hills, called les Maures after the Moors who had once inhabited this coast. The countryside was covered with towers the Gauls had built to keep a lookout for the greatly feared return of the Moors.

Towards evening we always had our second swim. Sometimes we would vary our life, which was completely directed by

Florenz, by going to Le Canadel and having Pernod at Mme Octobon's before lunch or before dinner.

Mme Octobon was a solid Belgian woman. Her husband was a fiery Frenchman who often attacked her with a carving knife, but because of their business they could not separate. They led a sort of Dance of Death. Wherever we went we were accompanied by our four dogs who were most unpopular in the neighborhood. Lola was always my favorite, but Florenz took a great fancy to Lulu, her eldest daughter, who greatly resembled a crocodile. In fact, he insisted on having both these animals share our bed. Lulu grew so enormous there was hardly room for me.

Florenz developed a passion for the game of *boules*. He instituted serious games on the terrace. Joseph the gardener was a great champion. He and Florenz laid out an orchard in front of Florenz's studio. They also raised tomatoes which were delicious when eaten raw and hot. At one period we had a wonderful pig called Chuto, who used to follow Joseph around with the devotion of a dog. It was painful to have to kill and eat Chuto and see his blood turned into black sausages. A specialist came from Le Lavandou to perform this operation in our kitchen. Chuto was so fat after Joseph had wined and dined him for months that we should have had enough ham for years. Unfortunately we had to take all the meat to Paris with us on a trip, and it turned green en route from the cold. We also had a chicken farm, but we spent so much money on grain to induce the birth of a few eggs that in the end we gave it up.

In the winter we suffered from the *mistral*. It lasted for days on end, filling the house with sand, breaking all the windows and obstructing the roads with fallen trees.

After Sindbad was a few years old he accompanied us everywhere, but Deirdre, who was still too young, was left behind with Doris. I think unconsciously she developed the feeling of

being not wanted by us and became extremely attached to Doris.
Florenz was full of vitality and drove us all over the country,
sometimes to Nice and back overnight without our stopping
to sleep. Once we went to visit Evelyn Scott at Cassis, arriving
at four in the morning. We often went to Toulon to shop for
delicacies and to spend a gay evening, or to St. Tropez to dine.
Our nearest large town was Hyères but that was so dull and
full of English retired civil servants that we went there only
to shop. In the evenings if we remained at home we always had
guests to whom we served the most delicious food and wine.
We were rarely alone. Either we had house guests or invited
people who lived in the neighborhood. We went to Paris for
the rainy season which started in November and lasted two
months; and every summer in the middle of August we went to
the mountains for three weeks to avoid the terrific heat.

Florenz loved traveling and especially driving. He drove as
though the furies were in pursuit of him. Once he took me to
Paris in nineteen hours without stopping to sleep. We stopped
only now and then to drink enough to keep going. As he drank
an awful lot, I was very nervous. I never knew what was going
to happen at such moments in the car. He would never let me
drive. For years we never set foot in a train. We went every-
where in our Lorraine Dietrich and later in our Hispano. Of
course I drove my little Citroën myself.

In the winter of '27 we went again to New York on the
Aquitania, this time taking with us two babies and two girls.
One was Doris, our new English nurse, sent by Hazel to replace
Lilly's successor who had gone back to England with boils.
Doris was very pretty. She was hospital trained, but she
looked more like a Gaiety girl than a nurse. By the time she
came to Pramousquier life was quite gay. She soon got herself
a beau and Lilly greatly regretted her rash behavior in going
back to England when Pramousquier bored her, but then it
was too late. The other girl was one of our handsome Italian

peggy guggenheim in 1908

peggy, hazel and benita guggenheim, in 1910

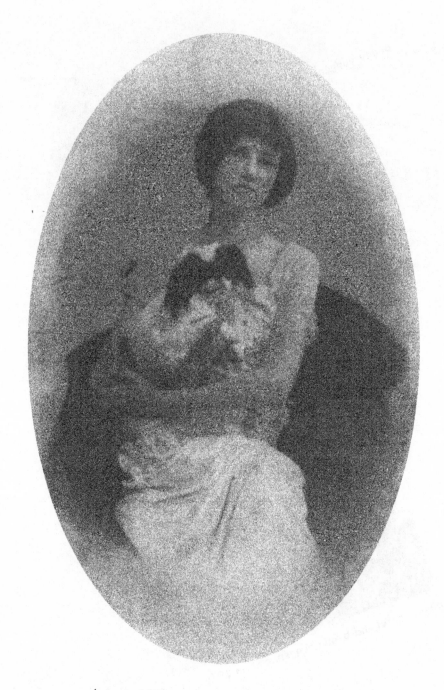

peggy guggenheim in 1913

maids. They both had great success wherever they went, and enjoyed New York immensely.

This time I arrived with fifty lampshades and fifty lamps. Mina had collected Louis Philippe bottles in the flea market, and Florenz had also suggested using the southern glass wine-bottles that we found at Le Lavandou as bases for the wonderful shades. They cost a few cents and I sold them for twenty-five dollars. Mina also used silver, blue and green witch balls for lamps. I became efficient and soon found myself selling everything to all the shops Mina had told me to avoid as well as to all the others. I had to mount the shades myself because I could not find anyone to do it for me. I sold five hundred dollars worth, and sent Mina a check, but she was furious because I had not obeyed her instructions. She was afraid her invention would be cheapened by the department stores. Finally in Paris all her ideas were stolen, and although she had copyrights she had to give up her business. It was impossible for her to conduct it without a businessman and a lot more capital.

When I arrived in New York, Benita told me that she was going to have a baby in August at about the time of my birthday. This was her fifth attempt. She had lost all the others in the early months and greatly desired to have a child, especially for her husband. This time she had great hopes of going through with it for she was already past the dangerous month when she had lost all the others.

Benita looked more beautiful than ever. Her pregnancy did not in the least unbecome her. Her long slender neck seemed even more graceful and accentuated as it rose from her rather more mature form. She had one dress that was black with a pink front. I used to tease her and tell her the black part was herself and the pink was the baby. She was shy and embarrassed by this joke. Her face looked exactly the same as it did when Lenbach painted her twenty-four years before. Her brown eyes and hair, her tiny nose and olive skin and her beautiful hands

with tapering fingers never seemed to change. She was calm and happy in her pregnancy and seemed quite content to drive with me all over New York, while her Swedish chauffeur helped me to deliver and carry Mina's bottles and lampshades.

Of course I never wanted to leave her but Florenz insisted on going up to Connecticut to finish his book *Murder, Murder*. We stayed in the house where Hart Crane boarded. I don't see now how Hart endured us with our noisy babies and Doris and the maid, but he seemed to enjoy having us and was very cordial. He lived an extremely monastic life up there, seeing nobody for months on end. In winter he nearly went mad from ennui and once threw his typewriter out of the window into the snow. He had a collection of strange records, one of the best being Cuban music.

Soon I left and went back to Benita for a short while, but Florenz again tore me away from her. This was much more tragic as I wanted to be with her for the birth of her child.

Regretfully I allowed Florenz to take me back to Europe. I promised Benita I would return alone in September after her baby was born.

When we got to Paris Florenz found a court summons. He had been tried in his absence and condemned to six months' imprisonment for throwing the bottles at the four gentlemen in the restaurant. One of them had not withdrawn his complaint. This was very serious and had to be dealt with at once. Odile's fiancé produced one of the best lawyers in France, Maître Henri Robert. He was a *batonnier* and therefore qualified to plead in court. Florenz was told to take him fifteen thousand francs in bank notes, as he was not supposed to accept any money for his services. When he saw Florenz's embarrassment at being unable to offer the money, he tapped on the table with French practical sense saying, "Mettez ca là." The trial took place in the Palais de Justice and was very impressive but the result was not satisfactory. The noble name

of Lafayette, who was a friend of Florenz's grandfather, was brought up, and a novel of Florenz's, which had been published in America, was produced. Florenz was let off his prison term but given a *Sursis*, which meant that if he ever had another offense, six months would be added to his sentence.

Soon after this I met Isadora Duncan who was then living in the Hôtel Lutétia in great straits, but nevertheless she gave us champagne. I am sure she hoped I would help her out of her difficulties, but I am afraid I didn't. She came to visit us at Pramousquier with the little Bugatti car she was so soon to meet her death in. Isadora had bright red hair and a wonderful purple and rose costume. She objected to my being called Mrs. Dale and named me Guggie Peggleheim. She said, "Never use the word wife." She was vital and colorful even at this late stage of her life, although she seemed to be rather demoralized. The news of her death upset me considerably.

In the summer of '27 Mary Butts came to stay with us and brought her daughter Camilla, a charming child but neglected by her mother, who was always up in the clouds. One day she got a sunstroke and was very ill. Doris and I had to look after her. Mary took a whole tube of aspirin in one day when her opium gave out. She believed in black magic and was perpetually trying to initiate Florenz into her mysteries. He loved the atmosphere she produced and she was extremely clever at flattering him.

In the middle of all this one day I opened by mistake a cable that was addressed to Florenz. It told him to break the news to me that Benita had died in childbirth. It was such a shock that I did not realize it. I was like the man who was cut in half by a very sharp sword and who laughed at his murderer. Whereupon the murderer said, "Get up and shake yourself." When he did as he was bid he fell in two. I pretended nothing had happened. I went right on doing some accounts I was in the middle of. When I got up, I felt virtually as though I had been

cut in two. I seemed to have lost part of my physical being. My first thought was that I had deserted Benita. I could not forgive myself for having come back to Europe with Florenz. I started to cry and couldn't stop for weeks. All I wanted was flowers. Odile and Florenz went to Toulon and brought back all they could find and put them everywhere. Odile was very nice and for once she really said the right thing to me; she knew what I felt because of her love for Florenz. I couldn't look at my children for days. I felt I had no right to have any.

Benita's baby was born dead. It was a case of Placenta Previa, the most dangerous thing in childbirth. It causes a hemorrhage which is usually fatal. The doctors, to cover themselves, pretended it had no connection with her miscarriages, but of course she never should have been allowed to have this child.

Florenz was painfully jealous of my suffering and kept insisting that I still had him in the world. That of course was not what I was thinking about at the time. It so much deranged him that he made dreadful scenes. After that I never felt the same towards him again and I blamed him for having separated me from Benita for all those years.

I received many condolence letters and began writing mad replies. I was slightly off my head. My greatest consolations were listening to the Kreutzer Sonata on the phonograph and the letters that Mary Loeb wrote me. She was Benita's closest friend and was suffering as much as I was. If only we could have been together at this time it would have helped. Peggy suddenly arrived from America with her husband and her daughter who was Deirdre's age. She was actually on the sea at the time of Benita's death and did not know of it. We went to Toulon to meet her and I drank lots of brandy to give myself the courage to break the news to her.

Every summer we had to leave Pramousquier for three weeks to avoid the terrible heat of the Midi which was very

bad for the children. This time Florenz drove all of us to a little mountain hut he had found way up in the Alps behind Barcelonnette. He loved the high mountains where he went climbing. We took Peggy and Doris and the three children. Peggy's husband did not come with us. He had gone to Paris on business. I was so miserable I could not eat or sleep. All I did was cry. Doris thought I was going to die. She fed me to prevent my losing any more weight. Florenz kept making scenes all the time. He stopped Peggy from talking to me about Benita by telling her I did not like it. I couldn't understand why she withheld from me my only consolation, and I remained alone in my grief. After weeks we discovered what Florenz had done through his jealousy.

The following year as a result of all this was an unusually stormy one and finally broke up my marriage. A fortune-teller in Paris said to me, "You will meet a man in the south of France who will be your next husband." I laughed at her and replied, "I never see any men in the south of France except our neighbor, an old farmer." But she was right. On the twenty-first of July, 1928, the first anniversary of Benita's death, I met the man who was to give me a new life.

As a result of Benita's death I decided never again to go to America. I inherited a lot of money but I could not bear the thought of spending her money so I gave it all away. Of all the consolations I was offered from everyone the one that impressed me most was from the *chefesse de gare* at Le Canadel. She was a warm, southern type and always helped me out of my difficulties. Living in such an out-of-the-way place, they were numerous. She was supposed to be the whore of the country-side, but she certainly had a very philosophical point of view. When she heard of Benita's death she said, *"Nous ne sommes tous que passagers sur cette terre."* In view of the fact that she lived in a railway-station it was most appropriate.

When we returned from the mountains Florenz's friend,

Betty Hunes, came to visit us, with her friend Dr. Carlozza, a Roman Rosicrucian. He tried to help me in my grief by teaching me his religion. He read my palm and he also predicted another husband for me. This so much enraged Florenz that he made a dreadful scene in Toulon one night. He threw me down on the Boulevard de Strasborg and then he burned a hundred-franc note. He was taken to the police and Peggy and I went to rescue him. When I protested at their interference in what I considered my affair, the police claimed he had a right to knock down his wife if he wanted to, but that he had no right to burn a banknote, as it was an insult to the Banque de France. An hour later he was released in spite of the Banque de France.

In the fall my mother arrived from America. Florenz drove me right across France to Cherbourg to meet her. It was the week-end of the Jours des Morts and of All Saints' Day, and wherever we drove we encountered hundreds of mourners carrying chrysanthemums to their relatives' graves.

The children came up to Paris to see my mother and I placed them in a kindergarten where they immediately got whooping-cough. I was worried that we would be put out of the hotel, but the manager pretended not to notice it, and only when we left sent me a bill for disinfection of the rooms.

Florenz went to Mégève, a little mountain resort, at the time quite unknown, to ski with Odile. He broke a rib and was laid up for a short while. I remained alone in Paris with the children, still absorbed by my grief. I was glad to be rid of Florenz as he was making terribly jealous scenes over Benita. One night he tore up the photographs I had had enlarged from snapshots taken of her years before. My room was full of them and he hated their being there.

During that winter I met Emma Goldman and Alexander (Sasha) Berkman. They were glamorous revolutionary figures and one expected them to be quite different. They were fright-

fully human. Emma was very vain and it took me years to see through her. First I worshiped her and when later I was disillusioned she did not like it and she revenged herself by leaving me out of her memoirs.

My mother had given us another car, this time a wonderful Hispano. We bought the chassis and then we ordered a silver-colored open body for it. Florenz always insisted on lots of air. By mistake the body turned out to be sky-blue instead of silver and had to be painted all over. When we finally got it we left for the south, taking Emma Goldman with us. She took to the Hispano as though it were the most natural thing in the world for her to be driving it.

Unfortunately the Hispano began to limp. It was ridiculous to have such a magnificent car that would barely move at ten miles an hour. It kept stopping all the time. Finally we were forced to remain overnight at Châlons and have the tank cleaned out. Then it flew like a bird. Emma was disgusted with the whole performance.

Very soon after we built the house for Bob and Elsa Coates at Pramousquier he decided to go back to America. Elsa remained a year without him and then she followed him. She offered her house to Kitty Cannell and Roger Vitrac. They came to live with us and we had a nice life with them. In the evenings we read Montaigne aloud and had delightful talks. One night we went to a brothel in Marseilles to see a special film. Afterwards Kitty, who was unwell, fainted. The whores were very sweet to her and looked after her with great kindness. During this brief moment Vitrac borrowed a hundred francs from Florenz and rushed upstairs. He got back before Kitty was revived and she was never any the wiser.

But of course we got restless and decided to travel again. Florenz and I put the Hispano on a boat at Marseilles and disembarked at Algiers. This is not the most interesting town of North Africa by any means, it is too Europeanized. I much

preferred Tangiers where I had been with Valerie. From there we motored in the desert to Biskra, Bou Saida and right down to Kairowan. At Kairowan we were offered the spectacle of the sword-eaters, but we refused to have this religious ecstasy performed artificially for our benefit.

In the desert we passed a broken-down Ford. An Arab squatted patiently by its side awaiting help, and twenty-four hours later he was in the same position with the same degree of patience. I really believe these people have no sense of time. Once we were arrested for giving a lift to two Arab boys who turned out to be running away from home. When we paid their return fare we were allowed our freedom. We also gave a lift to two English missionary ladies. I am sure they regretted it, because one of them became ill from the fumes of the Hispano and nearly fainted. We had a windscreen that kept out the air so efficiently that no one could bear to be in the back of the car.

Then we went to Constantine and Carthage and ended up at Tunis. Everywhere I bought fantastic earrings to add to my collection. It was all very much like Egypt, except that we had the new experience of driving through the desert.

Early in the following summer I invited Eleanor Fitzgerald, otherwise known as Fitzi, to come to Europe. She was much overworked by her theatre activities and needed a holiday. Because of the death of her lover she was extremely unhappy, and as I was still unhappy about Benita, we tried to comfort each other. Fitzi was a great friend of Emma Goldman.

part 2

chapter 2

end of my life
with florenz

In the summer of 1928 Emma Goldman was living at St. Tropez in a charming little house I had given her. She was engaged in writing her memoirs. We had finally convinced her that she must do this, and a fund had been raised to give her the where-withal to live during this period. I headed it and continued to add to it whenever necessary. She had for a secretary, as she herself couldn't put two words into readable English, a mad American girl called Emily Coleman. Emily, unlike most people who are mad, did not hide it. On the whole it was a pleasant quality because it manifested itself in terrific enthusiasms and beliefs which my cynical entourage would never do more than sneer at. She shared with Blake the persuasion that all things are possible if you have faith. She was passionately interested in people and in literature and life.

Emily looked like a little boy, although she was twenty-nine, and she had a son a few months younger than Sindbad. Even though I liked her at once it never occurred to me what a role she was to assume in my life. Emily insisted that she was a

writer herself and was merely helping Emma out in her
dilemma. She was, in other words, not Emma Goldman's secre-
tary. Emma adored her and mothered her and spoiled her, and
in return, without receiving any salary, Emily lived in Emma's
house and knocked her tremendous manuscript into shape.

Poor Emma much preferred anything to writing. She was a
woman of action, and was delighted if we motored over to
spend an evening with her, when she would give up her work
for the day and make us a marvelous meal. She was a Jewish
cordon bleu and her gefüllte fish was her *pièce de résistance*.
Florenz thought she ought to write a cook-book instead of her
memoirs.

Emily had a nice husband. He was a businessman in the
advertising world who had also written a book on psychology.
Emily had left him to stay with Emma because she needed this
climate for her health. It was the beginning of the end of their
marriage, although then she did not know it. At this time she
was in love with an Englishman whom she had met at St.
Tropez. She was constantly with him and his wife, and pro-
duced them in the way she always produces everything she
thinks she has discovered; with the delight a magician manifests
in bringing something out of a hat. And indeed they were
miraculous. Their names were John and Dorothy Holms.

When I first met John Holms I was impressed by his elastic
quality. Physically, he seemed barely to be knit together. You
felt as if he might fall apart anywhere. When you danced with
him it was even more apparent, because he could move every
muscle of his body without its being noticeable and without the
usual jerks one suffers in such cases. He was very tall, over six
feet in height. He had a magnificent physique, enormous broad
shoulders and small hips and a fine chest. He wore a small red
beard and looked very much like Jesus Christ. His hair was
wavy, thick and auburn red. His skin was white, but from the
southern sun it had turned pink. His eyes were deep brown and

he wore glasses; he had a classical straight nose. His mouth was small and sensuous and seemed to be pursed up under his moustache. Like all Englishmen he was proud of his ancestors but he hated his father, who was Scotch by descent and had been Governor-General of the United Provinces of India.

John was born in India and when he was a few years old he was separated from his parents and sent to boarding school with his sister in England. He loved his mother, a beautiful Irish woman descended from Nicholas Ferrar, the founder of Little Gidding. He rarely saw his family, who were living in retirement at Cheltenham. He found all contact with them difficult because he belonged to a different world. He knew much too much about theirs, and they knew much too little about his. His father had wanted him to enter the diplomatic service, but when the war broke out he was a student at Sandhurst Military College and joined up at the age of seventeen. At that time, he was as strong as a bull and had killed four Germans by hammering them on the head when he had surprised them breakfasting under a tree. For this, to his great shame, he was given the Military Cross. After six months of war on the Somme in the light infantry, he had been taken prisoner in a night patrol, and had spent the rest of the war (two years) in a German prison camp. In prison he met Hugh Kingsmill, who became a lifelong friend. His other great friend was Edwin Muir.

In the prison, because he was an officer, he had been pretty well treated and was unfortunately allowed to have all the liquor he wanted to buy. This undoubtedly had done him much harm, for his capacity for drink was greater than anyone's I have ever known. He drank about five drinks to other people's one and yet he never seemed to be affected by it until about three in the morning when he looked peculiar, with his eyes half shutting. However, he never behaved badly in any way. Drink made him talk, and he talked like Socrates. All his

varied education and knowledge of people and life, that should have been expressed in writing, came out in conversation. He held people spellbound for hours. He seemed to have everything at his fingertips, as though he had been in contact with everything, had seen everything and thought about everything. He was like a very old soul that nothing could surprise. This gave him a detached quality and I was greatly astonished much later when I discovered what passion lurked under this indifferent exterior. I always thought of him as a ghost. He was definitely a frustrated writer, although at one period in his life he had had a great success in London writing criticism, and he still received letters begging him to write articles. He could not get himself to write at all any more. And though he needed money very badly because he received only a meager allowance from his father, he preferred to live in the greatest simplicity at St. Tropez rather than go back to England. He had lived all over Europe since the war, in Ragusa, in Salsburg, in Dresden, in Forte de Marme, in Cagnes, in Zagreb and in Paris. He had been with his wife Dorothy for nine years, and she had traveled nearly everywhere with him. Now, however, they were more like brother and sister, their sexual life being over. They had led a very stormy existence. He had taken her away from a man called Bancock and had gone through months of hell, while she wavered between them. He had carried a pistol constantly, with the idea of killing himself if she did not remain with him. Dorothy at this time was very much absorbed in a book she was writing about Bancock; it was an extraordinary and beautiful book. She adored John and claimed that she was writing it for him. I am sure it was true. She must have been created by him, for no woman could live with him that long and not be entirely reborn.

Dorothy complained all the time about John, even though she loved him. She said she was a governess to a baby and had to do everything for him and could never leave him. She com-

plained because they were so poor. She complained because he
would not write. She complained because they did not live in
England and because he no longer desired her sexually and
she complained because he had never married her. She belonged
to a middle-class family and felt inferior because of this. She
was attractive and handsome; and also, strangely enough, had
red hair. But her eyes were not like John's. They were green
and cat-like. She had a beautiful white skin and a nice figure,
but she was seven years older than John, who was nearly thirty,
and that worried her. She was also sad because she had no chil-
dren. This was also a cause of complaint. They were a strange
couple and I was fascinated by them.

The first evening I met John was the anniversary of Benita's
death and I did not feel very happy. Florenz insisted on going
to St. Tropez to dance in the bistros. In the end I went too.
My melancholy turned into a kind of despertion and I re-
member getting quite wild and dancing on the table. This must
have made an impression on John Holms, but all I remember
now is that he took me to a tower and kissed me. This certainly
made an impression on *me*, and I can attribute everything that
followed to this simple little kiss.

Later I asked the Holmses to come to visit us at Pramous-
quier. They came overnight and we went in bathing at mid-
night, quite naked. John and I found ourselves alone on the
beach and we made love. He talked to me very seriously and
asked me what I liked in literature, and for some mad reason
all I could think of was May Sinclair. After that I did not see
him for a long time, because Florenz and I took the children,
Fritzie and Odile, Hazel and Milton Waldman to Maloja
for a month to avoid the summer heat of the Midi. I did not
forget John Holms, and I am certain that I was unconsciously
postponing him for my future because the minute I got back,
I went to find him.

As I say, the first thing I did when I got back to the Midi

was to look for the Holmses. They had left their house, and I did not know where they were. I went to the post office and, when I found out their new residence, I walked in on them. They were surprised and, I think, pleased. John took me for a walk on the hill behind his house. The landscape greatly resembled the English moors. Then he took me swimming at Ramatuelle. I was very happy with him and we got on very well. They had finally decided to go back to England, so that John could make some money writing and live again in the intellectual world from which he had fled. I invited them to come and stay with us at Pramousquier. At first they were reluctant, but when I offered them Elsa Coates's little house next to ours, they said they would think about it. Dorothy wanted peace and quiet to finish her book. In the end John made Dorothy come. She always did everything he wanted her to do. I liked her very much at this time and she liked me. I found her conversation fascinating. Soon she felt uncomfortable in my presence and began gently liquidating me, but that was when she suspected I was becoming a danger to her.

The day before I went to get them I felt a certainty about my future. I was living in the exciting expectancy of one about to enter into a new love affair. I really only acted from a blind force which drove me on and on. I could not live with Florenz any more as our scenes were becoming more horrible. In Maloja we had had another dreadful evening in a café, when he had thrown everything about, and in St. Tropez, after we got back, he had tried one night in a bistro to tear off all my clothes because he was upset by Odile's making a spectacle of herself dancing with her skirts up to her thighs, and because he was suspicious of John. Alexander Berkman had to come to my rescue. He stopped Florenz from making me quite nude in public, and then Florenz slapped me so hard in the face that, although I must have been quite drunk, I became sober.

By this time I had had enough, and I wanted to leave Flor-

enz, but I was afraid to go off on my own. Once Emma Goldman
had asked me how I could lead this kind of life. I told her that
I could not leave the children and that I did not want to talk
about it. But finally I decided things were too bad to continue.
A few months before, Florenz had thrown me down the steps
of his studio, and then burned up my sweater, and walked on my
stomach four times in the same evening. I told Florenz, sort of
vaguely and jokingly, that when we separated I would give him
Sindbad and I would take Deirdre. I imagine when John
Holms kissed me I unconsciously decided I would use him to
make my escape.

In the beginning I was not in love with John, but one night
when he disappeared for an hour, I got quite frantic. Then,
for the first time, I knew I loved him. We used to go out into
the country together and make love. Sometimes we went down
to the rocks under his house. The minute Florenz went up to
his studio and I saw his light lit, I ran over to John's house to
fetch him. That was our hour. Soon John began getting diffi-
cult about Florenz and asked me to discontinue my matrimonial
relations. I found this hard to do. It was all getting too much
and I wanted John to take me away, but he couldn't make up
his mind. He lived in a perpetual state of paralysis of will, and
he hated to give up Dorothy. Dorothy didn't think I was a
serious person, but John realized what he could do to me and
he was fascinated by the idea of remolding me. He knew I
was half trivial and half extremely passionate, and he hoped
to be able to eliminate my trivial side.

John and I wanted to be alone, if only for one night. Florenz
had asked us all to go to Toulon on a sort of spree. John and I
connived very carefully to avoid going on this party. In fact,
John was so clever that even up to the last minute I myself did
not know if he were remaining with me or not. However, he
did. Dorothy went off to Toulon with the others and at last we
were free to do whatever we wanted. We went to a real bed for

the first time, but got up in the middle of the night, fearing the others would return. We sat in the sitting-room for hours awaiting their return, all the time thinking we might have remained in bed. Florenz came home very late. He had left Dorothy in Toulon because she had drunk too much and was sick. The next day we all went back to fetch her. She was hysterical, but still not suspicious of me.

A few weeks of living under this strain was enough for me, and unconsciously I arranged to bring things to a head if John wouldn't. One evening, knowing that Florenz was about and not in his studio, which was the only time we were safe, I went over to John's house and kissed him. Florenz followed me and caught us, which I suppose was what I wanted, but what I had not foreseen took place: a terrible battle from which a death might easily have resulted. John was much stronger than Florenz, but he did not want to hurt him, and when Florenz attacked him, he merely tried to hold Florenz down until I went to get someone to intervene. I lost my head and went to get Dorothy, who was in the bathtub at my house. She took so long to get out, they might have been killed ten times. Finally we got the gardener to come to the rescue, and at the moment he entered the house, John was about to knock out Florenz in desperation because Florenz wanted to hit him with a heavy pewter candlestick. The gardener went to Florenz's rescue as he was his master.

Florenz told Joseph not to interfere, but at least that ended the deadly battle. Both were completely shattered. Florenz went back to our house and I went with him. He told me that he would not stand having the Holmses at Pramousquier any longer and that I was to get rid of them. Dorothy came in during the middle of the conversation and Florenz told her that John and I were lovers. She told Florenz that he was mad, but she looked distraught. Florenz went back to their house and told John that he would kill him on sight if he ever met him again. I was out of my wits, and I immediately arranged to have

the Holmses leave by a little back path and take refuge in Mme Octobon's bistro. While escaping, Dorothy injured her leg on the barbed-wire fence. Florenz went to the bistro to look for John, but Mme Octobon hid the Holmses and would not let Florenz see them. Then I knew it was all over, and I planned for everybody's escape. I bribed the gardener to take a note to the Holmses. I sent them some money and told them where to meet me. The Holmses got off to Hyères that night, and I was to join them the following day at Avignon.

It is very strange after living with a man for seven years to know that you are spending your last night with him. In the morning I asked Florenz if he would mind if I went to London for a few weeks to visit Peggy. Of course he thought this peculiar. When he said he would not like it I did not insist. I sent him to Hyères to the bank to cash a check, and when I kissed him goodbye, I wept. I can't imagine why he wasn't suspicious.

We had a very nice, primitive sort of girl staying in the house with us, Odile's sister-in-law. She was in love with Florenz and I was always urging him to make love to her, which he did. I hoped that after I left he would marry her, which he didn't. I took her part of the way with me so that she might bring back the car, and I also gave her a talk about Florenz and told her I was leaving him and that I hoped she would look after him. She was shocked and surprised for she had had no idea that was my intention. I kept quiet until the last minute before the train pulled out of St. Raphael, when I left her with a note of farewell for Florenz.

John and Dorothy spent the night in Hyères, and they were still there the next morning when Florenz went to the bank. Dorothy was terrified of Florenz. She thought he was a madman, and when she saw him in the street she made John climb up a water-pipe to hide in their room before Florenz killed him, which she believed Florenz had expressly come to Hyères to do. It was all very humiliating.

part 3

chapter 1

my life with john holms

When I arrived in Avignon and found John and Dorothy
Holms, the first thing I did was to throw away my wedding-
ring. I was standing on a balcony, and I threw it into the street
below.

Though this was a symbolic gesture, I have regretted it ever
since. It was such a nice little ring, and I have found myself so
often in need of one. Dorothy was very much upset because
her leg had become infected escaping over the barbed-wire
fence. She still did not know that John was really in love
with me, as he had not had the courage to tell her. He always
put off everything. We somehow still managed to make love
without her suspecting it. But I don't think that would have
worried her so much as the fact that we intended to live to-
gether.

We wanted to go to London, but Dorothy made me send for
my lawyer, who met us in Dijon, which was half-way to Paris.
When he saw John and Dorothy he warned me I was jumping
from the frying-pan into the fire. Unfortunately, he was also

Florenz's mother's lawyer, and that caused a lot of trouble as they felt I had stolen a march on them. I only wanted a legal separation, but he talked me into a divorce. I gave him a note for Florenz as the lawyer forbade my writing him. Worst of all he never delivered this note. He told Florenz of my intentions by phone, for which Florenz naturally never forgave me. The lawyer sent me home at once, telling me I had put myself in the worst possible position by leaving my domicile. After we had been in Dijon for a few days we left for the South.

The first night we got back we went to fetch Emma and Emily, and we all went to Fréjus for the night to talk about the divorce. Emma wanted to put in her word with Florenz so she wrote him a letter that made him furious. She told him to be big and to give me the children. I was still so afraid of Florenz that when I went home the lawyer suggested having me guarded by two thugs, but I declined such protection. When we broke all this news to Emily, she was rather upset because she was in love with John herself, and I think that only then did Dorothy realize what it was all about. Anyhow, I left John and Dorothy in a hotel in Grimaud and returned home. When I got there I found Deirdre alone with Doris. Doris told me that Florenz had gone to Paris with Sindbad and the girl Papi, who had taken wonderful care of him and had not let him out of her sight during all those terrible hours when he realized I had run away.

Florenz and I soon reached a deadlock about the children. I was willing to let Sindbad live with Florenz and I keep Deirdre, but I wanted to be guardian of them both. He would not consent to my being guardian of both of them. In the end he sent down our mutual friend, Peggy, who tried to fix things up. Finally, after keeping a lawyer waiting for three weeks at St. Tropez, we came to some agreement, and a document was drawn up to protect Florenz. His lawyer insisted on it before we filed petition for the divorce. I wanted very much to live

with John Holms, and only if I renounced him could I have stuck to my point and been guardian of both children. However, I did not think it fair to take everything away from Florenz, and also I had no idea how to bring up a boy. At that time I did not know that John Holms would be with me for so many years. I also felt compassionate about Florenz and did not have any idea that he would rearrange his life as quickly as he did.

The agreement about the children made me guardian of Deirdre, and Florenz of Sindbad. It was stipulated that I was to have Sindbad live with me sixty days a year. No condition was made about Deirdre living with Florenz. The divorce was then filed and asked for on the grounds of desertion of me by Florenz. It had to be brought up in Draguignan, the capital of the Var, the department Pramousquier was in. In three months, we would have to have a *conciliation*. In other words, Florenz and I would have to appear in court together and refuse for the last time to live together again.

Finally, before Christmas, John and I went away together. Dorothy had left for Paris. We motored all over the Bouches-du-Rhône and the Var. It was freezing cold, as only the Midi can be in winter after the sun has set, and I was suffering from sciatica, which I must have contracted in the woods making love with John when we had no other place to go. So the trip was not very successful.

Then we went to London where we did not remain for long. I had to live in Pramousquier, because of the divorce, and I thought I had to hide John, so he spent the winter in the Pardigon Hotel, ten miles away, and I motored over to see him every evening, returning home at four in the morning. Later Florenz told me that Kitty Cannell's sister had reported seeing us together in the hotel, so all my efforts at hiding were useless. In any case this would not have interfered with the divorce once Florenz had agreed to it.

Dorothy had left with the understanding that John and I would try it out for six months. She went to Paris and was unutterably miserable, and secretly hoped that John would come back to her.

In January I had to go to the *conciliation* at Draguignan. The South was covered with snow for the first time in twenty years. Trees were down, and the roads were almost impassable. John, whom I had taught to drive, drove me there. I left him in a café a few miles outside of Draguignan.

It was painful and embarrassing to meet Florenz again. It was the first time I had seen him since I had run away. For his birthday I had knitted him a beautiful sweater and for a divorce present he had sent me a pair of earrings. It was awkward coming face to face with him. He was very bitter, and when we met on the landing of the steps, waiting to be admitted to the judge, Florenz made sarcastic remarks to me.

When we went before the judge I had no idea how to reply to his questions and I kept asking Florenz what to say. I think that prejudiced the judge. He was a Presbyterian schoolmaster and decided that this was only another case of collusion. He could not understand why I was willing to give Sindbad to Florenz. After the *conciliation* Florenz and I had a drink and I wept. Finally I left him and went back to John, who was waiting in the café. He was in a state of anguish because he thought I had decided to return to Florenz.

The divorce actually took another two years to be granted, and then only on the grounds of cruelty. Doris and Peggy and the café-keeper of St. Tropez, all of whom had witnessed the scenes, had to appear in court to prove Florenz's cruelty. For all this I had to pay my lawyer ten thousand dollars (he said he never handled a divorce for less) and two thousand dollars to Florenz's lawyer. It certainly wasn't worth it but I only discovered what it would all come to long after I was in it.

When this was over we were more or less free and were able

to start out on our travels. It seems to me that John Holms and
I did nothing but travel for two years. We must have gone
to at least twenty countries and covered ten million miles of
ground. We wanted to go to Vienna. We arrived there on the
last train, after all the others were stopped because of the
blizzards, and found ourselves the only people in the *wagons-lits*.
The Danube was frozen and it was impossible to remain out-
of-doors for more than a few minutes at a time. Even then
one had to be covered from top to toe. We remained indoors,
most of the time in bed. I had never led such a wonderful
life before. John opened up a whole new world of the senses to
me, a world I had never dreamed of. He loved me because to
him I was a real woman. I refused to listen to him talk, and
he was delighted that I loved him as a man.

Although in the beginning I refused to listen to him talk and
fell asleep at night while he was holding forth to me, little by
little I opened my ears, and gradually, during the five years
that I lived with him, I began to learn everything I know today.
When I first met him I was like a baby in kindergarten but by
degrees he taught me everything and sowed the seeds in me
that sprouted after he was no longer there to guide me.

I am sure that during the first two years of our life I was
purely interested in making love, but when that lost its in-
tensity I began to concentrate on all the other things that
John could give me. I could pick at leisure from this great
store of wealth. It never occurred to me that it would suddenly
come to an end. He held me in the palm of his hand and from
the time I once belonged to him to the day he died he directed
my every move, my every thought. He always told me that peo-
ple never got what they expected from a relationship. I cer-
tainly never dreamed of what I was to get from him. In fact I
never knew that anyone like John existed in the world. I don't
know what he expected from me, but I don't think he was
disappointed. His chief desire was to remold me, and he felt

in me the possibilities that he was later to achieve, although
he admitted that he got many other things he did not expect.

When I first met John, not only was I ignorant of all human
motives, but, worst of all, completely ignorant of myself. I lived
in a repressed, unconscious world. In five years he taught me
what life was all about. He interpreted my dreams and analyzed
me and made me realize that I was good and evil, and made
me overcome the evil.

John not only loved women: he understood them. He knew
what they felt. He always said, "Poor women" as though he
meant they deserved extra pity for being born of the wrong
sex. He was so conscious of everybody's thoughts that it was
painful for him to be in a room with discordant elements.
Therefore he was supremely careful whom he chose to invite
together. He had a wonderful gift of bringing out people's
best qualities. He spent most of his time reading, and his
criticism was of a quality that I had never before encountered.
He was a great help to his writer friends who accepted his
opinions and criticisms without reserve. He never took any-
thing for granted. He saw the underlying meanings of every-
thing. He knew why everybody wrote as they did, made the
kind of films they made or painted the kind of pictures they
painted. To be in his company was equivalent to living in a
sort of undreamed of fifth dimension. It had never occurred
to me that the things he thought about existed. He was the
only person I have ever met who could give me a satisfactory
reply to any question. He never said, "I don't know." He
always did know. Since no one else shared his extraordinary
mental capacity, he was exceedingly bored when talking to most
people. As a result, he was very lonely. He knew what gifts he
had and felt wicked for not using them. Not being able to write,
he was unhappy, which caused him to drink more and more.
All the time that I was with him I was shocked by his paralysis

of will power. It seemed to grow steadily, and in the end he could hardly force himself to do the simplest things.

When I first met John he dressed badly. He wore his beard much too long, and had a broken front tooth from diving into a rock. After I had succeeded in arousing his vanity he remedied all these things by degrees and began to look quite different. In the beginning I cut his hair for him but later I forced him to go regularly to the barber, which for him was an ordeal. In London he bought some English clothes. He was always at his best in grey flannel trousers with a tweed jacket. He never wore a hat but always had a scarf of some sort which he perpetually left behind in bars when he was tight.

After we had spent six days in deserted Vienna, where all the restaurants were empty and where everyone was dying without coal, we went on to Berlin. Berlin was horrible, like what I imagine Chicago must have been at this time. I walked all over the city and saw nothing to justify my curiosity. We went to the opera and to some night-clubs full of gay boys, but it was all very dreary. I was delighted to get home again.

Soon after this we went to Corsica in a new Citroën we had bought, and made a complete tour of the island. John said the scenery reminded him of Donegal in Ireland, where he had spent his childhood. It rained most of the time, but what a beautiful, rugged and savage country it was. The food was not good and the hotels were bad, with the exception of a few English chi-chi places which had been built in the last few years. The land skirting the sea was rather like Italy. It was rarely flat and the roads were very winding where the sea had made deep inlets. We saw Napoleon's birthplace, and the home of the original anise from which Pernod is made.

After we got back John had to pay his yearly visit to his family. Of course he could not take me with him, and although his family thought he was married to Dorothy, she had never been to see them either. Actually, he had always put off legaliz-

ing his union with her, and after living with her so long there
seemed to be no hurry to go through all the red tape of getting
married. Only an extreme crisis could have made him take
this step.

When he came back from England I met him in Marseilles,
and we went at once on another trip, this time to the island of
Porquerolles. It is one of the three islands opposite the main-
land of the country we lived in, and could be reached by sail-
ing-boat from Giens. It was tropical and wild, and reminded
me of islands in the Pacific, although I had never seen any.
There was one little port, and many swimming beaches, and a
primitive hotel set in a jungle. We took many walks and, as we
were so happy to be together again, it did not matter much
where we were.

It wasn't long before Dorothy began to take our love affair
seriously. She had spent six months without John in Paris, and
of course she hated me. She went about saying the wildest
things, and writing John terrible letters against me. I had only
seen her once in the interval, and that was entirely by mistake.
When on our way back from London we stopped at Paris. John
had told her where he was staying on the Quai Voltaire, but did
not have the courage to tell her that I was with him. She ar-
rived early one morning and found us in bed. A dreadful scene
took place. She beat my feet and told me I was a wicked woman,
and she had to be removed by the *valet de chambre*. I was so
ashamed afterwards that I left the hotel secretly, and allowed
John to announce our departure.

Her hostility only egged me on. I must say I was pleased
that she was not really John's wife, for that would have put me
in a much worse position. But suddenly, in the spring, she
decided John had to marry her because she had resolved to
return to England. She claimed everyone had believed for
years that she was Mrs. Holms and would be in a false light
if people found out she wasn't, especially since she felt like

a deserted wife. John said he did not want to marry her. Naturally he would rather marry me if he married anybody, but I was still in the throes of divorce. Finally, she was so unhappy and became so insistent that John went up to Paris and married her.

I was looking after Deirdre at this time for Doris was on her yearly holiday. Deirdre was very much attached to Doris, and became even more so after the divorce, as she felt quite lost and insecure in all the confusion. When she was left alone with me for a month she clung to me like ivy to the oak and would not let me out of her sight. She was the most beautiful thing I have even seen at this age. Her hair was platinum blond, and her skin was like fresh fruit. She was still under four years of age, and living under these uncertain conditions upset her considerably. She liked John very much, but was surprised to meet him again. It was the first time she had seen him since he had been forced to leave Pramousquier. Deirdre never showed any signs of jealousy toward John; she just never wanted me to be out of her sight, and when once I tried to leave her in Paris for a few days with Peggy and her children, who were Deirdre's friends, she went on strike and I had to take her with me. She felt abandoned and frightened.

Peggy introduced us to Jed Harris in Paris. He wanted to rent our house in Pramousquier, so we went back to put it in order for him. He came down and stayed at Mme Octobon's at Le Canadel and appeared every day making new demands, as he did not think he would be sufficiently comfortable. We put in mosquito-screens for him and painted a room and did various other things to please him. Finally he lost his courage and ran away, sending me a check for five thousand francs indemnity. It was most generous, and later I rented the house to an American Princess called Murat, who appreciated my home more than Jed Harris had.

In Paris I saw Sindbad for the first time since the breakup.

It was a painful experience and released all the suppressed agony I felt over losing him. Sindbad was then living with his grandmother, but Florenz would not let me see him alone so we all went together to some park. The meeting was unnatural with Florenz present as a spy. Sindbad wore a little white sailor-suit with long trousers and seemed very strange. Although I never actually lost him, I imagine I came pretty near it. Florenz did everything in his power during those first years to separate me from my child. Florenz's behavior was caused partly by revenge and partly through fear that I would take Sindbad back. The divorce had not yet been granted, and the settlement that his lawyer had made was not really valid until it was incorporated in the divorce papers. Though I did not know it at the time, Florenz was living with a woman called Ray Soil whom he had allowed to take him in hand during his great misery and she was already giving him a child.

Ray and Florenz did everything they could to separate me from Sindbad. Fortunately they never succeeded, because the bond between Sindbad and me was too strong for anyone to break. Florenz was always threatening to take him away, and once he even suggested going to live in Russia. Finally John intervened and made me write the kind of letters to Florenz that would give him confidence in me, and he finally abandoned his suspicions that I was trying to get the child away from him. He more or less came to terms with me. But he never allowed me to have Sindbad for more than sixty days a year to the minute that the letter of the law allowed. The first years of my life with John were completely poisoned, as I was extremely miserable without Sindbad, whom I adored. My only consolation was that Ray was a very good stepmother.

We decided to make an extensive tour of northern Europe in our new Citroën car. There was just room for Deirdre, Doris and my dog Lola. I went south to settle the house, which had been rented for the summer, and to fetch Doris and Deirdre. It was

awkward breaking the news to Doris about John. However, if she had any scruples about my living in sin the thought of a trip to Norway and Sweden must have consoled her. We drove up to Paris to pick up John who had been in London for a few days. Then we started on our grand tour.

We motored all through Belgium and Holland, cut through Germany, crossed the Kiel canal and went to Hamburg. One of my strongest recollections of this part of the trip was my spending a whole day with tears streaming down my cheeks because I had had a terrible dream about my separation from Sindbad; the dream seemed to release all my repressed feelings, and I could no longer control them. By the time we arrived in Sweden, sometime later, I was so upset that I wanted to go back to Florenz. I felt I could no longer endure my life without Sindbad. John said Florenz would not take me back, and that he must have felt great relief (in spite of his first misery) from the fact that the tension which had once existed between us was over.

We went from Germany to Copenhagen, a provincial, dull and Nordic city and I hated it. I have never been able to get used to the North. It always frightens and chills me. I had felt the same way about Edinburgh years before, although I considered it a beautiful city. Then we went to Oslo, which I liked better than Copenhagen, but I really feel happy only in southern towns, or at least in Latin ones. After Copenhagen we traveled everywhere by boat and took our car with us. It was terrifying to drive it over the two little lopsided planks which were provided for its entrance and exit to boats. Sometimes, the car was picked up in the air by derricks and put on the boat. I once saw a Norwegian pony suffer the same fate, and I felt sorry for it when I saw its legs dangling in midair. Between boats we raced from one ferry to another driving over terrible roads, and perpetually getting out of the car to open and shut gates that enclosed cattle.

It rained every day in Norway and we could barely see the magnificent fjords except for a half-hour a day, between four and four-thirty, when the sun came out like clock-work. We were too late for the midnight sun, but in any case we weren't far enough north to encounter it. We went only as far as Trondjen, which is the most barren town I have ever seen, and certainly as far north as I have ever been.

Lola became pregnant in Trondjen and, since there was barely room for her in the car anyway, her increasing size made life more and more awkward. She and Deirdre shared a sort of bunk, and as Lola got fatter and fatter, Deirdre had to fight for her rights to maintain her place. Twenty minutes before we reached home Lola gave birth to her first puppy in the car, just behind John's neck. We named this offspring Trondjen.

We crossed the frontier high up in a part of Sweden that resembled Scotland. It was wild and moorlike, and one could travel hours without seeing a soul. Once we found a lone house with a tree growing out of its roof. We motored for miles through pine forests, with lakes, and as there were no towns anywhere we lost our way in the dark. We finally reached Stockholm at four in the morning. It looked so beautiful in the white night, I was bitterly disappointed when I beheld it in the daylight, all changed. We found the people most amiable and the food wonderful, especially the smörgasbord. Thirty or more dishes spread out for you at every meal! There was plenty of schnapps, but the pubs were open only at certain hours. We had no desire to remain long in this barren country without civilization, so we motored back through Germany just in time to spend a beautiful Indian summer in the Austrian Tyrol in September—what a contrast that was to the gloom of the North; and what a relief to have no more rain. On the way we drove to Weimar and saw Goethe's birthplace, through Thuringia's wonderful forests, and passed several days in Munich. From Munich we went to Bad Reichenhall.

Because of John's chronic mental paralysis, he put off writing to Dorothy all summer, although he carried her manuscript with him everywhere. He was supposed to revise it and return it to her. I was horrified by what seemed to me to be his callousness, never dreaming how much he himself was suffering from his neglect of her and his inability to do anything about it. Later he told me that he constantly had the feeling that a wolf was tearing at his breast. When we got to Trondjen he finally spent several days on her book and returned it to her. By one of those awful accidents of fate one of the pink feathers from my negligée got into the manuscript while I was reading it. This, when she finally received it, upset Dorothy considerably. She was miserable, for she had hoped that when John married her it meant that he would return to her, but by now she realized this was not the case.

I think one reason John was so attracted to me was because I was just the opposite of Dorothy. I took life rather less seriously and never fussed. I joked about everything and he brought out my unconscious wit; he even enjoyed being a foil for it. I was completely irresponsible and had so much vitality that I am sure I was quite a new experience to him. I was light and Dorothy was heavy. She was always sick and my health was marvelous. Both she and John suffered from insomnia. He would lie awake reading all night while I slept like a baby. Dorothy was dowdy and dressed with no taste. She had piano legs while mine were just the opposite. In fact John named me "Bird Bones." He didn't even mind my strange nose and, in honor of it, called me "Dog Nose." The peculiar thing was that Dorothy and I had the same beautifully shaped cranium and in that one respect we resembled each other.

When we got to Bad Reichenhall in Bavaria, a few miles from the Austrian Tyrol, we decided to remain there for the month of September. John wanted to write an article he had promised to some English paper, but of course he never did it.

The Austrian Tyrol is the country I love most in Europe. I adore the rocky mountains with the trees growing straight up into the air as rigid as telegraph poles. I love the soft-spoken Austrians and the wonderful atmosphere of relaxation they produce. Of course, this was before the Anschluss. Besides the lake that D. H. Lawrence describes in the *Captain's Doll,* there were many others just as beautiful, one with an old monastery in the center. We went to Hitler's future home, Berchtesgarten, without realizing what that name was to mean in a few years, and from there to Salzburg, although we were too late for the music festival. John had lived there at one time and had strange memories of Stephan Zweig whom he had met there.

I think this was one of the happiest times of our life. We had made friends with an Englishman and his Danish wife, and they had a daughter Deirdre's age, so we all had company. Bad Reichenhall itself is a horrid sort of "cure place," where you take baths for your health, but we remained there very little as we were perpetually motoring around the vicinity.

In Munich, we had bought a phonograph and lots of records, and that was the beginning of a real enjoyment of music which John aroused in me. He was horrified by my bad taste. No wonder. In those days I liked Rubinstein's "Melody in F" and Schumann's "Traumereï" better than anything else. Soon he made me appreciate Mozart, Bach, Beethoven, Schubert, Brahms, Haydn, Handel and later Stravinsky and "The Six." After I was once initiated, I sat for hours listening to music, but I always preferred to hear it at home. Occasionally John took me to concerts and to Mozart's operas.

We went back to Pramousquier at the beginning of October, and as I said before, we arrived just twenty minutes too late for Lola, who had already given birth to one puppy in the car. They were very beautiful babies, but the southern climate

did not suit them, probably because of their northern heritage, and Trondjen died of distemper.

We soon got restless, and went to Paris to live. At first we had no home other than the Hôtel de Bourgogne et Montana near the Place du Palais Bourbon. I had decided to sell the house at Pramousquier and give Florenz the proceeds, as I really considered it his property, having long since made him a present of the house which was actually in my name. So I sent for all the furniture and divided it with Florenz. My share I placed in storage. I had already given him the Hispano-Suiza, to sell for his divorce expenses.

Florenz was very secretive about his life, but soon I discovered, by chance, that he was a father again. He had had a little daughter and I asked him to let me see her. I felt badly, as I had had an operation performed in a convent by a wonderful Russian doctor called Popoff. The nuns were strict and dirty and had no idea why I was there. However, they tried to take care of me, and on Sunday morning woke me up at six to put a thermometer in my mouth which they never came back to remove. When I remonstrated they excused themselves on the grounds of being at prayer. Dr. Popoff, who was supposed to have been the *accoucheur* of the Grand Duchesses of Russia, admitted one to this convent for needing a *curetage*, and then was credited with saying suddenly, in the middle of the operation: *"Tiens, tiens, cette femme est enceinte."*

When I went south to settle Pramousquier I brought back my darling dog Lola. She had never lived in a big town before, and the first morning the maid took her out she got frightened and escaped. We had wild hopes of recovering her by searching in the lost dog's home, otherwise known as the *fourière*, and for months we went there daily. Finally we reduced our visits to two or three a week. Never have I seen a more heartrending and upsetting sight. The *fourière* was full of lost creatures who set up the most horrible howls to attract attention the minute anyone entered. Every day there were

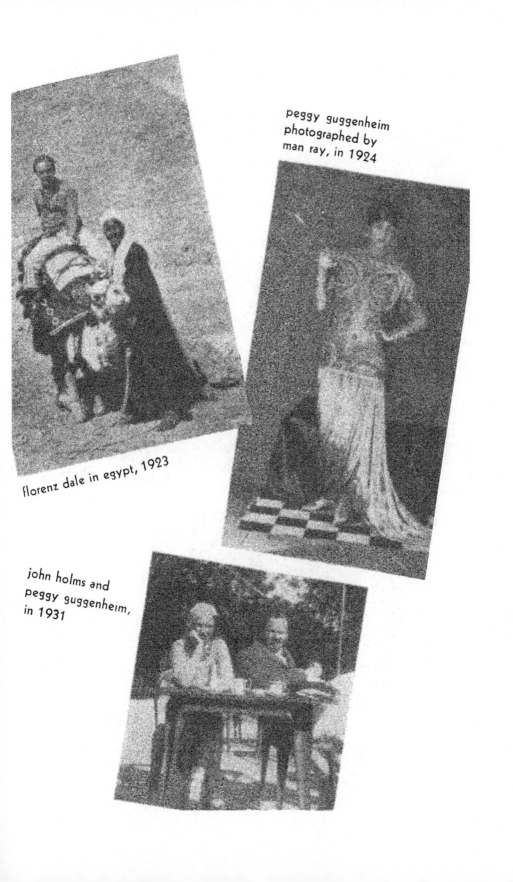

peggy guggenheim
photographed by
man ray, in 1924

florenz dale in egypt, 1923

john holms and
peggy guggenheim,
in 1931

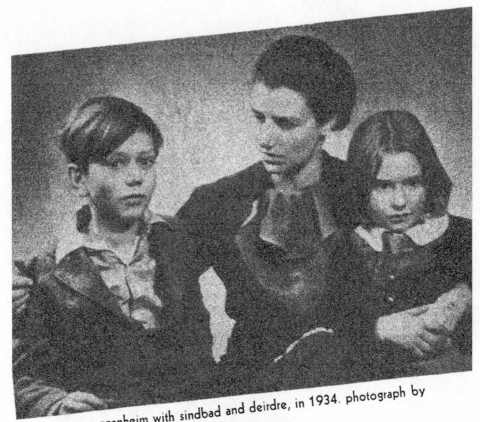

peggy guggenheim with sindbad and deirdre, in 1934. photograph by
barbara kerr-seymour

sherman—1936

new homeless beasts, but never Lola. The dogs must have thought we had come to claim them, or rather they hoped that their masters were about to rescue them. In the end, we had to give it up. Someone else must have wanted Lola as much as we did, or they would have brought her back to us because we placed a touching ad in the *Paris-Midi,* offering a big reward.

During this period I was slightly more friendly with Florenz, and he allowed me to see Sindbad every Thursday for the entire day, but would never let him sleep in my house. Soon after that he moved to the Marne; I used to meet him half-way, take Sindbad back to Paris for a short time and bring him back in the evening. This proved so tiring for the child that I motored down to La Fierte, where he lived, and tried to find places to go with him. Of course it didn't work. One day Florenz made a terrible scene when I brought Sindbad back, so I postponed my visits, expecting to have the child live with me for part of the summer.

Emily was in Paris, and we saw her quite often. We took Sindbad and Johnny out together on Thursdays, and thus started a lifelong friendship between the two boys, who were almost the same age. One night, when we were in a café, I left Emily and John and went to join Florenz at another table, little dreaming of the effect it would have on John. It seems he nearly went off his head, and Emily had to walk him up and down the street to calm him. The next day she warned me that I was playing with fire; and for the first time I realized what a passionate person John Holms was underneath his calm exterior.

We had rented a furnished flat with a studio in the Rue Campagne Première and, as it was leased under my married name, John used to be called Dale, which annoyed Florenz considerably. I therefore resumed the name Guggenheim to avoid trouble.

I took John to meet Helen Fleischmann and Giorgio Joyce.

We saw quite a lot of them and often with his parents, James Joyce and Nora. They lived an intense family life and it surprised John, who was so anti-family, that Giorgio should be so tied up with his parents. Lucia Joyce, Giorgio's sister, was often with them too. She was a sweet girl who was studying dancing. Giorgio had a good bass voice and used to sing for us, frequently with his father, who was a tenor. John enjoyed talking to Joyce but, since he never could have been one of Joyce's sycophants, the relationship was casual. They had both lived in Trieste, and I remember their reminiscing about the Bora wind, Trieste's worst evil. While it blew (and sometimes it lasted for days) ropes were put up in the streets to help people circulate.

Suddenly my mother arrived from America. I hadn't seen her since my separation from Florenz, and although she approved of that, she thought I was mad to give him Sindbad and she never forgave me for it. She had no idea about John, and it was difficult to initiate her. Fortunately, when she arrived Edwin Muir and his wife were in Paris, and when she came to see me she met them at my house. It was a good beginning. She would not believe that I was living with John, and that I wasn't going to marry him. She always called him Mr. Holms and treated him formally. She never liked him; she thought he was a terrible man for having married Dorothy, and because he didn't work. I tried to impress her a little bit by his family. She wrote down in her notebook "Governor of the United Provinces of India." After she had made several inquiries, she came back and told me I was wrong, that his name should have been Lord Reading. However, she had to accept John as she knew I would not see her otherwise. One day when the Muirs were in my house Dorothy came to the door and made a terrible scene saying they had no right to befriend me.

I liked Edwin Muir from the very beginning. He was frail and

timid, and so sensitive and pure that you could not do other-
wise than like him. You felt his talents, even though he was
shy and never acclaimed himself. Muir reminded me of a man
who has been asleep in front of a fire too long and could not
recover from his drowsiness. They had had a hard life and had
struggled painfully to keep alive by doing translations. They
were almost better known as the translators of *Jew Suss* than
as anything else. They had translated Kafka, and thus in-
troduced him to the English-speaking world. Muir always
consulted John before publishing his own books, and once,
when he hadn't, John said the book was a catastrophe. Muir
adored John and after his death, when I asked him to write
something about him, this is what he sent me. He enlarged
on it and used it himself in his own autobiography, *The Story
and the Fable.*

By Edwin Muir

Note

"I first met John Holms one Sunday morning in Glasgow
in the summer of 1919. Hugh Kingsmill arrived at my lodgings
with him as I was starting out for a walk in the country: when
I opened the door I heard their English voices echoing up the
stairs. Hugh had to go on to Bridge of Allan, and Holms
agreed to come with me. It was a still, warm day. We wandered
about the moorlands to the south of Glasgow, ate in a little tea-
room and returned in the evening, meeting a two-mile-long
line of courting couples as we approached Glasgow. Holms
was in the uniform of a Scottish regiment, glengarry, khaki
tunic and tartan trews. I cannot remember much about that
day except that we had an argument about Pater, and later dis-
cussed the merits of windy and calm weather: Holms hated
bracing winds and I, being then an admirer of Nietzsche, was
in favour of them. As we were returning he began to quote

Donne, whom I did not know at the time, and we stood leaning against a gate with the scent of hay in our nostrils while he mildly intoned:

> And while our souls negotiate there,
> We like sepulchral statues lay,
> All day the same our postures were,
> And we said nothing, all the day.

Then he recited the opening verse of 'The Relic,' stopping with delight at 'the last busy day' and the picture of the resurrected visitor waiting by the lover's grave to make 'a little stay.' These lines seemed to be in keeping with the rounded haycocks in the field and the long line of couples passing like a millennial procession in the evening light.

"The first thing that struck me about Holms was a still watchfulness which set me thinking of the Old Testament, never far from a Scotsman's mind. By the end of the day the watchfulness had turned into a watchful benevolence, which was characteristic of Holms if he liked anyone. The next time we met was in London after my marriage, and I saw a great deal of him later in Dresden, Forte dei Marmi and the south of France, where we both chanced to be living; and afterwards in London.

"Holms gave me a greater feeling of genius than any other man I have met, and I think he must have been one of the most remarkable men of his time, or indeed of any time. There was a strange contrast between his instinctive certainty and grace as a physical being, and the painful creaking of his will. In his movements he was like a powerful cat: he loved to climb trees or anything that could be climbed, and he had all sorts of odd accomplishments: he could scuttle on all fours at a great speed without bending his knees: walking bored him. He had the immobility of a cat too, and could sit for a long time without stirring; but then he seemed to be filled with a boundless dejection; it was as if he were a captive imprisoned far

within himself, beyond rescue. His body seemed to fit him for every enjoyment, and his will for every suffering. He had constantly the struggle which Wordsworth noted in Coleridge: 'the amazing effort which it was to him to will anything was indescribable.' The act of writing was itself an enormous obstacle to him, although his one ambition was to be a writer. His knowledge of his weakness, and his fear that in spite of his gifts, which he never doubted, he would not succeed in producing anything, intensified his stationary combat and reduced him to shaking impotence. He was persecuted by dreadful dreams and nightmares.

"His mind had a majestic clarity and order, and when turned on anything was like a spell which made objects assume their true shape and appear as they were, in their original relation to one another, as on the day of creation. He once had the idea of writing a poem describing the evolution of the species, pictorially, showing all the various animal forms developing from an archtype by an enormous foreshortening of time; and his talk often gave the same impression. It had no surface brilliance; it was awkward; he often seemed unable to finish a sentence: the same obstacle which kept him from writing, kept him from talking as he might have talked. What made his talk unique was its reality, the fact that it was never trite and never secondhand, but always concerned with real things. He could be amusing, and he loved witty conversation, but this was his distinguishing quality. His benevolence came out very strongly in his talk: it was as if he were looking at things with a fraternal eye and helping them to find themselves. But he had a keen enjoyment of the second-rate too, I remember him reciting T. E. Brown's poem:

A garden is a lovesome thing, God wot,

with sardonic gusto, his voice rising with pained incredulity in the line,

Not *God*, in GARDENS, when the eve is *COOL?*

to assume a fine gentlemanly condescension in

Nay, but I have a *sign.*
'Tis very sure He walks in *mine.*

"Like Hugh Kingsmill I always had a strong sense of his
goodness, although he was not good by his own standards. He
gave me more strongly than anyone else I have known, a feel-
ing of the reality of goodness as a simple almost concrete thing.
Sometimes he seemed to breathe a goodness so natural and
original that one felt the Fall had not happened yet, and the
world was still waiting for the coming of evil. These 'good'
times always brought with them a feeling of abundance, of fat
herds, rich fields, full streams, endless food and drink, and all
things gladly following the law of their nature. He had the
capacity for simple enjoyment which Yeats says goes with
goodness,

Except by an evil chance,

a line which would have made him smile. He had an equally
strong sense of evil, and a profound conviction of sin; but he
had no trace of Puritanism, and I think his guilt came finally
from his feeling that he was an immortal soul caught in the
snares of the world, and both liking and loathing the bondage.
His inability to express what was in him may have been partly
due to the intensity of this feeling, but that in turn greatly
deepened his sense of guilt, which grew with his failure to
write."

In the spring, John and I motored all through Brittany with
Deirdre and the maid, Doris being on her yearly holiday. It
either rained all the time, or seemed to, for the country was
covered with mist. We never saw the sun. Brittany had a certain
ferocity and wild beauty with its savage cliffs and red earth.
There were many pleasant beaches, but without sun they were

forbidding. We saw wonderful old Coptic churches and passed on the roadside many early sculptures of Christ. These *calvaires* were unpretentious and astoundingly beautiful.

We wanted to rent a house for the summer but after looking for one in every corner of the peninsula, we gave up the idea. We had not found the ideal spot. John would never make a compromise about where he lived. He would spend months looking for a place that he would only be living in for a short period. We usually wasted half of the summer in search of a residence, but he always ended by finding the perfect place. After Brittany we went all over Normandy and then gave up the idea of living there also. Finally, in desperation, I suggested we go down to the Basque country to St. Jean de Luz where Helen and Giorgio were spending the summer. As we were leaving, Emily showed up and we took her with us as far as Portiers. We drove through the Loire country, and visited all the Châteaux again. We had exquisite meals and wonderful wine—John was a gourmet and connoisseur of vintages—in all the provincial towns we drove through. We always did ourselves well.

When we arrived in St. Jean de Luz, we again began looking at houses. Helen and Giorgio lived in the center of town and wanted us near them, but of course John rebelled. Finally he found the most beautiful house, a few miles away from St. Jean de Luz out in the country at the foot of the Pyrenees. It was situated high on a hill and was completely isolated. It was called Bettiri Baita and belonged to a painter called Monsieur de Bonnechose, who was the tallest man I have even seen. Even John looked like a dwarf next to him. He himself had built this house out of stone that had been found on the premises. M. de Bonnechose really wanted to sell the house and all the land, but he rented it to us for a minute sum. We spent the most wonderful summer, when we finally got around to it.

At last I was to have Sindbad stay with me for a fortnight. Florenz suggested that he come and live nearby during this

visit; I think he was still afraid I was going to run away with
Sindbad. In order to allay his fears, I said he could have Deirdre
as a hostage, provided Doris went with her. When he consented,
we crossed southern France by train to Sainte-Maxime, where
we exchanged children. Florenz was then living at Cavalaire
near Pramousquier. The exchange was effected and I took
Sindbad to Emma's house for the day and then home with me.
Florenz had filled him with the most extraordinary stories and
had warned him not to let me run away with him. Sindbad
told me that he had come to visit me because Florenz said
that if he didn't I could send the police after him. Evidently
he had also promised Florenz he would not set foot in Spain
(we lived only a few miles away) for he refused to walk on a
bridge which connected the frontiers. When we visited some
underground grottoes that were partially under Spanish soil,
Sindbad insisted on coming out. We went on a little trip up
to Gavarnie and walked on a glacier and drove around the
Pyrenees. Emily was with us and that made things easier. I sat
behind in the rumble seat of the car with Sindbad and by de-
grees renewed my acquaintance with him. I resumed telling
him the exciting stories I had always invented for him. He
adored them.

John was a wonderful athlete. When he was drunk he used
to climb chimney-stacks and walls of houses with the agility
of a cat. He could dive from terrific heights like a bird and he
swam like a fish. He was also a fine tennis player and because
of his height he was expert at the net. His whole body was so
agile and elastic that he could do anything with it. He climbed
rocks like a mountain goat and used to make the most dan-
gerous trips along the coast. I was terrified of rock-climbing,
and Emily went with him instead. He also took Sindbad, and
they became very good friends after Sindbad thawed out. When
the fortnight was over I had to take him back to Florenz. It
was agonizing to be without him again, especially since I wasn't
to see him until Christmas.

After I returned with Deirdre and Doris, John took Emily and me on a little trip to Spain, high up in the Pyrenees. We lived practically on the border and the country was filled with smugglers who brought back fire water and cigars on foot and hid them in the bushes around our house. We drove to Pamplona, the city Hemingway had immortalized in *The Sun Also Rises*. I was so miserable at being separated from Sindbad again that this trip did not make much of an impression on me. All I remember is seeing the bulls being driven through the town into the corrals.

Emily and John always spent hours discussing literary matters. I used to leave them and go to bed early. All day I retired into my shell and read Dreiser's *An American Tragedy*. Once I had a dream that I walked into the bathroom and found Emily and John in the bathtub reading poetry. I both loved and hated having Emily with us. She had so much life that, in spite of my jealousy, I always sent for her when I got bored. She was determined to squeeze every drop of knowledge she could from John and was at him all the time. Once, when she was angry with him, she burst out in a fury, saying, "I wish I would never see you again." I was sitting calmly writing to Sindbad and I replied nonchalantly, "It could be arranged," but of course it never was, and our lives got more and more tied up. Emily was always staying with us or going on trips with us. She was like our child. She was passionately interested in writing and she used to send John pages and pages of her poems when she was not with us. Sometimes he groaned and moaned in despair; sometimes he thought they were good.

During this summer my divorce was finally granted, after two years.

In the fall we went back to Paris and lived in the Royal Condé Hôtel, near the Odéon. We began hunting madly for a house, and John as usual refused to live in anything we found. At the last minute, while I was trying to bully him into a very nice apartment that he didn't want, he found the ideal house.

It might have been built for us, it was so perfect in every
respect. Georges Braque, the painter, had built it for himself.
It was like a little skyscraper with one or two rooms on each
of its five floors. It was in a working class quarter, way out of
the center of Paris, on the Avenue Reille, almost at the Porte
d'Orléans; but opposite us was the reservoir and behind us was
a garden. Our neighbors were artists. On one side Amédée
Ozenfant had his school of painting. The view from the top
floor was miraculous for Paris. In front of us stretched a whole
field of grass which grew on the reservoir. In summer, the hay-
cocks were neatly piled, we thought we were living away from
the city. On the roof we had a terrace and a little pool, which
we did not discover until years later when we lent Gabrielle
Picabia the house and she unearthed it. We slept on the top
floor, and it was like a nest in the tree-tops. John had a study
here too. It was cold and uncomfortable and certainly the last
place he would ever have worked in, even if he had been able
to write, as it overlooked the reservoir. On the next floor below
we had one room the whole depth of the house, which served as
library, living-room, dining-room and guest-room when neces-
sary; also as a music room, where we played the phonograph
all day. In the second year we bought an English handmade
gramaphone with an enormous papier maché horn. This room
was like a large studio. It had windows front and back that
reached to the ceiling. Underneath, Deirdre and Doris had a
floor to themselves with two rooms, and below that was the
kitchen and cook's room, and on the street floor was the garage,
where we kept our Peugeot.

We lived in this house three years, but of course we always
went on trips and never seemed to be stuck there. Before we
had rented it we had signed a lease for three small apartments in
an enormous building not far from the Avenue d'Orléans. It
was built for artists, and each flat had a studio. The whole
place was cheaply constructed and consequently the walls were

thin. John, who could not bear any noise, insisted on having cork walls put into his apartment. This building was owned by a company that went broke, and it took years before they completed it. By that time we were living in our skyscraper house. We tried to recover all the money we had put into that place, but the French are good at holding on to anything they actually have in hand. Our lawyer was unsuccessful in recovering any part of the two thousand dollars we had invested in advance for rent, heat, alterations, etc. But little did I dream what service I was rendering a future husband. When years later I met the tenant who eventually occupied the flat he told me that a mad American woman had much improved his studio by inserting cork walls like those which Proust had. (That tenant was Max Ernst.)

John drove me to Antwerp to visit Emily, in a new Delage we had just bought. These were the last six months she was to spend with her husband, who was manager of an advertising agency. It was the worst possible time of the year to go north, and the whole trip was made through fog. We did not remain long, and the best thing we did was to hear Mozart's opera, *Don Giovanni*, sung in Flemish. It was heavenly. On the way back I stuffed the car with Belgian-made Player cigarettes, for they were so much cheaper than in France. At the frontier the car was searched and the cigarettes dragged out from all their hiding places. Every time the customs official asked if there were others I insisted that he had found them all. It became more and more embarrassing as he kept finding new ones. At last he found all and fined us heavily, saying that he could confiscate the car, but would not go to such limits. He took every cent we had and all the cigarettes, and we had to drive home penniless.

During this winter we saw quite a lot of Harold Loeb, my cousin, formerly editor of *Broom Magazine*. Both he and John were very fond of Jean Gorman whose husband, Herbert Gor-

man, was writing a book on James Joyce. Gorman used to bring out of his pocket the most insulting replies from people he had written letters to about Joyce. But Gorman was so delighted with the letters that he did not seem to realize how insulting they were to him.

John never wanted to go to bed. He liked to sit up conversing and drinking very late. Evidently Jean Gorman, whom we saw nearly every day, complained to James Joyce because she brought us this little poem he had written for her about us:

"To Mrs. Herbert Gorman who complains that her visitors kept late hours:
Go ca'canny with the cognac and of the wine fight shy
Keep a watch upon the hourglass but leave the beaker dry
Guest friendliness to callers is your surest thief of time
They're so much at Holms when with you, they can't dream of
 Guggenheim."

I was quite jealous of Jean Gorman; John liked her so much. I liked her too; she was a vital, proud little thing. She looked like a lizard. She was unhappy with her husband, and although she was breaking up with him, she had the pride and character to maintain a deep silence about her affairs, even when drinking. Finally she left for America, got her divorce and married Carl Van Doren.

At this time Deirdre was in Mrs. Jolas' bilingual day-school in Neuilly and was very happy. Doris drove her there every morning in a new little Peugeot car I had bought to run around Paris in, and either Doris or John and I went to fetch her every evening. That was about the only hour I saw her for she was already in school by the time we woke up.

John got up late as he slept so badly. He read most of the day and we went out every night to night-clubs in Montmartre or to cafés in Montparnasse or to friends' houses, or we had people at home. John always liked society after six in the evening, so when Deirdre went down to have her supper and go to

bed, we usually went out in search of people. Sometimes we brought home for dinner lots of unexpected guests for whom there always seemed to be enough food. We had a marvelous cook. If John stayed out very late, which he often did, I got so bored I went home without him. I hardly ever drank in those days and I could not keep up with him. Sometimes he spent the whole day in bed with a hangover and got up only for the evening. This used to make me extremely angry because I felt cheated of his company. He never wanted me to leave him, and was just as unhappy without me as I was without him. He was extremely dependent on me and never wanted me out of his sight.

In May we took Agnes Dew with us and went to Italy, first to Florence and then to Assisi where Emily was spending a few months for her health. John wanted to go to the Abruzzi, a part of Italy I had never visited. We drove down the Adriatic which was different from the other coast of Italy that I knew so well. John drove the Delage as if it were an aeroplane. I always felt we were in the air, not on the earth.

Going over a high mountain pass to Aquila we struck a blizzard, though it was in May, and the wires of the car froze. We had stopped on a very slippery road covered with snow to see the scenery a few feet before the peak. On our right was a drop of thousands of feet. John insisted before we died of the cold we turn the car around and go back. We could start it by rolling downhill, but the danger of pushing it over the cliff while we turned it around was terrifying. We had to calculate it to an inch, and it was almost impossible because the car kept slipping on the ice. I really don't know how we ever did it; it must have been the fear of dying in the cold that egged us on.

Emily, who was with us, refused to help in any way; she disliked the blizzard, and she just sat in the Delage while Agnes and John and I, by sheer force of will, managed to get it turned

around without its going over the side. John put his scarf under the front wheel to stop it from skidding and then we rocked the car back and forth, fearing any moment it might fall over the precipice. Even this fact did not make Emily budge. We pushed and pulled and made tracks in the snow for the wheels to be free. Finally we got to an inn at Norcia in the valley below where we were treated regally. It was the most primitive place I had ever been in. A whole baby goat was brought on the table for us and gallons of Abruzzi wine. Our beds were warmed with copper warming-pans. The inn-keepers were so sweet to us that we were happy we had not perished in the blizzard. We were thrilled to be in the country of D. H. Lawrence's *Lost Girl*. John and I were great admirers of Lawrence's books.

We left Emily in Assisi and went to Venice. For the first time since I had been with John he let me down—he did not share my passion for this miracle city. I got up early and walked miles alone every morning before he awoke. He complained about it all afternoon and made me so unhappy that finally I decided to leave. I think it is the feeling of death that permeates Venice which upset him. I can't explain in any other way his taking a dislike to a place that has so much beauty to offer in every form and from so many ages. We drove down the Brenta and saw the strange summer palaces of the Venetian nobles, so varying in type but all built within a hundred years of each other.

In June we began again to travel all over France to find a house for the summer. My relations with Florenz had reached a more friendly state, and Sindbad came to me regularly Christmas and Easter and for one month in the summer. Deirdre went to Florenz for an equal length of time. This made things easier. We took a beautiful trip through the part of France that lies between Marseilles and the Spanish frontier. It resembled the country of the Var, but was even wilder and covered with

grapevines. The few small towns, Port-Vendres, Banyuls, Cerbère, were filled with artists, and the life there must have been much like that of St. Tropez. After that we paid a visit to our friends, the Neagoes, at Mirmande, in the Drôme near Valence. They had bought three old houses in the one street village and lived a peaceful life, he writing and she painting, in this strange medieval town perched high up on a hill with its ancient crumbling structures. John did not want to leave but I egged him on as I was anxious to find a home for Sindbad, whose visit I was so much looking forward to. We went next to the Haute-Savoie and looked all around the Lac d'Annecy, but ended up in Paris, where fortunately we were able to contact M. de Bonnechose and rented his house again.

This year the Joyces, Helen and Giorgio, were not at St. Jean de Luz. They had been married in the spring and had gone off with his parents, James and Nora Joyce, to the north for the summer. We missed them and our wonderful tennis-parties. Emily joined us for part of the summer bringing with her an unpleasant little Italian who had followed us each separately around the streets of Assisi, even into the church, while we gazed at Giotto's masterpieces. He was so unbelievably unattractive and uninteresting in every way that John was horrified and began to work on Emily to disillusion her. It took many months. I said that at least I might as well benefit by his presence and use the occasion to refresh my Italian, since he could not speak French or English. That saved John a lot of unnecessary conversation. He could not speak Italian.

During this visit of Sindbad's he and Deirdre began fighting like cat and dog. I think there was a terrible jealousy between them because of the divorce. The first few days of Sindbad's stay were always rather a strain because he came from Florenz and Ray full of hatred for John. Sindbad used to say we led such easy rich lives while Florenz and Ray had to work hard. Ray was a second-rate novelist, but not quite bad enough in

those days to make the large sums of money she did later, when she frankly became a pot-boiler writer. They did translations. I gave Florenz and Ray a large income, which they kept secret, and Sindbad could not believe it when finally, after years of my being taunted, Djuna came to my rescue and told him the facts. Sindbad really was fond of John, who was marvelous with children and fed them spiritually and mentally, as well as taking them rock-climbing, swimming and playing rough-house games with them.

One day John drove Emily, her Italian and me to Spain for the week-end. We were so excited by the country we remained ten days with no other clothes except what we were wearing. For the first time in my life I went to bullfights and became more and more fascinated. We saw every type of bullfight, from little intimate country ones to Madrid's best. After I was satisfied that I had witnessed every variety, my curiosity died out and I never saw another one until fourteen years later, in Portugal. My most vivid memory of this trip was the desert we drove through from Burgos to Madrid, for every time the road curved we found ourselves in a different scene. The variety was unending, and the road was excellent. It had been built by King Alphonso for his personal benefit. In Madrid we met Jay Allen, an old friend of Emily's. They had worked together on the Chicago *Tribune* in Paris.

Once when the car broke down, John tried to explain, in a few broken words of Spanish, to a mechanic what was wrong with it. The mechanic politely told John not to exert himself so much, because the engine spoke much better Castilian than John did. At Avila, where we arrived at four in the morning, we found sheep grazing on the cathedral lawns, and at Toledo we spent the whole day searching for El Greco's painting of that city, not knowing it was in the Metropolitan Museum in New York.

We had to put up with Emily's Italian friend all winter, and

finally one day she sent for John and told him that it was all over. I was greatly relieved and could now come out with a few of the things I had been repressing. In fact, I was so nasty about him that she finally gave me a black eye, and had even worse intentions, but John saved me by removing her. She was in a dangerous state. Of course my mother thought that John had given me the black eye. I did not see Emily again for many months as I really was annoyed with her.

At Easter time I had arranged to fetch Sindbad and take him somewhere in the south for ten days. Florenz and Ray were then living in Nice and were on the verge of getting married. For some morbid reason Florenz decided he would like to have John and me attend this ceremony and the wedding party that was to follow. He therefore forced our hand by choosing for the great event the week we arrived in Nice. We did not want to go to the wedding, but we had to, so as not to offend the children. Emily and her son were with us and we all drove from Le Rayol, where we were staying, to Nice. It gave the impression to the outside world that we were all excessively friendly.

Peter Neagoe, who always called me "Lady Peggy," had come down especially for the wedding, and he asked us to drive him back to Paris with us. We were delighted, except for the lack of space. We had Sindbad, Deirdre and Johnnie Coleman as well as Emily and innumerable suitcases. I don't know how we all got crammed into the Delage. Only John was comfortable— he was in the driver's seat. To make matters worse, Peter said we had to go to Mirmande to fetch some mysterious packages that he had to take to his wife. After Mirmande one of these packages suddenly flew out of the car. We were forced to stop and retrieve what turned out to be his wife's corsets.

After we got back to Paris we went to London for a few days, and suddenly John got the idea that it would be nice to remain in England all summer. He hadn't lived there for years, and he felt it would be the ideal place to find a country house

to live in for several months. We rented a car and drove all through Dorset, Devonshire and Cornwall. We were tempted by Dorset, but of course John would not make up his mind about any of the houses we had seen. Only after we got back to Paris did he consent to write to the owner of a magnificent place we had found on the edge of Dartmoor. We took this house for two months.

The children were with Florenz in Austria. I flew to Zurich, which was half-way, to meet them, and brought them back to Paris. Of all the trips I had ever made in a plane, this was by far the most beautiful. We flew over the eastern part of France which is dotted with farm-lands of every color, and then over the Jura.

After I had collected the children, we started out for England in both our cars with Djuna Barnes, our cook, the maid and Doris, who drove the Peugeot. We took a night boat from Le Havre and in the morning landed at Southampton. From there we drove down to Devonshire.

part 3

chapter 2

hayford hall

The house we had rented was called Hayford Hall. It was a spacious, simply built, greystone structure about a hundred years old. The rooms centered around a large hall with a fireplace. This hall was well-proportioned, but its paneling was of an ugly new-looking wood and its furniture, though comfortable, was not attractive. The walls were covered with the usual ancestral portraits, shipbuilders from the Clyde. At the end of this room was a big cathedral-like window. All one could see through it were vast trees that kept out the sun. Apart from the eleven bedrooms, we never used any of the other rooms, except a very dreary dining-room, in which we ate our meals, adjourning immediately after to the hall. I am sure so much conversation was never made in this hall before or since.

The children had their own wing which consisted of several bedrooms and a large schoolroom downstairs where Doris reigned supreme. This was an ideal arrangement, but I was torn between the brilliant conversation in the hall and my children's company. They ate lunch with us and they rode with

us and swam with us and played tennis with us, but they were not admitted to the hall except on rare occasions. The bedrooms were simple and adequate, except for the beds which were as hard as army cots. One bedroom, however, was rather dressed up in rococo style, and it looked so much like Djuna that we gave it to her. It was in this room, in bed, that she wrote most of *Nightwood*. Now she does not agree, and says we gave her this room because nobody wanted it.

We never used the respectable-looking sitting-room armed with chintz-covered furniture, or the little writing-room supplied with a library of the world's worst books, a fox's brush and an elephant's foot waste-paper basket. The house, one may gather, was not the main attraction. It was the situation and the surroundings that were beautiful beyond belief. Hayford Hall's back door gave out on to Dartmoor. Its front entrance was approached by a driveway of monkey-puzzle trees. In the early morning we were awakened by rooks, who inhabited a tree outside our window.

Although situated on the edge of Dartmoor, Hayford Hall had its own vast gardens which were half cultivated and half wild. There was one garden, a quarter of a mile long, with herbaceous borders. There were beautiful lawns, a well kept grass tennis-court and two ponds covered with lilies where we swam, but on the whole one had the impression nature had not been tampered with, and that this place was still part of the moor. At nightfall thousands of rabbits scurried over the grounds in all directions. We also had some woodland with a stream going through it; and another stream ran by the house.

The moor is hard to describe; it was so varied and so vast. It was hundreds of miles square and completely uninhabited except by wild ponies. The ground was strewn with bones and skeletons. The only plants that grew were bracken and heather. In the parts that were swamps, as if to warn one, there grew a little feathery white flower. The moor was covered with streams

and enormous boulders. It was hilly but there were magnificent stretches for riding. Far on the other side was Dartmoor prison, but it was so far away that it meant a whole day's riding to get there and back. The wild ponies were rounded up once a year and tamed. We rented them for rides and though they were ridiculously inadequate, the children learned to ride them in a paddock. After a few weeks we took them on the moors. We had one real horse. When the ponies bolted after throwing the children, this horse, generally ridden by John, went in chase of the ponies.

The ponies belonged to a one-armed epileptic, who was sweet and patient with the children. He never tired or complained, and brought us as many as eight ponies at a time. Their bridles and saddles were forever slipping off or breaking, and it was impossible to get one's stirrups even. I remember one saddle whose girths would not hold, and I ended up by slipping more and more forward until I found myself on my pony's neck. The first year we had no serious accident. The second year was fatal, but that will come later.

Of course Emily spent the summer with us and she was always trying to get the best horse (there was really only one good one). It was called Katie and was a hunter. The other pathetic creatures were called Starlight, Mollie, Trixie, Polly, Ronie, etc.

One day Sindbad was thrown by Starlight, the children's favorite. He stood in the middle of the paddock crying, "Starlight, Starlight, come back!" But Starlight ran away and had to be chased for hours before he was caught. The great danger were the swamps, and we were generally guided by our one-armed groom who knew all the tracks over the moors. But often we left him with the children and went off with John, sometimes galloping for miles, getting lost, and escaping bogs by the skin of our teeth. Once John rode into a bog. Emily

and I screamed at him to get off his horse, and he did so, just in time to pull the animal out.

Our life at Hayford Hall was completely cut off from the world. Apart from the visitors who came we saw nobody. Djuna and Emily and Emily's son were with us all the time, and we asked other friends down for the week-ends.

Emily's uncle, a puritanical gentleman from New England, came the first summer. Of course, he thought I was married to John and called me Mrs. Holms, as did the two maids who were left in the house to guard it, in case we turned out to be barbarians. Emily's uncle, Mr. Coleman, was fascinated by our life and especially by John. He told Emily that he thought John was a superman who lived in another world. Emily's uncle was terrified by Djuna. She called him Papa, which he didn't like.

Mr. Coleman was shocked by his niece's behavior, as she was greedy at table, and made scenes if she were not allowed to ride Katie, which was really John's horse. Emily said one day, after her uncle had scolded her about her table manners, "I don't want to be a pig." I replied, "What are you going to do instead?" Djuna was annoyed because Emily tried to monopolize John and wanted to talk to him by the hour. They used to sit up until the early hours of the morning, John drinking but not Emily. She seldom drank. She did not have to; in fact she was overstimulated all the time. Djuna once told her she would be marvelous company slightly stunned.

Milton Waldman came down for a few days. He was having a nervous breakdown and, although he was greatly impressed by Hayford Hall, I doubt that he enjoyed it. My mother came but would never stay in my house, because I was not married to John. She was surprised when she saw in what style we were living, as she considered me a wild Bohemian on the edge of the gutter. William Gerhardi came with Vera Boyse. Antonia White and her husband, Tom Hopkinson. All these

people made life amusing, but we really had a better time when we were alone with our little foursome, even if we fought and it all got intense. We somehow spurred each other on. We liked to insult each other. Once John asked Sindbad to fetch a pair of scissors. Sindbad was busy and refused. John was indignant. He said, "That boy is ten years old and can't even fetch a pair of scissors." I replied, "You are thirty-five and you can't fetch anything." When I was complaining that John never wrote, he said to Emily, "Peggy would like to be the wife of Stravinsky." I replied, "Which one?" Once Djuna said to John, "Why, I wouldn't touch you with a ten-foot pole." I replied for him that he could easily touch *her* with one, a gentle compliment meant for John, not Djuna. One night Djuna appeared looking quite different. She had just washed her hair. I called her "cutie redcock." Later I fell asleep, as was my habit when fatigued by Emily's conversations with John, and when I woke up, John was playing with Djuna's soft fluffy hair. I looked at them and said to John, "If you rise, the dollar will fall." Djuna said to John, "You smug little red melon of a Shakespeare. Busy old fool, unruly son."

Djuna was writing *Nightwood*. She stayed indoors all day, except for ten minutes when she went for a daily walk in the rose-garden and brought me back a rose. Emily had threatened to burn *Nightwood* if Djuna repeated something Emily had confided to her by mistake. As a result Djuna was afraid to leave the house. She felt it necessary to guard her manuscript. She had no suitable clothes for the country, but in the evening she wore one of two very beautiful French gowns. Emily always wore a dirty sweater. She even rode in it. I usually wore riding pants and so did John. He looked handsome in them.

All our food came from Buckfastleigh, a little town miles below, where an abbey was being built. Doris drove down to shop every day with Marie, our French cook. On Thursdays she took Marie and Madeleine, the maid, to the coast for their

day off. We were about twenty miles from Torquay, a gay sea-
side resort. On Thursdays we ate steak and kidney pie and
cottage pie cooked by the English maid, who had been left
there to oversee us.

John often drove us down to the sea and discovered wild
coves where we could bathe in peace and quite. We also
went to local horse races, where our ponies were entered, so
you can imagine what kind of racing was involved. It was all
very crooked anyhow. We soon learned that the winners were
controlled by the local butcher.

At the end of the summer Djuna took Sindbad back to Paris,
where he met Florenz. She wrote me they met in a clinching
embrace. We let Deirdre and Doris go to visit Peggy and her
children, and we went to Bath and Glastonbury cathedral and
through Somerset with Emily and her uncle. After they left
us, we went to Cheltenham where John was to visit his family.
Of course I could not meet them as we were not married,
but his sister came to the hotel to see me. She must have been
shocked by the whole affair because she had heard such wild
tales from Dorothy about me. John tried to impress her with
our domestic life, led with the children at Hayford Hall, so that
she would realize how different it all was from what she
imagined. When she said goodbye she told me to look after
John. I was surprised because he always looked after me. I
never dreamed of looking after him, as future events will show.

In January we went up to Austria to Gargellen to ski with
the children. While we were away, Florenz and Ray lived in
our house in Paris. Sindbad was a good skier and even Deirdre
by now had had some practice with Florenz and could stand
up. Emily came with us and asked her friend, Peter Hem,
to join us. He was a dark little Scotsman, a frustrated writer,
who in desperation had buried himself in the Foreign Office.
Emily had been on his trail for four years already. He
loved her, but he would not marry her, and only someone

with her intense belief in performing miracles could have persevered so long. She had given it up temporarily, when she had gone away to Italy, but had gone back to it again. John liked Hem because he was so intelligent and he could talk to him. I liked him too, but at first he was very shocked by my frankness. I tried for years to restrain myself in front of him, so as not to horrify him. I succeeded so well that I finally gained his confidence and friendship. Hem was a very good skier and took Johnnie, Emily's son, and Sindbad on long trips. We could not have chosen a worse place for skiing, as Gargellen was on the wrong side of the valley. All the time we were there we were waiting for snow that never came. I don't know how John stood the strain of trying to ski for the first time in his life on these slippery frozen slopes. I never skied, of course, but went on a sled. At the end Johnnie got the chicken-pox, but we did not realize it and went on skiing. Afterwards Deirdre and Sindbad came down with it.

During this winter Sindbad, who had been madly in love with Marlene Dietrich for over a year, wrote her a very touching letter. He told her he liked beer and skiing and added, "I hate Greta Garbo. Don't you?" He asked her to send him a signed photograph. After several months he received a letter from one of her secretaries saying he could have one for a dollar.

In the middle of March we went to London. Dorothy seemed to want to end her hostilities against me. Astrology was her new hobby and she cast my horoscope—some fifty pages. We took her on a motor trip through the Cotswolds and Wye valley. We made our headquarters in a place called Morton-in-the-Marsh, where John and I slept in a feather bed. Emily was living on a farm somewhere nearby, and we motored all over the place together, ending up in Wales. It was very pleasant except for one evening when Dorothy made a dreadful scene. I think it was when she discovered that Emily had been at

Hayford Hall. Dorothy was no longer jealous of me; she had transferred all her feeling of hatred to Emily.

John wanted to help Djuna publish her novel, *Ryder*, in England, as it had been published only in New York. He wrote a note to an old friend of his, Sherman, who was a publisher in an avant-guarde publishing house. He met us in the Chandos pub. Some immediate combustion must have occurred. Sherman took a great fancy to me and leaped into the rumble seat of the car, where I had installed myself after we left the pub. He asked if he could lend me five pounds. This was because a moratorium had been declared in England and all American banks were closed. My mother had had the bright idea at this moment to wire me not to sell my capital. I could not even get a penny out of the bank. Sherman never published *Ryder*. I believe he did not like it, but he asked us if he could come to stay with us in Paris at Easter time. When he came, I fell in love with him. I did not tell John. I was very surprised and perturbed by the whole thing. I imagine I felt Sherman was a real man and John was more like Christ or a ghost. I needed someone human to make me feel like a woman again. John was indifferent to the worldly aspects of life and did not care how I looked or what I wore. Sherman, on the contrary, noticed everything and commented on my colthes, which I found very pleasant. One day he discovered me with a broom in my hand. The maid was sick and I was trying to clean the house. He took the broom and insisted on cleaning for me because he said I was doing it so badly. We soon found that we had the same recurring dream of encountering in the middle of the Atlantic an unknown island with three smokestacks. John got jealous, and after a dinner-party I had to be put to bed drunk. Sherman came up and tried to look after me and this caused more trouble. He went back to England and we did not see him again for several months. But I had a strange premonition that in one year I would be his mistress.

In the spring Milton offered us a house in London he had
borrowed, so we went to live in Trevor Square. We gave lots
of parties and got quite settled and felt we should remain in
England. We sent for Deirdre and Doris and the cook as we
had decided to go back to Hayford Hall. Deirdre arrived at
Folkstone with her hair so wild and fluffy that John named her
Flossy, which name she has kept to this day.

Sherman was separated from his wife. He had a daughter,
Debbie, about Flossy's age. We invited them to tea one day.
They looked so much alike it was unbelievable. They both
had a sort of stolid quality and resembled two oxen in har-
ness. Sherman was exceedingly handsome. He was taller than
John and had brown hair and eyes, one of which was damaged,
and a beautiful nose, slightly tilted. He was pale. He was an-
other frustrated poet. Sherman had produced a book of poems
and John was embarrassed because he wanted to discuss them
with him. However, John found one line he liked and, with
his usual tact and hypocrisy, coped with the situation. He did
not much relish Sherman's conversation.

In Paris that spring we had met Eugene Jolas, the editor of
Transition. John liked him very much and they used to sit
up very late drinking and reciting Hölderlin's poetry, which
Jolas knew by heart. Jolas's wife, Maria, used to sing duets
with Giorgio Joyce. She had a lovely voice, too.

In July we went back to Hayford Hall. It seemed all the
more wonderful the second year, for nothing had changed, and
we felt we owned it. The only difference was that we were
trusted, and the formidable housekeeper-maid and her as-
sistant were not there to guard us. To replace them we brought
two more servants of our own who had been working for us
in Trevor Square: Albert, a miraculous cockney who played
at being butler, and his wife, a sad Belgian called Louise. We
still had Marie, our cook, but Madeliene, our maid, had re-
mained in France. Albert now took over the catering and went

with Doris every morning to shop for food. He took every-
thing in hand and saw to it that we were well supplied
with liquor, which seemed to be his weakness. He also saw that
other people were supplied at the back door. I told him to
sell all the empty bottles but he said no one woud buy them.
However, one morning at six, he disturbed us by wheeling
this fantastic assemblage past our windows and thus got caught
red-handed. He made great friends with the butcher and did
a lot of dirty deals with him at the pony races. I don't doubt
that he sold or gave him all the empties. On Thursday's, when
Doris took the servants for their outing, she had great trouble
in bringing Albert back, he got so tight. He also served as a
witness against Mrs. Boyse whose husband divorced her soon
after her visit to Hayford Hall.

The second summer we seemed to have many more guests
than the first. Of course Emily, who behaved worse than ever,
and Johnnie and Djuna were with us, and Peter Hem came
several times. My new friend Wyn Henderson, who was later
to become so closly associated with me, dropped in on her
way to Cornwall. My mother came again and at the same time
Djuna's friends, the American-French painter, Louis Bouché
and his wife and daughter. He was an enormous man of some
six feet or more with the width of a giant. His wife was a
little dainty creature with a very young face and white hair.
He had a beautiful daughter Sindbad's age and Sindbad fell
in love with her. The Bouchés drank as much as John did, or
even more, and had to go to bed after a few days, they were so
sick.

In late August the children flew to Munich with Doris.
Florenz was to meet them there. I accompanied them to Lon-
don, where we spent the night with my mother. I had written
Sherman that I should like to see him. He had tried to come
to Hayford Hall and had phoned us somewhere on his route
to Cornwall but never found us. When I wrote to him my in-

tentions were very clear to me, but not in the least so to him. He was in Cornwall when he got the letter and never suspected why I was writing to him. He thought that I was alone in London and wanted to be friendly.

Soon after I returned to Hayford Hall, John met with the accident that was to cause his death five months later. It was due to a series of mishaps, all completely unnecessary.

One afternoon in late August we went horse-back riding in a typical Dartmoor rain. The rain wasn't bad enough to be uncomfortable but it was enough to cloud over John's glasses. Half-blinded, he allowed Katie, his horse, to stumble into a rabbit-hole and throw him. His wrist was entirely dislocated. For some strange reason I felt a kind of pleasure when I saw he was helpless, but I soon recovered. John walked home leading Katie, and Emily galloped back to get a doctor. Our local doctor came up from Totnes, a few miles away. I helped him to administer chloroform and he set the wrist very badly. John was in terrible pain and I was quite insistent that we get some morphine for him. The next day he was still in agony and we drove him over rough roads to the hospital where he was X-rayed. It was necessary to have his wrist in a plaster cast for six weeks, during which time I had to dress and undress him like a baby.

Finally, at the end of the summer, I decided Emily had gone too far. When she was about to leave in a few days she said to me, "I had such a happy summer." I replied, "You're the only one who has." She was so insulted she rushed upstairs and began to pack her bags. She intended to leave at once. Everyone hoped that I would ask her to remain. I didn't and not even at the station did I relent. John begged me to change my mind, but I would not; I was adamant.

As soon as we got to Paris I took John to the American Hospital, where he was examined and again X-rayed. They said he had a little piece chipped out of his wrist and recom-

mended hot salt baths and a masseur. The masseur was blind. He was supposed to break down the extra muscle tissue which had grown in the wrist and was preventing its being used freely. The agony John went through every time this blind man treated him was terrible to witness. Sweat streamed down his face and all over his body. Finally the masseur dismissed John saying he could do no more for him.

We had decided by this time to live in London. John had written only one poem in all the years he had been with me. I had done nothing but complain about his indolent life, never dreaming how unhappy he was about it. He thought that maybe in London, surrounded by stimulating people who spoke his own language, he might be able to start writing again. He spoke French so badly that he never could have intellectual conversations with the French.

When he drank a lot he always complained saying, "I'm so bored, so bored," as though this cry came from his very depths and caused him great pain.

We sublet our house in the Avenue Reille and put Deirdre in a *pension* with Doris, near Mrs. Jolas' school, with the idea of their joining us as soon as we were settled in London. By this time John's wrist allowed him to drive, but he still could not use it freely.

part 3

chapter 3

death of john holms

We were invited by Milton Waldman and Peggy to stay with them at Orchard Poyle until we had found a house. We motored into London every day where we saw every kind of unsuitable house and motored back to Buckinghamshire at night. Once when we went out on our tour Emily was with us and suddenly I got confidential and told her secretly about my attempt on Sherman. She was horrified and told me that I was completely irresponsible and mad and that I risked losing John. She frightened me so much that I then and there decided never to see Sherman again and lived up to my resolution until after John was dead.

We finally found a house through Wyn Henderson. It was in Woburn Square and, though very English eighteenth-century, it was really quite nice by the time we made it a little less formal. John was to live here only six weeks as he died in this house. Of course he never got around to writing, but he did have many people to talk to in London, including Hugh Kingsmill, who came back into his life a short time be-

fore his death, and Edwin Muir whom he loved, and Gerhardi who amused him frightfully, and Hem and other people.

Shortly after we were living in the house I got drunk one night and became very bitchy and taunted John about Sherman. I told him of my letter and my desire for Sherman. John nearly killed me. He made me stand for ages naked in front of the open window (in December) and threw whiskey into my eyes. He said, "I would like to beat your face so that no man will ever look at it again." I was so frightened that I made Emily stay all night to protect me.

John had always sent Dorothy all the money that he received from his father. It was very little, only two hundred pounds a year. On one of his visits to England he succeeded in getting an extra forty pounds a year. This was still not sufficient for Dorothy to live on and she wanted some assurance of security. She would have preferred a settlement but, since all my money was in trust, all I could do was to sign a legal document engaging myself to give her, for the rest of her life—even if I died first—the sum of three hundred and sixty pounds a year. Shortly after this John's father gave him outright five thousand pounds, in order to avoid death duties. He invested it in some safe government stock. I made him make out a will in my favor. Dorothy, having forced the marriage, was his legal heir, and I felt that in all fairness as she was now protected, I should be the heir. The strange thing was that I thought so much about death and seemed to have a premonition that John would die. I was always worrying that because I was not his wife, I would have no right to bury him if he died and would have to get Dorothy's permission or his family's. Of course I wanted to marry him but the thought of going through a divorce from Dorothy was too much for John and I was too proud to insist. He was practically paralyzed by this time in his will power and could not even write a note. Finally, when we were settled in Woburn Square, he de-

cided he would get a divorce and intended to speak to Dorothy about it, but of course it was never to be.

At Christmas, Sindbad came to London. Deirdre was with us and I had a hectic time trying to amuse them. They got so spoiled that they did not want to go any place except to cinemas, circuses and pantomimes.

All the time we were in Buckinghamshire John had been taking more massages from a person recommended by Milton. This came to an end when the massseur dismissed the case, claiming he could do no more. He said that if John wanted to be completely cured, he would have to undergo an operation. This was confirmed by a Harley Street doctor. It was a matter of taking an anaesthetic and having the extra growth in his wrist broken. It would take three minutes. John decided to have this done. The operation was arranged for, but had to be called off at the last minute as John had the flu.

At the end of the Christmas holidays, I myself took Sindbad all the way to Zurich to meet Florenz who was then living in Austria. The parting was extremely painful. When he left, Sindbad cried as he did not want me to spend the whole day alone in the station waiting for a return train, which I was forced to do. I too started crying and couldn't stop. I cried the whole way back to Paris where I went to see Agnes. She begged me to stay with her, but some strange thing was pulling me back to John and I left by the next train. When I got back to Victoria Station I thought of Sindbad and mentally blamed John for all the years of agony that my separation from Sindbad had caused me. I swore a terrible oath that I never wanted to see John again. In less than thirty-six hours he was dead.

He met me at the station and took me home. Our house was full of people. He suddenly announced that, during my absence, Emily had arranged for him to have the operation and it was to take place the next morning. All his friends were worried. They seemed to have a premonition that it was bad.

Gerhardi, who was writing a book about the Astral, warned
John that he would surely leave his body under the anaesthetic.
John replied, "What if I never come back?" He stayed up
drinking very late and the next morning woke up with a
hangover. If I had had any sense of responsibility I would not
have allowed the operation to take place. I can't imagine now
why I was ashamed to tell the doctors, who had already post-
poned the operation once because John had the flu, that it
would have to be called off again. Anyhow I allowed the doc-
tors to come. John wanted me to remain with him, and there
was no reason why I shouldn't. I held his hand until he was
asleep, but then the doctors firmly and politely waved me out
of the room and I went downstairs to wait. The whole thing
should not have lasted more than half an hour. When that
time elapsed I got nervous and went upstairs to listen outside
the bedroom door. There was no sound, so I went below again.
Shortly afterward one of the doctors went to get a little bag
from the front hall. This made me feel that something had
gone wrong and I was terrified, but I did not know what to do.
After what seemed hours they came down all together—
our doctor, who was a general practitioner, the surgeon, and
the anaesthetist, who was anaesthetist to the king. The minute
they came into the room I knew what had happened. John's
heart had given out under the anaesthetic.

After the operation all three had gone over to the other side
of the room and had left him to his fate. Suddenly the physi-
cian noticed that John was failing, and then they had tried,
too late, to revive him. They had cut open his chest and in-
jected adrenalin into his heart and massaged it, but to no avail.
They had killed him and they knew it. They were frightened.
Everything they said made them seem more horrible to me.
They had the insolence to apologize for the embarrassment of
having this occur in my house. Then they told me stories of
people dropping dead on the street from heart-failure. They

were worried because they knew there would be an inquest and they wanted to save themselves. Our physician, who was Milton's doctor, phoned to Buckinghamshire and asked him and Peggy to come and look after me. Knowing that it would be hours before they could arrive, the doctors departed and left me completely alone. I went up and looked at John. He was so far away it was hopeless. I knew that I would never be happy again.

The strange thing was that I had, for a second, felt a sense of relief when the doctors told me he was dead. It was as though I were suddenly released from a prison. I had been John's slave for years and I imagined for a moment I wanted to be free, but I didn't at all. I did not have the slightest idea how to live or what to do. I was absolutely bankrupt. Peggy and Milton arrived. None of us acted in the least solemnly or artificially. I was calm and there was no fuss. They sent for Emily. Peggy, who was practical, asked Emily to live with me as she herself had to go back to her children in a few days.

For years I had told Emily that if John were to die, I would never see her again. Now I was only too happy to allow her to give up her own life and stay with me. She slept in our room and we talked about John for nearly two months and that saved me. I can't think of anything else that would have been better. All my feelings of jealousy vanished when we wept together and shared our grief. I said to her, "Now that John is dead, we are running into eternal danger." We were.

In the afternoon the undertaker came to take away John's body. I asked to have his watch and his dressing-gown removed and I put them on at once and felt nearer to him and slightly safer. But as his body was being taken down the stairs, I suddenly remembered the oath I had made at Victoria Station wishing never to see him again, and I let out a terrible scream, because I felt I had killed him.

I wanted to have John cremated and we sent for his sister

and Dorothy. John died on January 19, 1934, at the age of thirty-seven. The next day was Dorothy's birthday, and he was cremated on Emily's birthday, January 21st. There had to be an autopsy and an inquest. Edwin Muir insisted that I have a lawyer present at the inquest in case any trouble arose. I was questioned by the coroner, and gave a report of the history of John's accident and of its consequences. The coroner was very polite and human. To my great surprise, he said to me more as a statement than as a question, "And you lived with him." And I replied, "Yes, for five years." Then a report was read on the autopsy. It seemed that all of John's organs were very much affected by alcohol and he was in rather bad shape. The doctors were exonerated.

After that we had the cremation. I didn't have the courage to go. Muir and Hugh Kingsmill and Dorothy and John's sister and Emily and Milton were present. I would not allow anyone else to be there. I went, during this hour, to a Catholic church in Soho with Peggy and we lit a candle. After that I came home and sat on the floor in our bedroom, where John had died, and listened to Beethoven's Tenth Quartet on the phonograph. While I was sitting there in my extreme agony, John's sister came up to say goodbye to me. She had caught me completely unawares and for the first time she realized what John had meant to me. She said, "Whatever your life is to be, I hope it will be happy." It seemed strange at that moment to think of the future.

Emily spent a lot of time with Dorothy and tried to look after Deirdre. We didn't want to tell her that John was dead. She loved him very much. One day, when we were in a bookshop, she asked me when he would come back from the nursing-home where she believed he was staying. I said, "Never. He is in heaven with the angels." A few days later she came home early from her school in Bloomsbury and refused ever to go back. Emily and I tried to find a new one in Bloomsbury. In the

middle of my misery I endeavored to talk to the principal about Deirdre. The strange thing was that the principal of the school, whom I met again years later, told me that the day in which I had come to her was the worst day of her life. It certainly was one of mine. Doris had just been married and, although she was willing to come back, I was so jealous of her that I used her marriage as an excuse to look after Deirdre myself. But, in my awful state of misery, I wasn't very good at the task. Deirdre got the flu and was in bed for weeks because the doctor thought she had a higher temperature than she really had, as I did not take it by mouth. I finally found a good school for her in Hampstead where she was happy.

By the time Dorothy left we had come to some new agreement about her future. I gave her all of John's money and books and promised to give her another one hundred and sixty pounds a year. This time she trusted me and tore up our legal contract.

After John died I was in perpetual terror of losing my soul. Every day I looked in the mirror and watched my mouth sag more and more. That was a symbol of what I feared was happening to me. I did lose my soul and I knew it. If I found it again, how could I cope with it without John to guard it? I believe that in the future life some day I will find John again and my soul will be safe.

Muir and Hugh Kingsmill came often to my house. They felt that by sitting there they could in some way be closer to John. We were all most unhappy. I felt perpetually like seizing someone's hand and begging them to say something emotional. Gerhardi was offended that I had not allowed him to go to the cremation, and had even wept about it, but we soon had a reconciliation. I received many letters of condolence. They were comforting. All John's friends saw him in a different light.

One day I received a letter in Sherman's handwriting. I

nearly fainted, for I had completely forgotten him. He wanted to know if he could do anything for me. He wanted to help me with the usual things, thinking I was a foreigner in England. But it was too late, as they had all been attended to. As for the rest, it was too soon. But I began to think about him again, and by degrees I realized that I would use him to save me from my misery.

In February the lease of our house in the Avenue Reille expired, and I was forced to go to Paris to see the landlord and come to some terms with him, as we had made several alterations on the ground floor.

We had sublet the house to a sweet little couple, Charlotte and Ronnie Morris. I had taken a liking to her at once because she so much resembled my friend Peggy. They could not afford the house but we let them have it at their price. When I went to Paris it was at the time of the Stavisky scandal and I had just received a cable from my mother saying, "Avoid Paris dangerous." It certainly was. A maid had been shot on a balcony at the Crillon Hôtel and there had been a sort of revolution and lots of street fighting. It was over when I arrived. When I went to the Avenue Reille to remove my furniture I found a little bunch of roses Charlotte Morris had placed for me on the table of our living-room. I was touched at what I assumed to be her understanding of how I felt about returning to this house where I had been so happy with John. I hated the thought of their having lived in it, but I was glad at least that they were such nice people. I had all the furniture removed and put into storage. When the house was empty I felt better— nothing remained there of my life with John for other people to be connected with.

part 4

chapter 1

my life with sherman

Besides John's friends, who came to our house as though to be nearer him, I saw very few people. Wyn Henderson was our neighbor in Woburn Square, and she kept sending her son Ion to see me. I allowed him to sit and play our E. M. G. gramaphone but I barely noticed his presence in my house. I began to think more and more about Sherman. It became an obsession, and I finally realized nothing else would save me from my misery. I told Emily that I wanted him, and then said I didn't mean it. Soon I made her write to him and meet him in order to see how he felt about me. They had a drink in the Café Royal. When she came back she told me that he had spoken nicely about me and that at least he was free, being separated from his wife. I invited him to dinner, and Emily invited Hem. I must have made my intentions very clear this time because Sherman took me home with him. He thought I was a wonderfully brave woman, prepared to start a new life. I had fooled him completely, and when I burst out crying he realized his error and wrote this poem for me which he produced the following day.

Doubting I lay, but you too brought
Tears from a world I had not shared,
Till in accord our bodies stirred
And broke the tyranny of thought,
Finding again what treasure lies
In secret hushed between your thighs.
And stillness in the blood confirms
The age-old act we thus rehearse
An uncontracted universe
Swing in the circuit of our arms,
For the wild gift between your thighs
Drove out the terror from my eyes.

Sherman fell very much in love with me and thought I was
like Cleopatra, and quoted Shakespeare to me. "I found you
as a morsel, cold upon dead Caesar's trencher." I imagine
he thought of himself as Anthony and of John as Caesar. He
also said that I reminded him of the following very flattering
lines, "Age cannot wither her, nor custom stale her infinite
variety /Other women cloy the appetites they feed; but she
makes hungry where most she satisfies/ For vilest things be-
come themselves in her; that the holy priests bless her, when
she is riggish." However, it was all very painful because of my
unhappiness about John. I had been completely dependent
on him; I was incapable of thinking for myself. He had
always decided everything and as he was so brilliant it was
much simpler to accept his judgments than make my own.
He had told me that when I tried to think I looked like a
puzzled monkey. No wonder I avoided it whenever I could!
Apart from this I had a bad conscience about being un-
true to him only seven weeks after his death. I tried therefore
to hide Sherman. I did not want anyone to know about the
affair, and I always managed to get home before dawn.

Soon after John's death Agnes Dew came to London on
some business and she stayed with me in Woburn Square. I

gave a big party for her and in the middle of it I retired to my room and wept. I was not prepared to face the world.

Wherever Sherman took me I had memories of John and often burst out crying in public. Poor Sherman always hoped that I would get over my grief and that we would eventually be happy together. He told me much later that I cried on his shoulder every day for a year and a half. Sherman deserved a better fate, especially since he had been unhappy with his wife for a long time and had ended up with a nervous breakdown. He had been married for nine years, but had not lived with his wife all that time. They were uncongenial. They had been to Russia together during the revolution and Sherman, who was a revolutionist at heart, had fallen in love with a Bolshevik woman. He remained with her for six months after his wife had returned to England, only to have to return home himself in the end as his passport expired. After that Sherman went to Brazil to his brother's ranch to recover his lost health. He had been sick for years.

Sherman was the son of a family doctor who had had a large practice outside Birmingham. There he had lived in a big house with a garden, completely removed from the world, with his one brother and seven sisters. His father died while Sherman was still at Cambridge, and Sherman felt his loss very much and his early responsibilities of being head of the family. His mother was a gentle English lady living in retirement and great modesty. She was supposed to be the illegitimate daughter of Earl Grey, and indeed she looked aristocratic. She was so feminine and so ladylike she had always done exactly what her husband had wanted, and now, although she rarely saw Sherman, she adored him and treated him in the same way. He had just bought a little house for her in Sussex near the downs and he intended to go down there for week-ends.

Sherman was working in an avant-guarde publishing house

that belonged to one of his brothers-in-law, a millionaire who wanted to spend some of his money usefully.

Soon after I was with Sherman I had to leave him to go and spend Easter with Sindbad. I had promised Sindbad in the station at Zurich, when he had cried so much, that I would. I did not want to go at all because I considered Florenz John's worst enemy, and it would be unpleasant for me to be with him and Ray at this time. In the end I decided I could bear it, because Nina, an Irish friend of Ray and Florenz and strangely enough also of John, was there, and I knew she would make things easier for me.

I took Deirdre with me and we spent about ten days in Kitz-bühl. It was extremely painful to go back to the Austrian Tyrol where I had been so happy with John. But I was glad to be with Sindbad, and Florenz was very kind and made a great effort to get closer to me again. I suddenly realized that all my troubles with him about Sindbad were over. A few years before a fortune-teller had told me, "You will get your child back through someone's death." It had never occurred to me it would be through John Holms's death. I had thought of everybody else's.

Florenz came up to my room and put me to bed every night. He wasn't satisfied until he made me cry. He forced me to talk about John. I didn't want to. I finally accused him of being very happy about John's death, but obvious as it was, I never got him to admit it. He said I should have another man. Of course I did not tell him about Sherman, but he suspected I had somebody when I returned to London so soon. I went home leaving Deirdre with Florenz as it was her Easter holiday.

When I got back to London Sherman met me and told me that he had been very sick during my absence, and that we had to go away to the country at once. We drove down to Surrey and stayed a few days at an inn. I had a new Delage by now, because after John's death I could not bear to see the old one any more or drive in it without him. My mother had made

me a present of another car. I got rid of the Peugeot also and
bought one that I could drive myself.

Sherman drove me to Sussex to show me the house he had
bought for his mother. It was in a little English village called
South Harting, just under the downs. The village was ab-
solutely dead, like all such places in England, but it was in the
midst of the most lovely country. Naturally, it had a fine
pub. Sherman also took me to see his sister Laura and his
brother-in-law, the publisher, whom he called Brad. They had a
lovely home. Sherman and Brad seemed to be the very best of
friends, having been to Cambridge together. Brad's wife Laura
was the most beautiful creature I had ever seen. She had
enormous blue eyes, long lashes and auburn hair. She was
very young, still in her early twenties, having been married
at the age of sixteen. Out of seven sisters, she was Sherman's
favorite. They were all extraordinary girls. One of them
was married to a fisherman in Martigues, and another one had
three illegitimate children by a world-famous sculptor. An-
other lived in Hertfordshire with her illegitimate child, while
a fourth spent half the year as a maidservant in order to be
able to live in peace the other six months in a cottage she had
bought on Thomas Hardy's favorite heath. Later she adopted
a little boy and was reported to have had a love affair with
Lawrence of Arabia, whom she met on the heath, but when
I knew her she was most virginal. Another one was married to
a famous South African poet. They were Catholic and later
became fascist and lived in Spain. One very normal one
married a garage owner and led a happy life having children.
In his youth Sherman must have been overwhelmed by so
many women, and prefered not to see most of them any
more. However, I was fascinated by them and eventually
managed to meet them all. Sherman had a younger brother
whom he liked. He had returned from Brazil and was now
farming in Hampshire.

Sherman was a straightforward, honest person with a won-

derful sense of humor, and a fine mimic. He was simple, and disapproved of all snobbishness and chi-chi. He was a puritan and a frustrated poet. He was a revolutionary at heart, but all his habits and tastes belonged to the class in which he was born. He spoke beautiful English as well as excellent Russian, French and Italian. He was well educated. His tempo was quite different from mine. I moved about ten times faster than he did, and almost went mad waiting for him to finish sentences. He was five years younger than I which made me self-conscious. He found me very sloppy and would have liked me to dress much better than I did. He did not like me to have any grey hair.

After six months the lease of my house in Woburn Square expired and I moved to Hampstead with the greatest of delight. I could not bear to have Sherman come to the house where John had died. It was a relief to be in a place where Sherman could visit me freely, and even stay at night. Of course I continued to hide him.

Deirdre's school was near this house which was why I rented it. For the first time since Doris left she was very happy.

In the summer Sherman helped me find a house in the country for the children. I fussed nearly as much as if I had been John Holms, and Sherman got very annoyed with me and made me rent a lovely place that was a few miles away from his mother's, in South Harting. He was editing a book and wanted to live at home, where he could work easily and yet be able to come and visit me.

The house I rented was called Warblington Castle. It was a pretty farm house with nice gardens and a tennis-court, and was supposed to be an historic sight, since it could boast of a twelfth-century tower, still standing on its grounds and forming part of a wall with a moat. It was a public monument and open to the public who visited it on occasions.

Emily and Johnnie came down with us and Sindbad, who for

the first time had traveled all alone across Europe. I invited Sherman's daughter who lived with his mother, as well as one of his nieces, to stay with Deirdre. Emily's friend Phyllis adored our children and I persuaded her to come and look after them. Deirdre learned to ride a bicycle and I was in fits and trembling all summer over this fact. I have never been able to do this simple little thing myself.

We could not swim very much at Warblington as it was on a muddy inlet. We had to motor over to Hayling Island, ten miles away, in order to reach the sea.

Warblington Castle was very large, so we could invite quite a few guests. Sherman came and went, and when he was with me I hid him in the tower bedroom I had chosen, away from everyone else. One day when Antonia White came into my room there was a pair of Sherman's grey flannels on my bed. In order to keep my secret I wore the trousers myself, although they were several sizes too big for me. At breakfast Sherman and I would arrive separately and greet each other politely. Even Sindbad did not suspect, but finally had to be told, because he resented Sherman's correcting him. We managed to get horses and went for wonderful rides. The whole time I was bemoaning Dartmoor but Warblington Castle was a perfect place for the children.

Once when Sherman was away working on his book we sent for Hem, telling him to come and join the women and children. Emily was always begging me to invite Hem, because she had so much trouble making him do what he really wanted to do. He resisted her with all his strength. He adored the life she gave him, but he made her fight for every gram that she forced on him, knowing all the time he would die without it. Of course he came to Warblington.

When Antonia White visited us she was rather worried by my vagueness, and Emily told me that I should behave more like the sort of hostess that Antonia expected. I rushed out and

bought her a croquet set and various other things which I
thought might please her. Emily said, "You mustn't overdo it,"
and I replied, "Oh, but I must."

Milton had given us a sweet little Sealyham dog. He wasn't
quite a thoroughbred but he was nice-looking in his funny way.
When John had died the dog was unhappy for he felt he had
no master anymore. Our butler Blisset took charge of him and
brought him everywhere. He even took him to the cinema
where Robin, as the dog was called, barked wildly at his
counterpart on the screen.

During the summer I bought a wife for Robin. She was a
thoroughbred Sealyham, and Sindbad, with his great passion
for tennis stars, named her Borotra. When I got her home, I
discovered she had one bad eye and realized then why she
had been sold to me so cheaply.

We had various guests, among them were Milton and Peggy,
and Mary and Willard Loeb who arrived from New York with
two daughters. Willard was one of my favorite cousins. He was
a great music lover and owned ten thousand phonograph
records. He played tennis like a champion. Mary had been
Benita's best friend and this was the first time I had seen her
since Benita died. John's death seemed to have wiped out the
agony of Benita's, but I was happy to be able to talk about her
to Mary. As usual I hid my relations with Sherman from all
these people, or thought I did. After five weeks our lease was
up and the children had to go to Kitzbühl to stay with Florenz.
Sherman and I drove them down to Dover and put them
on a boat. They went alone together, right across Europe.
Sindbad was eleven years old and Deirdre was nine. They were
a wonderful little pair. Sindbad wore Tyrolian pants with a
dagger thrust in his belt.

After they had left, Sherman took me to live in his house
at South Harting. His mother was away on her summer holi-
day with one of her daughters and allowed me to stay there.

Sherman was finishing his book and I had very little to do all day. I lay in bed late reading *The Possessed* by Dostoevsky. It is the only one of his novels I have never grasped, even after reading it twice. It is so confusing, none of the characters stand out. The only part I like is the scene of the childbirth, which takes place in an adjoining room while all the political drama is going on next door.

When Sherman finished editing his book we drove to Wales. Laura and Brad had been to Pembrokeshire and had sung its praises, so we went there too. It is the only place in the British Isles that looks anything like the Continent. The houses were all painted bright colors, as in Italy. There were beaches miles long with enormous boulders and there were no people to be seen anywhere. The coast was rocky and wild.

We took long walks over fields and moors covered in heather, and visited manor-houses. The Welsh gentry had had an eighteenth-century social-life like that of the Irish.

We lived in a little boarding-house on a river which was owned by a half-mad ex-sea-captain and his wife, who had formerly been the Duchess of Manchester's maid. She gave us a bedroom and a sitting-room and wonderful five-course meals, with three choices for each, all for the modest sum of fifteen shillings a week per person. (Fifteen shillings was equivalent to three dollars and seventy-five cents.) It was unbelievable. Her husband, the captain, had built this house to resemble a boat, and it was surrounded by his derelict fleet in which he had once sailed up and down the coast. He had been an important ship-ping agent in former days. Now he was as finished as his boats, and although he always talked of mending them we knew he never would.

Opposite this house, on the other side of the river, lived a mad family. It seems they had two daughters whom they had kept under the table sewn up in bags for years and never allowed out until the authorities intervened.

I was still very unhappy about John all the time I was in Wales.

On the way back Sherman took me to the Black Country where he was born and raised. He took me to see his family home which had been sold, and in return I took him to Warwick Castle where one of my uncles had lived with a mistress. I don't think Sherman believed me until the guide, who was taking us over the Castle, mentioned their names.

When we got back to South Harting I tried to rent a house near Mrs. Sherman so that Deirdre could go to day-school with Debbie, Sherman's daughter, and his niece Kitty. There were no houses to be rented, but there was one little Elizabethan cottage for sale and Sherman made me buy it. Soon after I took this step I decided to commit suicide, I was still so unhappy about John. I therefore put the house in Sherman's name as I intended to die. Of course I didn't and I went to live in the house instead.

It took some time to get my furniture over from Paris and settle the house. In the meantime Deirdre came back from Kitzbühl and lived with Mrs. Sherman. Mrs. Sherman had about thirteen grandchildren. She lived entirely for them and for her own children, but she immediately accepted Deirdre and was very kind to us both.

part 4

chapter 2

yew tree cottage

Yew Tree Cottage was my new home. It was named from a tree which must have been over five hundred years old, and which grew in front of the house, towering over its roof. It was a beautiful cottage because of its exposed rafters and beams. In the sitting-room was an enormous fireplace, so spacious people could have sat in it. The windows of the house were small and from the sitting-room you could see cows grazing in meadows a few feet away. It was a small house with two living-rooms and four bedrooms, one bathroom, a kitchen and larder. The great attraction was the grounds. There was about an acre of land belonging to this property, but the whole countryside seemed to be a part of it. It was at the foot of the downs, but we were actually in a valley and we had a stream running through our garden, which was all sloping.

The real reason I wanted this house was because it was on the bus line between Harting and Petersfield, where Deirdre wanted to attend school with Sherman's daughter and his niece. It was one hundred yards from a little road that was not a

main road, but which I always insisted on calling so, as a result of summers spent on the moors. I felt upset by the thought of the world being at my gate, but I later appreciated the convenience of the bus and the deliveries it made for us from the shops.

Sherman immediately engaged a gardener for me and began laying out the most lovely lawns and flower beds. He was a very good gardener himself and did a lot of the work. He had what is called a "green thumb."

Deirdre and I lived alone in this cottage with a darling little Italian maid we had had since London in Woburn Square. Sherman came to visit me but he would not live with me, and I was unhappy every time he left.

At Christmas I was to visit Sindbad again in Kitzbühl. I wanted Sherman to accompany me but he thought he wouldn't. However, at the last minute he decided to come. I had Deirdre with me and I got an extra berth for Sherman in another stateroom. He happened to share this stateroom with Ira Morris, whom none of us knew at that time, but who had contributed years before to Sherman's review, the *Almanac*. He was traveling with his beautiful Swedish wife, Edita, and their child, Ivan. Ira was my Aunt Irene's nephew and though I had heard a lot about him I had not met him. His father I knew quite well. He was the eccentric millionaire meat-packer who had been American Minister to Sweden. Both Edita and Ira were very ambitious writers.

Sherman, who had never skied before, was much too venturesome and had a bad accident the first day. He broke several fingers and had to have his hand put into a horrid apparatus that pulled his fingers back into shape. This apparatus was about one foot long and as it stuck out in front of him it preceded Sherman wherever he went. Every day he had to go to the doctor to have a heat treatment. This whole business upset me for it reminded me of all the agonies John had been

through just before he died. I am afraid I was not nearly as sympathetic to Sherman as I should have been.

I spent many hours reading to Sindbad, who had just recovered from pleurisy and was still in bed. Ray acted the efficient nurse, and made me feel *de trop* as much as she could. Sherman was badly neglected and besides he felt quite out of our family life. He liked Edita very much and got on quite well with Ray, who had had her first story published in his review—he no longer liked her books, as she wrote worse and worse novels.

Against his better judgment Sherman decided, because of my insistence, to come and live with me in Yew Tree Cottage and bring his daughter Debbie with him. When we told this to Ray she had the impudence to ask me how I could take the responsibility of looking after Debbie. It was rather strange considering she had brought up Sindbad for over five years. I told her Debbie was so responsible she would look after all of us. Ray basked in the idea of my being an incompetent mother in order to prove her superiority.

When we got home Sherman and Debbie moved into Yew Tree Cottage, and I found myself once again the mother of two children. I loved Debbie. She was just the opposite of any child I had ever known. She was so mature, calm, sensible, self-contained and well-behaved, and so little trouble. She was intellectual like her father and loved to read and to be read to. She had a wonderful influence over Deirdre, and Deirdre over her. She became less priggish in our home. They got on marvelously and were soon like sisters. They used to dress up in a strange collection of old clothes and costumes we kept in a chest, and gave charades, plays and all sorts of performances. Kitty, Sherman's niece, was the third actress. Their only audience was Mrs. Sherman, her lady companion and myself, and occasionally Sherman, when he could be torn away from his

intense intellectual life. In the evening I read to Debbie and
Deirdre while they ate their supper.

Sherman was wonderful to the children. They adored him.
But one day Debbie said to him, "Pa, you look so monotonous."
When we asked her what she meant, she replied, "You know,
sort of going on and on." Sherman wanted to instruct the chil-
dren in the facts of life and procreation. He drew all kinds of
diagrams for them, which meant nothing to Deirdre. Finally
we reminded her of the times when she had seen dogs mating.
She was so horrified that she turned to me and said, "Mama,
you mean to say that you did that?" and then as an afterthought
she added, to put everything right, "Of course, only twice to
make me and Sindbad."

Soon after Sherman moved into Yew Tree Cottage I made
him give up his job as director of his brother-in-law's publish-
ing firm. At the end of our garden he built himself a little
one room house in which to write. His health was bad and he
needed a quiet life in the country with exercise and little
drinking. He wrote a lot and became interested in a new
review which he helped to edit. He soon began to read Karl
Marx's *Das Kapital* and was immersed in it for months.

During this time I read Proust. I sat in bed under the Tudor
rose which adorned my wall wearing fur gloves and shivering
from cold. Dreadful drafts circulated from the holes in the
ceiling where the beams were located. My room was so big
it was impossible to heat it. I had a few little oil burners which
I carried around with me when I got up and dressed and re-
tired into the bathroom. Sherman disapproved of my reading
Proust. He wanted me to read Karl Marx.

Downstairs the sitting-room with the enormous fireplace
was filled with smoke. Sherman did everything he could to
alter this catastrophic state of affairs. Finally two local builders
called Peacock and Waller, who had built Sherman's little
house, overcame the smoke problem by raising our chimney

a few feet and cutting some branches off the yew tree. After that Sherman, who loved building and remodeling houses, completely did over the second sitting-room. Here he had already installed a stove that burned day and night. At least we had one warm room to come down to in the morning, which was a great blessing. By tearing down walls and closing up the formal ugly entrance door he made a really beautiful room. He had wonderful taste and chose perfect furniture and glazed chintz hangings. Then he had lovely bookshelves made for my records. The room gave out onto the garden, and in summer the sweet smell of tobacco plants wafted in through the windows.

Sherman had foreseen everything except one thing. In rebuilding the house he had accidentally imprisoned my old Venetian oak chest and we realized it could never come out of the house again. In fact it is still there, though the house is sold, and I shall have to go back and tear down a wall if I want to get it back again.

Besides making such a beautiful home for me, Sherman had a gravel tennis-court built, and a little swimming-pool and a cricket-pitch for Sindbad. He sowed grass seeds to make lawns. He completely transformed the grounds and made the most lovely gardens by collecting every variety of plant he could find.

We had an amiable gardener called Jack, who played on the local cricket team in Petersfield. He worked very hard as he had to keep two engines going to feed us light and water. About a quarter of a mile from the house, down by a lake which belonged to our neighbor, we had a little house with a gasoline engine to pump water up to us. Our tank was small and the water problem was a daily affair. The engine was perpetually out of order but Jack knew how to cope with it. When he went on his yearly holiday I was very nervous, and once we had to carry buckets of water for three days.

The engine that generated electricity was in the garage just

in front of our house. It made a terrible chuck-chuck noise
and gave us feeble light. Only after I had lived in the house for
four years was I able to connect up with the main electric line
and thus end all our troubles.

The first winter we lived in Yew Tree, Sherman and I rented
a flat in London in the Adephi quarter with Phyllis Jones. She
had just returned from America where I had sent her for a
little trip as she badly needed a change of thought.

However, I rarely went to London with Sherman, for I still
felt ashamed of my faithlessness to John's memory and pre-
ferred to hide in Yew Tree Cottage. In any case, I was very
busy trying to retype all of John's manuscripts that I had
fallen heir to. I wanted to have them published. Hugh Kings-
mill had a whole collection of letters he had conserved and
Dorothy had the replies that Hugh Kingsmill had written to
John. We decided to do a book of these. I did not want Sher-
man to know how much I was still preoccupied with John, and
I tried to work without his knowing it.

Sherman and I were really not at all congenial and the
situation got more and more obvious and painful. We did not
like the same people and we did not like the same things. He
hated me to drink and for some perverse reason I now
found it necessary to do so, though when I had lived with
Florenz and John, who drank so much, I had indulged very
seldom. I was all the time comparing Sherman with John and
even went as far as to tell Sherman that he had bored John and
that John had only gone to find him in London because he
wanted to publish Djuna's book.

Sherman's writing did not go very well and he was un-
happy. He began to spend more and more time on Karl Marx.

In the spring Sindbad came to stay with us for two months.
Florenz decided to put him in an English school and in order
to be with him the first year, he also decided to stay in Eng-

land, though he disliked it heartily. Sherman taught Sindbad
Latin and I taugh him English grammar.

When Florenz and Ray came they left all their many little
daughters in the pub at South Harting and went down to
Devon to find a house. Sindbad had to live in a warm climate
because of the touch of pleurisy he had recently recovered from.
So they settled at Seaton and spent a year there, frankly
hating it.

Sindbad became great friends with Jack, the gardener, and
went with him to watch him play cricket. This must have
started his great passion for that exceedingly dull game, be-
cause Sindbad thought of nothing else for years to come. He soon
knew the scores and the names of all the famous players and
became a great authority on the subject. He also played on his
school team. I could not share this enthusiasm, and in fact have
never even understood the game. Sindbad was a good tennis-
player and swimmer, and Yew Tree Cottage was an ideal home
for him with the court and the little pool and the cricket-pitch.

After I had been with Sherman about a year and a half I
began to get the idea of running away from him. I tried it on
various occasions, but he always got me back. I didn't
want to live with him and I didn't want to live without him.
He still loved me very much, though I did everything to destroy
it. I don't see how he could have endured me so long.
Once I was so awful to him that he slapped me hard in the face
and then was so ashamed of himself that he burst into tears.

In the summer we went back to the same place in Wales and
the following Christmas we flew to Paris and went to Mar-
tigues to visit Sherman's sister who had married the fisherman.
I took to her at once. She was beautiful, like all Sherman's
sisters, but she was not at all happy. She seemed to have got
herself into an awful jam. I think she wanted to leave her hus-
band. He was a big, rough, handsome, Swedish-looking fisher-
man who had an inferiority complex as a result of marrying

into another class. Ellen, his wife, couldn't leave him be-
cause of their child. They both adored it. They lived a very
simple life and she had to work hard at some job because his
fishing did not bring in enough for them to live on.

We stopped in Paris on the way back. Sherman wanted to see
Dorothy Dudley who was translating a book about Mussolini
for his firm, of which he was still adviser. We also met Gala
Dali for the first time. She was a friend of Agnes' and, though
she was handsome, she was too artificial to be sympathetic. Sher-
man was very much impressed by Agnes' wonderful taste and
found her new house in Montsouris exquisite. I had taken it
for granted, but of course he was perfectly right.

My life in Yew Tree Cottage was so domestic I seemed
to do nothing but look after Deirdre and Debbie. They were
always having colds and flu. No wonder, as our house was so
cold, and the temperature of the rooms so uneven. I seemed to
spend weeks administering inhalations and medicines, taking
temperatures and reading to sick children. All this made me
desire to have a child by Sherman. After his long illness he
seemed incapable of giving me one, and I wanted to find out if
it was really his fault or mine. It was, I discovered, his.

My mother adored her grandchildren with such fervor that
Deirdre could not do otherwise than be touched by her affec-
tion and reciprocate it. Sindbad was not grateful. Once when my
mother arrived from America, after a long absence due to
her bad health and several operations, Deirdre said to her,
"Oh, grandma, how striped you look." My poor mother cer-
tainly had grown older.

When she arrived at Yew Tree Cottage she met Emily. My
mother had traveled on the Ile de France and asked Emily,
who had just come on a ten-day boat, if she had ever been on
the Ile de France, adding, "The vibration is terrible, terrible,
terrible." Once when I told my mother how frightened Florenz
was of Ray and how she kept him in order, my mother re-

plied, "Too bad he wasn't frightened of you, frightened of you, frightened of you."

The third summer Sherman took me on a sailing trip on the Norfolk broads. We invited Rigid Edgwell and his wife Jackie to accompany us. Rigid was Sherman's oldest friend. They had been co-editors of the *Almanac* and both had been directors of Brad's publishing house. Rigid was a good poet and critic. He was painfully introverted and very shy unless he was drunk. Jackie I had known for years. She was a good-natured, lively girl who helped make Rigid more comfortable in the world by being natural, if not hearty. I don't know how she ever got into the Bohemian world, but once there she stuck fast.

They were very agreeable on this trip and we had a good time, except that I hate sailing more than anything I can think of. It makes me restless, nervous and unpleasant. I probably ruined everyone else's fun. In fact, I think Jackie and I finally left the men to sail alone and walked down the shore.

We all went to Woodbridge, a miraculous eighteenth-century town, famous for its sheepskin industry, with at least a hundred pubs and an old market-place with a beautiful building. All the houses were over two hundred years old. I bought a pair of beautiful gloves and soon after this Yew Tree Cottage was filled with natural sheepskin rugs that I kept ordering by mail.

Not long after our Woodbridge trip, Sherman's wife wanted to marry again. For years she had been in love with a young actor and finally decided she wanted a divorce. Sherman said I would have to be co-respondent. I protested violently because Mrs. Sherman had left Sherman long before I met him, and I considered this most unfair. But Sherman said I was living with him, and there was no other way to do it, since he would not divorce his wife. The whole thing was very silly. We had to be found in a room together, Sherman in a dressing-gown and I in bed. A detective came down from London early in the morn-

ing, so that the children would not know about it. After that he wanted to come again, but Sherman said he would not go through it a second time, it must suffice. The divorce was granted on the "humble petition of Mrs. Saddie Sherman." It read that Sherman and I had sinned not once, but many times. I often wondered how they knew. The only place this fact was ever recorded was in my diary, where I had written, "fighting all day, f—— all night."

We had very few guests at Yew Tree Cottage and I led an extremely lonely life, getting more and more depressed. I was almost melancholic. The long winters with nothing to do but remain indoors, or take walks in the mud, or play tennis and freeze kept me inactive most of the time. My only joy was reading. I reread *Anna Karenina*, my favorite book, *War and Peace*, *Wuthering Heights*, Henry James's novels, all the novels of Defoe, given to me by Sherman, *Pepys' Diary*, and the Countess Tolstoi's life of her husband. I started to ape her fiendishness and found myself behaving more and more like her. In the evenings I read *Robinson Crusoe* and *The Last Days of Pompeii* aloud to the children. But I wasted a lot of time buying our food myself and, as I always forgot something, I used to drive into town several times a day. Emily came down on a few occasions, but she never felt that Sherman liked to have her there, though he said to her, "Emily, you make me feel like a welcome guest."

Emily, who passionately disliked playing tennis, one day when I asked her to have a set broke out into a fury and threatened to smash every racquet in the house if I ever invited her to play again. As I had several tennis racquets on approval from a shop in Petersfield I became terrified and immediately rushed them back. But Emily loved the children and they adored her. She seemed to fit in with people of every age.

Jackie and Rigid came several times. When Florenz and Ray first came to England they paid us a visit, but then Sher-

man decided he was not going to see them any more, since he disbelieved in all this false friendship. Ray and I really hated each other. Djuna came down once, and Dorothy Holms several times. The Morrises came, but they were not in England often. Once we had a visit from the Muirs with their strange child, who was an infant prodigy and at the age of eight played the piano like a virtuoso. Agnes came once, Phyllis came once, caught the flu and didn't come for ages. On the whole I lived alone, except for Sherman's family whom we saw quite a bit of. I liked Laura and her husband and also Sherman's brother, the farmer. Sherman had one friend called Wilson Plant, who was in the British Colonial Service and was stationed on the west coast of Africa in the bush. Out there he read Joyce and Djuna Barnes's books and seemed to be *au courant* of everything. He came to see us whenever he was home on leave.

Whatever else I found inferior to my former life, I certainly could not include the downs. They were just as fine as the moors and much safer to walk on. One was in less danger of getting lost or drowned in a bog. They extended for miles and although the scenery was not so varied as Dartmoor, it was equally beautiful and its vegetation and wild flowers far surpassed what grew in Devon. We constantly took walks on the downs and at a certain time we rode there. One could drive right up to the top and then park the car and walk for hours.

Bertrand Russell had a house up there. I think he lived with a new wife and a young baby. One night he gave a lecture in Petersfield about the horrors of the next war and everything he foretold was not far from the actual truth as most of it occurred. It was a good prophecy but in no way helped to save the world from its doom.

The whole countryside abounded in pheasants which were shot down during the season in the woods that belonged to our neighbor, a general. He was an unpleasant bowlegged man who owned the biggest estate in the vicinity with a false

Elizabethan house. We used to take long walks and we had a
right of way through his estate. One day when I was with
Debbie and Deirdre, Robin, the Sealyham, began chasing
pheasants and the general, meeting us in his fields, screamed
and swore at me because Robin was not on a lead. He was so
extremely rude that Sherman wanted to write him demanding
an apology, but we were handicapped by Sherman's not being
able to think of the correct title for me. Debbie suggested that
Sherman should refer to me as his darling Peggy. In the end
we had to give it up.

As we were not married the gentry did not call on us,
thank God, and we did not frequent our neighbors.

At the edge of our property were beautiful woods. In the
early spring they were filled with wild garlic and later with
bluebells, campion and irises, and a strange flower that re-
sembled an orchid. This was in contrast to all the flower-beds
and rock-gardens that Sherman had planted. The children
loved to find bird nests and we had the heavenly cry of the
cuckoo and at night there were nightingales. What the chil-
dren loved most was wandering around in our garden without
clothes and swimming in our little pool.

Our food was very bad since Jack, the gardener, had in-
troduced into the household as cook his fiancée Kitty. She
really only knew how to make Yorkshire pudding and roast
pheasant. I decided to have her taught cooking and I invited
Beppo, John's old friend and a schoolmate of Dorothy's, to
teach Kitty. Beppo consented to give her a course. We had
a real fiesta. It lasted over a week and we cooked about four
dishes a day. I learned them all as well, to spur Kitty on, and
that was how I began to cook. Never before had I tried to do
anything except scramble eggs.

We made the most marvelous meals and tried them all on
Sherman. He loved them but he said he didn't care who made
them. At the end of the ten days, I turned out to be a real

cook instead of Kitty. I finally succeeded in getting her to put salt and pepper in our food which I felt was a great feat. After that we had the most delicious *paellas* and *boeuf en daubes* and Spanish omelettes, onion soups, *coq au vin* and chicken in sherry. I used to collect recipes for Kitty on the rare occasions when I went anywhere.

Soon after that, Kitty and Jack were married in the Petersfield church. It was an impressive affair, with Debbie and Deirdre as bridesmaids. Poor Kitty was terrified as she did not quite know what to expect, and Jack even more so, since he did know. They went off on a honeymoon and when they came back they talked as though they had done everything except what had worried them so much before. They were a happy couple and they created a lovely atmosphere in the cottage. Sherman soon built them a new wing onto the kitchen. Fortunately they had no children till long after.

During the winter that Florenz lived in Devonshire he lost his uncle, his father and Odile. She died in the American Hospital at Neuilly, where John had been. She died, strangely enough, under the same circumstances as John. She had an operation and passed out under the anaesthetic. Florenz was terribly upset, and when I saw him shortly after he was bitterly armed against my sympathy, for he knew how much I had hated Odile.

Florenz had come up to Petersfield to see Deirdre act in a school performance of *The Pied Piper of Hamelin*. She had the leading rôle and I had made the most marvellous costume for her, half yellow and half red. Deirdre attended a little dame school in Petersfield with Debbie and her cousin Kitty who still lived with Mrs. Sherman. I felt guilty about separating Debbie and Kitty when Debbie came to live with us, but Mrs. Sherman said it was natural for Debbie to live with her father, and indeed it seemed to do her a lot of good.

Deirdre was embarrassed by the fact that I did not have the

same name that she had. She wanted me to use hers, Dale, but I thought I ought to use Sherman's. He sent me to the principal of the school, a very respectable old maid, and told me to ask her what to do. We walked up and down the garden for ages before I had the courage to approach this delicate subject. Finally when I did, she asked me if I were going to marry Sherman. When I said no, she told me that I should keep my own name, since it was really mine. That ended the problem, but I never forgave Sherman for making me have this idiotic interview.

In the spring of 1936 the French Surrealists gave a huge exhibition at Burlington House. It was their first showing in London and it had a great success. Sherman was excited about it and tried to get Djuna and me to go. We were both blasé and refused, saying Surrealism was over long ago, and that we had had enough of it in the twenties. In view of future events this was a most strange coincidence.

part 4

chapter 3

communism

By degrees Sherman got more and more interested in Karl Marx and fell more and more under his spell. He began applying Marx's theories to everything. He gave a course of lectures to prove that all the great writers were revolutionary. He lost all sense of proportion and criticism and saw everything in one light. I went to these lectures and asked questions to embarrass and confuse him. After John's brilliant mind and detachment, all this was too silly for me to endure.

Sherman got more and more involved and finally joined the Communist Party. All the money I gave him, which formerly went to paying for the building he had done on the house and on other things, now went to the Communist Party. I had no objection to that at all. I merely got bored listening to the latest orders from Moscow, which I was supposed to obey. Sherman wanted me to join the Communist Party but he said that they would not accept me unless I did a job for them. I wrote a letter to Harry Pollitt, the head of the Party, and said that I wanted to join, but that I could not take a job as I lived

in the country, took care of two little girls and had no free time. Of course I was accepted.

Sherman went around the country in a second-hand car he had bought for the purpose, giving lectures and trying to recruit new members. I saw him less and less as he was so busy. I was more and more alone, and became more and more unhappy. It was during the period of the Spanish War and he was very excited about it. I was afraid he was going to join the International Brigade, but his health would not permit.

The only people he now wanted to invite to Yew Tree Cottage were Communists, and it didn't matter what other qualifications they had: if they were Communists they were welcome. I found myself entertaining the strangest guests. Any person from the working class became a sort of god to Sherman. As I got more and more bored I fought more and more with Sherman. Not that I was against Communism as a principle. I just found it difficult suddenly to have my whole life directed by Sherman's new religion, for it had certainly become that. He was like Sir Galahad after he had seen the Holy Grail. During the time of the Moscow purges I was upset because I thought Stalin had gone rather far, but Sherman explained it all away. He had a marvelous way of convincing me that everything the Communists did was right. I must say they are pretty clever.

At Yew Tree Cottage, Robin, our dog, became quite ferocious and suddenly turned into a wonderful watchdog, barking at everyone who passed on the road and biting everyone who wore a uniform. The postman delivered the mail in fear and trembling. Finally Sherman had to tie up Robin in a barrel. He beat him so badly that I was horrified, but he did manage to cure him and we were able to let Robin loose once more. He finally married his fiancée Borotra and gave her a lot of puppies. After which he became so bored with Borotra and her offsprings that we had to give her away. In the winter the house was filthy as a result of all the mud they brought in from their

long walks over the downs. It really was intolerable. Robin got sadder and sadder as he got older, but later he consoled himself by playing with cats.

Sherman bought a Siamese cat which went around the house crying like a baby all day. One day we found it poisoned in the garden behind Sherman's little house. We suspected the General.

Sherman liked to ride and he bought himself a horse, but when his Communist activities became all-engrossing he gave the animal to his brother, so that he himself would be free and have more time to devote to the cause. He gave up everything for Communism and enjoyed his asceticism. Of course I found life worse and worse under these conditions.

If Sherman didn't succeed in getting me to "go Communist," he was successful with his brother-in-law Brad, who soon drove Laura crazy with the *Daily Worker* doctrines. Eventually Brad turned his publishing house into an organ for Moscow. Rigid became a staunch Communist and Jackie, being the ideal wife, swallowed Communism whole to ensure having a peaceful life. I made an honest attempt to be dishonest and I just couldn't make the grade. I became like a bull when it sees red. Only in my case I saw red every time I heard Communism mentioned. If Sherman were angry with me, instead of calling me a whore, he would call me a Trotskyite.

When Sherman's oldest sister and her husband, the South African poet, fled from Spain during the revolution we went to see them. They were living at Brad's house and behaving like refugees. They were so outrageously Fascist that Sherman would never see them again.

Once when Sherman was away on a Communist job, Gerhardi came down to visit me at Yew Tree Cottage. He made me promise that he would not see Sherman as they were so far apart intellectually and politically. Suddenly Sherman returned without warning me and a most awkward situation arose. They

got into terrible arguments and Gerhardi never would believe
that I had not arranged it all on purpose.

We often had invasions of rats and, since there was no Pied
Piper in the region, Sherman had to take upon himself the job
of exterminating them. He lured them all into hay piles to
which he set fire, and as they ran out he killed them by knock-
ing them with a big stick. To enable himself to do this horrid
business he pretended the rats were Fascists and called them
ugly names each time he hit one. The rats got into the house
and died from a poison we left for them. They died in the
most awkward places: under floor boards which had then to
be taken up, and one rat even got into our water tank. This
caused a fearful commotion, as its dead body stopped the flow
of water and the whole tank had to be cleaned out.

In the summer of 1936 I went alone to Venice for ten days.
I had to take Sindbad back to Florenz, who was once more
on the Continent, so I stayed over and met Agnes in Italy.
The first few days I was with Sindbad and Agnes, but after
they left, when I was all alone, how happy I was. It had never
occurred to me before that I could enjoy being alone, without
talking to anyone except casual people for days on end.
I kept the most peculiar hours and did anything that I felt
like. I was unhampered by any influence or criticism and could
enjoy Venice to my entire delight.

I walked miles all over the city at any time of the day or
night and ate anywhere I happened to find myself. I revisited
all my favorite churches and museums, and felt the same delight
I always had in Carpaccio. I had only one temptation during
these ten days, but I fled from it as though it were from the
devil. It was a good-looking young man whom I kept meeting
everywhere, but I was still in love with Sherman.

On the way back I stopped over in Paris with my mother and
bought some clothes. That always made her very happy. She
had been down to Yew Tree Cottage a few times for the day

and was very surprised by my new life and more disapproving than ever. She wanted to give me her pearl necklace but Sherman told me if I took it I would have to sell it and give the money to the Communist Party. Of course my mother kept it.

When I returned to London Sherman had found a three-room flat he wanted to take opposite the Foundling Estate. It was high up in the tree-tops and very small, but quite cozy. We had long since abandoned the place in the Adelphi, as it was too small for Sherman and Phyllis. Sherman furnished this place with his usual good taste. I did not live in it very much for I stayed down in Petersfield.

Sindbad was now a boarder at Bedales boarding-school. It was the first established co-educational school in England and was supposed to be progressive. Sindbad adored it because he played cricket on the school team and thought of nothing else. I was delighted Florenz had placed him in school so near me. It was only about six miles from Yew Tree. I fetched him every Sunday for the day, when he played tennis and swam and ate Kitty's *paellas* and English truffles.

Debbie had graduated from the Dame School and was now in a progressive boarding-school at Wimbledon. Deirdre wanted to be with her, so she went too. In the beginning both Deirdre and Sindbad hated being in boarding-school but they soon got to love it. Deirdre came home every week-end with Debbie.

In December the news of Mrs. Simpson and the King's intended marriage began leaking through to all the readers of American papers. No English people knew of it. *Time* magazine was censored and cut before it was sold, but Ray had given me a subscription which arrived straight from America; so I was one of the few people who knew about the affair. I told Sherman and we made a bet that if it were true and the King married Mrs. Simpson, he would marry me.

One night when Emily and I were in Yew Tree, Sherman sent me a telegram announcing "the great American victory" and congratulating me. Naturally I told him he had to keep his bet and marry me. But he knew it was too late and since we were getting on so badly about Communism there was no point in tying ourselves up. He had just made his last attempt on me by trying to recruit Emily, but he had failed.

I was so furious when he refused to marry me that I went out into the garden and tore up his best flower-bed. It contained many rare plants and I took every one of these and hurled them over the fence into the field next door. It happened to be the coldest night of the year. The next day I was so ashamed that I collected all the plants and got Jack to assist me. He acted as though nothing unusual had occurred and helped me to place them in a wheelbarrow. We replanted them all with the exception of the few which had died of the frost overnight. This incident did not help to further my matrimonial aspirations. But I named the flower-bed Mrs. Simpson's Bed.

During the week of the abdication we lived in the greatest state of excitement. Everything in England came to a standstill except the sale of extras. All the shops were empty, people just couldn't think of anything else. Finally we heard the King's abdication speech over the radio and even Sherman cried.

Sindbad was staying with me during this exciting period as he was recovering from scarlet fever. He even forgot about cricket for a week in favor of the latest abdication bulletins.

Suddenly everything was over with Sherman. He could endure no more. He said he had done all he could for me during the past three years and it was of no use, it wasn't what I wanted. I had killed his feelings for me and he was through. He really meant it. I don't see how he had stood it so long. The trouble was that I was still in love with him. He hated

this because he said that I had never loved him, that I was only in love with him. It was true.

We had to separate, so Sherman kept the flat in London and I retained the cottage. Sherman asked if he could come down for week-ends. He wanted to see Debbie and he loved Yew Tree, which was really his own creation. Of course, I said yes, he could come, for which I suffered greatly.

I lived alone all week for the children were in school and on week-ends I looked forward to Sherman's visits. When he came he insisted on sleeping with me. This caused great confusion. One week-end, when Phyllis Jones was with me, Sherman and I had a row about Communism and I got so bitchy that he hit me. I slipped and fell. There was blood everywhere. Phyllis tried to stop me from sleeping with Sherman but we always started again somehow.

At Eastertime I went to Paris and tried to forget Sherman. I didn't. When I came back he told me he was in love with a young Communist woman, called Patsy, who used to work in his publishing house but who was now doing a party job. She was very attractive and I had been the first one to remark on it. She looked rather American, with a tip-tilted nose and a smart little figure. I had been to a party at her house.

Sherman had another staunch follower, Greta. She was in love with him and when I finally had to tell her about Patsy in order to clarify the situation, she became even more political and attended a summer school for Communism. She did this, however, only to get some life. The poor woman lived alone with three daughters on a hill the other side of Petersfield. Greta loved to have men around and thought of the summer school as a last resort to recruit them. She was right, because she found wounded soldiers from the International Brigade and invited them to her house to recuperate. Greta was a strange woman from the upper middle class, and she had led a peculiar life and was completely *déclassée*. When I first met her

I thought she was a D. H. Lawrence heroine. But she became a good friend of mine and when Sherman neglected her I consoled her by my friendship. Finally her eldest daughter married a truck-driver and she didn't seem to mind, for she thought it was a sign of the times.

Sherman was very upset about his new love affair because Patsy had a husband. They seemed to belong to the Communist Party to the extent of having no say about their private lives. Sherman did not want to interfere and break up their marriage, and anyway Patsy wasn't quite ready to leave her husband, who was much older than she was, and whom she rarely saw. Also they had a child. They both belonged to the working class. Suddenly they were sent abroad on a mission together and Sherman was very unhappy.

Sherman and I took six months to really end our mutual life. As he came down to the cottage and insisted on sleeping with me the whole thing became very painful. I found myself being dragged into my life with him again and again instead of making a clean break. Once we even tried to live together in London. I never went to the flat. If I were in town, I stayed with Phyllis. But then Sherman suddenly invited me. Of course it didn't work. We were too incompatible to live together anymore.

The one thing we had in common was the children. He adored them and that was what had kept us together. They loved him too.

In the summer Sherman took a short vacation and went down to Swansea. He wanted me to come too, with the children. I couldn't make up my mind but in the end I joined him. It would have been a wonderful holiday if only we hadn't been so at loggerheads. I loved Dorset ever since I had been there with John. Sherman took us to beautiful places and we walked and swam and enjoyed the three children's company.

Sherman was upset about Patsy and worried about what

Harry Pollitt thought of this affair. I teased him unmercifully by telling him that Pollitt had sent for me to come and talk to him, and Sherman believed me. The strange thing was that a year later Pollitt did send for me; so I lied only in so far as I set the date too soon.

My mother arrived in Europe that summer very ill and, although I knew she had had several operations, I got a fearful shock when her maid told me that she had only six months more to live. I stayed with her in London and later in the summer I joined her in Paris.

All the strength the poor woman had left she expended on the International Exposition that was held in Paris in the summer of 1937. She loved it and we spent hours there.

At this time I said to Emily, "I think my life is over." Emily replied, "If you feel that way, perhaps it is."

part 5

chapter 1

guggenheim jeune

When the fact dawned on me that my life with Sherman was over I was rather at a loss for an occupation, since I had never been anything but a wife for the last fifteen years. The problem was solved by my friend Peggy, who suggested that I start a publishing house or open an art gallery in London. I immediately renounced the idea of a publishing house, because I decided it would be too expensive. Little did I dream of the thousands of dollars I was about to sink into art.

The obvious person to help me was Emily's friend, Henry Slaughter. He was a young Surrealist painter of thirty. He was also a photographer, a poet and a producer of G. P. O. films. He was dynamic and always bursting with a new idea; but, as he had too many, he never got much accomplished. He was a sort of genius, and he looked like Donald Duck. We began our collaboration by searching for a place for the gallery. Everything was vague on my part. My mother was dying, and I knew that I would never settle down to anything before she died. I expected to go to New York to spend Christmas with

her, the last one of her life; and I was really only playing with the idea of a gallery.

Henry came down to Petersfield for the week-end. Emily was there, and as she was finished with him, she offered him to me as though he were a sort of object she no longer required, and I went in his room and took him in the same spirit. He had strange ideas about pleasures in life, and one was to spend the week-end in a millionaire yacht club. He never achieved this ambition with me, since it was so far removed from my normal taste. But he did follow me to Paris where I was staying with my mother in the Hôtel Crillon. When Henry came I took a room in a small hotel on the Rive Gauche. It was filled with Napoleonic furniture and looked very formal.

Henry was very pleased with his ugly, emaciated body. He kept jumping all over the bed saying, "Look at me! Don't you like me? Don't you think I'm beautiful?" I had no desire to spend the week-end in bed. I insisted on going to the Paris Exposition every time I could manage to get him out of the hotel. He wanted to meet Marcel Duchamp, so I took him to see him, and in return he took me to meet André Breton in his little art gallery, Gradiva. Breton looked like a lion pacing up and down in a cage.

Henry came a second week-end, but then I refused to leave the Hôtel Crillon, and he had to take a room alone. I had Debbie with me, and used her as an excuse not to live with him. I really could not endure the thought of another week-end in bed with Henry. He went to see Yves Tanguy to ask him if we could exhibit his work in London. Henry had wild ideas about the way of presenting Tanguy's paintings. None of us understood these ideas, but Tanguy politely agreed. He must have been surprised by the strange trio we made.

Finally, I had to tell Henry that our affair was over, and that we could only be friends in the future. I put the blame on Sherman, and said I was still in love with him. We were stand-

ing on one of the bridges of the Seine, and I remember how Henry wept. I think he had hopes of some kind of a wonderful life with me, surrounded by luxury, gaiety and Surrealism. After this was settled we had a good time at the Exposition, where I was able for the first time to study modern art.

After Henry left, Sherman came to talk over our separation which really had to be settled. It was complicated because of the children, the house and the flat. We did not make much progress over these matters, since, to Sherman's great surprise, I took a double room and we spent all our time making love and visiting the Exposition. He was very happy in Paris because of the *Front Populaire*, which was at its height.

Sherman had come to talk over our separation, but I begged him not to leave me until I was settled in the gallery. He was adamant, however, and insisted on ending our life upon his return to London. I remember spending a whole day at the Exposition with tears streaming down my cheeks. But it did not alter things in any way. Sherman expected soon to live with Patsy, but when he got back to London he wrote me of his great disappointment—she would not leave her husband. That did not alter his decision in any way about me.

My children came up from Mégève and we all lived at the Hôtel Crillon with my mother. Those were the last days we spent with her; she died in November in New York before I could reach her.

When I took the children back to England, Sherman and I finally arranged our separation on a practical basis. He moved to Hampstead and I kept the flat. I gave him the furniture and rented Yew Tree Cottage from him. He now had a job with the Communist Party and this extra rent money came in very handy. He asked me to continue having Debbie for week-ends with Deirdre. I was only too pleased, but her mother made a lot of trouble and the situation became almost as

complicated as my divorce from Florenz. In the end it was decided that Debbie would come every third week-end.

After a while things petered-out with Henry. He had so many other occupations that we gave up our collaboration. I finally rented a beautiful second floor in a building on Cork Street and engaged my friend Wyn Henderson as secretary. She was extremely clever and had the whole place decorated for me while I went off to Paris to try to arrange a Brancusi show. She named my gallery Guggenheim Jeune.

When I got to Paris, Brancusi was not there. But Marcel Duchamp and Agnes introduced me to Cocteau and we decided to give him the opening exhibition. At that time I couldn't distinguish one thing from another. Marcel tried to educate me. I don't know what I would have done without him. To begin with, he taught me the difference between Abstract and Surrealist art. Then he introduced me to all the artists. They all adored him, and I was well received wherever I went. He planned shows for me and gave me lots of advice. I have him to thank for my whole life in the modern art world.

Marcel Duchamp first presented me to Arp, the sculptor, who was an excellent poet and a most amusing man. He took me to Meudon to see the modern house he had built for himself and his wife Sophie. They each had a whole studio floor, and there was a garden full of Arp's work. Sophie was an abstract painter and a sculptress. His work was more Surrealist, but he managed to remain on both sides of the fence and exhibited with both groups. Sophie, a Swiss school teacher, edited an interesting magazine called *Plastique*. Arp was always trying to further Sophie's career and, since her work was dull, it often became painful to be so bothered about nothing. They had done one good sculpture together called *Sculpture Conjugale*. Sophie was a wonderful wife. She did everything possible for Arp besides doing her own work and running the magazine. The

first thing I bought for my collection was an Arp bronze. He took me to the foundry where it had been cast and I fell so in love with it that I asked to have it in my hands. The instant I felt it I wanted to own it.

I must have gone to Paris expecting something to occur but I never dreamed for an instant what was in store for me. In spite of the fact that I took every consolation which crossed my path, I was entirely obsessed for over a year by the strange creature whom I shall call Oblomov. He came into my life the day after Christmas, 1937. I had known him slightly. He had been to our house in the Avenue Reille. I knew that he was a friend of James Joyce, that he had been engaged to his daughter and had caused her great unhappiness.

Oblomov was a tall, lanky Irishman of about thirty with enormous green eyes that never looked at you. He wore spectacles, and always seemed to be far away solving some intellectual problem; he spoke very seldom and never said anything stupid. He was excessively polite, but rather awkward. He dressed badly in tight-fitting French clothes and had no vanity about his appearance. Oblomov accepted life fatalistically, as he never seemed to think he could alter anything. He was a frustrated writer, a pure intellectual. I met him again at Helen Joyce's.

That evening we dined at Fouquet's, where James Joyce gave us an excellent dinner. Joyce inquired a lot about my gallery in London, and as usual was charming and very attractive. He wore a beautiful Irish waistcoat which had belonged to his grandfather.

After dinner we went back to Helen's and then Oblomov asked if he could take me home. I was surprised when he took my arm and walked me all the way to the Rue de Lille, where I was living in a borrowed apartment. He did not make his intentions clear but in an awkward way asked me to lie down on the sofa next to him. We soon found ourselves in bed, where we remained until the next evening at dinner-time. We

might be there still, but I had to go to dine with Arp, who unfortunately had no telephone. I don't know why, but I mentioned champagne, and Oblomov rushed out and bought several bottles which we drank in bed. When Oblomov left, he said very simply and fatalistically, as though we were never going to meet again, "Thank you. It was nice while it lasted." During his short disappearance Joyce, to whom he was a sort of slave, got very worried. Helen guessed he must be with me, so our secret was public. After that I moved to Agnes' house as she was in the hospital and I did not see Oblomov for some time. One night I met him on a traffic island in the Boulevard Montparnasse. I must have been looking for him without realizing it, as I was not at all surprised when I found him. It was as though we had both come to a rendezvous.

We went home to Agnes' house where we lived for twelve days. We were destined to be happy together only for this short period. Out of all the thirteen months I was in love with him, I remember this time with great emotion. To begin with he was in love with me as well, and we were both excited intellectually. Since John's death I had not talked my own, or rather his language. And now I suddenly was free again to say what I thought and felt.

In spite of the fact that I was opening a modern art gallery in London I much preferred old masters. Oblomov told me one had to accept the art of our day as it was a living thing. He had two passions besides James Joyce. One was Jack Yeats and the other a Dutch painter, Van Velde, a man of nearly forty, who seemed to be completely dominated by Picasso. To please Oblomov I bought a picture of Van Velde's and promised to give him a show in London.

Oblomov was a writer and brought me his works to read. I thought his poems were bad. They were so childish. But one of his books, which had just been published, was rather extraordinary. I suppose he was much influenced by Joyce, but he

did have certain strange and morbid ideas which were quite original and a wonderfully sardonic sense of humor.

The thing I liked best about our life together was that I never knew at what hour of the night or day he might return to me. His comings and goings were completely unpredictable, and I found that exciting. He was drunk all of the time and seemed to wander around in a dream. I had a lot of work to do because of my gallery and often I had to get up in the afternoon to see Cocteau, who was to have the opening show. Oblomov objected to this; he wanted me to remain in bed with him.

It seemed ironic that I should create a new existence for myself because I had no personal life, and now that I had a personal life, it had to be sacrificed. On the tenth day of our amours Oblomov was untrue to me. He allowed a friend of his from Dublin to creep into his bed. I don't know how I found it out, but he admitted it saying that he simply had not put her out when she came to him, and that making love without being in love was like taking coffee without brandy. From this I inferred I was the brandy in his life, but nevertheless I was furious, and said that I was finished with him. The next night he phoned me, but I was so angry that I refused to speak to him. A few minutes later he was stabbed in the ribs by an unknown maniac on the Avenue d'Orleans and taken to a hospital. I had no idea of this and as I was leaving for London I wanted to say goodbye to him. When I called his hotel the proprietor told me what had happened. I nearly went mad. I rushed to all the hospitals in Paris but could not find him. Finally I phoned Nora Joyce, who told me where he was. I went to him at once, and left some flowers and a note telling him how much I loved him and that I forgave him everything. The next day James Joyce went to see Oblomov in the hospital and I went with him. As he was semi-blind, it took Joyce a long time to be conducted by his secre-

tary to the right ward. But by a sort of instinct I rushed in
and without any help found Oblomov. He was surprised to see
me, as he thought I had left for London. He was very happy.
I said goodbye to him. I knew he was in good hands be-
cause Joyce was looking after him, and that he would be laid
up for a long time. I had to go back to London to open my
gallery, but I meant to return to Paris as soon as I could.

My life in London was hectic. There was so much work to
be done, I don't know how I survived. To begin with I
had to refurnish my flat, since I had given Sherman all the
furniture. Then I had to open the gallery, and obtain the names
of hundreds of people to invite to the opening, and have a
catalogue and invitations printed and sent out. Luckily Agnes
and Marcel Duchamp flew over for the opening and Marcel
hung the show and made it look beautiful. Cocteau sent me
about thirty original drawings for his play, *Les Chevaliers de
la Table Ronde.* I had also borrowed the furniture which he
had designed for it, and he especially made some dinner plates
which were in the same spirit, and two designs on sheets. One
of them was rather too much for the English Customs, who held
it up at Croydon. Marcel and I rushed down to release it.
The trouble was that Cocteau had portrayed pubic hairs over
which he had pinned a leaf. On promising not to exhibit this
sheet to the general public, but only to a few friends in my
private office, I was permitted to take it. The opening was a
great success, but what pleased me most was receiving a wire
of *auguri* signed "Oblomov."

I called him Oblomov from the book by Goncharov that
Djuna had given me to read long before. When I met him I
was surprised to find a living Oblomov. I made him read the
book and of course he immediately saw the resemblance be-
tween himself and the strange inactive hero who finally did not
even have the will-power to get out of bed.

Conversation with Oblomov was difficult. He was never

very animated, and it took hours and lots of drink to warm him up before he finally unraveled himself. If he ever said anything to me which made me think he loved me, as soon as I taxed him with it he took it back by saying he had been drunk at the time. When I asked him what he was going to do about our life he invariably replied, "Nothing."

As soon as we could leave London, Agnes, Marcel Duchamp and I went back to Paris. Oblomov was now out of the hospital and was convalescing in his hotel. I took a room there but I don't think that pleased him at all. My sister Hazel had a wonderful flat on the Ile Saint-Louis which I was able to borrow. It had no furniture, only a big bed and lots of her own paintings (she was a good primitive painter.) I tried to take Oblomov to live with me on the island, but he refused to remain there all the time. He came and went and always brought champagne to bed.

Oblomov had a friend called Liam. He was a little dark man, a sort of dried-up intellectual and a Thomist. He tried hard to attach himself to me, and I used to tease Oblomov about him with great tactlessness. I often said I wanted to sleep with him. Oblomov had an inferiority complex, and as I had talked to him so passionately about John Holms, and also made fun of Henry to him, he conceived the idea that he really was not at all the man I wanted. One day he announced that he was never going to sleep with me again and told me to have Liam, for then at least I might be satisfied. I was so infuriated by this proposition (though I now realize it was entirely my stupidity that made Oblomov suggest it) that I went and slept with Liam. Oblomov looked dignified and sad as he walked away from us, knowing what was going to happen. The next day Oblomov asked me if I liked Liam, but I must have said "No," because Oblomov came back to me. We were very happy together for twenty-four hours, and then everything was ruined. We met Liam for lunch and he asked Oblomov if he were

interfering in his life, as he had only just realized that I really belonged to Oblomov. To my great surprise Oblomov gave me to Liam. I was so horrified I rushed out of the café and walked all over Paris in despair. I went to Oblomov's hotel and made a terrible scene, but it did no good. He said he was no longer in love with me.

Even if our sex life was over nothing else was. Our relationship continued unchanged in every other respect. We were perpetually together, and I felt the same ecstasy in his society as I had previously. At night he walked me home over the bridge behind Notre Dame. When we reached my front door Oblomov went through the most terrible agonies trying to decide what to do. But he always ended up by pulling himself together and running away. This caused me incalculable misery and I spent nights lying awake, longing for his return.

Oblomov had little vitality and always believed in following the path of least resistance. However, he was prepared to do anything for Joyce, and he was always leaving me to see his great idol. I was very jealous of Joyce. I think Joyce loved Oblomov as a son.

In 1938 Joyce had a fifty-second birthday. Maria Jolas gave him a dinner-party at Helen Joyce's. Oblomov was in a state of great excitement about suitable presents. He went with me and made me buy a blackthorn stick. God knows why. As for his own gift he very much wanted to find some Swiss wine, Joyce's favorite beverage. I remembered that John Holms and I once years before had dined in a Swiss restaurant with Joyce, and I went back to the Rue Ste. Anne, found the place and asked them if they would sell some wine. Of course they consented when I told them whom it was for. Oblomov went to get it and was very happy. At the dinner-party Joyce offered a hundred francs to anyone who could guess the title of *Finnegans Wake,* which was just about to be published. Oblomov I am sure won the bet. At the party were present only Joyce's

sycophants. I met again Herbert Gorman, whom I had not seen for years. The table was decorated with a plaster model of Dublin through which ran a green ribbon representing Joyce's beloved Liffey. Joyce got very tight and did a little jig by himself in the middle of the room.

Marcel sent me to see Kandinsky. He was a wonderful old man of seventy, so jolly and charming, with a horrid wife some thirty years younger. Everybody adored him and detested her. I asked him if he wanted to give an exhibition in London, and as he had never shown there he was delighted. He had a friend in England who owned a lot of his pictures, Sir Michael Sadleir.

Kandinsky, who was upset by my uncle Solomon Guggenheim's supplanting him by Bauer, his third-rate imitator, claimed that though he had encouraged my uncle to buy Bauer's paintings now that Bauer had taken his place he never told my uncle to buy Kandinsky's paintings. He wanted me to get my uncle to buy one of his early works. It seems that it was one my uncle had wanted for a long time. I promised to do my best, never dreaming of the result.

Kandinsky and his wife arranged the whole London show themselves. It included paintings from 1910 to 1937. I merely sent them a plan of the gallery and they even decided where each picture was to be hung. They were very businesslike. No one looked less like an artist than Kandinsky, who resembled a Wall Street broker. Mrs. Kandinsky behaved horribly and I am surprised they ever sold any pictures: she was so grasping. At the end of the show, I bought one of the 1937 period. Since then in New York I have bought many others, but I wish I now had several that were in my show.

One day, during the exhibition, an art teacher from a public school in the north of England came to the gallery and begged me to allow him to show ten Kandinskys to his pupils at the school. I was delighted with the idea and wrote to Kandinsky for his permission. He wrote back that he was very much

pleased but with his usual businesslike attitude added that the pictures should be insured. When the show was over my school-master came and strapped ten canvases on to his car and drove away with them. I am certain Kandinsky had never been so in-formally treated before.

As I had promised Kandinsky, I wrote to my uncle asking him if he still wanted to buy the painting that he had so long desired. I received a friendly answer saying that he had turned the letter over to the Baroness Rebay, the curator of his mu-seum, and that she would reply herself. In due time I received this extraordinary document:

Dear Mrs. Guggenheim "jeune"
Your request to sell us a Kandinsky picture was given to me, to answer.

First of all we do not ever buy from any dealer, as long as great artists offer their work for sale themselves & secondly will be your gallery the last one for our foundation to use, if ever the need to get a historically important picture, should force us to use a sales gallery.

It is extremely distasteful at this moment, when the name of Guggenheim stands for an ideal in art, to see it used for commerce so as to give the wrong impression, as if this great philanthropic work was intended to be a useful boost to some small shop. Non-objective art, you will soon find out, does not come by the dozen, to make a shop of this art profitable. Commerce with real art cannot exist for that reason. You will soon find you are propagating mediocrity; if not thrash. If you are interested in non-objective art you can well afford to buy it and start a collection. This way you can get into useful contact with artists, and you can leave a fine collection to your country if you know how to chose. If you don't you will soon find yourself in trouble also in commerce.

Due to the foresight of an important man since many years col-lecting and protecting real art, through my work and experience, the name of Guggenheim became known for great art and it is very poor taste indeed to make use of it, of our work and fame, to cheapen it to a profit.

Yours very truly,
H. R.

P. S. Now, our newest publication will not be sent to England for some time to come.

During the Kandinsky show Liam came to visit me in London. We did nothing but talk about Oblomov, whom we both adored. I think Liam wanted to marry me, but I had so such desire. It was a great relief when he returned to Paris after a week.

Cedric Morris, one of my oldest friends, was a painter of flowers who had an iris farm and a school of painting in Suffolk. He wanted to have a show in my gallery, but he did not want to exhibit his beautiful flower pictures for which he was famous. Instead he wished to exhibit some fifty portraits he had done of London celebrities. The portraits were in most cases nearly caricatures, all of them on the unpleasant side. There was no reason for showing them in my Surrealist and Abstract gallery, but Wyn and I loved Cedric so much that we could not refuse. He covered the walls three rows deep. I think he must have hung nearly one hundred of them. One evening during the exhibition we gave a party to stir up a little trade. The result was most unexpected. All we stirred up was a terrible row. One of the guests, an architect called Mr. Silvertoe, so much disliked the portraits that in order to show his disapproval he started burning the catalogues. Cedric Morris, naturally infuriated, hit Mr. Silvertoe and a bloody battle took place. The walls of the gallery were spattered with blood. The next day Cedric phoned to apologize and offered to remove his paintings. Of course we did not let him.

A few months later Arp came to visit me. Marcel Duchamp had helped me arrange a show of contemporary sculpture, and Arp who was one of the exhibitors came over to further it himself. Arp was very domestic about the house. He got up early and waited impatiently for me to wake up. He served me breakfast every morning and washed all the dishes. We had so much fun together and were so gay that it really was a delightful week. We went to Petersfield. Arp was enthusiastic about the English countryside and loved the little Sussex churches. He went back to Paris with a porkpie hat and a bread

box under his arm. He knew only one word of English, "candle-sticks." His vocabulary did not increase during his stay.

During Arp's visit I was invited by Epstein to go and see his work. Of course I took Arp with me. This greatly enraged Epstein who barely wished to admit Arp until we protested that he was a great admirer. Epstein hated the Surrealists and thought Arp should not be interested in his work. But on the contrary Arp was fascinated by the strange things we saw, among them the enormous figure of Christ lying entombed. Epstein's portraits are miraculous. They certainly are as good as anything done in the Italian Renaissance; but I hate his other concoctions.

The sculpture show was a great success because of its tremendous publicity. To begin with, it was not admitted into England as art. Mr. Mansen, the director of the Tate Gallery, had not passed on it, and therefore it could enter the country only as bronze, marble, wood, etc. This would have meant that I could only import it by paying heavy duty which I would have done had it come to the worst. But this was really so scandalous that Wyn made the critics sign a petition protest-ing against Mr. Mansen's verdict. This stupid old law existed in order to protect English stonecutters from foreign competi-tion. It rested with Mr. Mansen to decide what was art and what wasn't; he abused his privilege and declared that none of this was art. However he not only lost his case, but pretty soon his job as well. My case was brought up in the House of Commons as a result of the petition and we won it. From then on any sculpture, whether abstract or not, was to be admitted into England without necessity of approval of the director of the Tate Gallery. I thus rendered a great service to foreign artists and to England. Brancusi was one of the exhibitors and his Sculpture For The Blind was reproduced in Tom Driberg's column in the *Daily Express*. All the other papers immediately took up the story and the exhibition became famous. The other

exhibitors were Alexander Calder, Pevsner, Henry Moore, Arp's wife, Henri Laurens and Duchamp-Villon.

At this moment what I had told Sherman a year ago to tease him, actually came true. Harry Pollitt, having read so much about my success in my battle against Mr. Mansen, decided that I was much too important a person to have lost. He sent for me, telling me that he was certain he could fix up all my difficulties about Communism in ten minutes. I wrote back and said I was much too busy to go to him but that he "should come up and see me some time." He never did. By this time Sherman was living with Patsy. Later he married her.

One day Rigid Edgwell invited me for dinner and asked me if I would render a great service to the Communist Party. They wanted to borrow my flat for Aragon and a whole convention of Communist writers who were coming to London. They needed a very chic apartment, as when the English writers had been invited to Paris they had been royally received at a hotel on the Avenue de l'Opera. I protested, saying my flat was not nearly grand enough as it was on the third floor without a lift and was a modest little affair in Bloomsbury without servants. The Communists had to look elsewhere.

Wyn was a most remarkable woman. I don't know what I would have done without her. She made everything go like clockwork in the gallery, though she had had no previous experience of this kind. She was a typographer by profession and had run several modern presses. Therefore, we had the most beautiful invitations and catalogues printed. She had a lot of common sense, extraordinary tact and social grace, remembering the faces of all the people who came to the gallery whom I never recognized. She had a great zest for life. One day I made her count up her love affairs. When she came to a hundred she stopped. At this period she was very fat, although she must have resembled a Venetian beauty in her former years. To her great sorrow she now had much less success with men than

before, but she was never jealous of anyone else's happiness. In fact she was always egging me on to enjoy myself. Years before she had pushed her favorite son Ion in my way, and now she tried it with Nigel, the younger one. He was a darling but I really only regarded him as a sweet baby, but I loved his soul and felt we were made of the same clay. When this did not work and she discovered that I was still in love with Oblomov, Wyn sent me back to Paris. Oblomov was flattered by my visit and by my constancy. He was in a strange state, and told me that our life would be all right one day. Ever since his birth he had retained a terrible memory of life in his mother's womb. He was constantly suffering from this and had awful crises, when he felt he was suffocating. He never seemed to be able to make up his mind whether or not he was going to have me, but he did not want to give me up. To replace our sex life, we used to drink wildly and then walk all over Paris until the early morning.

My passion for Oblomov was inspired by the fact that I really believed he was capable of great intensity, and that I could bring it out. He, on the other hand, always denied it, saying he was dead and had no feelings that were human and that was why he had not been able to fall in love with Joyce's daughter.*

I asked Helen Joyce what to do about Oblomov and she suggested that I rape him. So one night, when he was very indecisive and seemed to be yearning towards me and floating into me in spite of himself, I went home with him thinking how much less I should really like him if I ever had him. In fact, as he took my arm, I had the illusion of everything being settled and I thought, "how boring." Neverthless I went home

* A poem written by Oblomov: They come
 Different and the same
 With each it is different and the same
 With each the absence of love is different
 With each the absence of life is the same

with him and insisted on remaining all night. He suddenly became terrified and rushed away and left me in his apartment alone. I was so upset that I got up at four in the morning and wrote a poem which I left on his desk, and then went back to England.

> A woman storming at my gate—
> Is this inevitable fate?
> From far away the hammer fell:
> Was that my life or death's last knell?
>
> To my void she came much wanting
> Shall I chance this fear unending?
> Shall I face the pain of rupture?
> Shall I execute the future?
>
> Every step I take she battles,
> Every inch the death-knell rattles.
> Shall I kill her Holy passion?
> Destroying life, not taking action.

So once again I had to renounce Oblomov. I was, however, destined to see him soon in London, where he came for the opening of his dearly beloved Van Velde's show. When the paintings were hung in my gallery, they looked more Picasso than ever. All the critics seemed to think so and they gave Van Velde little publicity. However, Van Velde was very happy, as I kept buying all his paintings under different names, or as gifts for my friends. This was all because I loved Oblomov so much and he loved Van Velde.

I took the Van Veldes down to Petersfield for the week-end and filled the house with Van Velde gouaches. Oblomov followed us after much deliberation. We had quite a nice houseparty, since the George Reaveys came too. When I had gone to bed in the dining-room, having given my bedroom to the Reaveys, Oblomov came and talked to me. He told me he had a mistress and asked me if I minded. Of course I said no. She

sounded to me more like a mother than a mistress. She had
found him a flat and made him curtains and looked after him
generally. He was not in love with her and she did not make
scenes, as I did. I had met her once in his room before she was
his mistress, when I was, and I could not be jealous of her; she
was not attractive enough. She was about my age, and we were
both older than Oblomov. After he told me all this, I was even
more keen than I had been to get off with Mittens.

Mittens was a Surrealist poet and the director of the Sur-
realist gallery, my neighbor in Cork Street. We had a united
front and we were very careful not to interfere with each other's
exhibitions. I bought paintings from Mittens. He was a gay
little Flamand, quite vulgar, but really very nice and warm.
He now wanted me as his mistress, so we were to have dinner
together. Before Oblomov went back to Paris I went off with
Mittens and took a diabolical pleasure in doing so.

The affair with Mittens did not last long. I told him how
much I loved Oblomov, and then I ran away and went to Paris
again to see him. Mittens was the editor of a Surrealist paper
which was rather good, but, like Mittens himself, a little too
commercial. The paper advertised everything Mittens sold in his
gallery, and he produced my catalogues free-of-charge in ex-
change for an advertisement that I paid for. I wanted to get
control of this paper and improve it, but Mittens was jealous
and would have no other collaborator besides Henry Slaughter.
This time I went to Paris and took my car with me for
Oblomov. I wired him I was coming, but he did not meet me
at Calais as I had hoped. He merely waited for me listlessly in
his apartment and seemed bored with me.

One afternoon at his flat, when the Van Veldes were there,
Oblomov and Van Velde began to exchange clothes. It was a
rather homosexual performance, disguised, of course, by the
most normal gestures. I accused Oblomov of being in love with
Van Velde. After that we went to a dancing place and an awful

scene followed; Oblomov went away leaving me with the Van Veldes.

Oblomov and I did not get on well after this and I did not see much of him. I was living in Agnes' house and one day I said to her, "There's no point in my being here, as I never see Oblomov." I decided to go back to London. Before leaving I wrote him a letter telling him I would like to say goodbye. This seemed to bring him back to life, as we then arranged to drive the Van Veldes to the Midi where they were going to live.

It was difficult to leave because Oblomov always spent the week-ends with his mistress and he could not suddenly change his habits. He managed to get off at two o'clock on Sunday, and we all departed in my Delage. Oblomov drove us to Marseilles and then we went to Cassis for the day. The Van Veldes were surprised by all this, as they never could make head or tail of our relationship. They had seen Oblomov and me fight so often that they never dreamt we could always begin all over again where we left off.

We deposited them in Marseilles and started off for the north. I had wasted so much time waiting around Paris for Oblomov that now I really was in a hurry to get back, as I had to drive Yves Tanguy to London in time for his exhibition. On the way back we stopped at Dijon. I had many memories of this sad town; I did not think I would ever add any more. Oblomov's behavior was so strange that I can never forget what happened this time. By mistake we had a dreary dinner in a depressing restaurant, which was stupid, considering Dijon is famous for its excellent food. Oblomov had no flair for the right places, and his Protestant upbringing made him automatically shun the pleasant things in life. When we went to a hotel he took a double room. This I thought strange, but then all his behavior was most peculiar. We got into separate beds. I soon crept into his, and Oblomov jumped out and got into

the other bed saying I had cheated. When I asked him why he had taken a double room he said it was thirty francs cheaper than two singles.

The next morning we walked all over Dijon. I was happy to be with Oblomov, who really was an ideal companion as he loved to see beautiful things. It was a pleasure to visit the museums with him. We really got on marvelously well, and I told him how much nicer he now was than he had been. He said I was much easier to get on with, since I no longer made scenes. This trip ended all too soon because of Tanguy. We parted with sorrow, Oblomov as usual regretting he relinquished me.

Early the next morning I left for England. For some unknown reason the car would not start, and I wasted an hour before I could get off. This made me late for Tanguy and his wife. Our whole trip consequently was a mad rush to Boulogne and we nearly missed the boat. The Tanguys had never been to England and this was an exciting adventure for them. They were unspoiled and so different from all the blasé people I knew that it was a pleasure to be with them. When we arrived in London I turned them over to Peter Dawson, an English Surrealist who had invited them to live with him. He was frantic with joy about their being in London and felt he owned them, although he barely knew them, having met them only once in Paris.

I had to go down to Petersfield to see Deirdre, whom I had abandoned for five weeks. Peter and Tanguy were to hang the show over the week-end. Hazel was living in my house and Deirdre spent week-ends with her. We unpacked an enormous trunk containing my mother's silver, which had arrived from America. Hazel and I divided it up while a friend took the rôle of referee. Neither of us really wanted any of it, it was ugly and Victorian. There was the enormous tea-set I have already referred to. We both refused to accept it and decided to sell

it. Later, when Djuna saw it, she said we should give it to Nora Joyce: it was just her style. Too bad I did not follow her advice, because I left it to be sold in a jeweler's shop in Petersfield and have no idea what has happened to it even today. After the week-end I went up to town leaving Deirdre at her school in Wimbledon.

The Tanguy exhibition was beautifully hung and looked wonderful. It was a retrospective show, and some of the earlier paintings were entirely different in feeling from the later ones. There were two of this early period I wanted very much. One called *Palais Promontoire* belonged to Mrs. Tanguy and she would not sell it. It had almost no color, which made the drawing show to greater advantage. The other one was a yellow canvas that Peter Dawson owned. Instead, I acquired *Toilette de l'Air,* which was full of color, and produced a strange rainbow effect when you looked at it upside down. Mittens insisted on giving me a small painting as a present after bargaining with Tanguy, which annoyed us all. There was also a wonderful painting called *Le Soleil dans son Ecrin.* This picture frightened me for a long time, but I knew it was the best one in the show, and I finally got over my fear and now I own it.

We had lots of parties all the time; Mittens gave a wild one in Wrenclose's home where he lived. Wrenclose, the owner of the gallery Mittens ran, had a lovely house in Hampstead. He was not in London at this time. He was rich and was always traveling. Everybody was tight at this party and the next day the neighbors complained about the goings-on in the garden. Peter Dawson had a girl who kept appearing in a different costume every hour with the most silly excuses.

Finally Tanguy and I decided to leave together and go to my flat. We must have warned Wyn, for she facilitated our departure, but a man called Charles Ratton, who had come to London specially for the show, insisted on following us. He suddenly remembered, when we were in the cab, that he had

forgotten his braces and wanted to go back. We wouldn't hear of it and we got rid of him as soon as we could and went to my flat where we spent the night. After that it was difficult to see Tanguy alone because of his wife. Wyn came to our rescue and invited Mrs. Tanguy to lunch and kept her occupied all one afternoon.

The Tanguys soon got bored with the Dawson ménage and came to live with me. Tanguy had a bad ulcer, and he suddenly had a severe attack. I ran all over London trying to find him a medicine called Tulane. When I obtained it he revived, and we went to Petersfield for the week-end. Tanguy got on very well with Hazel, whom he named *La Noisette*. The house was full of so many people, including Hazel's friends, that no one knew where to sleep. Finally Hazel left, or rather I packed up her things and sent them to London where she had gone for a few days. Hazel didn't at all mind this barbarity.

The Tanguys and I remained alone with Deirdre and Debbie. We left the gallery to Wyn. The Tanguys adored the children—Mrs. Tanguy particularly, as she had never had any of her own. They really were like creatures in a fairy-tale. They dressed in wonderful clothes and had long flowing manes, Debbie very dark and Deirdre very blond. They painted in Sherman's little house. Tanguy and Deirdre exchanged paintings.

Mrs. Tanguy was not very happy, as she was jealous of my being with Tanguy all the time. One day she disappeared, and we got a phone call from the pub in South Harting asking us if we knew her, and should they lend her money to come home in the bus. They thought she was the children's governess, as she was French. She must have been exceedingly tight for a governess.

Our enormous fireplace had a very strange effect on me; for years I wanted to jump into it. I had to hold myself together not to do so. One night when Tanguy was with me I nearly

achieved my purpose, but this time by mistake. We were hav-
ing a heated argument and in my animation I slipped and was
rescued by Tanguy just in time or I would have been where I
had wanted to be for so long, among the flames.

Before we left London Wyn conceived the marvelous idea
of renting a motor-boat and giving a party on the Thames. We
took lots of people and drinks with us, and at midnight found
ourselves at Greenwich. The party was wild and drunk, and
many scenes occurred from various jealousies. This was sup-
posed to replace the publicity parties we usually gave in the
gallery in the evenings, but it certainly did not result in sell-
ing any pictures.

Suddenly Tanguy found himself rich for the first time in his
life. As Surrealism was just becoming known in London his show
had been a great success. He was a simple man from Brittany,
who had been in the *Marine Marchande* for years. His father
had once had a position in one of the *Ministères*, and Tanguy
said he was born in a building on the Place de la Concorde.
This did not make him pompous. He had come to André
Breton in 1926 and joined the Surrealists, painting in their
style. Yves had been mad at one time, and of course was ex-
empted from the French army. He had a lovely personality,
modest and shy and as adorable as a child. He had little hair
(what he had stood straight up from his head when he was
drunk, which was quite often) and beautiful little feet of
which he was very proud. Tanguy was about thirty-nine years
old. He adored Breton the way Oblomov adored Joyce, and
seemed to think his whole life depended on his being a Sur-
realist. It was worse than having a religion, and it governed
all his actions, like Sherman's Communism. He left a Manx
cat in Paris with a friend and every few days sent him a pound
note in a letter. The pound was really destined for the main-
tenance of the friend, Brauner, a Roumanian painter, more
than for the cat. After a few weeks I drove the Tanguys down

to Newhaven and they went back to France. I was sad and Mrs. Tanguy cried, but I knew I would be seeing Tanguy again before long.

Soon after, Deirdre had to go to Mégève to spend her summer holidays with Florenz. Sindbad was staying with me for his vacation. My mother's maid had just arrived in Paris with my mother's string of pearls, which she was bringing to me. This was a small part of my inheritance.

I wanted to see Tanguy. I had to manoeuvre quickly and cleverly. I sent Sindbad to Sherman's for the week-end, took Deirdre in my car down to Newhaven where we caught the afternoon boat, and wired Florenz's mother to meet us. She was delighted to take Deirdre in charge and keep her till the train left for Mégève. I then went to see my mother's maid and got the pearls. She was in an awful state about them and was delighted to get rid of them. They were the least of my concerns. I was to meet Tanguy in a café at six.

While we sat plotting our elopement so many people saw us together that we had to move to a less known café, and even then we decided it would be safer to leave Paris at once. Tanguy had no baggage of any kind. I had only a little bag. We took a train for Rouen, where we arrived at three in the morning. It was almost impossible to get a room and we went to at least ten hotels before we found one. The next day we wandered around Rouen and took a train for Dieppe, where it was pouring rain. We had missed the last boat so we spent the night at Dieppe in a chic hotel on the port. So far no one had seen us except Nancy Cunard, who tactfully pretended she had not. We were worried for fear Mrs. Tanguy would discover our whereabouts. When we arrived in Newhaven and got into the car, we felt safe and drove home in great style.

Sindbad liked Tanguy very much but had no idea why he was there without his wife and kept asking for her. While Tanguy was with us he did a lot of drawings in green ink,

which was the color he always used. There was one drawing
that looked so much like me I made him give it to me. It had
a little feather in place of a tail, and eyes that looked like the
china eyes of a doll when its head is broken and you can see in-
side. Tanguy read Proust, which I think must have bored him,
and we took long walks and went to a cricket-match and were
very happy. But he got restless and wanted to go back to Paris to
do things for Breton who was soon returning from Mexico.
Sindbad and I motored him down to Newhaven and then we
went to visit Hazel in Kent. We went up to London for a few
days as Sindbad wanted to go to a cricket-match.

Suddenly Oblomov appeared. He was on his way to Ireland.
I put him up in my flat. When Oblomow saw a photo of me
and Tanguy on the mantlepiece looking happy together, he
became curious and could not help showing it. I was leaving
the next day for Paris and offered him my flat in London. He
wanted me to remain with him until the next day, when he
was going to Dublin. I refused. I suppose he wanted me because
he knew that I had somebody else. I told him I was forced to
have all my other lovers in order to keep him as a friend, and
I blamed him for my double life. He offered me his apartment
in Paris. It was on the Rue des Favorites, which made every-
one laugh when I gave them the address. It was in a workmen's
building, but it had a nice studio, bedroom and kitchen and
bath. There was no telephone and it was far away, in the fif-
teenth *arrondisement*, but I accepted it as I knew Mrs. Tanguy
would never find me there.

I drove Sindbad to Paris and put him on the train, which
we made by one minute. It was a mad race through Paris.
I don't know how we ever did it. Little did Sindbad suspect
Tanguy was waiting for me in the station when I said
goodbye. Tanguy and I spent the first night in Oblomov's
apartment and then he disappeared for forty-eight hours. As
neither of us had a phone I was rather worried and thought

all sorts of awful things had occurred. Finally he came back and told me what had happened. There had been a row at a Surrealist party, and it had ended up with poor Brauner, the painter, losing an eye. He had had nothing to do with the row, in fact he was an innocent onlooker. Dominguez, an awful brute, had seized a bottle and hurled it at someone else, and it had broken and rebounded in Brauner's eye. Tanguy had taken him to the hospital, where an operation was performed to remove the pieces of glass, his eye having fallen out at once. Tanguy promised Breton he would go to see Brauner every day. As Brauner was a Surrealist, Breton felt responsible for him. Tanguy and I now had to give up our project of going on our holiday to Brittany and I remained in hiding from Mrs. Tanguy in Paris. I was careful what cafés I frequented so as not to meet her.

One day, when I was having lunch with Agnes, Tanguy and Mrs. Tanguy came into our restaurant. I was very embarrassed and didn't know what to do. Agnes told me to go and say *bonjour* to her. Her reception was not cordial, but it was definite. She didn't utter a word. She just picked up her knife and fork and hurled three pieces of fish at me. Tanguy took her home soon after, but the owners of the restaurant were not very pleased. It happened to be the restaurant where I always went with Oblomov. The owners were old friends of ours. They had once allowed us to go up into their private apartment to hear Giorgio Joyce sing on the radio. We had been making a futile search for a radio and at the last minute they had come to our rescue.

Now that Mrs. Tanguy knew I was in Paris, life became more difficult. Tanguy was afraid she would follow him or find us together. Of course she did not know where I lived, but she was a woman with a mystic sense and often knew things for no obvious reason. I really liked her and did not want to make her unhappy. I never meant to take her

husband away from her, and he had had many other affairs. Tanguy told me that she stayed home and wept. I must say this upset me. One day when he was in the hospital with Brauner, where he told me not to come for fear of meeting his wife, I waited for him next door in a café. We were supposed to go and see a doctor for Tanguy's ulcer. Mrs. Tanguy followed him to the café and made an awful scene. He had to take her away in a taxi. This was most unfortunate, as it meant giving up the doctor. Tanguy was sick and neglected his health badly, and Mrs. Tanguy was incapable of looking after him. She was just like a child. They both drank too much and had fearful rows, but in some way were very much attached to each other. Sometimes when they had rows she disappeared for days.

Every morning Tanguy came to my house to fetch me. We spent the whole day together, then he went home to his wife. I was living in Oblomov's apartment. He had gone to Brittany with his mistress in my car. I was still terribly in love with him. Tanguy once said to me, "You don't come to Paris to see me, you come to see Oblomov."

We were all upset by Brauner's accident. The poor thing had to have a second operation on his eye, as the doctor had not removed all of the glass. After that we bought him a glass eye. He had enormous pride and courage and began to paint very well once he was readjusted to life. I went to see him with Tanguy and bought one of his paintings. He showed me the painting he had done of himself the year before with one eye falling out of its socket. He seemed to have prophesied this catastrophe, and after it occurred his paintings made great progress, as though he had been freed from some impending evil.

If Mrs. Tanguy and Brauner had a mystic sense, I don't think I fell far behind them. One day Tanguy took me to a bookshop to find a volume called *Huon de Bordeaux* by Gaston

Paris and illustrated by Orazi. This was a book Tanguy had
received as a prize in his schooldays. I paid little attention to
what he was doing, in fact I didn't even know what he was
searching for. I went next door to look at a Larousse Encyclo-
pedia which I wanted to buy for Tanguy. When I came back
I walked absent-mindedly up to the bookshelves and the first
book I pulled out was the one Tanguy had been seeking for
half an hour. I think this pleased him more than anything I
ever did for him. Tanguy really loved me, and if he had been
less of a baby I would have married him though the subject was
never mentioned. He always told me reproachfully that I
could have had anything I wanted from him. Florenz and my
children were all for the marriage, but I needed a father and
not another son.

I went back to London just in time for the Munich crisis. I
must admit I have never been so scared in my life. I com-
pletely lost my head. When the war came a year later I felt
no personal fear of any kind; but this time I was panicky. I
began by having all the paintings from the gallery moved to
Petersfield. They did not belong to me and I felt a great re-
sponsibility about leaving them in London. As for myself and
the children I thought we ought to get away. I was going to
Ireland with them and Djuna. She sat at the bottom of my bed
wrapped in my marabou cover and said, "We'll be bombed in
feathers." Sindbad refused to leave his school, and Florenz
phoned from Mégève and said that if I went to Ireland he would
never be able to see us again, so we decided to remain. I was
also worried about Tanguy and wired him to leave Paris. I
had a fixed idea that London and Paris would be bombed the
first day of the war. The evening Chamberlain came back from
Munich I spent with Ira and Edita Morris. They took me to
Edward O'Brien's house, where we heard Chamberlain on the
radio. Then we realized it was over. "Peace in our time," or
one year.

When Breton came back from Mexico he brought with him a collection of extraordinary nineteenth-century portraits and all sorts of popular peasant art. I wanted to exhibit this collection, but as most of it was very fragile it turned out to be impossible to transport them to England without paying a high insurance rate for breakage. They were shown in Paris, however. Breton had a studio apartment in Montmartre full of paintings and objects he had been collecting for years. The best things he never wanted to sell, but when he needed money he was willing to part with a minor object. As this was now the case, Tanguy took me there and I bought a beautiful pair of plaster hand-painted Mexican candelabra. They were so delicate they were perpetually breaking and finally had to be abandoned.

Breton was a marvelous talker, he seemed more like an actor or a preacher than a poet. He sat in a café surrounded by his disciples. Sometimes there were as many as forty. When the war was declared it was funny to see him appear in the uniform of a medical officer. In the last war he had served in the Army as a psychiatrist and this time they made him a doctor, though he had forgotten everything he ever knew about medicine. He went around with medical books in his pockets. Breton was a handsome man of about forty, with a head like a lion and a big shock of hair. He had a kingly appearance, but his manners were so formal and so perfect that it was difficult to get used to being treated so courteously. He was pompous, and I always felt he had no sense of humor. He had a blonde, artificial, Surrealist-looking wife called Jacqueline. She had been an underwater dancer but came from a bourgeois family. They had a child called Aube. Both Jacqueline and Aube followed Breton everywhere and the child was a pest in cafés. Tanguy adored the whole Breton family.

At this time there was a terrible feud among the Surrealists and they were split into two camps. Eluard had taken away half

or more of Breton's followers. They were both too strong to be leaders of the same party, and as one or the other had to give in, and as neither of them would, the party broke in two. Breton must have given orders to his disciples not to speak to any of the rebels, because Tanguy would not permit himself to remain in the room with any of the other group. The whole thing was ridiculous. All this complicated my life even more, because, while I could never go anywhere with Tanguy, fearing I might meet Mrs. Tanguy, he could never go anywhere with me where he might meet the rebels.

After bringing back all the paintings from Petersfield to the London gallery we opened the season with an exhibition of children's paintings. I had been to Deirdre's school to speak to the art master there. He was an ideal teacher and gave the children complete freedom. As a result they did the most beautiful work. I borrowed a lot of his star pupils' work, and Florenz sent me some his children had done. I also received a batch from Paris from Maria Jolas' school. Dora Russell sent me some from her school as did the schoolmaster who was the admirer of Kandinsky. Peter Dawson who taught art sent me a lot done by his pupils, but everyone said he did them himself. At the last minute Freud's daughter-in-law brought in some paintings done by Freud's grandchild, Lucien. One was of three naked men running upstairs. I think it was a portrait of Freud. We sold a lot of these paintings. All of Deirdre's were sold, and my dentist ordered a duplicate of one. Roy Campbell's daughter had made a very pretty little water-color. One of her grandmothers brought in her other grandmother who bought it, and took it back to South Africa. Mittens bought a gouache that he thought was very Surrealist, done by one of Florenz's children, and Wrenclose purchased another.

One day a marvelous man in a highly elaborate tweed coat walked into the gallery. He looked a little like Groucho Marx. He was as animated as a jazz-band leader; which he turned out

to be. He showed us his gouaches, which were as musical as Kandinsky's, as delicate as Klee's, and as gay as Miro's. His color was exquisite and his construction magnificent. His name was John Tunnard. He asked me very modestly if I thought I could give him a show, and then and there I fixed a date. Later he told me he couldn't believe it, he was so used to being turned down. During his exhibition, which was a great success from every point of view, a woman came into the gallery and said, "Who is this John Tunnard?" Turning three somersaults, he landed at her feet saying, "*I* am John Tunnard." At the end of the show I bought one of his best oil paintings. Alfred Barr has been trying to buy it from me ever since he has seen it. I was happy to think I had discovered a genius.

Another day Piet Mondrian, the famous Dutch abstract painter, walked into Guggenheim Jeune and instead of talking about art asked me if I could recommend night clubs where he could dance. As he was sixty-seven years old I was rather astonished, but when I danced with him I realized how he could still enjoy himself so much. He was a very fine dancer with his military bearing and full of life and spirits.

I still had many paintings by Tanguy in London and I kept selling them all the time. There was one I wanted Donald Wrenclose to buy as he had the best collection of Surrealist painting in England. When he came to the gallery to see this Tanguy, he immediately appreciated it and bought it though he already owned several other Tanguys. It was in this way, in trying to render him a service, that I rendered Tanguy a great disservice, because I got friendly with Wrenclose at the same time. Wrenclose had a pretty little house in Hampstead and gave wonderful parties and entertained a lot. He looked like a man made of straw and he really seemed quite empty. His ex-wife had once said of him, "He is a barn to which one could never set fire." If he had no passion, he replaced it by charm and good taste. He certainly was capable of love. All

his walls were covered with Surrealist paintings. He was the
great promoter of Surrealism in England, and had arranged
and brought over the big Surrealist show in 1936 which had
been such a success. Wrenclose was a bad painter himself,
but he was extremely attractive, quite good-looking, had great
success with women and was always having affairs. He had one
eccentricity: when he slept with women he tied up their wrists
with anything that was handy. Once he used my belt, but
another time in his house he brought out a pair of ivory brace-
lets from the Sudan. They were attached with a chain and
Wrenclose had a key to lock them. It was extremely uncom-
fortable to spend the night this way, but if you spent it with
Wrenclose it was the only way. In his house he had beautiful
paintings by the romantic Belgian Surrealist Delveau whom
Mittens had discovered and was furthering. Once we slept
under my favorite painting of Delveau's, the "Women with the
Lamps." I was so thrilled; I felt as though I were one of the
women. I own one of these paintings which I bought from
Mittens. It represents four women growing out of trees. Their
legs are replaced by the bark of the trees. They are always the
same women, as Delveau's model was his wife, whom he adored.
It is strange how different she can appear from different sides.
In the paintings she is very handsome but her breasts are too big.

After a few months Tanguy finally got to London, where he
had been meaning to visit me for ages. I met him at the station
and the minute he saw me he knew something was wrong.
I did not admit it for days, but in the end I told him I was
caught in a trap and had to extricate myself, and that I was
unhappy. I knew Wrenclose was in love with an American girl
in Egypt. I did not tell Tanguy who it was that was causing me
all this trouble, but Wrenclose gave a party and, as we sat hold-
ing hands all evening, Tanguy must have guessed. He was sad
all the time he was in London, even though we went about a
lot and lived together quite happily. We went to a cocktail party

where the host asked if I were Mrs. Tanguy. We decided that I would be Mme Tanguy de Londres.

Tanguy felt rich as he was selling so many pictures. He had already spent, given or thrown away all the money he had made from the show. When he returned to Paris he used to take pound notes, roll them into a ball and throw them to people in cafés. I think he even burnt them. How I wished I had kept the money for him. He told me I should not have given it to him all at once. Now he bought us all presents. He gave me an orchid every day, and he gave me a painting. He gave Sindbad a wonderful stop-watch full of gadgets, Deirdre a miniature paintbox, and bought himself some English clothes. He soon went back to Paris as he was unhappy about Wrenclose. On the way back he made friends with the captain and was allowed to steer the boat into the harbor.

While Tanguy was in London we were invited with Wrenclose to Henry Moore's for dinner. His wife, a Russian, cooked us a wonderful meal. Afterwards Moore showed us his new sculptures. They were minute. I think I had given him the idea of making smaller things by writing him, at the time of my sculpture show, how much I admired his work, but how sorry I was that I had no room in my house for any of it. Now I could easily have one. He had several casts made and one day brought me two in a suitcase to choose from. Moore was a very simple man from Yorkshire, about forty years old, and he taught art to earn a living. He was having great success selling his things in London and exhibited in all the galleries. He did wonderful Surrealist drawings also. I liked them better than his sculpture.

During this period I gave a *collage* show. Half of it was sent from Paris by Arp, who had gone to great pains to collect it. The rest I found in London. I borrowed some from Wrenclose and other people, and I got all the artists to make amusing new ones. As there was no limitation to the material used, we

received every kind of object. Benno made one with a kitchen grater on it. Wrenclose hung the show for me. We put the old Picassos, Braques, Arps, and Massons in one room and all the less restrained works together in another room. Florenz sent some very obscene *collages* which we had to hide. Wrenclose lent me a few by Max Ernst, who is certainly the master of *collages*. As he was not mentioned by the critics in the reviews, Wrenclose was disgusted by their ignorance. After the opening I gave a large party at the Café Royal, as was my habit. I remember suddenly, in the middle of dinner, urging Wrenclose to go to Egypt to get his lady-love. He was surprised and asked me why I took such an interest in his affairs. I said, "Because I like you so much I want you to be happy, and if you don't go and storm her gates she will never come." He was touched by my interest in his affairs and followed my advice and brought back the lady he had been pining for so long.

In January I went to Paris and finally got over my passion for Oblomov. I remember saying to him one day, "Oh, dear, I forgot that I was no longer in love with you." I think it was as a result of consulting a fortune-teller. She seemed to think it was the moment to marry him or give him up. She said he was an awful autocrat. When I told this to Oblomov he said, "Have you decided not to marry me?" I was relieved to say "yes." After thirteen months of frustration it was about time it was over.

I was still friendly with Tanguy and saw him constantly. He painted a little pair of earrings for me. I was so excited I couldn't wait for them to dry and ruined one by wearing it too soon. I then made him paint me a second one. The first two were pink, but I thought it would be more fun if they were different colors, so he now made one blue. They were beautiful little miniature paintings and Herbert Read said they were the best Tanguys he had ever seen. Tanguy also designed a little phallic drawing for my cigarette lighter which he had Dunhill engrave. It is the smallest Tanguy drawing in the world.

I came back to London giving up the idea of both Oblomov and Tanguy. But I soon was in worse trouble. I got involved with an English sculptor called Llewellyn. The affair was very vague, but the consequences were disastrous. The pleasure gained from it was hardly worth the trouble it cost me. It all started because he was at rather loose ends, his wife being sick, and I took him home with me one night, which caused him great remorse, because of his wife. He had to be discreet and could only see me secretly or on business. We worked hard together on a Spanish Relief Committee which he organized. He collected paintings donated by all our artists from Paris and London. He wanted to borrow my gallery in order to hold an auction sale of these pictures, but in the end he found a house in Regent's Park that was more suitable. We held three auction sales on three successive nights, and sold the pictures for ridiculously low prices; most of the people, taking advantage of the artists' generosity, came for bargains. The whole thing was run in a state of great confusion and the auctioneers were ignorant of art. We had a nice drawing of Joyce done by Augustus John and a handsome 1937 Picasso, which raised good prices. I bought my first Ernst and a Llewellyn abstraction for normal prices, but most of the things were underbid, and we had to put a minimum on them. We raised a few hundred pounds, but we should have done much better considering the quality of the work and the cause involved.

Llewellyn had a wonderful house in Hampstead where he and his wife both sculpted, and gave parties to which it was considered quite an honor to be invited. They were snobbish and both belonged to old English families.

All my troubles arose from the fact that Jack Bedford invited us to Calais for a week-end, I mean Llewellyn and me and another couple. No one knew of my connection with Llewellyn; in fact he sketched most of the day with Jack's wife and I spent all my time talking to Jack, who was a delightful companion.

He took us to marvelous restaurants, and we had a most enjoyable two days, and then the others went on to Paris and I returned to Sindbad, who was spending his Easter holiday with me. When I departed Llewellyn brought me a little bottle of brandy to the boat, and I am sure he was delighted I left before we were found out. After that I spent three months in a state of great uncertainty, not knowing whether or not I was pregnant.

Every time I thought I was, I decided I wasn't, and vice versa. I had a stupid female doctor who spoke to me over the telephone and refused to see me. She was convinced I had had a miscarriage. I seemed to have had three. As time went on I got more and more ill and remained in bed for days. Jack Bedford invited me for the week-end to his beautiful home in the Cotswolds. I spent a whole afternoon weeding the gardens and pushing a heavy wheelbarrow, hoping it would have some effect, but it didn't alter matters.

One afternoon Llewellyn asked me out to his house in Hampstead to see his wife's work. The minute I entered the room and saw her I knew we were both pregnant. Shortly after this she had a miscarriage. She was taken to a hospital in the middle of the night in a dangerous condition. The irony of the situation was that they wanted a child. I offered mine to Llewellyn, but he refused it on the grounds that he could make a lot more.

After weeks of uncertainty I went down to Petersfield and consulted my local physician. I took an awful chance, but I must say he stood the shock very well. He had a test made on a mouse in Edinburgh, and after several days told me that it had proved positive. I then asked him to help me out of my troubles, but he said he could not take the risk. I protested on the grounds of being so ill, but he said that would doubtless pass in a few weeks time. I then went up to London and finally consulted a German refugee doctor. He said a blind man could see that I was pregnant and that I was much too old to have a

child especially after not having had one for fourteen years. I was greatly relieved to find some one to end my troubles.

While I was in the nursing-home Jack Bedford came to see me, bringing armfuls of flowers. He had no idea what ailed me, and little did he suspect the dangers I had incurred in Calais. Another visitor to the nursing-home was Herbert Read. He looked so paternal. I am sure all the nurses thought he was the father of my child. He was even less suspicious than Bedford of my illness. He came to talk about our museum project, which by this time was well under way.

In March I had had the idea of opening a modern museum in London. It seemed stupid to go on with the gallery, which was suffering a loss of about six hundred pounds a year although it appeared to be a successful commercial venture. I felt that if I was losing that money I might as well lose a lot more and do something worth while. I approached Herbert Read, who was trying very hard to promote modern art in England. I liked him immensely and felt we could work well together. I made him give up his position as editor of the stuffy *Burlington Magazine*, and in exchange gave him a five-year contract as director of the new museum which we were to open in the fall. He offered to help me for six months without accepting any money until we started; but he borrowed one year's salary in advance as he wanted to become a partner in Routledge's publishing house and buy some shares in it.

We spent weeks trying to find a suitable place for the museum but did not succeed until summer. I tried to think of ways to cut down my own personal expenses, in order to have sufficient money for the project. In fact, I had decided to live a monastic life in order to be able to produce the necessary funds. Actually I did not have nearly enough money for this venture as I had commitments of about ten thousand dollars a year to various old friends and artists whom I had been supporting for years. I could not suddenly let them down for the

museum, much as I wanted to. I intended to buy no more clothes, sold my Delage and bought a cheap little Talbot. Every penny that I could raise was to be used for the museum. As we had no money to buy paintings, we decided to borrow them or try to get people to give them to us. I went to my aunt, Irene Guggenheim, asking her if she thought I could get my uncle Solomon to give me something, but all she said was that the Baroness Rebay would have to be consulted and then maybe I would get a Bauer. I thanked her very much and left. Mr. Read did better—he got promises from lots of people. We had a marvelous press. The *Evening Standard* came out with a hideous photo of me with Deirdre. Djuna's comment was wonderful. She said, "The only chance you had, you muffed." I really looked horrible, although I am generally photogenic. Mr. Read's photo appeared in all the papers, and I believe he was celebrating his fiftieth birthday at the same time.

One day a young woman came into the gallery. She looked very masculine and said she had been sent by Marcel Duchamp, so we treated her well. She wanted to photograph Read and me in color. She had a large collection of celebrities she had already photographed, and was doing more in London, where she had succeeded in making everyone in the intellectual world pose for her. I thought it would be amusing to give her a chance to show her slides in my gallery. I combined this with a farewell party. Hundreds of people came, mostly gate-crashers. Gisèle Freund showed her slides. Everybody was delighted to see celebrities in color, even more so than in black and white. We also had an enormous bar, so the party was a success. I was so ill at the last minute that I nearly did not appear. Llewellyn's wife, who had just recovered from her miscarriage and had no idea I was pregnant, told Llewellyn to throw me over his shoulder and take me to the next party. When I said I could not stand up, she asked me what ailed me and I said I had a sprained ankle.

After that Miss Freund photographed Mr. Read and me in my little flat. We couldn't get the camera far enough away, so I sat at Read's feet, while he showed me a book of Duchamp's. Behind us was a painting by Tanguy. We had to choose whether to cut this or ourselves in half. We decided to favor ourselves. Later Miss Freund gave me two photographs of Read's head. She had done a wonderful job. You could even see his closely shaven beard getting ready to grow again.

Mr. Read was a distinguished-looking man. He looked like a Prime Minister, and seemed to be very well-bred, though he boasted of being the son of a Yorkshire farmer. He had grey hair and blue eyes, and was reserved, dignified and quiet. He was learned and had written innumerable books, which I made him autograph as I had copies of all of them. He soon became a sort of father in my life and behind his back I called him Papa. He treated me the way Disraeli treated Queen Victoria. I suppose I was rather in love with him, spiritually. We had many meals together and we got very friendly; we talked a lot about John Holms and I made Mr. Read promise he would finally have the book of John's letters published for me. He told me how much he thought of John's criticism. I found an old article of John's about Read which was only moderately flattering, so I did not show it to him. It had appeared years before in the *Almanac*, Sherman's review. Mr. Read and I had planned a wonderful future for ourselves. We were going to New York after the opening of the museum to raise money and to study the workings of the Museum of Modern Art. I blush now to think of our innocence.

Djuna was very much against the whole project and was extremely nasty about it all. She told me that I would soon find myself in the rôle of signing checks for Mr. Read, who would be running the whole show. Mr. Read had been rather nervous about staking his future with me. He wanted some kind of a reference, and as I could not give him one he went to T. S. Eliot,

his best friend, and asked him what to do. Mr. Eliot, whom I
had never met, reassured Mr. Read by saying, "I have never
heard Mrs. Guggenheim spoken of in any but the highest
terms." That settled it, I guess, for Mr. Read.

Mr. Read could hardly believe his good fortune. He must
have thought I had tumbled from heaven. He had been
curator of several museums, and could easily have been one
again, and might eventually have been knighted; but all his life
he had dreamt of making an ideal modern museum, and he
showed me an article he had written on the subject. His first
idea was to have an opening show in which we would exhibit
borrowed paintings of the whole field of art we were to cover.
Most of these were to be brought from Paris. This list, which was
later revised by Marcel Duchamp, Nellie van Doesburg and
myself because it contained so many mistakes, became the basis
of my present collection. He wanted to start with the first Ab-
stract and Cubist paintings from 1910, but every now and then
he would relapse into Cézanne, Matisse or Rousseau and other
painters whom I thought we ought to omit.

When Mr. Read came to visit me in the nursing-home he
brought a specific proposition from Mittens and Wrenclose,
who wanted to be in on the project. It seems that they had been
offered free a whole floor in a building of a famous dressmaker's
in Berkeley Square. If we accepted this gift and Mittens with it
on a small salary, Wrenclose promised to lend several of his
best Picassos. All this seemed unnecessary to me, as Mittens and
Wrenclose were my avowed enemies by then. We had had a
terrible fight about an Abstract show which I had given in my
gallery. You can therefore imagine my surprise when Mr. Read
brought me this offer. I categorically refused it, but I think
Mr. Read wanted to accept it.

Phyllis Jones came and took me out of the nursing-home
and brought me to Petersfield to recover from the operation.
I was in a state of collapse and spent most of my time in bed re-

reading Proust and making budgets to find enough money for
Mr. Read.

One day Mr. Read phoned me to say that he had been offered
the ideal spot for the museum. It was Sir Kenneth Clarke's
house in Portman Place. I made a great effort and came up to
town to look at it. I was still very feeble. In fact I did not
recover for another three months—in all, six months of my life
were ruined by this illness.

Lady Clarke showed me all over her beautiful house. It
really was the perfect place for the museum, even though it was
Regency and not modern. Lady Clarke, who had been a gym
teacher, was particularly pleased with an air-raid shelter she
had made in the basement. She told me she was going to live
in the country to please her children. I was so silly I did
not realize that she was preparing for the fast approaching war,
and I thought I was very lucky to acquire her house. The only
trouble with it was that it was too large, so I conceived the
idea of living on one of the upper floors. But to my dismay Mrs.
Read conceived the idea of living on another. We soon began
arguing about which floor we would occupy.

We actually took the house, but as our lawyers were away on
a holiday I never signed the lease, and when war was declared,
I had no legal obligation towards Sir Kenneth Clarke. He, how-
ever, thought that I had a moral one, and told Mr. Read he
expected an indemnity as he could have let the house to some-
one else. He suggested that I give the indemnity to a committee
he had formed for artists in distress, to which he had by then
sacrificed his house. Mr. Read considered Sir Kenneth Clarke
was richer than I. Therefore I concentrated on Mr. Read to
whom I felt not only legally, but morally obligated.

After all this I began to think about a summer holiday. I
needed a good rest and I wanted to go abroad before the
museum opened. I was also to meet Mr. Read in Paris in the
fall and have all the pictures lined up for him by then. For

months I had been trying to get down to Chemaillere in the Ain, where Gordon Onslow Ford had a château for entertaining the Surrealists. I hoped he would give us some paintings out of his collection for our museum. Tanguy expected me to come there, but because of my health I had put it off. I wrote to Tanguy, but his replies got more and more vague, and I finally realized that I could not join him and that he must have a new girl-friend.

I then accepted the invitation of Nellie van Doesburg to go to the Midi. Nellie was my newest friend and I did not know her very well at this period. About a year before she had walked into my gallery and given me a long lecture on who her husband had been and who she was. I was not in the least impressed and thought she was funny. I allowed her little by little to force her way into my life. I don't like women very much, and usually prefer to be with Athenians if not with men. Women are so boring. Anyhow I asked Nellie to live in my flat, or most likely she asked herself, and as I had a guest-room I let her come.

Nellie was a well-groomed woman of my age with a neat little figure, blue eyes, and red hair which was sparse and dyed. She dressed carefully, looked very attractive but made up too much. Because of her excessive vitality even I envied her. Her passion for abstract art was fanatical, which was why she had come to me. For ten years she had been the widow of van Doesburg, the co-editor, with Mondrian, of the magazine *de Stijl*. He was also a painter, architect and theoretician. He was a sort of twentieth-century da Vinci, and Nellie worshipped his memory, which fact touched me very much.

One night in Paris Carl Nierendorf took us out to dinner, and we all got tight, Nellie and I weeping on his shoulder about our dead husbands. He never got over it. As a sentimental German he thought it was wonderful, which it was. When Nellie came to London I always put her up in my flat, and when I was in Paris she did her best to make me stay with

her in her home in Meudon that her husband had built before his death. I always refused to live in Meudon because of Tanguy, but I never told her why. I once brought Nellie down to Petersfield and she made great friends with my children. She was so young and vital that they loved her.

In August I started out for France in my little Talbot car, never dreaming I was saying goodbye to Yew Tree Cottage forever. I let Sindbad drive through Normandy. It was also the last time I saw Normandy. Now I can't bear to think of the devastation and ruin brought to this beautiful country.

When I arrived in Paris I got Sindbad a sleeper to Mégève and then collapsed. My health was still fragile. As soon as we could Nellie and I started out for the Midi. We decided to go to Mégève and stop on the way, if possible, to see Onslow Ford. For some reason we never got there, but we did get to Mégève. The children had been begging me to come to visit their new home for years. Florenz had bought a house there in 1936. With Nellie as an excuse I could easily live in the hotel and leave in a few days. So we spent a week in this little skiing village, which by now was quite fashionable in winter. I did not like the place and never have, but the children adored it. Florenz and Ray were very hospitable; they had a beautiful home and the children were happy to have us there.

After that we motored to Grasse where we were to be the guests of Mr. Bourello, Nellie's friend. He was a cordial businessman of Armenian extraction, a sort of adventurer who couldn't bear to feel money near him without getting at it somehow or other. He suggested every possible combine to me in order to attach some of my money, but as he was not nearly crooked or clever enough, none of his propositions came to a head. His latest interest was modern art, about which he knew nothing, but for which he was prepared to do anything. He was even ready to replace Mr. Read though he had no qualifications to do so.

Bourello and Nellie had just put on three exhibitions of Abstract art in Paris. The artists told me they were awful, but artists are never satisfied, and I did not believe it was as bad as they made out. Nellie really knew her job. She had wonderful judgment, and I have never seen her make a mistake.

Mr. Bourello had rented a house and Nellie and I shared it with him. There were two floors; he lived downstairs, and Nellie and I lived upstairs. There was one bathroom for us all. It could be reached only through our bedrooms, which it connected, so I named it the Polish Corridor.

Mr. Bourello saw to it that we had wonderful meals and lots of drinks. We really had a nice life in this funny little house lost up in the hills of Grasse. Bourello had great vitality and although he was still going around on two canes, as a result of a train accident which had nearly cost him his life, he rushed around the country in my car and bought a chapel in La Tourelle which he started to transform into a house. He was very ambitious and was a *chevalier de la légion d'honneur*. Nellie and I saw him as the future mayor of La Tourelle. He was over fifty-five.

Every day Nellie and I drove down to the sea. We were always trying to get away from Mr. Bourello and go on trips. We managed to escape to Le Canadel to Mme Octobon, where we spent a few days with this old friend, the innkeeper. I wanted to see my home at Pramousquier. It had been sold to bourgeois people and was completely transformed into a conventional Midi home. I hated to see it like that.

While we were at Le Canadel we went to see the Kandinskys. They were living in the stuffiest hotel of the whole coast, the Kensington at La Croix. I am sure Kandinsky's wife chose it. We drove them around, and when we showed them where we lived in Mme Octobon's café they nearly fainted. It was so unchic. I think they thought we were joking. During our visit

a general mobilization was declared, and we rushed back to Mr. Bourello.

Mr. Bourello was the most optimistic man I have ever known. Of course he didn't believe there was going to be a war. When it was declared, he thought it would be over in a few weeks. The more he listened to the radio, the more encouraged he felt. God knows why. I certainly was rather worried and had no idea what to do next. Mr. Bourello said, "*Elle cherche les enfers.*" He thought I was looking for trouble.

At the beginning of the war I was a pacifist and was afraid Sindbad would join up. Nothing could have been further from his thoughts at that time. He was only sixteen. I did not know what to do about the future, but Florenz kept very calm and decided everything for me. He wrote me reassuring letters and I took no steps for the time being.

In Grasse we were surrounded by the army. Soldiers seemed to be everywhere. They were billeted all around our house and looked completely unprepared for war, which they turned out to be. Whole regiments passed by our house at night, and even in the daytime. We never knew where they were going. The mobilization went on for days and there seemed to be no equipment or organization. It all looked hopeless. There was a lot of time to be gained while Poland was being taken, but no one went to her rescue.

One day when I was down in Cannes waiting in line to send one of my many wires to Florenz or to Kitty to move everything from London to Petersfield, a strange incident occurred. We were all terribly tense, as people are in the first stages of a war, and no one felt like joking, especially in that rather fatiguing business of getting off long wires. A homosexual who was a few steps ahead of me suddenly came out with the wonderful remark, "Dear me, the way everyone is acting one would think France was at war!" If we hadn't been so upset I think we would have all burst out laughing, but I am

afraid he missed his shot. One day we were told that Cannes would be bombed in two hours. It didn't seem to make much impression on anyone.

We had great trouble in getting gasoline, but always managed somehow. Bourello did not want us to use what we had, but I was so excited about being in my beloved Midi again that I couldn't bear to stay still; I perpetually wanted to drive and revisit all the places that had meant so much to me during the four years I had lived in that region. I was in a state of excitement every minute and had to show Nellie all the places where things had happened to me in that very emotional period of my life.

I soon gave up the idea of going back to England, as Florenz decided the children should remain in France. We could not all be scattered about in different places, and the war would soon make travel impossible. I therefore had to relinquish the museum, which would have been impossible anyhow, since we could not have borrowed paintings and exposed them to the bombings of London.

I conceived a wonderful scheme of forming an artists' colony for the duration of the war, and inviting all the artists who wanted to join us to be my guests, and to receive a small allowance. In return they would give me paintings for the future museum. Nellie and I began looking all over the south of France for suitable accommodations for our colony. We looked at hotels, châteaux, houses. This gave me a good excuse for traveling, and as I really believed in the project it became a sort of mission. At one moment we thought Les Baux would be the ideal place, but it was not available, as the French Government was going to requisition it.

Had I known more about artists at that time I never would have dreamt of anything so mad as trying to live with them in any kind of harmony or peace. Nellie really should have known better. As soon as I got back to Paris and met a few of

the people we had thought of inviting, I realized what a hell life would have been. They not only could not have lived together, but did not even want to come to dinner with each other. There were so many little feuds and jealousies, it was unbelievable.

While we were in the south we went to visit Albert Gleize and his wife. They had several homes, one at Calvaire, and one at St. Remy, and another across the Rhone. The first was a comparatively simple house near the sea, but at St. Remy they had an enormous estate which they had been trying unsuccessfully to farm for years. At the outbreak of the war Mrs. Gleize had been lent a donkey by the *commune*, and with it and a couple of Spaniards she had serious intentions of raising enough food to help save France from starvation. She wanted me to join her in her efforts, but vague as my project was, I felt hers was even more so. They had had a beautiful house built in the real Provencal style, and received us in a delightful manner. They were vegeterians, but produced exquisite meals which they served at the most peculiar hours, having no sense of time. Gleize is an intellectual and is as much a writer as he is a painter. They are very charming people, and like most married couples provide great mirth for the public in their personal relations. Mrs. Gleize interrupts him every time he tries to speak, which is really a pity as he is a very interesting man.

When we finally got back to Paris I went to live with Nellie in her home at Meudon. Her house was so constructed that in order to make a new room all you had to do was to move a rolling door. It was very convenient.

I found Tanguy again. He was living alone in a beautiful apartment owned by an American princess. I had once sent him to see this lady, as I hoped she would buy a picture. The description he had given me of her the next day would never have made me suppose she would be his future wife. She had

just left for America, and he was to follow her if he could get
his papers. She had done everything she could to help him,
and then went ahead trusting he would follow. If not, he was
to join my colony.

I ran around Paris with Tanguy while he got his final papers
and then he suddenly disappeared. He was spending the last
days with his wife. A touching thought. She and I now became
good friends again, as I was no longer her enemy. She sold me
the painting I had wanted for so many months, "Palais Promon-
toire," and I promised Tanguy I would pay her monthly in-
stallments for it. So in a way I inherited her after Tanguy's
departure.

I put Djuna on the same boat that Tanguy sailed on. She
was in a complete state of collapse, and I told Tanguy to look
after her. Of course he didn't. I saw them off at the Gare
d'Austerlitz late one night. It was very dramatic, and really
gave one a feeling that we were at war. There was a terrible
tension in the air, and the station was almost in darkness. I
did not have the slightest desire to leave, and was not in the
least afraid.

Florenz wrote me he was thinking of putting Sindbad in
an English school near Pau. I decided to go to see the school
and look for houses for my colony, as I had not yet found the
ideal place. We drove from Mégève right across France in two
cars, which seemed ridiculous. Sindbad and I drove the little
Talbot, and Ray and Florenz had their Renault. As we were
to part company at Pau we found it necessary to have both
autos. The trip was beautiful through the Dordogne and the
Massif Central with the late autumn reds and browns. We
visited wonderful old churches and ate magnificent meals in
the old French tradition. Pau is a very dull town but the war
seemed to have livened it up. The school was a silly little place
compared with Bedales, and Sindbad frankly hated it. He was

very unhappy to renounce cricket and not be allowed to return
to Petersfield.

I stayed on a few days after Ray and Florenz left, hoping
Sindbad would get settled. In the meantime I began looking
around for a château again. I got hold of an agent and went
all over the countryside with her. By this time my project had
assumed an official character, as I found myself using the name
of M. de Monzie, the Minister of Education, who the agent
thought had sent me to find a château. It was a complete error,
but I let it go at that as I thought it sounded better. In France
such things are useful. I had some vague connection with M.
de Monzie, whom I had never met. As a result of this I was
royally received everywhere, and was shown the most beautiful
châteaux, which of course I never took.

In my absence Nellie, who was by now the secretary of the
new scheme, went around to see all the artists to find out if
they were interested in our project. There was little enthusiasm
shown except by certain artists who were on the rocks. To
everybody's relief we finally gave up the idea.

I then had to face a settlement with Mr. Read. I tried to get
a visa to England, as I wanted to go and talk to him. This was
refused me, but I was told that I could apply for one for the
duration of the war, if I were prepared to go back with my
children, and remain there. As this was out of the question I
gave up the idea. It was a good excuse to give Mr. Read, as
I really did not want to go on with the thing. Mrs. Read's
resolution to live in the museum rather terrified me. Some
time later my friend Hem, in the Foreign Office, said he
could get me a visa. By then I arranged everything by corre-
spondence. Our lawyers broke our contract, and Mr. Read
accepted half of five years' salary, minus what he had already
received. He bore me no ill-will, but he was very much dis-
appointed, as he thought London would have been the ideal
place for the museum during the war. I felt I had rendered him

a great service in freeing him from his dull job on the *Burling-ton Magazine*, and as he was two thousand five hundred pounds the richer for our brief association, and as a result of this, a partner in Routledge, I had no qualms. He soon decided to write a book about his life and dedicate it to me. He wrote the book, but his wife may have objected to the dedication, as he omitted it. When all this was over he decided to call me Peggy, and we have remained the best of friends and still correspond.

part 5

chapter 2

my life during the war

Anthony, an old friend of mine, was in great trouble. His wife
had gone mad and was rushing around Paris with two blue
Persian kittens which she took everywhere in order to attract
attention. She was having an affair with a house-painter in the
country, and also tried to seduce every man she met. Anthony
had retired to Paris and was living with our friend Alec. He
came to get me hoping I would console him and give him some
advice. He was very worried about his child, and wanted to get
it away from his wife. One night when we were in a restaurant
his wife came in with the nurse who was supposed to guard her.
She made an awful scene and I left at once. The whole thing
was painful and Alec and I were terrified that Anthony was
going to have her locked up. We did not realize how ill she
was and we tried to prevail upon Anthony to leave her in free-
dom. She was going about incurring debts with all the dress-
makers, as she had the *folie de grandeur*. She went to the police
and denounced as spies her friends Elsa Schiaparelli, James
Joyce and some other people. She really was getting dangerous,

but I hated the thought of her being locked up. This she finally brought on herself by becoming violent. Anthony had removed the child, and this was too much for her. The police finally took her to a horrible *maison d'aliénés*, but Anthony had her moved to a sanatorium where she was supposed to be looked after, but of course wasn't. We cabled her brother to come to take her back to America, and he arrived by Clipper. He was not surprised, as she had already been in a sanatorium for over a year in Switzerland. Anthony had remained with her there, and had looked after her, but now he felt he had come to his end. Her brother could not remove her, as she was too ill, but he arranged to have her go as soon as she was calmer. He wanted Anthony to take her to New York, but Anthony refused. He said he could not leave as he was subject to induction into the French Army. In the middle of all this I had a bad accident.

One night after dining with Brancusi I came home and received a visit from Oblomov and Anthony. I was living in Agnes' house, which she had lent me as she had gone to Arcachon with Marcel and the Dalis. She did not want to leave Paris, but Marcel was so afraid of being bombed that he could not remain, and she followed him unwillingly. Oblomov got very tight, and Anthony and I put him to bed. We sat up drinking. The next morning Oblomov was still in the house, so I decided to take him with me to meet Kandinsky, to whom I was going for tea. I had always wanted him to see Kandinsky's studio out in Neuilly-sur-Seine, in a modern apartment house. Oblomov had translated the preface to the catalogue for Kandinsky's exhibition, and, as he was an authority on German art, I thought he ought to see Kandinsky's paintings.

We were not destined to see Kandinsky that day. When we went down the marble steps to the door we passed Fanny, Agnes' maid. I caught her eye, and it occurred to me that she recognized Oblomov, to whom she had served breakfast in bed

when we lived in Agnes' other house. (She had moved again to a bigger one next door.) The memory of all this was so upsetting that I missed my footing and fell down the stairs. I landed on my right knee and completely put it out of its socket. Fortunately Nellie was with us as Oblomov stood by quite helplessly in his usual paralyzed state. Nellie made him carry me to a sofa, and sent for her doctor. He put the knee back into position, but I already had water on it. The next day, Nellie took me to the American Hospital in an ambulance where I was X-rayed and sent home, nothing being broken. I had to remain in bed, as I couldn't move, so I got used to lying quietly and peacefully during air-raid warnings. We never were bombed at this time, so I did not mind the sirens.

In a few weeks after a great deal of massage I was able to walk again. I had to find a place to live because Agnes and Marcel were returning to Paris since it seemed so safe. Anthony wanted me to take a room in the hotel where he was living with his family. I certainly did not want to get so much involved with him, so I went to another hotel.

At Christmastime I returned to Mégève to see the children, but the slippery winter weather made it almost impossible for me to get about with my bad leg, and I did not enjoy it. On my way home I went down to the lake of Annecy to see a new school that Sindbad was entering. Pau had not proved a success.

When I got back to Paris I started very seriously to buy paintings and sculptures. I had all the museum funds at my disposal, now that the problem of Mr. Read was settled, and lots of free time and energy on my hands. My motto was "buy a picture a day" and I lived up to it.

I rented the princess' apartment which I had found Tanguy living in. It was the most beautiful place I have ever seen. It was on the Ile St. Louis behind Notre-Dame on the Quai d'Orléans, on the seventh floor, having been retrieved from the attic, and under the eaves. It had a terrace, where you

arrived in the lift, and across which you walked in order to enter the flat. There was a big studio with three exposures and a little silver-papered bedroom and dressing-room and an elegant bathroom. The Seine played the most lovely reflections on the ceiling of my bedroom; I always lay in bed Sundays watching this. I was happy as all my life I had wanted to live by a river.

Here I gave a lot of dinner-parties. I cooked the dinners myself with the help of Fanny, Agnes' maid, who came to me daily. Nellie hated my home; she said there was no place to hang pictures. Nevertheless I manged to place all the smaller ones. The big ones had to remain in Lefebvre's storage, where I could see them whenever I wanted.

Anthony's wife stayed all winter in that dreadful nursing-home, and they would never have relinquished her, and all the money she brought them, if I had not again insisted that her brother send for her. Finally, with the help of two nurses, a doctor and lots of drugs, she was put on a train for Genoa and caught a boat to New York. I went with Anthony to a storage house and packed all her clothes. I then inherited her two Persian cats, who were no longer the darling little kittens they had been. One so much resembled Anthony that I named it after him, and the other one I called "Sans Lendemain."

Before Tanguy had left, he had taken me to see Brauner. Brauner had by now quite recovered from his accident and was painting very well. He was living with a Jewish girl, who worked in one of the Ministères, to support him. Nellie and I went to see him and I bought another of his paintings. It was so much admired by my doctor that I gave it to him to settle part of my bill. Brauner's paintings always had a great success. I remember giving another one in England to a school-teacher who could not afford to buy it.

All winter I went to artists' studios and to art-dealers to see what I could buy. Everyone knew that I was in the market for

anything that I could lay my hands on. They chased after me, and came to my house with pictures. They even brought them to me in bed, in the morning before I was up.

For years I had wanted to buy a Brancusi bronze, but had not been able to afford one. Now the moment seemed to have arrived for this great acquisition. I spent months becoming more and more involved with Brancusi before this sale was actually consummated. I had known him for sixteen years, but never dreamed I was to get into such complications with him. It is very difficult to talk prices to Brancusi, and if you ever have the courage to do so, you must expect him to ask you some monstrous sum. I was aware of this and hoped my excessive friendship with him would make things easier. But in spite of all this we ended up in a terrible row, when he asked four thousand dollars for the "Bird in Space."

Brancusi's studio was in a *cul de sac*. It was a huge workshop filled with his enormous sculptures, and looked like a cemetery except that the sculptures were much too big to be on graves. Next to this big room was a little room where he actually worked. The walls were covered with every conceivable instrument necessary for his work. In the center was a furnace in which he heated instruments and melted bronze. In this furnace he cooked his delicious meals, burning them on purpose only to pretend that it had been an error. He ate at a counter and served lovely drinks made very carefully. Between this little room and the big room which was so cold, it was quite unusable in winter, there was a little recess, where Brancusi played Oriental music on a phonograph he had made himself. Upstairs was his bedroom, a very modest affair. The whole place was covered in white dust from the sculptures.

Brancusi was a marvelous little man with a beard. He was half astute peasant and half real god. He made you very happy to be with him. It was a privilege to know him; unfortunately he got too possessive, and wanted all of my time.

He told me he liked going on long trips. He had been to India with the Maharajah of Indore in whose garden he had placed three "Birds in Space." One was white marble, one black, and the third one bronze. He also liked to go to very elegant hotels in France and arrive dressed like a peasant, and then order the most expensive things possible. Formerly he had taken beautiful young girls traveling with him. He now wanted to take me, but I would not go. He had been back to Roumania, his own country, where the government had asked him to build public monuments. He was very proud of this. Most of his life had been very austere, and devoted to his work. He had sacrificed everything to this, and had given up women for the most part to the point of anguish. In his old age he felt it very much and was very lonely. Brancusi used to dress up and take me out to dinner when he did not cook for me. He had a persecution complex and always thought people were spying on him. He loved me very much, but I never could get anything out of him. I wanted him to give Giorgio Joyce a portrait in crayon which he had done of his father, James Joyce, but I could not make him do so. Florenz suggested jokingly that I should marry Brancusi in order to inherit all his sculptures. I investigated the possibilities, but soon suspected that he had other ideas, and did not desire to have me as an heir. He would have preferred to sell me everything.

I vanished from Brancusi's life for several months, during which time I bought for one thousand dollars a much earlier work of his, "Maestro," from Paul Poiret's sister. It was the very first "Bird" he did in 1912. It was beautiful, but I still hankered after the "Bird in Space." So Nellie went to see Brancusi and tried to patch up the row. I finally went back to his studio and we began all over again to discuss the sale. This time we fixed the price in francs, and by buying them in New York I saved a thousand dollars on the exchange. Brancusi felt cheated but he accepted the money.

One day I was having lunch with him in his studio work-
shop and he was telling me about his adventures in the last war.
He said he would never leave Paris this time. In the last war
he had gone away and as a result he had broken his leg. Of
course he did not wish to leave his studio and all his enormous
sculptures. They could not possibly be removed. At this point
of our conversation a terrific bombardment of the outer boule-
vards of Paris took place. He knew at once that it was the real
thing, but I did not believe it, as we had had so many false
air-raid warnings. We were only a few blocks from the Porte
de Vaugirard, where some bombs were falling, and the noise
was infernal. He made me move from under the glass roof
into the other room, but I paid no attention at all and kept
going back to fetch wine and food from our lunch table. After-
wards we emerged into Paris, where the news was confirmed.
All the factories of the outer boulevards had been bombed, and
a lot of school children killed.

Brancusi polished all his sculptures by hand. I think that is
the main reason they are so beautiful. This "Bird in Space"
was to give him several weeks' work. By the time he had finished
the Germans were near Paris, and I went to fetch it in my
little car to have it packed and shipped away. Tears were
streaming down Brancusi's face, and I was genuinely touched.
I never knew why he was so upset, but assumed it was because
he was parting with his favorite bird.

I wanted to buy a painting by Jean Hélion, and heard that
he was in the Army, stationed near Paris. Nellie wrote to him
and he came in on a flying trip to sell me one. As he had been
in the Army and deprived of the company of women he was
delighted to be with Nellie and me. We appeared very feminine
and brilliant to him with all or make-up, and he said we were
the first paintings he had seen for a long time. We rushed all
over Paris to find his works that were stored in various places
and I bought an enormous canvas that we found in the attic

of a friend's house. I gave Hélion Herbert Read's anthology, *The Knapsack*, especially compiled for soldiers, and I felt at the time that I would never see him again. Little did I imagine that he would one day be my son-in-law. Later, when he escaped from the German prison camp where he had been interned for nearly two years, he found the money for his painting still available in a French bank and it saved his life. We had a wonderful dinner opposite the Gare Montparnasse and he rushed back to join his regiment.

One day I found a funny little picture at a dealer called Poissonnière, who claimed it was a Dali. It was extremely fascinating and very cheap, but it was most unlike Dali. I said I would buy it if he would get it signed by Dali. So poor M. Poissonnière, who was waiting to be transferred from Paris any minute, being in the Army, rushed down to Arcachon with the painting. He brought it back duly signed.

After that I still wanted a real Dali, by that I mean one that would be recognized by the public, and one of his best period, 1930 or thereabouts. A handsome little one was brought to me in bed early in the morning and I bought it at once, from a lady dealer. But it was very small and I still wanted to buy a big important one. Much as I objected to Dali and his goings-on, I still thought it necessary to represent him in my collection, which was supposed to be historical and unprejudiced. Agnes was a great friend of the Dalis, so the first time Gala came to Paris she invited us to dinner together. We got into terrible arguments about my life, of which Gala did not approve. She thought I was mad to sacrifice it to art, and that I should marry one artist and concentrate on him as she did. The next day she dragged me all around Paris to find a Dali painting. We went to a storage house and to their mad apartment which was empty while they lived in Arcachon. I found a good painting, which she thought more appropriate than the first over-sexual one I had chosen quite innocently, not notic-

ing what it represented. The one she chose certainly is sexual enough. It is called "The Birth of Liquid Desires" and is horribly Dali.

I also wanted to buy a sculpture of Giacometti's. One day I found a badly damaged plaster of his in an art gallery. I went to see Giacometti and asked him if he would mend it for me if I bought it, as I wanted to have it cast in bronze. He told me he had a much better one in his studio. As it proved to be just as good I bought this one, and he promised to see to the casting of it. This took several weeks, and one day he arrived on my terrace with what resembled a strange medieval animal. He looked exactly like a painting by Carpaccio I had seen in Venice of St. George leading in the captive dragon. Giacometti was extremly excited, which surprised me because I thought he had lost interest in these early abstractions, which he had long since renounced in order to carve little Greek heads which he carried in his pocket. He had refused to exhibit in my modern sculpture show because I would not exhibit one of these. He said all art was alike, but I did not agree. I saw no reason for his little Greek heads and much preferred my bronze, which certainly was far from classic.

May I here introduce Mr. Putzel. He is nearly my twin in age, a man of great force of character. Since I have known him I have been doing everything he wants, or resisting him with all my strength. The latter weakens me so much that I have no energy left for more important matters. He first became known to me in the winter of 1938, when he wrote me from Hollywood to wish me good luck on the opening of my gallery and to announce the closing of his. At the time, he sent me some Tanguy paintings that he had exhibited out there and that were to be included in my forthcoming show. I met him a few months later at Agnes' in Paris and was surprised to discover he was the opposite, physically, of what I had imagined he was going to be. I had expected to meet a little black hunchback.

Instead of this he turned out to be a big, fat blond. At first
he was nearly incoherent, but little by little I realized the
great passion for modern art that lurked behind his incompre-
hensible conversation and behavior. He immediately took me
in hand and escorted me, or rather forced me to accompany
him, to all the artists' studios in Paris. He also made me buy
innumerable things that I didn't want; but he found me many
paintings I did need, and that balanced our account. He used
to arrive in the morning with several things under his arm for
my approval and was hurt when I did not buy them. If I found
and bought paintings "behind his back," as he must surely have
considered any independent action on my part, he was even
more offended. He and Nellie disliked each other only as rivals
of extreme passions can.

In the winter of '38-'39 Putzel decided he would take me to
meet Max Ernst. I resisted futilely as usual. I knew Ernst's
work well, and really wanted to buy a painting. He had had an
exhibition in London in Mittens' gallery, and Wrenclose owned
a great number of his best works. Ernst knew who I was and
I suppose he assumed I came to buy a painting. Ernst had a
terrific reputation for his beauty, his charm, and his success
with women, besides being so well known for his paintings
and his *collages*. He certainly was still very good-looking in
spite of his age. He was nearly fifty. He had white hair and big
blue eyes and a handsome beak-like nose resembling a bird's.
He was exquisitely made. He talked very little, so I was forced
to carry on a continuous chatter about Mittens and Wrenclose
and their gallery and mine. At the feet of Ernst sat Beatrice,
his lady-love. I had seen them around Paris and thought how
intriguing they appeared together. She was so much younger
than Ernst; they looked exactly like Nell and her grandfather
in the Old Curiosity Shop. I tried to buy a painting of Ernst's,
but the one I wanted belonged to Beatrice, and another I liked
was declared by Putzel, for some unknown reason, to be too

cheap. I ended up instead by buying one of Beatrice's. She was a young pupil of Ernst and not well-known but very good and full of imagination. Everyone was delighted by this and I never thought about Ernst again until the winter of the war, when I found some marvelous paintings of his at a dealer's and bought three at once. At this time he was in a concentration camp.

Nellie took me to meet Pevsner, the Russian Constructivist. I had known his work in London, and knew his brother Gabo quite well. Pevsner was a timid little man who reminded me of Al Jolson's joke, "Are you man or mouse?" I think he was mouse. His constructions were beautiful, and I bought one which must have been inspired by a mathematical object. Pevsner was an old friend of Marcel Duchamp, but had never met Agnes Dew. We took her to Pevsner's for dinner, and when she told him she had been Marcel's mistress for over twenty years he just could not believe it. He did not even know of her existence, and he had seen Marcel every week of his life for as many years. Pevsner conceived a great passion for me, but as he was mouse, not man, I did not in the least reciprocate this feeling. He behaved like a schoolboy in the spring. We became great friends. When he could not get his wife to leave Paris during the German occupation, I sent him money, and looked after him all during the war.

At Eastertime I went down to Mégève to fetch Sindbad and Deirdre and took them to the Col de Voza to ski. I brought with me Jacqueline, a friend of theirs. We drove in my little Talbot singing old southern ballads, which she taught me on the way. We all enjoyed the holiday very much except Deirdre, who was unhappy to leave Mégève. Sindbad and Jacqueline had a fine time and so did I, as I became enamored of a little Italian in the hotel. He was perfectly horrible, an impossible creature, but very handsome in a flashy way. This occupied most of my thoughts as I was left alone all day, not being a

skier. On the way home I drove Sindbad back to Mégève with
my new acquaintance. After the Italian had left by train I
stayed the night with Ray and Florenz. The next morning, just
as I was leaving, I slipped on the stair and sprained my ankle
and cut open my elbow. Ray and I, as usual, were not getting
on well, so I insisted on leaving after I had had two clips put
in my arm. I don't know how I ever got back alone in my car
to Paris in this state, as I couldn't walk and couldn't use my
right arm.

During the winter I spent much time with Virgil Thomson.
He and Putzel and I used to eat a lot of our meals together.
Virgil was going to help me arrange concerts in my museum if
I ever had one. He gave charming Friday evening parties at
which he kept open house. He did a musical portrait of me
which was not in the least resembling, but for which I posed
quietly for several hours, reading his book, *The State of Music,*
which is very smart. I thought it would be nice to marry Virgil
to have a musical background, but I never got far with the
project.

One night at Agnes' there was an awful row about my
saving my paintings. Agnes said it was indecent to think of
anything except the refugees. She intimated that if we managed
to get a *camion* we would run down the refugees with the
paintings. Virgil was very sweet to me, and I remember weep-
ing in his arms in my little car afterwards while he tried to con-
sole me for what I consider my oldest friend's unnecessary
tongue-lashing.

Virgil left Paris before I did, and when I got to America
he was one of the first people I looked up. By then he was the
most famous music critic in New York, and was so well-known
he told me he no longer did anything he didn't enjoy. He was
quite independent. When I told him I had brought Max Ernst
to America and was living with him he made a prize remark.

He said, "Lots of ladies seem to have enjoyed that before."
But I am getting way ahead of events.

The day Hitler walked into Norway I walked into Leger's
studio and bought a wonderful 1919 painting from him. He
never got over the fact that I should be buying paintings on
such a day. The next day I bought from Man Ray one of his
early works, a 1916 painting and several Rayograms.

I tried to rent a suitable place to show my paintings, but
the Germans were advancing so quickly that I finally had to
rescue my collection and ship it out of Paris. I had actually
rented a beautiful apartment in the Place Vendôme. This apart-
ment was not only the birthplace of Chopin, but also had been
the establishment of O'Rossin the tailor. The first day I saw
it was the fatal day Hitler marched on Norway. The owner
of the building did everything in his power to discourage me,
but when I insisted, he said, "Think it over and come back
tomorrow." I went back and told him I had not changed my
mind, so he had to give in. I gave him my lawyer's name, who
turned out to be an old friend of his, and this greatly facilitated
matters. I then got the architect Vantongerloo to draw up plans
for the remodeling of this spacious place so that I might live
in it as well as make a museum there. It was much over-
decorated in the *fin de siècle* style, and I insisted on having all
the angels removed from the ceiling and scraped off the walls
before we started painting it. At this point, however, it was
so obviously impossible to continue with the scheme that I
finally realized the only thing to do was to ship the pictures out
of Paris before it was too late. At the last minute I made an
attempt to use the cellars for the museum. However this was
not allowed as they were being reserved for air-raid shelters.
The extraordinary thing was that I neither signed a lease or
paid a cent deposit on this apartment, and in spite of that the
owner removed all the *fin de siècle* décor without any guar-
antees from me. After I left Paris, I had a bad conscience and

sent him twenty thousand francs indemnity. I have never known such a landlord.

The only thing to do with the paintings was to ship them out of Paris or store them in an underground vault. Léger told me he thought the Musée du Louvre would give me one cubic meter of space somewhere secret in the country where their pictures were being sent. I had them all packed and taken off their stretchers when, to my dismay, the Louvre decided the pictures were too modern and not worth saving. After innumerable plans I decided to send them to my friend Maria Jolas, who had a château near Vichy. This was a most fortunate choice, as things turned out, since the Germans were only there for a short period and were quite unaware of the presence of my cases in the barn.

After that I really should have left Paris myself. The Germans were advancing so quickly, but I could not tear myself away from my new friend Bill. For two months I had been with him every afternoon. We used to sit in cafés and drink champagne. It is really incomprehensible now to think of our idiotic life, when there was so much misery surrounding us. Trains kept pouring into Paris with refugees in the direst misery and with bodies that had been machine-gunned en route. I can't imagine why I didn't go to the aid of all these unfortunate people. But I just didn't; instead I drank champagne with Bill. At the last minute my traveling permit expired, and when I tried to renew it I was refused a new one. I had a dream that I was trapped in Paris. When I found that I could not leave, I remembered my dream and was very scared. The Germans were getting nearer every minute. All my friends had left. Bill decided to stay, as his wife was too ill to be moved.

Finally I fled with Nellie and my two Persian cats three days before the Germans entered Paris. I took the Talbot, as I had plenty of gasoline. I had been saving it up for weeks in *bidons* which I kept on my terrace. We left for Mégève just as the

Italians declared war. By then I did not need any papers, as there was a general exodus of about two million people. It was terrific. The main road to Fontainebleau was jammed with cars four abreast, all creeping along in first gear. They were laden down with every conceivable household object and advanced at the rate of one mile an hour. Everything was enveloped in a cloud of black smoke let loose by the Germans or by the French, I never found out which or why. We were covered with soot. I managed to get off the main roads finally and followed little side-paths. But after the first few hours it was much easier to advance, as nobody was going east. Everyone was trying to get to Bordeaux. Several times I was warned not to go east or I would meet the Italian Army. In fact I was afraid I would be sent back by the police if I insisted. But we were allowed to continue and, needless to say, did not meet the Italian army, which never got far into France. On the way we learned the dreadful news of the fall of Paris and a few days later came the tragic armistice terms. There wasn't much left of France, but what there was we clung to desperately.

I found Florenz and the children resolved not to move. He did not want to add to the miseries of the road. As the Germans advanced everyone went on the road hoping to escape them. The confusion and misery and hunger and bombings that they suffered were unbelievable. After the armistice no one seemed to realize what had happened to France. The people all seemed to be in a daze as though they had been hit on the head with a hammer. It was very sad to see France like this. We still had plenty of food, but we realized how much was being sent to Germany. We were quite cut off from occupied France and had great difficulty in getting letters across the border. We soon discovered that for five francs letters were carried at many points, so we did not lose touch with our friends.

My children were happy to see me, and I decided to take a house for them for the summer on the Lac d'Annecy. Deirdre

and Sindbad, at the tender ages of fifteen and seventeen, were terribly in love with a brother and sister called Edgar and Yvonne Bundt. My son especially was suffering all the pangs of a first love-affair which was unfortunately one-sided. In order to please them I took a house practically next door to their friends, and as a result I never saw them. They spent all their time with this strange half-American, half-French family. They played tennis and they swam and they went on picnics and they went to Annecy on motor-bikes. They returned reluctantly for meals, and then went down to the Bundts again. This was all quite natural, as they were so in love, and I had neither a tennis-court nor a lake to offer them. Sometimes I joined them, but on the whole I preferred to keep away from this mad family, as they later proved themselves to be.

For company I had Hans Arp and his wife and Nellie, who lived with me. They were worried about the future, as they could not go back to Meudon in occupied France. They were all Hitler's avowed enemies, besides which they had left all their possessions in Meudon. Arp wanted to go to America and start a new sort of Bauhaus. He was very nervous about the war as all his predictions had come true and he foresaw the future in very gloomy terms. He was madly anti-German and would not let us listen to any German music. If Mozart or Beethoven came over the air he immediately turned off the radio.

During the summer I got rather bored and started having my hair dyed a different color every few weeks to amuse myself. First it was chestnut, which certainly was the nearest to nature, but then I got the wild idea of having it bleached bright orange, which made me look like Dorothy Holms. When I came home from the hairdresser's Sindbad laughed, but Deirdre burst into tears and made me have it changed to black, which way it has remained ever since. As a result of all the time I spent in the beauty parlor I conceived a sort of weakness for the little hairdresser who worked so hard on my beauty.

From re-reading D. H. Lawrence I also got a romantic idea that I should have a man who belonged to a lower class. Therefore, on the coiffeur's free days I used to fetch him in my car and we drove off into the country together. He took me to a marvelous bistro where we danced. Later I took Florenz there and we gave a birthday party, but we did not invite the coiffeur. In fact, I was ashamed of him and kept him hidden. I spent hours sitting with Deirdre in the beauty salon, as my own hair didn't take up enough time. She never suspected anything, but she considered him a bad hairdresser and regretted that I had made her get a permanent wave from him.

Soon this got boring and I needed a change. There was not much choice. The only other man about was an old fisherman, who looked like Brancusi and took a great fancy to me. He let Nellie and me swim off his raft, which was a great privilege. It was very nice because in that way we could avoid the Bundts. There was also a very amusing pansy who lived on the top of our hill. One day, seeing "G B" on the back of my car, he left a note in it, inviting us to his house as he claimed to be a friend of the English. He proved to be a good neighbor and gave us wonderful meals and sold us delicious wine which he made from his vineyard.

There was no one else except Mr. Bundt or his brother-in-law, who suddenly came home as an escaped prisoner. It was a touching scene to witness, as the whole family got hysterical, especially Mrs. Bundt, who nearly went off her head with joy. Florenz was down from Mégève visiting us at the time, and we retired discreetly in the middle of the family emotions. One night I went down to the Bundts, where I was always welcome, with the idea of finding the brother-in-law, or *l'oncle*, as Nellie and I called him. I brought him back to our house for dinner. The next night, just when he was leaving, in came Mrs. Bundt, his sister. She asked for her brother. I was rather surprised and realizing I must be careful said he had gone home long

ago. At this moment he heard her loud voice claiming him, and he jumped out of the window into the garden before she could find him. She then searched the whole house saying she could not sleep unless he came home. She made a terrible noise, and not only the Arps, but the children and the cook were awakened. The next day, when we were swimming off the fisherman's raft *l'oncle* came and told me that he could never see me again. I insisted on getting in his boat and trying to talk to him but he looked nervous and soon brought me back. I never saw him again, though Sindbad did everything to bring him to me. Instead I had a visit from Mrs. Bundt, who came, she said, to warn me that her brother was a *maquereau* and that she would not allow me to be imposed on by him. I said I was old enough to look after myself, and later I heard from Mr. Bundt that she had done the same thing before on a similar occasion.

Mr. and Mrs. Bundt hated each other and lived together separately. She was his housekeeper and they both adored their children. Mr. Bundt had an old mother of eighty, who made great friends with me. The old lady supported them all. Not knowing about the *histoire* I had had with *l'oncle*, she told me that her daughter-in-law had suddenly become very ill and nearly died. I gathered this was a way of recapturing her brother when she thought she had lost him. She must have extracted a promise from him never to see me again. Mr. Bundt was quite amusing and Florenz and Arp made friends with him. He was very entertaining. He thought I should go to Africa with him and try to wipe out syphilis among the natives. I never took this proposition seriously. When Nellie's twenty-five-year-old negro friend arrived to visit her, the whole Bundt family was horrified. Mr. Bundt came up for dinner to meet him, and the young negro spent the evening trying to inform Mr. Bundt about the negroes' position in Europe and Africa. He was an intellectual negro and talked very well.

By the end of the summer I got my pictures sent from the château by Giorgio Joyce who was living nearby. They were at the Gare d'Annecy for weeks before we realized it, and then when we found out, we had no idea where to put them. Every day Nellie and I went to see if they were safe. We covered the cases with tarpaulins and tried to keep the rain off them by moving them away from the part of the ceiling that was leaking. They remained on the *quai de petite vitesse* for months.

Being Jewish, I could not go back to Paris, but I wanted to exhibit the pictures somewhere. Nellie was a friend of M. André Farcy, the Director of the Musée de Grenoble. He liked modern art, so I sent her to see him and ask him to help us. She came back with no definite promise, but with an invitation to me to send my pictures to the Musée, where he would at least shelter them. That was better than the *quai de petite vitesse*. We immediately dispatched them and followed them ourselves.

M. Farcy was in a very bad jam himself at this time and nearly lost his museum directorship. Because of the Vichy government he couldn't do much for me. He did want to give an exhibition of my paintings, but he was so scared that he kept putting it off. The museum's collection of modern art he hid carefully in the cellar, as he was expecting Pétain's visit to Grenoble. He gave me perfect freedom in the museum, where I unpacked my paintings and had them photographed. I could bring my friends to see them; in fact I could do anything except hang them. I had a room to myself where they were all stacked against the wall. M. Farcy would never fix a date for the show, claiming that he must pave the way with Vichy first. He did not want me to remove the paintings, but after six months I lost my patience and told him that I was going to America. He begged me to leave the paintings with him. I hadn't the slightest intention of leaving them with him

and I also had no idea how I could send them to America, but I knew that I would never go without them.

M. Farcy was a funny fat little man in his fifties. He liked to get away from home and from his adoring wife. Whenever we invited them for dinner he came alone, giving some excuse about his wife's inability to accompany him. Later I discovered he never conveyed my invitation to her. He was very gay when he was with Nellie and me, and told us wonderful stories. In his youth he had been a cyclist and had done the *tour de France*. You could hardly believe it from his present appearance. One evening after six, when we were sitting in the museum, he took my hand and began caressing my palm. Then, in a low voice, he asked me if I did not feel anything. I insisted that I did not feel the slightest tremor, as it suddenly occurred to me that his great weakness for ladies probably led him to make love to them in the museum after closing hours. He was forever running all over France giving lectures, and as he often stayed away a longer time than his wife expected we wondered what he was up to. He loved modern art, but he didn't know one thing from another. He often asked me who painted my paintings, and invariably when we came round to Marcoussis he said, "What, Brancusi?" I had one painting by Vera da Sylva he liked, because he thought it was a Klee. When I left Grenoble, I offered him this painting or a Tanguy as a present. But when he asked me for the hundredth time if it were a Klee and I said "No," he chose the Tanguy. In spite of this he had managed to collect quite a nice number of modern paintings for the museum without any funds to back him. That probably was why he was not very well in with the Vichy government, which nearly dismissed him.

Through Nellie I had met Delaunay and his wife Sonia. He had been an important and good painter about thirty years ago. I wanted to buy one of his paintings of that period, as his contemporary ones were horrible. But he was foolish

enough to ask me eighty thousand francs for it, so of course
the deal did not come off. Putzel had found one at Leonce
Rosenberg's of the same year for ten thousand. When I was
in Grenoble the Delaunays were exiled from their home, which
was in occupied territory, and they were living in the south
of France. They had rescued a few paintings, and they began
again to try to sell me one. They wrote and phoned Nellie every
minute to make her get me to take the painting which I had
not bought in Paris. Finally I got so bored that I offered to
buy it for forty thousand francs.

Delaunay came up to Grenoble and he really was charming.
I think most artists are better without their wives. He brought
his painting with him. He very kindly restored for me a Gleizes
I had bought in Paris, from the widow of Raymond Villon,
Marcel's brother who died in the last war. When Delaunay
left, I gave him my darling cat Anthony as I could no longer
endure living in one room with these two foul-smelling crea-
tures. Delaunay loved cats, and this one took to him at once.
Soon after this Delaunay got very sick and wrote me many
letters about his own illness and about the cat. I had no idea
Delaunay was dying and I was sad when I got the news.

Florenz had decided it would be safer for us to go to America
in the spring, as we were being perpetually threatened with
German occupation of all of France, and we knew that the
United States would be involved in the war sooner or later.
The American Consul had been urging us to leave for over a
year and a half, and we had difficulty in renewing our passports.
We had the children to consider and the possibility of being
cut off from America with no money. Worse still was the
prospect of being put in a concentration camp. I was de-
termined to go to Vichy to see our Ambassador and try to get
him to help me with the shipment of the paintings. But we
were more or less snowbound all winter and could not travel.

Just at this time, as though he has fallen from heaven, René Lefebvre arrived in Grenoble.

When René came to Grenoble I had been having terrible rows with Nellie, and I more or less insisted that she should go to live in Lyons. Her negro friend was working there in the university. After we were separated we got on much better. In fact there was no reason for our fights, but I was happier working alone on the catalogue of my collection. I typed for hours every day, but my room was so cold that I had to retire to a little office which the manager of the hotel lent me. Arp had written a preface for the catalogue and I was trying to get Breton to do one as well. Florenz could not make head or tail of these quarrels, which I explained to him passionately every time he came down to Grenoble. He called it all the Battle of Grenoble and we let it go at that.

René was one of the partners of the firm in Paris which had handled for me all shipping of paintings from Paris to London, when I had the gallery there. I told him my troubles, and to my great surprise he said nothing could be easier than to ship my collection from Grenoble to America as household objects, provided I could send some personal belongings too. He suggested sending my little car which I had left in a garage six months before, as I was not permitted to drive it because of gas shortage. The trouble was I forgot which garage I had left it in. So we wandered around to all the garages of Grenoble and finally came across it. M. Farcy had to give us his authority to remove the paintings, and then René and I set to work and together we packed them up in five cases with my linens and blankets. This, of course, was a great favor René conferred on me, but by this time we were having an affair, so he was very happy to render me any service. All this lasted for two months and it was very enjoyable. So there was really no hurry about getting the cases packed. At the end of two months I ran away

from him and went to Marseilles. This was my second trip there
this winter. I will explain the other one first.

During my stay in Grenoble I received a cable from the
Princess, Tanguy's wife, asking me to help rescue and finance
the passage to America of five distinguished European artists.
When I cabled to inquire who they might be I received the
reply, "André Breton, Jacqueline Breton, his wife, and his
daughter Aube, Max Ernst and Dr. Mabille, the doctor of the
Surrealists." I must say I protested that Dr. Mabille was not a
distinguished artist, nor were Jacqueline and Aube, but never-
theless I did accept the charge of the entire Breton family
and of Max Ernst. I was also trying to rescue Victor Brauner
who had written me to ask if I could save him. He was hiding
in the mountains near Marseilles living as a shepherd, and since
he was a Jew I felt he might eventually get in great trouble.
Breton was in Marseilles. I now combined my efforts and went
down to Marseilles to see the Emergency Rescue Committee.

Varian Fry, the head of the committee, raised and distributed
a lot of money among stranded refugees, many of whom were
in hiding from the Gestapo. He worked underground to get
them into Spain and Portugal or Africa and from there to
America or Cuba. He also helped to repatriate the British
soldiers who were still in France after Dunkerque and who
wanted to join de Gaulle. Fry's right hand man was Daniel
Bénedité, who had previously worked in the office of the Prefect
of Police in Paris. They were assisted by Bénedité's English
wife, Theo, and various other efficient people. With them was
a handsome American girl, Mary Jayne Gold, who gave them
vast sums of money for their noble work, in which she also
took a hand. They all lived in an enormous dilapidated
château outside of Marseilles. At the moment, Breton and his
family were their guests. Here Breton held court and sur-
rounded himself with Surrealists. Before I arrived Breton and
Fry and Mary Jayne Gold and Bénedité had been arrested and

held incommunicado on a boat for days during Pétain's visit to Marseilles. They had finally managed to get a secret note through to the American Consul who rescued them.

Fry asked me to come and work with the committee. He wanted me to take his place while he returned to the States for a brief visit. I was so frightened by the fact that they had been arrested and by the general black-market atmosphere of Marseilles and all the strange goings-on that I went to the American Consul for advice. I wanted to know what the committee réally represented. The Consul warned me to keep out of it. He did not tell me why, and at the time I had no idea what a dangerous job Fry was doing. The American government was perpetually trying to get him to go back to America to avoid difficulties with the Vichy government. However, he stuck it out to the bitter end. Living in Grenoble and thinking only about art I was completely unconscious of the underground and had no idea what all this was about.

The whole atmosphere of Marseilles was dominated by the black market and everyone was engaged in some illegal deal to get a visa, a passport, or some food or money. Later I got used to it, but in the beginning I was terrified. I went back to Grenoble after giving Breton and Fry some money.

After I had promised to pay Ernst's passage to America, Florenz and René suggested that I ask him to give me a painting in exchange. I wrote to him and he wrote back and said he would be delighted and sent me the photograph of one he considered suitable. It was a lovely painting, but from the photo did not appear to be very much, so I wrote back and said I thought it was a nice little picture, but perhaps I would prefer another one.

In the meantime Ernst had written asking me to send him six thousand francs and a letter for a lawyer, testifying that I had seen the sculptures in his house, and that they were worth at least a hundred and seventy-five thousand francs. It

seems Beatrice had gone mad and made over their house to a crook in order to save it from the Germans, not knowing he would take advantage of the situation and seize the property. When Ernst emerged from the concentration camp and discovered what had happened, he thought he might at least try to recover the sculptures with which he had decorated his house. He was able to get his paintings out at night. I had seen his sculptures reproduced in *Cahiers d'Art*, and was glad to do this for him. Max Ernst had a reputation of liking very young girls, and one day René said to me, "What would you do if Ernst ran away with your daughter?" I said, "I would rather run away with him myself." Ernst had also written me to tell me how Beatrice had disappeared, and that he thought she was in Spain and had gone mad. It all sounded very cold-blooded. Later I was to discover how passionately he still felt about her.

chapter 1

my life with max ernst

When I arrived in Marseilles the second time the whole atmosphere of the château was changed. It was no longer dominated by Breton, who had finally managed to get all his papers, and had gone to America with his family. The Surrealist court had disappeared, but Max Ernst was living there, hoping to get away soon. Brauner met me at the station.

The very first night we met Ernst in a café and made a date with him for the next day to see his paintings at the château. This was the first time I had seen Ernst since I had been to his studio with Putzel two years before, and he certainly appeared much older after all his experience in concentration camps. He looked very romantic wrapped in a black cape. He seemed happy to see me and delighted at the prospect of showing me his new paintings. The next day Brauner and I went out to the château, and Ernst made a marvelous display of all his new works. I think that he was upset because I was so much more excited about the old ones, and tried to buy them all, instead of the new ones which I frankly did not yet like. I didn't man-

age to conceal my feelings. We soon came to some agreement, by which I was to give Ernst two thousand dollars minus the money he already owed me, in return for which I was to get innumerable paintings. Brauner kept rushing around finding *collages* of historic interest, and Ernst said that I could have all these too. He was very generous. In the end we celebrated with a bottle of wine that Ernst had brought from his vineyard in St. Martin d'Ardèche. As the next day was his fiftieth birthday, we decided to have a party.

In the morning I met René on the Canebière and asked him to come and see Ernst. I then tried to persuade him to go and rescue some of Ernst's paintings that were left behind in his village, but René balked at this. Ernst invited us all to celebrate his birthday by eating sea food with him in the *vieux port*. Afterwards we went to a black-market restaurant with Fry and had a wonderful dinner. René, who was with us, was supposed to return to Grenoble. But I took compassion on him as he had stood up in the train all the night before, and I said that he could spend the night with me, and should leave next morning.

By this time I was getting off with Ernst, and when he asked, "When, where, and why shall I meet you?" I replied, "Tomorrow at four in the Café de la Paix and you know why." As Brauner followed me everywhere (he was always with us) I had to slip my key to Ernst, and pretend to say goodnight to him, in order to fool Brauner.

When I began my affair with Max Ernst it was not serious but soon I discovered that I was in love with him. After ten days I had to leave him, because I had told Florenz that I would come and spend Easter with him and the children at Mégève.

At this time Florenz was having a sort of crisis in his affairs with Ray. They had been breaking up for a year, and he was unhappy. When Max put me on the train he cried, and he promised he would follow me to Mégève. So I felt pretty sure

this was not the end of my life with him. He had given me
all his books in Marseilles and even one that he had previously
inscribed to Beatrice in no uncertain terms. "To Beatrice real,
beautiful and naked." He also gave me her books, which he
had illustrated. I read them on the train, and wrote him from
Valence how much I liked them; then from habit I wired René
to meet me at Grenoble where I had to spend the night on
my way to Mégève. I tried to explain to René that I was in love
with Max. The next day I left for Mégève.

I didn't hear a word from Ernst and was very unhappy.
Finally Florenz and I went down to Lyons to obtain visas for
Spain and Portugal, as we hoped to be able to leave for America
in about a month with all six children and Ray. We were to
meet Marcel Duchamp in Lyons and I had planned to go back
to Marseilles with him to try to find Max again. The minute
we arrived in the hotel in Lyons Max phoned that he was in
Mégève. Of course I decided to go back. Marcel was surprised
and annoyed at my sudden change of plans. As soon as we had
obtained the visas, which we did with great ease since we were
Americans, Florenz and I returned to Mégève.

Max had arrived at Mégève wearing his black cape, and the
children thought he was a very romantic figure. Deirdre
knew his books, so she welcomed him warmly. It seems he
spent the whole evening telling them tales about himself and
Beatrice, about her departure and his troubles. They were most
sympathetic, and he held them spellbound for hours.

After a week Max and I went back to Marseilles. We sat up
all night in the train and it shocked me to see how old he
looked when he was asleep and snoring. We had great difficulty
in getting a room in Marseilles as the population had tripled
since the fall of France. He took me to the château. Afterwards
I got a room in my old hotel and Max stayed with me at night.

We were all busy trying to get to America. Ray had reserved
ten places on a Clipper for us, hoping to include her new

friend whom she was rescuing from concentration camps. But
Florenz, though he behaved like an angel to her all through
this period, refused to travel with this gentleman. I must say
I didn't blame him. That left us one extra seat on the Clipper,
and of course Max hoped to get it. Brauner also wanted this
seat, but his papers were not yet in order and in the end the
poor man was denied a visa as the Roumanian quota was filled
for two years. We had a third candidate, Jacqueline, the friend
of Deirdre and Sindbad. She had a very insistent mother who
succeeded in forcing us to take her daughter with us. She did
pay the girl's passage, however, which was a great relief, as I
had to pay all the others.

Ray finally bought her friend a place on the *Winnipeg*, a
boat which sailed from Marseilles. When he was out of danger,
that is, out of France, she began to concentrate on our de-
parture, which until then was more or less of seceondary im-
portance to her. She was living in Cassis at this time with her
friend and some of her babies, who were ill, and Florenz came
down to Marseilles to see the children, whom he adored.

Our papers were not exactly what one might call in order. I
had forged a false date on my traveling permit in order to
prolong it, and Florenz didn't have one at all. Max's visa to
America had expired and we spent days getting it renewed.
All the foreigners had to queue up in the street outside the
American Consulate, but Americans showing their passports
were admitted at once. I used to accompany Max and wave my
passport at the officials, so he never had to wait in the street.
He had not only been in three concentration camps, but he was
Hitler's avowed enemy and he was therefore to travel on an
emergency visa. In order to leave the station at Marseilles,
you had to show your traveling permit to the police, but we
knew an exit through the *buffet de la gare* where there were
no police. When Florenz arrived we took him out this way.
Ray came into Marseilles to meet him, and though we frankly

detested each other she tried to be friendly, as I was taking her and her whole family to America.

I had dinner with Max and Ray, Florenz and Marcel, and René who turned up in Marseilles again, this time with a whore from Grenoble. During dinner Ray, who was always very dramatic, told me that the boat on which I had shipped all my paintings to America had been sunk. She loved to imagine things like this. Then she and Florenz got into a terrible row, because she refused to go to Mégève to pack before she had dispatched her friend to America. Florenz began throwing things around the café. Max was rather surprised, but Marcel and I were used to this. René quieted him down and then Ray wept; I offered Ray and Florenz my room for the night although they were no longer living together, and went to the château with Max.

Max had many friends from concentration camps. He was perpetually meeting these people. They seemed more like ghosts than anything else, but to him they must have been real and brought back many memories. To me they represented a new, strange society. He always mentioned the name of the camp where he had met them, as casually as if he were referring to St. Moritz or Deauville or Kitzbühl or some other equally well known resort.

At this time all Jews were being combed out of the hotels in Marseilles and were being sent to live in special places. Max told me not to admit that I was Jewish if the police came to question me, but that I should insist I was an American. It was a good thing he had warned me, because early one morning after he had left and the breakfast cups were still on the table, one of the police arrived in plain clothes. I was absolutely terrified, but I insisted that I was an American and said I was leaving soon for America. He examined my papers and saw that I had changed the date on my traveling permit. I swore the officials of Grenoble had done this. Then he com-

plained because I had not registered in Marseilles. I was frightened not only for myself, but for Max and Florenz. The former had no right to sleep in Marseilles and the latter was traveling without a permit. I also had a large sum of money on me from the black market, for which I wouldn't be able to account if I were searched. When the detective asked me to whom Florenz's valise and béret belonged I said they were my husband's, who was in Cassis. That made him all the more certain I was Jewish, as that was the spot where the Jews were segregated. He asked me if my name were not Jewish and I said my grandfather was a Swiss, from Saint-Gallen. He had never heard of it. Then he began looking around the room and under the bed to see if I were concealing any Jews. Finally he asked me what was in the cupboard. I told him to look and that he would find no Jews in there. In the end he said, "Come with me to the police. Your papers are not in order." I refused to get dressed in front of him, and I did not want to let him take my papers away with him, so I told him to wait outside the door. He took my papers and went outside. I followed him as soon as I could. I was worried that I might disappear and that Florenz and Max would not be able to find me. I wanted to leave a note for them and hide all my money, but I did not know how to do either. When I came out of my room the detective was not in the hall. He was with his chief in the lobby. When his chief saw me he apologized and told his underling to leave me alone. At this time Americans were popular in France, as we had just sent the French a big shipload of food. I was then politely asked to go and register with the police in Marseilles, where I actually intended to go that day in any case, and the chief told me how to get there. He seemed happy to be able to direct me. Later on when I complained to the hotel manageress about this visit, she said, "Oh, that is nothing, madam. They were just rounding up the Jews."

Leonor Fini was a great pet of Max's. She came to see us in

Marseilles and arrived just after I had got rid of the police. I always accused Max of having two Sophies instead of one, like Arp. He had Beatrice and Fini, and was perpetually trying to further their careers. Fini was a very handsome girl with a free manner. She came from Monte Carlo, where she was refuged and was painting portraits in order to live. She wanted to see Max's new paintings and brought me a little one of hers which I had previously bought after having seen a photograph of it. Florenz, Marcel and I did not like her spoiled vedette manner. Max adored her and wanted me to. He always seemed to require my approval of everything. He introduced me to Fini as a patron of the arts, not as his mistress. I am certain that he wanted to hide this fact. The painting Fini brought with her was a charming little affair that looked like a picture postcard. Later, in New York, Breton very much objected to its being in my collection, but because of Max he couldn't do anything about it. Max thought it was wonderful because Fini painted it, but then he liked the work of any beautiful young girl who admired him. With male painters he was not so indulgent.

Soon after this, Max got all his papers in order and wanted to leave for Spain. He needed fifty dollars in bills in order to travel through Spain and arrive in Lisbon with some money. It was forbidden to export any francs. In order to obtain this money he should have applied to the Banque de France for a permit, but he did not have time. The only other way was the black market which was then not available. Fry had told me that the painter Chagall had the large sum of eight thousand dollars he wanted to transfer to America before he sailed. He made Fry ask me if I would not take this money from him and give it to the committee for their relief work and reimburse Chagall in New York. Naturally I could not afford to do this, but I did take one thousand dollars, which I gave Fry for his fine work. Knowing how much Chagall had, Max and I went to him and asked him to lend us fifty dollars. When we asked

Chagall for the money, Chagall hemmed and hawed and said he knew nothing about money, but added that his daughter arranged all his affairs for him. He said we could come back and talk to her in the afternoon, but when we came back she was not there. By this time we were quite desperate. We happened to meet Fry in the street and told him our troubles. He immediately took sixty dollars out of his pocket and handed it to Max.

The next day Max left with all his canvases rolled up in a suitcase. I had to remain in Marseilles in order to arrange to withdraw from the Banque de France the five hundred and fifty dollars each that we were entitled to for our Clipper passages. Application had to be made to the Banque de France and the money registered on our various passports. All this took about three weeks, much longer than I had expected. I had bad bronchitis and retired to bed reading Rousseau's *Confessions*.

One day, when I was walking to a restaurant, I met my old friend Jacques Schiffrin. He was surprised to see me, and happy too, if anything could have made him so at this stage of his collapse. I have never seen anyone so demoralized and frightened of the Nazis. Of course, he was right to realize what his fate would be if he remained in Europe: concentration camps, torture and death. But he hardly had the strength left to get out of France. I think all his papers had expired one by one while he was waiting for a boat. I did everything I could for him, but it was difficult to get him passage. Finally at the last minute, Fry managed to find room for him on a boat and he got off, only to be seized en route and taken to Lisbon, where at least he was safe; eventually he reached New York.

Nellie came down to Marseilles to stay with me until I left. We were reconciled, and I tried to do everything I could to get papers for her to come to New York. Unfortunately it all had to be done from the other side, and I left her behind, with

only faint hope of her following me. The Banque de France
business took so long that I grew impatient, as I wanted to join
Max. I had had one letter from him from the frontier and also
a note asking me to save the tenth place on the Clipper for
him. All the time I was trying to get Brauner to America,
but his case soon became hopeless. At the last minute I had to
wait for Jacqueline, who was to go with me. Florenz and all
the children got off before I did, to my great joy, as I did not
want to travel with so many babies and suitcases.

Jacqueline and I had a lovely trip by ourselves. It was strange
getting out of France, and at the frontier I was searched from
head to foot, naked. It was wonderful to be free of the Gestapo
and to enjoy life again. We had marvelous meals in Spain.
The markets overflowing with food. It seemed almost wicked
after France, where I had lost about ten pounds from under-
nourishment. I am sure there was terrible poverty in Spain:
the people looked miserable, as though they were still close
to all they had been through.

When I arrived at the station in Lisbon I was met by Florenz,
Deirdre, Sindbad and Max. Max looked strange and, taking
me by the arm, he said, "I have something awful to tell you."
He walked me down the platform and surprised me by say-
ing, "I have found Beatrice. She is in Lisbon." I felt a dagger
go through my heart, but I pulled myself together and said,
"I am very happy for you." By this time I knew how much
he loved her. Max was overcome by my reply. My children
were very much upset by this, and my son thought I was getting
a dirty deal.

We all went to the hotel and tried to be natural, and had a
drink out of a bottle I had brought. Max took me for a
walk all over Lisbon and told me the whole story of how he
had managed to discover Beatrice's whereabouts. I felt as
though I had been stunned and wandered around in an
agonized daze. Finally he took me to meet Beatrice at the home

of an English girl. There was a lot of talk about a Mexican, whom Beatrice was about to marry in order to get a passport to go to America. She said he was very sensitive, and she did not want him to know that we knew about it. They asked me to join them for dinner, but I refused. Before she left she kissed Max goodbye and pinned a carnation on him.

I went back to the hotel and sat through a painful meal, consisting of some ten courses, with Florenz, Ray and the children. The next day we all moved to different hotels. Jacqueline, Sindbad and I went to the Frankfort-Rocio Hotel, and Florenz, Ray and all their children moved into a *pension* where Max was living. Deirdre soon left them and joined us. We remained here for two weeks.

I was so unhappy I wanted to go back to England and get a war job, and I began trying for a British visa. This, of course, was practically impossible, so I got the idea of marrying an Englishman whom we had met on the train and with whom we had become very friendly. In this way I could have reëntered England. Fortunately, my Englishman disappeared, but anyhow Florenz told me I had no right to abandon my children and that it was my duty to take them to America. I therefore gave up this mad project.

I saw very little of Max at this time and tried to put him out of my mind, but I soon had a definite feeling that my life with him was not yet over. He seemed to spend all his days with Beatrice and at night was alone and used to wander around Lisbon with Florenz. This I found painful, as they rarely took me with them. I couldn't make head or tail out of all the complications with the Mexican. I did not realize Beatrice was living with him. (Max carefully hid this fact from me.) One night we all had a crazy party together, Beatrice, Max, Florenz, Ray and the Mexican. He turned out to be very nice but possessive about Beatrice and took her home and locked her up in their apartment. This made me realize that she was living with him.

It was a mad evening, full of terrible scenes. Ray left early
and the rest of us went and danced in a night club where Sind-
bad hoped to lose his virginity. He was ashamed to arrive in
America with it. We all tried to dissuade him from losing it in
a country that was so rampant with venereal disease as Portugal.

After this party I told Max it was a *charmante soirée*, and
from then on we called such wild, fighting parties *charmantes
soirées*. There was a wonderful café called the Leão d'Ouro
where we all went to eat sea food. Sometimes we met Max and
Beatrice there. She was not very friendly toward me, so I was
rather astonished one day when she brought Max to my room
and seemed in some strange way to be giving him to me.

Soon after this, Beatrice went to a hospital to have an opera-
tion on her breast. Max spent the whole day with her and only
left her in the evening, when the Mexican, who was by then her
husband, came to see her. I went to visit her and realized more
than ever how much Max loved her. They spent the whole day
reading and doing drawings together and seemed to be in per-
fect harmony. He was completely happy when he was with her,
and miserable the rest of the time. She had become great friends
with Ray, who was in the same nursing-home for sinus. Beatrice
could not make up her mind whether to go back to Max or
remain with her husband. She never knew what she wanted in
life, and seemed to be perpetually waiting for someone to
hypnotize her in order to make her decide. She was a pure
medium and could be easily influenced. In the end it was Ray
who persuaded her to remain with the Mexican. As he had
originally been a friend of Max, Max felt bitter about this and
thought it was a dirty trick. He despised the Mexican and
always made fun of him, calling him an *homme inférieur*. The
three of them were often together and must have had an
unpleasant time. I don't think Beatrice really wanted either
of them. There was a moment when she preferred a certain
toreador she had met to both of them. She felt that her life with

Max was over because she could no longer be his slave, and that was the only way she could live with him. Beatrice was beautiful; I realized it more than ever in the hospital when I saw her in bed. Her skin was like alabaster and her hair was rich in its black waviness; it swept all over her shoulders. She had enormous, mad, dark eyes with thick black brows and a tip-tilted nose. Her figure was lovely but she always dressed very badly, on purpose. It was connected with her madness. She had just come out of an asylum, where she had been confined for months, long after she was well. She had written about all her adventures and they were really terrifying. God knows how she ever got out of the place, but after she did she met the Mexican in Lisbon, and he looked after her. He was like a father to her. Max was always like a baby and couldn't be anyone's father. I think she felt she needed a father more than anything else, so as to give her some stability and prevent her from going mad again.

When Beatrice left the hospital Max begged her not to go back to live with the Mexican, but she said she must remain with him until she left for America. Max had reserved another place for her on the Clipper and when she told Max this, he was so upset that he decided to leave Lisbon and go out to Monte Estoril with Florenz where he had taken rooms for himself and the children. Of course I went along too. As we were waiting for the Clipper, we had no idea how much longer we would have to stay in Portugal. The seaside was a much better place for the children than Lisbon.

On the first night at Monte Estoril my life with Max began all over again. I was looking for Florenz to say good night to him when I met Max in the hall. I asked him the number of Florenz's room. He told me the number was twenty-six, which was actually his own. Of course I never said good night to Florenz.

This only started a new round of trouble. Max was constantly

waiting for Beatrice to phone him. She often came and spent the day with him when I felt so let down that I wouldn't speak to him for days. But as we were at Monte Estoril for five weeks there were plenty of variations.

One night when I went to Lisbon with Florenz for dinner I met Beatrice at the Leão d'Ouro. We had a terrible scene and I told her either to go back to Max, as he wanted nothing more than that, or to leave him in peace with me. She said that she only saw him out of pity and had no idea he was with me, and that she certainly would leave him alone. In the train on the way back I begged Florenz to save me from Max, but he said Ray had told him not to interfere, that I would only hold it against him afterwards if he did. I was so upset that I rushed into another compartment of the train and got off at the next station and went back to Lisbon where I took a room at the Frankfort-Rocio. The next day I phoned Florenz to tell him where I was. He was greatly relieved.

Florenz had dragged Max out of bed when he discovered I was not on the train, and made him come down to the station and wait with him for the last train. He said to Max, "This is your business. You wait for the train." When I told Max about my scene with Beatrice he was so upset that I wrote her a letter asking her please not to end her visits. But she never came again. I think her husband preferred it that way.

All the time we were in Portugal Florenz behaved like an angel to Ray. When she was sick in the hospital she was perpetually making him send telegrams to her friend. These cost hundreds of *escudos*, and not only did he send them, but paid for them even when all our funds were getting low. Ray was worried that her friend would not get into the States. He had several adventures en route, his boat being captured and, in the end, would not have been admitted to the United States without a five hundred dollar bail. Ray asked Florenz if I would lend the money, and when I said I couldn't, she made him

cable his mother for it. Not knowing anything about their separation, Mrs. Dale lent them a part of the money. I was so enraged to see Florenz behave so angelically to Ray, when she had made him act so fiendishly to me in our divorce, that I quarreled with him. Max, who hated the Mexican with a ferocious hatred, disapproved of Florenz's superhuman behavior, and lectured him on the sweetness of revenge.

Our life in the hotel was rather strange. The children were looked after by Florenz and by Deirdre and Ray's oldest daughter, as Ray remained in Lisbon and came for the day only on Sundays. We had a long table in the middle of the hotel diningroom. I sat at the head between Florenz and Max. On either side of them were long rows of children consisting of Sindbad aged eighteen, Deirdre aged sixteen, Jacqueline aged sixteen, Bobby (otherwise known as Sharon) aged fourteen, Apple aged eleven, Kathe aged seven and Clover aged two. No one knew whose wife I was or what connection Ray and Beatrice had with us. We were always being asked the most embarrassing questions. There was a porter in the hotel whom Florenz named Edward the Seventh, because of his resemblance to the King. His tact was so great that on one occasion, when I phoned from Lisbon to say what train I was arriving by, he guessed my dilemma and, not knowing to whom I wanted the message delivered, went to the dining-room and facing both Florenz and Max, said impersonally, "Madam arrives on the nine o'clock train."

The children were also leading a terrific life of their own. They too had many problems. Jacqueline was in love with Sindbad and Sindbad was in love with Miss Bundt. He was also very worried about his virginity. One evening when Florenz was in Lisbon, Max and the children and I got into a terrific argument about who was the greatest genius in the world, living or dead. Sindbad claimed it was Napoleon, and Max and I claimed Max was a much greater person than Napoleon. No one could

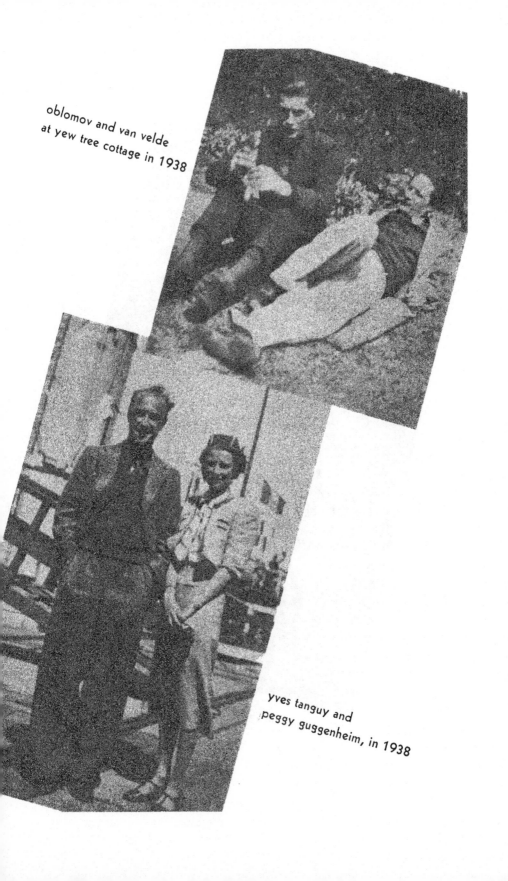

oblomov and van velde
at yew tree cottage in 1938

yves tanguy and
peggy guggenheim, in 1938

max ernst, in 1942. photograph by berenice abbott

prove his case, and I am sure the children thought I had gone mad from being so much in love.

Portugal's chief source of income undoubtedly comes from its fishing industry. Next to Monte Estoril was a little fishing village called Cascais, which was a quarter of an hour's walk from our hotel. For a change we sometimes went there to swim, as we spent most of the day on our own beach. But it was after dinner that we liked best to stroll there. The fishing boats came in at night, and we went down to the beach to watch them unload. Millions of silver creatures were carried in baskets on the heads of the peasant women to the market a few hundred yards away, and at midnight the fish were all sold. One could buy marvelous lobsters for almost nothing. Apart from these women and a few whores, no other women appeared in Cascais. When the men danced in the streets or did running-jumps over bonfires, it was without female companions. The people had a great dignity but looked sad. Cascais appeared to be more like an African village than a European one. There was something rather mysterious about it and you never knew what was going on inside the houses. They seemed to be hermetically sealed, their walls closing up the lives of all the women, who were not allowed on the streets.

One night, when Max and I were wandering around, we saw two beautiful girls in a window combing their hair. They beckoned us to come into the house. We did so with much difficulty, forcing our way through closed doors and a court-yard; and when we finally reached the first floor, our beautiful girls had entirely disappeared and in their place was a Trappist monk lying on a bed praying.

There were many little wine shops which offered indifferent Portuguese wine for a few *milreis*. You could sit on wooden benches and talk or make signs to the fishermen. They were friendly and were always asking us to go fishing with them. They never went far out to sea. In fact, they usually clustered

together in the port within swimming distance. One day I swam out to them and when I got close they wanted me to come on board their boats, but I was frightened and swam back.

One evening at Cascais I went swimming naked. It was pretty dark, but Max was terrified. The Portuguese are Catholic and we were always being taken up by the police for wearing what they considered indecent bathing-suits. As they could not speak French or English they used to measure the outstanding parts of our bodies, make scenes, and then proceed to fine us. We protested violently and went back to the shops which had sold us the suits. They exchanged them for others, but the police were never satisfied. Men were not allowed to wear trunks alone and women were supposed to wear skirts. It was a great pity because Max had such a beautiful body. The evening I swam naked Max was also terrified that I would drown. He kept wailing from the beach, "What will become of me if you drown?" I think he was afraid he would never get to America without me, because when he arrived in Lisbon he could not get the passage which presumably the Museum of Modern Art had reserved for him and had even paid a deposit on. After this wonderful midnight bath I dried myself with my chemise and we made love on the rocks. We soon discovered our error, as it turned out to be the town's chief latrine. Fortunately we were lying on a raincoat which we had borrowed and we had to scrub it for hours before returning it. On the way home we stopped in the bar of the chi-chi hotel next door, and I hung my chemise on the bar railing to dry. Max loved my unconventionalities.

One night I sprained my ankle when we were walking home. Again I fell into some *merde*. It seemed to be my fate. For days I could not walk, and Max carried me around on his back. It gave him an occupation and took his mind off his troubles. He seemed to enjoy looking after me. One night when we were sitting in a café in Cascais the fireman from the fire-station

opposite came to get us and insisted on showing us all his wonderful fire-engines. He saw that I could not walk and offered, in spite of Max's presence, to take me home in one of the vehicles. Naturally I declined.

There was a riding stable very near our hotel and Florenz made the children ride every day. Max had bought a lot of riding tickets and rode with Beatrice in the country for hours. Her husband joined them on occasions. But when she no longer came to see Max he took me instead. The country was wonderful in its tropical luxuriousness. The further inland we went the richer it became.

One night, when we were all out for a stroll, Florenz picked up a strange-looking girl in a salmon satin dress. She had a dark face and a little black mustache. We could not talk to her, but we took her along with us to our café in Estoril and gave her some ice-cream. After that she became so devoted to us that we were never rid of her. We had great difficulty in finding out what she did. She said that she sewed, but when we asked her to make some dresses for the children she took us to a friend in Cascais who was a real dressmaker. Florenz's girl, who wrote her name on the sand as Jesus Conception, became devoted to me. She insisted on drying me when I came out of the sea and when I sprained my ankle carried me on her back, to Max's great annoyance. She had a sister, and between them they owned two dresses and one bathing-suit. This caused great complications when they came to the beach together. We took Conception everywhere with us. But she was not welcome in the English Bar or in our hotel, where Edward the Seventh frowned on her, and practically refused her admittance. By degrees we gathered what her real occupation must have been. But to us she was just a friend, and Florenz swore he never gave her a penny, even when he was alone with her on the beach at night. She taught us to speak Portuguese. Every morning we found her waiting for us on the beach. The same in the

afternoon when we came out after our siesta. She was our only native friend.

We often went to Cintra, a wonderful palace built high up on a hill and surrounded by incredible boulders, which looked as if they had been brought there on purpose. The gardens had tropical flowers and trees of every description. The castle itself was more like a dream than a reality. It had a Surrealist quality, at it was all covered with fantastic sculptures. Apart from this it had terraces and ramparts like Elsinore. Hamlet's ghost might well have walked there and felt quite at home. The interior was not so exciting: there were a great many Victorian bedrooms and an enormous reception-room with many sofas and chairs arranged in little groups. When Max saw this he said it would be an ideal place for a *charmante soirée*. The Portuguese royal family had lived here fifty years ago. I think the sculptured walls reminded Max of the work he had done in his home at St. Martin d'Ardèche and made him very miserable. But it also must have stimulated him, for I am sure they had an influence on his future painting.

Max had a very strange gift of foreseeing the future, or rather of "forepainting" it. He always painted countries before he got to them. He painted the Far East long before he ever saw it, and he did the same thing with America. Everyone thought he painted the Petrified Forest while in the west, but he painted it while he was in the concentration camps of France.

All the time we were in Portugal Max was very miserable about Beatrice, and Florenz was very miserable about Ray. We used to sit for hours in the little English café that overlooked the sea wondering if we would ever leave. The extreme unhappiness of these two men saddened me and I was pretty wretched myself. It all seemed so silly that we could not help each other out of our miseries.

One day, in broad daylight, the spirit of John Holms appeared to me and burning two holes in my neck warned me

to give up Max, saying that I would never be happy with him. This was like a vision or stigmata. If only I had accepted his warning! But it is my fate to go through with the impossible. Whatever form I find it in, it fascinates me, while I flee from all the easy things in life.

Max could not get a visa for Trinidad, and the Pan-American Airway could not sell him a ticket until he obtained one. I sent many cables to England and Herbert Read saw to it that he got the visa at once.

Finally on the thirteenth of July, 1941, the Pan-American Airways sent us all off together on the American Clipper. We were eleven people: one husband, two ex-wives, one future husband and seven children.

The Clipper trip was very dull except for one hour spent in the Azores, where I bought a gigantic hat, in which the reporters insisted on photographing me upon my arrival in New York. The worst part of the whole trip was half a broiling day spent in the Bermudas. Here our luggage was gone through and all our books and letters read by the censors. We were examined separately by the British Intelligence about conditions in France. We all told them completely different things, which must have left them confused. The children were air-sick and kept vomiting into paper bags and losing the braces which they were wearing for the purpose of straightening their teeth. Max had a terrible fight with Deirdre while our beds were being made, because he thought he was being cheated out of one. To settle the matter I took Deirdre in with me, and she gave him hers. Early in the morning there was a magnificent sky that looked like a Tanguy painting. For the rest of the trip we saw nothing but sea. At one moment we passed over the American boat that was carrying Beatrice and her husband to New York. During the voyage we sat in comfortable chairs and walked in and out of the Clipper's three rooms and drank whiskey.

Before we landed, Max asked me to leave the family and take

a room with him. Florenz's mother had reserved a large suite at the Great Northern Hotel, and we were all invited there as her guests. As soon as we arrived she reimbursed me for the Clipper passages of Florenz, Ray and their children.

The first sight we had of America was Jones Beach. It looked very beautiful from that height. There were about forty people on the Clipper when it started out, but thirty more came on at the Bermudas. We seemed to be the only ones the press seized upon. We were all photographed over and over and asked a million stupid questions. Lots of our friends met us, including Jimmy, Max's son, who had been in America for four years, and of course Putzel. He told me that my collection had arrived safely. Jimmy had enormous blue eyes like Max and was so delicately made that he looked like a miniature. Just as Max was about to greet Jimmy he was seized by the officials, and not allowed to talk to him. This made a marvelous photograph for the Press and appeared in the papers. It seems the Pan-American Airways could not accept the responsibility of admitting a German into the United States without a hearing. I offered bail, but to no avail. Poor Max was whisked away. I gathered from the officials that the last boat had left for Ellis Island, so Max would have to spend the night in a hotel as a guest of the Pan-American Airways, guarded by a detective. He was not supposed to talk to anyone, but they said they would let me know where he was being taken, and the rest was up to me.

I followed Max to the Belmont-Plaza and took a room there. Then I began phoning him every half-hour. About the third time he told me the detective gave him permission to meet me in the hotel bar, otherwise known as the Glass Hat. I went there with Putzel and we met Max and had a drink. Then the detective, who called me Max's sister, suggested we all have dinner in Max's room. We said we preferred to go out, and he gave his consent. He followed us through the streets at a respectful dis-

tance and refused to join us at dinner, but remained alone at the bar of the little restaurant.

It was very strange to arrive in New York on the fourteenth of July after an absence of fourteen years and have to be followed by a detective. The first person we saw in the restaurant was Katherine Yarrow, a girlfriend of Beatrice's who had been instrumental in helping her to escape from France. In fact, she had taken her to Portugal. Max was so upset by this that he refused to shake hands with this girl, and we almost had a dreadful scene. After dinner the detective said he wanted to take us to Chinatown, but we preferred Pierre's bar. He told us we were wasting our money and tried to prevent us from going there. Suddenly he chucked me under the chin and said, "Peggy is a marvelous girl." When we went back to the Belmont-Plaza he asked Max if he didn't want his sister to sleep with him, saying it was perfectly safe, as he would be sitting outside the door all night with a gun in his pocket, guarding not only Max but a G-man in a room opposite. I declined his offer, as I was scared, and the next morning he phoned me early to say it was time to go to Ellis Island. He apologized for not having known who I was the night before, but I never understood what he meant by this. He so much admired a five-cent straw hat and walking-stick that Max had bought in the Azores that he accepted them as a parting gift. At the ferry he handed us over to an official of the Pan-American Airways.

We were accompanied by Julien Levy, Max's dealer in America, who was prepared to testify at the hearing if necessary. The minute we landed Max was whisked away and imprisoned. I spent the next three days from nine until five on the Island waiting to be called as a witness in Max's hearing. I was almost out of my head, fearing he would be sent back to Europe. I could not speak to him on the phone, because I was at Ellis Island, but he was free to phone me if he wanted to.

I went to all the relief societies working there and sent him reassuring little notes. Julien tried to get his uncle, a Borough President of New York City, to help, but there really was nothing to do except to wait patiently. Unfortunately a Spanish boat had docked half an hour before the Clipper and there were fifty people on that boat, who had to pass before Max. Luckily Julien came out the first two days and helped me while away the dreary hours. I had not seen him for years and he had very much changed during that time. He was quite fascinating and wonderful company. He had greatly improved since the days when, as a young man in Paris, he had married Mina Loy's oldest daughter. From him I found out all about America. On the third day his business prevented him from coming, so I was forced to be alone. Julien wanted to know if he should find a girl for Max. This was almost prophetic as things turned out, but at the time I said it was too late. He did not seem to know I was in love with Max, or maybe he was trying to find out what our relationship was.

Luckily Jimmy turned up on the island on the third day. He had been sent by the Museum of Modern Art with letters of recommendation. He looked so sweet with his wonderful, big blue eyes. I knew Max was saved when Jimmy was called as a witness. Suddenly a guard said, "Your case has been heard. Your friends are waiting for you outside." I nearly fainted. Max was free.

Jimmy had a job with the Museum of Modern Art at fifteen dollars a week. I don't know how he managed to live on it. His health had suffered greatly from it, and he used to have attacks of nervous cramps. I think they came from his being underfed for so long, but they were also brought on by any emotional strain. Our arrival in America and all the excitement that it entailed gave Jimmy cause for quite a few of these attacks. The minute Max got out of Ellis Island Jimmy asked him if he could leave the Museum. His job was not only very

badly paid but it was also of a menial order; so of course Max said, "Yes." He promised to give Jimmy double what he had received at the Museum.

Jimmy longed to be friends with Max but Max felt uncomfortable in his presence and did not know how to talk to him. I immediately took Jimmy to my heart and became a sort of stepmother to him. In a way I always felt like Max's mother too. It seemed to me he was a baby deposited on my doorstep and that I had to look after him. That was why I was so frantic every time he was in trouble. I always felt that when I would no longer be useful to Max he would have no further use for me. This spurred me on to doing the most difficult things for him. I not only tried to obtain everything he needed, but also everything he wanted. It was the first time in my life that I had felt maternal toward a man. When I told Max that he was a baby deposited on my doorstep, he said, "You are a lost girl." I knew he was right and was surprised that he realized it.

Max, like all other babies, always wanted to be the center of attention. He tried to bring all conversations around to himself, no matter what they were about. He loved beautiful clothes and was jealous when I bought new dresses, because he would have loved to wear them himself instead of drab, male garments. In his paintings he portrayed himself and other men in marvelous Renaissance costumes. Once in Marseilles, when I bought myself a little sheepskin coat, Max was with me and he was so envious that I ordered him one too. No man had ever bought anything in this shop before, and the shopkeeper was rather surprised. However, the coat was made to order for Max, and when he wore it he looked like a Slavic prince.

We decided not to go back to the Belmont-Plaza and chose the Shelton instead. Jimmy said we should take separate rooms. They were adjoining but not connecting. Then a very strange life began, and I suddenly felt married again. I had lived alone for four years.

Now I acquired a stepson. I felt much more at home with Jimmy than with Max. He was awfully happy to have a step-mother and we got on wonderfully well. Everything I didn't do with Max I did with Jimmy. I took him to shops, while I replenished my wardrobe (I had given away all my clothes in France.) But if I took Jimmy to buy clothes with me, Max couldn't go shopping without me. He made me choose everything he ordered. I encouraged him to buy a trousseau. He looked so beautiful in American clothes, for he had a perfect figure and was extremely elegant by nature. I gave him the diamond and platinum lorgnon with the watch that had belonged to my mother, and he used it instead of glasses. It suited him perfectly, making him look English and aristocratic.

While Max was on Ellis Island I went to see Breton. He was installed in an apartment the Princess had rented for him for six months in the Village. It was very comfortable, but looked unlike his usual surroundings. He seemed worried about his future, yet in spite of this he was determined not to learn a word of English. He wanted to hear all about Max and our life in Lisbon and what had occurred between Beatrice and Max. The report had gone around New York that Max would not leave Beatrice in Lisbon, and that that was why we had remained there so long. Breton did not gather that I was in love with Max. We talked a lot about Beatrice and Max, and Breton confirmed my opinion that she was the only woman Max had ever loved.

This was the first opportunity I had to thank Breton for his poem *Fata Morgana*, which he had sent me before leaving France. The Vichy government refused to allow its publication, but in America he soon found a publisher and it was translated into English. Breton had had many adventures on his way to America and had spent weeks in Cuba waiting for a boat. I think he was depressed and did not know what to do next.

As soon as Max was free he went to see Breton and asked

him to dinner. Breton was anxious to get Max back into
his group again. After all, Max was his biggest star and Breton
had lost him during the Eluard crisis. The Surrealists were
always playing at cat and mouse, and it was comparatively easy
for Max to be seduced again. As soon as I arrived at the Bre-
voort Hotel, where I joined them for dinner, Max rushed up
to me and kissed me, so that Breton would know what our
relationship was. I think he was terribly surprised.

At the request of the Princess I soon put Breton's mind at
rest and promised to give him two hundred dollars a month for
a year. That would give him time to find out what he would do
in New York, without worrying.

The first thing we did was to go down to Long Island for a
week-end with Louis and Marian Bouché. They came to see
me and said that they would be glad to have us visit them some
time near Oyster Bay. I asked them to take us at once out of
the terrible heat of New York. Bouché, though he was not
an Abstract or Surrealist painter, had long been an admirer of
Max's work and seemed to know all about it. They were very
sweet to us and gave us a lovely week-end. The last time I had
seen them was at Yew Tree Cottage in 1938.

When we arrived in New York the Museum of Modern Art
was having a Picasso show. Wrenclose had sent all his paintings
to New York for the duration, and some of the ones I knew best
were in this exhibition. The Museum owned a lot of Max's
paintings and *collages*, since Alfred Barr had bought fourteen.
Most of them were in the cellar, however, as was the custom
of the Museum of Modern Art. I remember going down into
the depths there and finding Brancusi's sculpture "The
Miracle." It was a miracle to find it there. Upstairs they did
show a "Bird in Space" very much like mine but made twenty
years earlier. The collection of the Museum was pretty fine.
They had wonderful Picassos, Braques, Légers, Dalis, Rous-
seaus, Arps, Tanguys and Calders, but not one Kandinsky. In

the garden they showed sculpture. The atmosphere of the whole place was that of a girl's college. Yet at the same time it looked rather like a millionaire yacht club. I am sure Henry Slaughter would have adored it.

We went to see my uncle's Museum. It really was a joke. There were about a hundred paintings by Bauer in enormous silver frames which overshadowed the twenty Kandinskys. There was one marvelous Léger of 1919, a Juan Gris, a lot of Domelas, a John Ferren, a Calder, a Delaunay and a few other less interesting painters, whose names I can't remember. From the walls boomed forth music by Bach—a rather weird contrast. The museum is a beautiful little building completely wasted in this atrocious manner. Max called it the Bauer House; the Museum of Modern Art he called the Barr House; and Gallatin's collection in the New York University building was the Bore House. It really was boring because, although he had some nice abstract paintings, the surroundings were so dull that one had no pleasure in looking at them. Max was annoyed because Mr. Gallatin, no longer considering his painting sufficiently abstract, had removed it. This collection is now in a museum in Philadelphia.

What Max liked best in New York was the Museum of Natural History. He was delighted by the mathematical objects, which he claimed were much better than Pevsner's constructions. Another museum Max adored was the Museum of the American Indian, the Hay Foundation where Breton took us. It has the best collection of British Colombian, Alaskan, Pre-Colombian, South Sea, Indian and Mayan art.

In contrast to the Bauer House there exists in the Plaza Hotel a really fine collection of modern paintings owned by my uncle, Solomon Guggenheim, but only accessible to the public by special invitation. Aunt Irene lives there with my uncle surrounded by the most beautiful Picassos, Seurats, Braques, Klees, Kandinskys, Gleizes, Delaunays, Chagalls and a Lissitzky. I took

Max there and Aunt Irene was delighted to meet him, but being rather confused, she thought he had replaced Herbert Read in my life. I told my Aunt Irene to burn all the Bauers and move these paintings to the Museum. She said, "Shush! Don't let your uncle hear that. He has invested a fortune in Bauer." Next time I saw her was when she came to my house, and, meeting Florenz whom she hadn't seen for seventeen years, she mistook him for Max. When I put her right she said, "I thought something was wrong because Ernst looks so much older." As a matter of fact they were born the same year, but Max certainly looks ten years older than he is. Max and Florenz were often mistaken for each other. One day when Florenz invited us all to lunch to meet Bob Coates, Bob first met Max and asked him if he were Florenz, whom he had not seen for fourteen years. Max took him along and presented him to his long-lost friend.

One night Jimmy met Beatrice in a drugstore in Columbus Circle, and was in a terrific state of excitement about it. He hadn't seen her for years. He had been alternately in love with her and jealous of her because of his abnormal attachment to Max. Max couldn't wait until he saw Beatrice. She had brought all his paintings with her. When he got them, he hung them up in Julien Levy's gallery and invited Breton, Putzel, Florenz and a few other people to see them. They were greatly admired. Max saw a lot of Beatrice and, just when I told Jimmy I couldn't stand it any longer and I was going to leave Max, we were all invited to California by my sister Hazel.

Max was delighted to be invited anywhere, and I was pleased to see my sister again and to get out of the heat of New York. I also wanted to see Arenberg's famous collection of painting in Hollywood. Sindbad, to whom I had just given my little Talbot automobile, went up to Rhode Island with Florenz and all his children. Deirdre and Jimmy came with us. Just when we were leaving by airplane, Hazel wired that she was getting

a new nose and could we postpone our visit for a few days? It was too late to change our plans, so we went to San Francisco. From then on we called Hazel *le nouveau nez.*

The trip over America was incredibly beautiful. Max and I were thrilled every minute, but Jimmy and Deirdre were very sick. We flew so high poor Deirdre nearly died, and had to be given oxygen. At Reno I took her out, thinking the air would help her but she nearly collapsed in the ladies' room. She therefore missed all the marvelous scenery over Salt Lake, miles and miles of land covered with salt, where the sea had receded, and then stretches of blue and purple ⁓water. It was better than any painting, the colors were so delicate and the expanse so vast.

At San Francisco it was very exciting to see the Bay and all the bridges from above. It is a beautiful city and from the air the approach is ten times better. We enjoyed the Chinese restaurants and theatres and the modern art museums. We went to the Courvoisier Gallery and bought two paintings by Charles Howard. It was so nice to come into contact with his work again after all this time and he had made great progress since I had given him a show in London in 1939. It was very pleasant seeing him again. He was working in a shipyard and I think was rather sad.

We went to Dr. Morley's fine San Francisco Museum. I asked if I could see her but her secretary said she was too busy. I was very much offended. However, I was not prevented from meeting her, as Sidney Janis, the critic, was in the Museum, where he was showing a large exhibition of his primitives. When he told Dr. Morley that Max was there she took us out to a wonderful fish dinner, in what seemed to be America's Marseilles, and drove us all over the countryside showing us the sights. She was hospitable and charming and full of life. I asked her if I could send her exhibitions when I got my museum going,

and she replied she would like it very much. She told me she gave a hundred and twenty exhibitions a year.

Max thought the primitive paintings quite remarkable. There happened to be a reporter in the Museum at the time, who interviewed him, and quoted his enthusiasm for this show. A scandal ensued as *The Art Digest* refused to take Max seriously, and said he was making fun of the American public. I had to write a letter to *The Art Digest* telling them that he really meant it, and admired this painting more than any other produced by Americans.

Before we left San Francisco we got into awful rows with Deirdre about Ray. Max hated Ray because she had induced Beatrice to go off with the Mexican, and I too had always found Ray objectionable. Poor Deirdre had lived with Ray for two years because of the war, and was fond of her. She tried hard, but with no success, to justify Ray's behavior to Florenz. The fight became so fierce that Deirdre refused to come with us to Los Angeles. We nearly missed the plane, but at the last minute she gave in, and came along, because she was afraid to remain alone and penniless in San Francisco.

When we arrived in Los Angeles we found Hazel with a beautiful young husband. He seemed such a contrast to Max who looked so old. He was studying to be a pilot, as he wanted to be in the air force (in which he was to lose his life) as soon as America joined the war. They seemed very happy together, in fact it was the only time I ever found Hazel happily married. She painted a lot and one day asked Max if he could teach her to paint a jungle. He was amused and gave her a lesson, but afterwards he claimed she had not paid much attention to what he had told her.

Max and I had no idea where to live, or where to establish the museum. We began to look at houses all over California. The place we came nearest to buying was a fifty room castle at Malibou, built high on a hill. An American woman had con-

ceived the idea of this extraordinary establishment but her funds had given out, and she had been forced to abandon the place. There were thousands of tiles, made by Spanish workmen, who were brought to this country especially for that purpose. The tiles had never been incorporated in the castle, however, and were stacked on the floor. We thought the whole place in its unfinished state was like a Surrealist dream. In Marseilles I had invited Breton to live in my museum in America and hold his Surrealist court there, and this place seemed to be the ideal spot for all these activities. Of course no one ever would have come out here. The distance made it impracticable. Another disadvantage was that the road to the castle disappeared in the rainy season.

There was one other house that tempted us very much, but it was situated on a steep incline overlooking the sea. The drawback was that the land was gradually slipping away at the cliffend of the garden. One tree was already lost and we did not know how long the house could remain, since it was so perilously near the edge.

Deirdre's one idea at this time was to meet or at least see movie stars. Hazel took her to a cocktail party where she met Charlie Chaplin. On her sixteenth birthday I gave her a dinner party it Ciro's, the restaurant most frequented by the movie people. Unfortunately it was the worst night of the week and there wasn't one star present. Deirdre burst into tears in the car going home. But to compensate for this I sent her to a Red Cross ball given by the Royal Air Force, where she could be sure to have her heart's desire and see all the movie people. She went quite alone, dressed in a long white evening dress and little white fur cape, looking like Cinderella dressed for the ball. She swept in majestically and had a most wonderful evening. Only long afterwards did she admit she had not recognized the stars.

Hazel had a secretary, Albert Bush, who was a poet. He con-

ducted a poet's hour on the radio. He wanted Max to give a little talk about France and what was happening there and why he had been forced to leave, and what his impressions of America were. I interviewed Max and translated what he said, and taught him to pronounce and read it in English which he couldn't speak at all. Jimmy and I sat in our newly acquired Buick listening to Max's interview on the radio. He did very well and only made one funny error in pronunciation. That was when he came to the word "hospitable," which he spat out with the accent on "pit." Jimmy had a pronounced father-complex and adored Max as much as I did. We were always trying to do everything we could to make Max feel important in America. Jimmy was very good at publicity and Max was happy when he appeared in the public eye. He didn't seem to exist unless people noticed him. However, he was always very dignified and never made a fool of himself.

In Hazel's house we had a bedroom, a sleeping porch and a nursery at our disposal. I was supposed to share the nursery with Deirdre, but I slept with Max in his room, or we slept on the sleeping porch. Sometimes I changed my room three times a night to fool the maids. Over our bed was a family motto in Latin saying, "Never too much." It was Hazel's husband's room.

Max painted on the sleeping porch, and I was particularly thrilled when I woke up there to find opposite me, on his easel, his latest paintings. It was like being present at their birth.

I think my brother-in-law must have found it very trying to have us all descend upon him in this way, especially as Max didn't speak English and he couldn't speak French or German.

At one of Hazel's parties we met George Biddle, who considers himself America's greatest painter. He made a great effort to be nice to Max and talked about Surrealism, which

I am sure he must have hated. Not knowing who he was, I naively said to him, "Do you paint too, Mr. Biddle?"

On my birthday Max and I cooked dinner for fourteen people. He made a wonderful fish soup, from fish which he had caught himself early that morning, and I made a *paella*. At this party we met Hazel's friends, the Gonzales, both painters, who lived in New Orleans. He was Spanish and she was a charming American girl. Albert Bush drank to my health saying, "Only Peggy knows 'The Importance of Being Ernst.' " In Hollywood we found Man Ray (with a new young wife) and Bob McAlmon and Caresse Crosby. It was nice to see old friends from France again. Bob tried to help me find a college for Deirdre, but all she wanted was to go to dramatic school and become a star in the movies, so I finally decided to leave this demoralizing atmosphere.

One reason I had come west was to visit Arenberg's collection of modern art. It is probably one of the finest in the world. Every room of his funny old Victorian house is crammed with magnificent paintings. Even the corridors and the bathrooms are like the best rooms of a museum. Apart from owning practically all the works of Marcel Duchamp, he has many fine Brancusis, a wonderful Rousseau, a Chirico, Kandinskys, Klees, Miros, lots of Picassos, a few Ernsts, Tanguys, Dalis, Gleizes, Delaunays. His cubist collection made me very jealous, but his later things are not nearly up to mine. In fact where he left off, I began. Lately he had been collecting mostly Pre-Colombian sculpture. He is a sad man, who now has a much greater interest in proving Bacon wrote Shakespeare than in anything else. In spite of this, he has a great passion for Duchamp. In his house I met the painter John Ferren and his wife Inez. Ferren had lived in Paris for years and wore a red beard. Later I bought two of his paintings in New York and his wife brought out my catalogue (to say nothing of typing the manuscript of this book).

After we had been with Hazel for three weeks, we motored to the Grand Canyon where I was to meet Emily Coleman. She was now married to a cowboy and living on a ranch. At this time Max was showing some pictures in San Francisco where Julien Levy had rented a gallery and I told Max to go there if he wanted to, and join me later, but I think he was afraid of losing me so he came along. When we got to the Grand Canyon I left Max with Jimmy and went to Holbrook with Deirdre to fetch Emily. When I kissed Max goodbye he said very pathetically, like a baby, "Are you ever coming back?" For two days he wandered around alone, as he never could speak to Jimmy, and found a shop with wonderful Indian masks, totempoles and Kachina dolls. He wanted to buy them all. He was like a child, and having found himself suddenly in the position of being rich he wanted to buy everything he fell in love with. I put him off as much as I could, but in the end he always got what he wanted.

Emily and Max got along very well. She told me how much I showed my insecurity with him, and that pained me. I had hoped to hide it. After a few days we took Emily back to her sordid home on the ranch. I could not understand how she could live in such unspeakable squalor. I never saw her husband.

From there we drove on to Sante Fe. We passed Albuquerque and Gallup, where there were beautiful shows of Indian art. We were supposed to go to the Indian Reservation to see the Hopi dances. That was one of the reasons Max had come west. But Jimmy told us we had passed the road miles after we were beyond it, and we were so furious we never went back. When you have to drive hundreds of miles a day, you do not want to add to the number. Max did all the driving, which made me angry, but I let him and made terrible scenes afterwards. We spent several days in Santa Fe and played with the

idea of living there, but much as we loved the scenery, we knew life there would be deadly.

While we were motoring through the Texas desert, Deirdre developed a bad sore throat and a high fever. We were forced to remain four days in the most extraordinary place I have ever been in. Wichita Falls was like an oasis, an oasis for cockroaches. They came in from the desert at night, attracted by the lights of the town. When you walked in the streets, you felt them scrunch under your feet four layers deep. They climbed up the walls of the houses and managed to get in, despite the screens. At the movies they got into my low-necked dress and into my hair. When we came home we found Deirdre and a bell-boy on all fours searching under the bed for one of these creatures. Deirdre could never endure any bugs, and these were too much for her. In the daytime they all vanished. Apart from this, Wichita Falls was a very dull place. The heat was unbelievable. You just couldn't go out until after sunset and then there was no place to go. If you drove half a mile in any direction you were in the desert. You had to buy your drinks in a drug-store and carry them with you to the hotel restaurant. That is a Texas law. We had stolen from some hotel a book telling us about the state liquor laws. As they varied so much, it was just as well to be prepared beforehand.

I was also much interested in the state marriage laws, because I wanted to marry Max. Every time we came to a new state, I sent Jimmy to find out what were our chances of marrying at once. Deirdre, however, soon put an end to all this by making Max admit that marriage was too bourgeois for him to go through with. She was jealous of my feeling for him and was clever at putting in her oar.

Our next stop was New Orleans, where the heat was terrific, although it was September. When we asked for a mint-julep we were told that summer was over and there was no more mint. The same thing happened when we wanted bananas.

Hazel's friends, the Gonzales, were charming to us and showed us everything, including plantation houses and swamps. They introduced us to all their friends. Dr. Marion Suchon showed us his paintings in his office, where he painted between patients' visits. We had wonderful meals in the French quarter and felt more at home there than anywhere in America.

Max had a long interview with a local paper and was photographed in our bedroom with one of his paintings that the Museum of Modern Art later acquired. The next day the social editor came to interview me and took my picture with Deirdre and Jacqueline, who lived in New Orleans. I hid everything that belonged to Max that was in our room, thinking it more proper. But to my dismay in walked the same photographer who had been there for Max the day before. Max was jealous that we were having publicity and Jacqueline's grandmother, a Southern lady of the old school, had the evening edition of the paper omit our photograph.

After New Orleans we motored back to New York. Of all the states we went through, I liked Tennessee the best. It had the most wonderful scenery and red earth. But we were destined to live in New York.

When we arrived in New York we went to the Great Northern Hotel. The first thing to do was to put Deirdre in school. I chose the Lenox High School, a preparatory to Finch's Junior College. She boarded at Finch's and came home week-ends. Nothing could have been less appropriate than this stuffy school. She managed to survive it for two years, when she was graduated. Snobbish Finch Boarding School was too much for her to endure even during the week, and as soon as we had a house she insisted on living with us.

I started to look for a place for the museum. Florenz, who was living in Connecticut, tried to get us to be his neighbors. There were two houses we almost bought, one of which particularly fascinated Max because thirteen suicides had taken

place there. The other house was sold ten minutes before we saw it.

In New York we looked everywhere. Finally we found a dream of a house on Beekman Place overlooking the river. We thought it would be the ideal place for the museum, except that it was too far away from the center of town. But we couldn't resist it. We intended to sleep in the servants' rooms when we were there, and to live in the country. However, we were not allowed to open a museum in this section. We had to take the house for ourselves, to live in instead. It was the most beautiful house in New York. It was a remodeled brownstone mansion called Hale House on the East River and Fifty-first Street. It had a big living-room or chapel with an old fireplace that might well have been a baronial hall in Hungary. The chapel was two stories high and the whole front of the room gave on to the river, where we had a terrace. There was a balcony above with five little windows overlooking the chapel. Here five choir-boys might well have sung Gregorian chants. On the third floor we had our bedroom in the back of the house, and in the front Max had a beautiful studio with another terrace. Deirdre had the second floor to herself. Out of the servants' rooms we made a guest suite. We had a big kitchen and, since we both cooked a lot, we ate many meals in there. Max was a marvelous cook and made especially fine curries.

It had been the Museum of Modern Art, at the request of Jimmy, which had started the machinery in motion to bring Max to America. When we arrived we expected a warm reception from the Museum, which we did not get. Alfred Barr was in Vermont and sent Max a telegram of welcome. He made a little show in the Museum of Max's and other people's *collages*, but we did not see him until the fall. *Collage* is undoubtedly Max's greatest contribution to art.

I had heard a great deal about Barr from Nellie van Doesburg and other people. His books on modern art had been my Bible for years, so I was naturally longing to meet him. We

went to see him one day, and I was surprised to find someone
who looked like Abraham Lincoln. His conversation was serious
and learned. He was shy but very charming, and I liked him at
once. Later, when I knew him better, I hated his cagey quality,
and never knew what he was driving at; but he is one of the
people whom I respect in the world who has done a pioneering
job and done it well. When we were in the Great Northern
Hotel he came to see Max's paintings. He was crazy about them,
but he never could get the Museum to buy what he wanted. He
always had to fuss and fuss and bargain, and drove me crazy
with his indecision. Just before he arrived a sparrow flew in
at the window. Barr was delighted to find Max, the King of
Birds, harboring this little creature. Finally Barr gave me a
Malevitch, of which he had thirteen in the cellar, for an Ernst.
Everyone was delighted, and Barr was impressed by my genuine
passion for art. I gave Max the money that was not involved
in this exchange.

When we moved into our house we gave a huge house-warm-
ing party. Beatrice came, looking most ravishing, for once
marvelously dressed in a sort of impromptu costume with a
white mantilla. There was a terrible fight between enormous
Nicolas Calas and little Charles Henri Ford, and in the middle
of it Jimmy rushed to take down the Kandinskys from the walls
before they were splattered with blood. Barr thought that was
real devotion on Jimmy's part, to rescue my paintings before
Max's. Jimmy was already my secretary. He was efficient and
bright and knew everything, and I loved him and we got on
marvelously. The house was entirely warmed by the blood of
these two intellectuals. Maybe that started us off badly because
we never had a moment's peace in that wonderful place. Peace
was the one thing that Max needed in order to paint, and love
was one thing I needed in order to live. As neither of us gave
the other what he most desired, our union was doomed to
failure.

When I finally got my paintings out of storage and hung in

the house, I asked Alfred Barr to come to see them. I was in a state of great excitement to know what he would think of them. We invited him and his wife to dinner. I had already been to their house for cocktails, when Daisy Barr had embarrassed me terribly by asking what had occurred between Max and Beatrice in Lisbon. I began by hating her, but the more I saw of her the better I liked her. She is a very attractive woman and delightfully un-American. Daisy Barr seems Irish, but she is half Italian. They came for dinner and brought Jim Soby and his wife. At this time Soby was being broken-in to take Alfred Barr's place in the Museum of Modern Art, but I did not then realize all the machinations of that institution and never will. They were much interested in my collection and thought I had some very fine things. Soby bought a painting of Max's, a sort of portrait of Beatrice sitting on a rock. It was called "Arizona." He had painted it in Europe and finished it in California.

After Julien Levy came back from California he took a small gallery on Fifty-seventh Street. He had not been very successful in the west. We were annoyed with him because he had sold one of Max's paintings much too cheaply. Max did not want to exhibit in his gallery in New York as it was too small, so he decided to show with Dudensing's instead. This was my idea; I had talked Max into accepting Dudensing's offer.

When I first lived with Max I had no idea how famous he was, but little by little I realized it. People were always coming up to him and treating him with reverence and respect, like a great master. He took his adulation very well. He was perpetually being photographed for the press. He loved this, and he hated to have me included. Once, however, he had to succumb and we appeared in *Vogue* with our little dog Kachina, a Tibetan Lhasa terrier, who was all overgrown with white hair and looked like Max. Max bought an enormous chair about ten feet high. It was a Victorian theatrical property. He sat in it as though it were his throne, and no one

else ever dared use it, except Deirdre. He was always photo-graphed in this chair.

The paintings Max had done in France between periods in concentration camps, or while he was actually in them, started a completely new phase of his work. The backgrounds of these paintings greatly resembled the desert land of Arizona and the swamps of Louisiana which he was soon to visit. It is unbeliev-able that he had this foresight. It seems to have been his special gift to forepaint the future. As his painting was completely unconscious and came from some deep hidden source, noth-ing he ever did surprised me. At one time, when he was alone in France after Beatrice had left, he painted her portrait over and over in all the landscapes that he was so soon to dis-cover in America. I was jealous that he never painted me. In fact it was a cause of great unhappiness to me and proof that he did not love me.

One day when I went into his studio I had a great shock. There on his easel was a little painting I had never seen before. In it was portrayed a strange figure with the head of a horse, which was Max's own head, and the body of a man dressed in shining armor. Facing this strange creature, and with her hand between his legs, was a portrait of me. Not of me as Max had ever known me, but of me as my face appeared as a child of eight. I have photographs of myself at this age and the likeness is unquestionable. I burst into tears the minute I recognized it and rushed to tell Max that he had at last painted my por-trait. He was rather surprised as he had never seen the photos. Because my hand was placed where it was and because it was between two spears, I named the picture the "Mystic Marriage." I asked for it as a present, telling Max that now he need never marry me, as this sufficed. I have still to describe the rest of the painting, as this was only one-third of it. In the center was a figure which Max admitted to be Deirdre's back, and on the left hand side was a terrifying sort of monster. It portrayed a

woman in a red dress with her stomach exposed. This was un-
doubtedly my stomach, but the figure had two heads which
resembled nobody. They were animal heads and one looked like
a skeleton. Sidney Janis claimed I was this monster, which he
considered very strong, but that was later, when Max took this
for a theme and made an enormous canvas of it. In this new
painting my beautiful little girl's head disappeared completely
and gave way to a portrait of a strange unknown person accom-
panied by Deirdre. The original Deirdre in this painting
gave way to a totem-pole with a head made of a substance re-
sembling brains. Much later I showed these photos to Alfred
Barr because I wanted him to corroborate my theory, and he
was much impressed by the resemblance.

I don't think Emily really liked Max's paintings but she did
appreciate his *collages*. She gave him long lectures about them
which he did not in the least understand. However, to hide his
ignorance and to show his appreciation he always replied,
"Oui, oui, oui." I once said to Emily, "There are three reasons
why I love Max; because he is so beautiful, because he is such
a good painter and because he is so famous."

At this time I was still trying to complete my collection and
buy all the pictures that Mr. Read and I had meant to exhibit
in London, in our opening show, as a survey of modern art from
1910 to 1939. There were many paintings that I had not been
able to obtain in France because of the war. These I now
bought in America. Breton and Max helped me a great deal in
my choice. I was finishing the catalogue, and every time I
bought another painting I rushed a new photograph and bio-
graphy over to Mrs. Ferren, the publisher. Max did a beautiful
cover for the catalogue. I was rather worried about the book,
however, and decided it was very dull. I asked Breton to save it.
He was always telling me it was *catastrophique*. It probably
would have been if it had not been for him. He spent hours of
research and found statements made by each artist; we included

these and photographs of their eyes. Breton's preface was excellent, containing a whole history of Surrealism. I got Mondrian to do another preface for me, which Charmian Wiegand put into English, and I included the one Arp had done for me in Europe. Besides that, Breton told me to add the manifestos of the different movements in art of the last thirty years, and then we included statments by Picasso, Max, Chirico and others. In the end the book turned out exceedingly well, being an anthology of modern art rather than a catalogue. We called it *Art of This Century*.

As Max sold more and more paintings he bought more and more Indian, Colombian, Alaskan and New Guinea art. We had practically no furniture and all these things made the house look very beautiful. Max got hold of a little man called Carlebach, or rather Carlebach got hold of Max. He let him have his collection on credit and Max paid him whenever he sold a painting. I was very much annoyed that Max refused to contribute to the household expenses. I think he based his refusal on the grounds that I still supported Florenz. Finally, Max reached the point where he would not even put aside money to pay his income tax. Carlebach used to phone Max almost every day to come around to his shop on Third Avenue to see some new things that he had found for him. He was perpetually scurrying around and finding things with which to tempt Max. There was no end to his ingeniousness and his activities. He even made deals with museums and got them to cede things to Max. Once he found out that I collected earrings and immediately got together a large quantity and began to work on me. But I did not succumb. Of course Max did, and bought me a beautiful pair with Spanish baroque pearls. But I resisted any further efforts on Mr. Carlebach's part, as I considered him sufficiently dangerous with his totem-poles and masks. One day Max bought a beautiful, wooden painted animal that looked like a burial object. He said he had bought

a little table, but it certainly was more like a cradle. At one
time Max had had a passion for wooden horses and the house
was full of these. He also bought a British Colombian totem-
pole twenty feet high. It was a terrifying object and I hated to
have it in the house.

After Pearl Harbor the question of marriage came up again.
I did not like the idea of living in sin with an enemy alien, and
I insisted that we legalize our situation. In order to avoid pub-
licity and the taking of a blood-test, we decided to go down to
Washington to visit my cousin, Harold Loeb, and get the thing
done quickly in Maryland. The night before we left we had
an awful row, and when Deirdre came home Max was still
looking unhappy. Deirdre, who was against my marrying, said,
"Mama, how can you force the poor thing to marry you? Look
how miserable he is." Max and I both said he looked this way
because of our row, but Deirdre would not believe it, and con-
vinced me she was right. I was so upset the next morning that
I ran to Putzel and told him all my troubles. He said that I
should get married if I wanted. I phoned Max and asked him
how he felt. He said he wished to go to Washington, so we
drove down there.

In Maryland they refused to marry us. We only had divorce
papers in foreign languages which they could not translate.
Besides, Max could not prove his first divorce, and they would
not accept his second as proof of his first. They told us to go to
Virginia. In Virginia you had to be a resident, over eighteen
years of age and have a blood-test taken. We did not have much
difficulty in proving that we were of age; the Loebs gave us the
residence. As to the blood-test we managed to survive it. Com-
pared with being a blood donor, it was nothing. When we got
our marriage license we were asked when we wanted to marry.
We said, "At once." They telephoned a judge who lived around
the corner and he said we could come immediately. How-
ever, he did not admit us for some time but kept us waiting on

his doorstep. We were accompanied by Harold's wife, who was doing everything to help us. When the judge finally admitted us, we found he had a girl with him. He said, "This poor little thing's husband, a doctor in the Navy, has just gone to sea and I am consoling her." We understood why he had kept us waiting so long. Max could not speak English and when he was asked to *wed* me, he understood *wet,* which he repeated. The ceremony was very simple and I did not have to promise to obey. When it was over we did not know how much to give the judge. Vera Loeb thought five dollars, but Max only had ten which he offered. The judge and his girl-friend were so delighted that she tickled the palm of Max's hand. I think that partially consoled him for being no longer free. Afterwards we went back to Washington and Max invited my cousins to a wonderful dinner to celebrate.

The marriage gave me a feeling of safety, but did not stop our rows, as I had hoped. They were awful and often lasted forty-eight hours, during which time we would not speak to each other. The fights were about nothing of importance. We fought if Max took my scissors without asking my permission. This annoyed me because they were the scissors John Holms had used to cut his beard. We fought if Max would not let me drive the car because he preferred to drive himself. We fought when he got bored because I had the flu and took too long to convalesce. We fought about the lay-out of my catalogue, after we had both worked peacefully on it together for hours. We fought most of all about his buying too many totem-poles. It was all ridiculous and childish. The quarrels upset him terribly. He could not work and wandered around New York for days. I was also very unhappy and was always the first one to make up. He was too proud to do so himself. The worst of it all was that we fought in public. We fought anywhere we happened to be.

During the winter we made great friends with Ozenfant, a

most fascinating man. For three years he had been my neighbor
in the Avenue Reille, where I lived in Paris with John Holms.
During all that period I had not known him. Now he lived on
Twentieth Street, and we often went there to delicious dinners
cooked by Marthe, his wife. I wanted to buy one of Ozenfant's
Purist paintings, as I considered it of historic interest. All my
advisers were against it, but I bought it all the same. I am
very glad, because the Museum of Modern Art neglected him
badly and bought a Jeanneret instead. There is no reason to
consider Jeanneret superior to Ozenfant. They worked together
in 1920 and it is unfair not to realize their equal value.

I was very busy all winter working on my catalogue, and post-
poned renting a place for the museum until this was finished.
People came to the house to see the paintings and ended up on
the top floor in Max's studio. Putzel brought customers and
Max sold a lot of paintings and bought more and more totem-
poles and Kachina dolls and masks. It took me all winter to get
my catalogue ready, as Breton took so long to do his article,
which turned out to be about sixteen pages, and then Florenz
had to translate it. By then the spring had come and the art
season was over.

One of the things from which I suffered most was the fact
that Max was never intimate with me. He considered me a sort
of lady whom he was slightly afraid of, and never addressed me
as *tu*; because of this I never felt he really loved me. Once, when
I asked him to write something in the books he had given me,
he merely wrote, "For Peggy Guggenheim from Max Ernst."
This was upsetting, as I remembered what he had written for
Beatrice. He always made me feel that he would have liked me
much better if I had been young and vulgar. He admitted that
he liked stupid, vulgar girls.

Beatrice used to phone Max to come and take her to lunch.
Sometimes he would spend the whole day with her and they
would wander around New York, something he never did with

me. It made me wildly jealous and I suffered agonies. In the morning he always worked after we had breakfast, so he never bothered to wear street-clothes. If I found he was dressed to go out my heart sank, because I knew he was going to dedicate the day to Beatrice. On these occasions I used to lunch with other people. Sometimes with Alfred Barr, but more often with Jimmy Stern, whom I invited to our house. He was a fascinating Irishman, a friend of Oblomov and Florenz. I had quite a *béguin* for him, but as our conversation was restricted to intellectual matters and to long talks about John Holms, whom he had never met, he did not suspect my feelings. He is a very good writer and surprisingly little known for one so talented.

Max was so insane about Beatrice that he really could not hide it. Once I made him bring her back to lunch and asked Djuna Barnes to come and meet her. Djuna said it was the only time that Max seemed human or showed any emotion. Normally he was as cold as a snake. He always protested and said he was no longer in love with Beatrice, and that I was the person he wanted to live with and sleep with. But I was never reassured and I was very happy when she went to Mexico.

We went to lots of parties at various houses, but the best ones were given by Mrs. Bernard Reis. She was a wonderful hostess and served marvelous meals. She loved to fill her home with Surrealists and then give them a free hand to do what they liked. Of course Breton took advantage of this to make us all play his favorite game, *Le jeu de la vérité*. We sat around in a circle while Breton lorded it over us in a true schoolmasterly spirit. The object of the game was to dig out people's most intimate sexual feelings and expose them. It was like a form of psychoanalysis done in public. The worse the things that we exposed, the happier everyone was. I remember once, when it was my turn, asking Max if he had preferred making love at the age of twenty, thirty, forty or fifty. Other people asked you what you would do about sex if your husband went to war or

how long you could go without it, or what your favorite occu-
pation was. It was ridiculous and childish, but the funniest part
was the seriousness with which Breton took it. He got mortally
offended if anyone spoke a word out of turn; part of the game
was to inflict punishment on those who did so. You had to pay
a forfeit. Breton ruled us with an iron hand, screaming "*Gage!*"
at every moment. In the end the forfeits were redeemed in the
most fantastic manner. You were punished by being brought
blindfolded into a room on all fours and forced to guess who
kissed you or something equally foolish.

In the spring Max had his exhibition at Dudensing's. I gave
a big party for him after the opening. It was one of the best
parties I have ever given. It went right off from the start with
no effort.

The show had a great *succès d'estime*, but the pictures were
not sold as they were priced too high and Dudensing had the
wrong clientele for them. The same week the Hartford Athen-
eum bought one that was not in the show. After that Putzel and
I sold the paintings, all to different people who came to the
house. I loved being a painter's wife and by this time was insane
about the new paintings. Charles Henri Ford devoted a whole
number of his magazine *View* to Max. It was an amusing issue
and good for Ford as well as for Max. Max appeared in it
photographed on his throne by Berenice Abbott, and on our
terrace with his Kachina dolls photographed by James Soby.
Breton, Calas, Sidney Janis, Henry Miller, Julien Levy and
Beatrice wrote articles about him for this issue, and he wrote
his own biography. A lot of paintings were reproduced with
the catalogue of the exhibtion.

After that Max went to Chicago where he was to have a show.
I did not want to accompany him. My catalogue was finally
coming out and I was extremely excited. He had a good time
while all I thought about was my book. Several bookshops made
window displays for me and it was thrilling to see my first

surrealist gallery, art of this century, designed by berenice abbott

abstract and cubist gallery, designed by berenice abbott

production so well received. It began to sell at once, thanks to
Jimmy's foresight in advance publicity.

I could not sleep all winter until Clifford Odets left for
California. He occupied the two top floors of our house
and his study was over our bedroom. Every night he rehearsed
his plays until four in the morning. I have never heard such
noise. One night his bath ran over and began leaking through
my ceiling, and dripping on to my dressing-table. To make
amends he gave his friend, J. B. Neumann, two seats to take
me to see *Clash by Night*. I much preferred it to *Waiting
for Lefty*, which Sherman had taken me to see in London in
a Communist theatre which had benches without backs.

Shortly after Max came back he became infatuated with a
very wild and crazy girl, who was either perpetually drunk or
under the effects of benzedrine. She was very funny, quite
pretty and full of life; but she was terribly American, and at
the time seemed to be nearly off her head. One could always
tell if Max were excited about a woman: his eyes would nearly
pop out of his head with desire, like Harpo Marx's. Nothing
much occurred with this girl, however, and we left New York
to spend the summer on the Cape. As soon as we were gone,
Jimmy fell madly in love with her. Because of unforeseen cir-
cumstances we were only away a fortnight, but when we came
back Jimmy had clinched the affair. He did not want Max to
know anything about it, and I suspected the whole thing was
caused by his father-complex.

Our summer was curtailed because Max had trouble with the
FBI. It was my fault. I was forced to go down to Washington
for a hearing on Nellie van Doesberg's case. I had been trying
to get her to America, but it was not easy. When I finally got
the affidavit through, the State Department refused it; but with
the help of Sumner Welles, who was a friend of Helen Joyce's
brother, I obtained a hearing in Washington and the visa was

granted. It was too late, however. I could no longer get Nellie out of France.

I sent Deirdre up to Wellfleet, Massachusetts, with Max in the car to Matta's, where they stayed for a week to look for a house. When I arrived they thought they had found one. It was a horrid little affair in the wilderness with a kerosene stove and a gasoline pump. This reminded me of our Yew Tree Cottage pump and of all our efforts to keep it going when the gardener was on holiday. I decided not to take it and we looked for others all over the vicinity. We ended up by taking a dreary affair belonging to a lady painter in Provincetown. She lived below us. There was a studio and some living-rooms and lots of bedrooms. Max got the studio and as usual wanted everything else too. Deirdre had to fight for her rights to get a place where she could paint.

I then made Max leave Matta's, in spite of the fact that he told me he ought to get a permission from the Board of Enemy Alien Registration. It seemed silly to bother, when we only moved fifteen miles away.

The first day we were in Provincetown the FBI drove up along side of us as we were walking in the street and seized Max by the wrist. They said they wanted to see him. We told them to come at two o'clock. When they arrived they searched the whole house, asked us where we all slept, looked in our suitcases, and went off with Max and a box of matches with a Free French sign on it. They said, "We are taking your husband for a ride." I was terrified and did not know what to expect. They kept him for hours and he returned in an awful state. It seems they had tried to terrorize him into denouncing Matta as a spy. They wanted to know how many *ladders* Matta had on his roof. Max misunderstood them to say *letters* in his name, and answered five. They had already been to Matta's house before I arrived in Welfleet and had questioned Max. They complained because the radio was too loud and, when

Max turned it off, they said he had no right to touch it as it was a short-wave set. They now used that against him and made a report which they sent to Boston. They told him that if he didn't tell everything he knew about Matta they would hold him until his gray hair was much grayer than it already was. From then on, every time we sat down to a meal, they walked in and bothered us some more. Finally they came one day and took Max off to sign the report they had made, warning us that it was no longer in their hands to judge the case. We waited in fear and then one day, at lunchtime, they came and said Max would have to go to Boston to have a hearing with the District Attorney. I insisted on going too, and as I was his wife they could not refuse. At last I could prove to Deirdre that marriage was useful. We left her with some friends and told her we had no idea when we would be back.

It took hours to get to Boston in their car and, when we arrived, it was almost too late for a hearing. The District Attorney was very nice and allowed us to explain who Max was and who I was. He had once had some job with the Guggenheims. Unfortunately he could not discharge Max without first submitting him to a hearing before a jury, and that meant he would have to keep him in custody overnight. In order to spare Max this unpleasantness, he decided to phone the New York Bureau of Enemy Aliens and see what they had to say. Luckily for us they accepted full responsibility, claiming Max was their case, and asking to have him sent back. We got a pass to travel and were given seventy-two hours in which to return, which was better than having Max imprisoned in Boston. So we went back to Provincetown.

The next day we met Varian Fry, who happened to be in Provincetown, and having lots of connections there he tried to arrange matters for us. But it was no use. We had to go back to New York. Once we were home again we phoned our friend, Bernard Reis, who knew about everything and always helped

everyone in difficulties. He made contact with someone in the Bureau of Enemy Aliens and explained the case. When we went down there we were well received and Max was set free at once. He was allowed to go back to Provincetown, but was advised to keep away from the coast.

We remained all summer in New York in our lovely house on the East River. This was very bad luck for three people. One was Marcel Duchamp, to whom we had lent the house; the second was Jimmy, who was having his holiday and liked to bring his new love to breakfast on our terrace; and the third was Sindbad, who had a key to the house and often brought his girl-friend there, having no other suitable place to take her. Marcel Duchamp remained with us and moved into the little guest suite, but our sons were out of luck.

Kiesler was happy to have me back, as he could now take me all over New York and show me the wonderful things that he was having made for the museum, which was finally to open in the fall. A few months before, Putzel had said to me one day, "Why don't you get Kiesler to give you a few little ideas about decorating your gallery?" Kiesler was the most advanced architect of the century, so I thought this was a good suggestion, never dreaming that the few ideas would little by little end up in my spending seven thousand dollars for the construction of the gallery. He was a little man about five feet tall with a Napoleon complex. He was an unrecognized genius, and I gave him a chance, after he had been in America fifteen years, to create something really sensational. He told me that I would not be known to posterity for my collection of paintings, but for the way he presented them to the world in his revolutionary setting.

We had lots of parties at night in our house on the river. It was the coolest place in New York. One night very late after a party Max, Marcel Duchamp and Jack Sage, a composer of percussion music, and his wife Zia all got undressed while

Kiesler and his wife and I looked on with contempt. The object
was to show how detached one could be. But Max entirely
failed to attain this object, as Zia's presence in the nude had an
immediate and obvious effect on him. I am afraid Zia took it
all rather too seriously, as she wept copious tears in a bus one
night soon after this, Kiesler told me, because she decided Max
was not the angel she had suspected him to be.

One night after a party in our house when, having drunk
quite a bit, I rushed out in search of adventure, I went to a
bar on Third Avenue just as it was closing and forced my way
in. Some people at a table asked me to join them and gave me
drinks. I only had ten dollars on me, but I insisted on paying.
One of the men said it would be safer if he kept the money for
me for the rest of the night. About five o'clock we all went to
Chinatown to eat. I told these people I was a governess and
lived in New Rochelle. I did not ask them what they were, but
it dawned on me pretty soon that they must be gangsters and
up to something. They had parked their car in a dead-end
street near the East River and they were arguing about some-
thing that was hidden in the rumble-seat. In spite of my
drunken condition I realized it was high time to leave. They
wanted to drive me to New Rochelle but I declined, and I
asked for my ten dollars, or at least part of it. I tried in vain
to retrieve enough for a taxi or carfare, but in the end I was
forced to walk home over a mile at seven in the morning. The
next time I passed the bar where I had met the gangsters I went
in with Max and Marcel and asked for my money back. The
bartender, who I was certain had been to Chinatown with us,
disclaimed all connection with these people and said he did
not know them. Max's chief worry about all this was the trouble
he might get into as an enemy alien if I got mixed up with
gangsters.

Another night when we were having a big party for my
birthday, Gypsy Rose Lee announced her engagement to

an actor called Alexander Kirkland. He was very charming
and handsome, but seemed hardly suitable as a husband.
William Saroyan was present too. In fact there were en-
tirely too many stars about, and there were great jealousies.
Putzel took Gypsy upstairs to buy another painting of Max's.
She already owned one. Jean Gorman, who was then Mrs. Carl
van Doren, went upstairs also. If I had not been so occupied
with Luigi, who suddenly kissed me for the first time after
knowing me for twenty years, I would have gone upstairs too
and seen to it that the sale was not ruined. Jean was very tight
and confused everything, and Max gave Gypsy the picture for a
very modest price, and threw in another one as a wedding
present. When they came down again Gypsy knew that I was
annoyed and said it wasn't fair that she should get a present
on my birthday. A few weeks later we motored up to Gypsy's
country house, where she was to have a midnight wedding. It
was a very theatrical performance and the newspaper re-
porters were so much in evidence, and so welcome, that they
did everything short of interrupting the ceremony, which was
performed by a sort of musical-comedy clergyman. Gypsy did
the blushing bride stunt very well and her husband, like all
bridegrooms, seemed terrified. I never knew what the marriage
was about, but it did not last long, and several months later
Gypsy told me it was all off. At the wedding Max was photo-
graphed by *Life* magazine sipping champagne with a South
American heiress. *Life* made a dirty crack about his having
married into the Guggenheim fortune, and how he was now
seen drinking with another heiress, as though money were his
chief preoccupation in the world. Gypsy's mother and Kirk-
land's mother were both present at the wedding. They took it
all very seriously. Mrs. Kirkland told me she was honored to
have her son enter such a distinguished family.

 After Luigi kissed me I began to think we might finally
consummate our suppressed desire for each other, which had

been hanging fire for twenty years. One night, when Max and Luigi and I were dining together, I got terribly tight and I undressed and put on a green transparent silk rain coat and ran around the house egging Luigi on. Max asked Luigi if he wanted me and of course he had to say no. To make matters worse I said the most terrible and insulting things to Max. Max began beating me violently, and Luigi looked on with his usual detached air, not interfering in any way.

Over Labor Day we were invited to Southampton to Geoffrey and Daphne Hellman's. They were a charming couple, and I looked forward to the visit. This time Max got permission to travel. I started off well by telling Max that now that I felt he no longer desired me he could have someone else. But I am afraid I failed to maintain this self-sacrificing attitude. There was a pretty girl there called Peggy Reilly who began to flirt with Max. She played up to him as a *grand maître*, which was just what he adored. One afternoon, when we were coming home from the beach, they went ahead on bicycles and disappeared for a short time, just long enough to arouse my suspicions. I made a terrible scene. Max protested violently, saying I really went too far to think that he could make love on a bicycle. This, at any rate, completely spoiled my week-end, and I would not talk to Max for days.

I was perpetually running away from Max and going to Florenz. On one of these occasions, Max rushed downstairs and seized our dog Kachina from my arms as though she were the child in a divorce. It was a terrific anticlimax, as we were all expecting him to beat me up. Max was a great believer in revenge. He was always thinking about it. He might have walked straight out of the Old Testament. But he had a wonderful sense of humor, turning everything into a joke, and if he were hurt he never showed it. He was quite jealous of Florenz and called him "Your husband." I perpetually com-

plained about Max to Florenz in Max's presence. It must have been very humiliating for him.

About this time Elsa Schiaparelli, whom I had known for twenty years since the days when she wore black taffeta *robes de style* and wanted to go into the antique business to make her fortune, never dreaming that she was to set the fashions for the entire western world, came to ask me to help her arrange a Surrealist show for a charity called the Coordinating Council of French Relief Societies. I sent her to Breton. With the help of Max and Marcel Duchamp, Breton organized a big exhibition, which was held in the Whitelaw Ried Mansion, an ugly, old-fashioned building. Marcel decided to cover the ceiling with strings that he criss-crossed the entire length of the room and which extended from wall to wall. It was difficult to see the paintings, but the general effect was extraordinary. At the opening I made a scene because the pictures I had lent did not have my name on them, and every other lender was acknowledged. Max's photograph was taken at this moment and, as he was standing next to beautiful Daphne Hellman, I must have appeared in the role of a jealous wife.

Kiesler did not want the Surrealist show to open before our gallery—which was located at 30 West Fifty-seventh street, and was nearly ready by October—but everything was late and we had to let the Surrealists get ahead of us. It made no difference, however, because ours was so special and wonderful: it was called Art of This Century, and had been awaited with such curiosity that we had no rivals. Absolutely nobody knew what Kiesler had invented for my gallery. Even Max was not admitted until two days before the opening. At first he balked at having all the frames removed from his paintings, but when he saw how well all the others looked he decided not to be different. Kiesler had done a wonderful job. The publicity we got was overwhelming. Photographs appeared in all the papers and, even if the press didn't unanimously approve of

Kiesler's ultra-revolutionary method of showing paintings, at least they talked about it sufficiently to bring hundreds of people a day to the gallery.

Kiesler had really created a wonderful gallery. Nothing like it had ever existed before. The Surrealist Gallery had curved walls made of gum-wood. The unframed paintings, mounted on wooden brackets protruded about a foot from the wall, each with its own spotlight. The lights went on and off, to everybody's dismay, first lighting one half of the gallery and then the other. People complained and said that if they were looking at one painting on their own side of the room, they would suddenly have to stop and look at a different one in another part of the room. Putzel finally made me abandon this lighting system and keep all the lights on at the same time.

In the Abstract and Cubist Gallery, where I had my desk next to the entrance door, I was perpetually flooded in a strong fluorescent light. Two walls consisted of an ultramarine curtain which curved around the room with a wonderful sweep and resembled a circus tent. The paintings hung at right angles to it from strings. In the center of the room the paintings were clustered in triangles, hanging on strings as if they were floating in space. Little wooden platforms holding sculptures were also suspended in this manner.

Kiesler had designed a chair that could be adapted for seven different purposes. It was covered in vari-colored linoleum with ply-wood at the ends, and could serve as a rocking-chair, with support for the back and was restful; or it could be turned over and used as a stand for paintings and sculpture; or as a table or a bench. You could combine it with planks of wood and make other furniture out of it. The gallery was supposed to seat ninety people, so there were also little folding chairs of blue canvas to match the wall. The floors were turquoise. Kiesler also designed an ingenious rolling storage-stand, both to store paintings and to exhibit them so that you could bring

them in and out when you wished to look at them. This was
very ingenious and saved much space which I needed to show
my large collection.

There was a beautiful daylight gallery that skirted the front
on Fifty-seventh Street, and was used for current monthly
shows. Here pictures could be shown in frames on plain white
walls. In order to temper the light, Kiesler had put up all along
the window a transparent screen made of ninon. In one cor-
ridor he placed a revolving wheel to show seven works of Klee.
The wheel automatically went into motion when the public
stepped across a beam of light. In order to view the reproduc-
tion of Marcel Duchamp's works, you looked through a hole
in the wall and turned by hand a very beautiful spidery
wheel. The Press named this part of the gallery, Coney Island.

Behind the blue canvas I had an office which I never used; I
wanted to be in the gallery all the time to see what was going
on. I had given Kiesler a free hand in all this with two ex-
ceptions: in the first place I told him I wanted to abolish
frames altogether, but that was just what he wanted too, so
we were in perfect accord. However, he had worked out one
plan for the Abstract gallery which I found too complicated
and turned down. But his second attempt was such an im-
provement that I never regretted my decision.

The opening was dedicated to the American Red Cross and
the tickets were a dollar each. Many of the invitations were
lost in the mail, but hundreds of people came anyhow. It
was a gala opening. I had had a white evening dress made for
the occasion, but by then I was more dead than alive. We
over-worked and struggled day and night to get the gallery
ready in time. In fact workmen were still in the place when
the Press started to come.

We had dreadful money difficulties. More and more bills
kept coming in. Finally, when I realized how much Kiesler's
total cost exceeded his estimate I practically broke with him

and refused to invite him to my house, but I maintained a formal museum-façade. He was keen on publicity and wrote a threatening letter to one woman reporter who had given me a long interview to be syndicated all over the United States of America, insisting that his name appear too. He said he did this to protect himself as his former inventions had been stolen. She was so frightened by the letter that she would have dropped the whole article if I hadn't managed to patch up her difficulties with Kiesler just as the gallery was opening.

All this was exciting and new, and I was delighted to get away from home, where I always felt Max did not love me. He looked very happy at the opening. He was a cross between the Prince Regent and the museum's biggest star. Fourteen of his paintings were on exhibition, more than anyone else had. A few days after the opening he went to New Orleans, where the Gonzales had arranged a show for him. In New Orleans he had a much smaller audience than we did, and he was jealous of the success the museum was having.

While Max was away I was untrue to him for the first time, with Luigi, at last after twenty years. It was really too late and was almost like incest. When Max came back I was so engrossed in the gallery that I neglected him completely. He was left alone all day in our enormous house, with no lunch, as the maid only came to make dinner and there was never any food in the icebox. I would come home in the evening about six-thirty, and he was always happy to see me and made me a drink. He would open the door with a charming smile. Then we might have enjoyed what was left of the day if I had not been so boring, with my endless talking about the museum, how many people came and how many catalogues I had sold. At that time I used to sit at the desk and collect the entrance-fees I had made up my mind to charge, and for which everyone hated me. Finally Putzel put a stop to this, but not before six months had gone by.

In the mornings, as I had to get up early, Max was annoyed and refused to have breakfast with me. He never came downstairs until I had left the house, although he often appeared the minute after, when I could see him through the window from the street.

Before the opening of the gallery I had decided it would also have to be a gallery where I could sell paintings for Max and young unknown artists. However a great confusion arose in the minds of the public as to what was and was not for sale, as I have consistently refused to sell most of my private collection.

Soon after the gallery opened, Sindbad, Emily's son and Jimmy, my secretary with whom I always worked happily, all came up for the draft. Sindbad had volunteered for the E. R. C. at Columbia but had been turned down and was waiting to be drafted. Suddenly Jimmy left me, as he thought he would be in the Army soon and wanted a fortnight's holiday first. To replace him he found a friend who had once worked with him in the Museum of Modern Art. Emily's son was turned down by the Draft Board, and so was Jimmy and in the end only Sindbad was accepted. Florenz and I were terribly upset, but Sindbad took it very well. We all went down to Pennsylvania Station to see him off and suddenly he was swallowed up in a sea of unknown, tough-looking boys and disappeared. We were without news for days. Finally we had a letter saying he was in Atlantic City, and Florenz, Deirdre and I went down to see him. He looked such a baby in his uniform with his GI haircut. It nearly broke my heart to leave him.

part 6

chapter 2

end of my life
with max ernst

One night when I had a rendezvous I told Max I was going to a concert with Putzel. He often really took me to concerts on Sunday afternoons. This particular evening Max must have suspected that I was not with Putzel because he suddenly phoned him to ask how much money he could get for a Chirico drawing that he wanted to sell. I had warned Putzel, but he had fallen asleep. When the phone rang he woke up with a start and answered it, and to his horror it was Max. Of course it was too late to do anything about it, but he pulled himself together and hung up, saying, "I will phone you later." He phoned Max back and said he had left me at the opera to go home and turn off an electric stove he had left on by mistake. When I got home I found Putzel at my street-corner waiting for me in pajamas over which he had hastily thrown an overcoat. It was snowing. He told me what had happened, and when we got to the house Max opened the door for us and I burst out laughing. There was nothing else to do. Putzel fled.

On the nineteenth of January, John Holms had been dead
nine years. His anniversary still upset me very much. I gen-
erally managed to spend it with Emily if possible. But this time
Edita and Ira Morris gave us a party. Late in the evening I
got up and ran out in an awful state of hysteria. Ira followed,
rather worried, but I told him I was going to see Emily. Once
I was with her I burst out crying and told her everything
between Max and me was over, and that I would never go back
to him. I said I knew he was incapable of any real emo-
tion and had nothing to do with my inner life, and that I had
married him because he was a baby deposited on my doorstep.
But now he no longer needed me. In the morning I went home
to tell Max my decision. He was worried, as it was the first
time I had been out all night. He phoned Jimmy at once to
tell him I had come home. His emotion upset me and I was
immediately sucked back into the family life again.

Soon after this I gave an exhibition of work by thirty-one
women painters. This was an idea Marcel Duchamp had
given me in Paris. The paintings submitted were judged by a
jury consisting of Max, Breton, Marcel, James Sweeney, James
Sobey, Putzel, myself and Jimmy, who left in the middle of the
session, when his girl-friend came to get him. Fearing her paint-
ing would be turned down, which it was, he withdrew. Gypsy
Rose Lee had done a self portrait in *collage* which was very
clever and which we exhibited in this show.

When Edward Alden Jewell, the art critic of the *New York
Times*, came to see the show he wrote a long article in *The
Times* in which he said: "The elevator man, who is tremen-
dously interested in 'Art of This Century,' told me on the
way up that he had given the place an extra-thorough cleaning
(and indeed it did appear immaculate) because Gypsy Rose
Lee was expected in the afternoon." The superintendent, who
was very jealous, fired the elevator boy for getting this pub-
licity. When I told Mr. Jewell what had happened he was con-

siderably upset because he thought the boy had lost his job through him. I became very friendly with Mr. Jewell, and translating his name into French I now call him "Mon Bijou de l'Epoque." This was his comment on the Surrealist gallery in the *Sunday Times*: ". . . it looks faintly menacing—as if in the end it might prove that the spectator would be fixed to the wall and the art would stroll around making comments, sweet or sour as the case might be."

I made Max work hard for this show. He had to go around to all the women, choose their paintings and carry them in the car to the gallery. He adored this, as he loved women, and some of them were very attractive. He was always interested in women who painted. There was one called Annacia Tinning, a pretty girl from the Middle West. She was pretentious, boring, stupid, vulgar and dressed in the worst possible taste but was quite talented and imitated Max's painting, which flattered him immensely. She was so much on the make and pushed so hard that it was embarrassing. She wanted to be on the jury and I had to refuse her. We had met her at Julien Levy's the year before and Max had fallen for her at once. Now he became friendly with her, and as I was in the gallery all day he was happy to have a companion. She also played chess with him, which was something I could not do. He took a great interest in her painting but I was surprised that he gave her so much thought since she was vastly inferior to Beatrice, who really was a creature of genius. I couldn't understand his infatuation. Max protested and said in the most pathetic manner that she was not the *fille de rien* which I accused her of being.

One night I opened a special delivery from Miss Tinning addressed to Max. It was a very silly letter written in bad French, and enclosed in it was a piece of blue silk, which she claimed to be her hair. It made me quite wild with jealousy, as she assumed that Max must be as unhappy without her as she was without him. She was somewhere in the Middle

West. After reading the letter I hit Max's face several times as hard as I could. Max could not have taken this letter very seriously, because he later read it aloud to Emily and me to prove it was not a love letter. He thought it was funny.

One night Alexander Calder invited us to one of his *bals musette* in a bistro on First Avenue and Ninetieth Street. Max insisted on bringing along Miss Tinning. I was annoyed and didn't really want to go myself, because I wasn't feeling well. Max said he would go without me. I knew Calder didn't like Max, and I didn't think Miss Tinning would be an asset; anyhow I was furiously jealous and felt humiliated. I phoned Max at Miss Tinning's to tell him not to take her to the *bal musette*, threatening him that if he did I would lock him out of the house. She insisted on speaking to me herself, and told me she did not wish to make trouble between Max and me and would send him home at once. He came home, but I did not talk to him and I went out.

Another night Max was invited to a party without me and, though he had declined, I forced him to accept, as I wanted a night off to spend with Luigi. Max afterwards claimed this was what broke up our marriage; since I had given him complete liberty, and for the first time he spent the whole night with Miss Tinning, as a result of which he fell in love with her. All this was for nothing, because I could not even make contact with Luigi, and went to the theatre with Deirdre instead. The next day we went to Sidney Janis' for cocktails and suddenly Max got very scared and asked if I was going to make a scene, as Miss Tinning had arrived unexpectedly. I said, "Of course not," and ignored her, as I have done ever since.

A few days later there was a Surrealist gathering at Kurt Seligmann's and Marcel Duchamp phoned Max to come. Max did everything in his power to stop me from accompanying him as Miss Tinning was to be there. I was so enraged that I left him at the door and asked him to give me the key of

our house. Naturally, he went to live with Miss Tinning. But a few days later her husband came back from the Navy on furlough, and she and Max both had to flee. Max had great trouble finding a room in New York and was scared to go to any of our friends, as it would cause trouble with me.

In desperation I went to Breton. He was very much surprised by my suffering and said I must see Max and at least talk things over with him. He promised to send Max to me. He scolded me for taking the house-key away from Max, and said it was a terrible thing to do to an enemy alien. I said that it was Max's fault for refusing to let me go with him to the Surrealist gathering, and that he had humiliated me too much. In the end Jimmy sent Max to see me.

When Max came I was nearly off my head and I told him that I would commit suicide if he didn't come back to me. He said it was hardly the moment for us to try to live together, and that we should both calm down first. He asked me if I would let him take Miss Tinning to Arizona, and come back to me afterwards. I nearly had a fit.

At this period I was in such a state of nerves that Deirdre had to follow me everywhere. She was worried about me, as I crossed streets without paying any attention to the traffic. One night we invited Breton to dinner and, although we hoped to make things better, everything got worse. Max, Agnes and Marcel were there and some other people. We got into arguments about *VVV* magazine, which Marcel, Breton and Max were publishing. Max had promised me a free ad in it, and now Breton refused to let me have it. I wanted it on principle, as I felt I had done so much for the Surrealists. But Breton maintained that all his life he had sacrificed to truth, beauty and art, and he expected everyone else to do as much. Deirdre said all the Surrealists were *mesquin* because they quarrelled so much. Breton was very much offended that a little girl should insult him, and he held me responsible for my daugh-

ter's doing so in my house. Max took this as an excuse to join Miss Tinning, who had been phoning him all evening. This ended our relations with Max, who disappeared for days.

Deirdre did her best to patch things up between us, but she didn't succeed. The next time I saw Max I offered to give up Luigi if he would give up Miss Tinning, but he said it was too easy for me if I were tired of Luigi to ask him to give up Miss Tinning. One night he accompanied me to a dinner party and told me all about the gay life he led with her. He acted in every way as though he meant to stay with me, but after dinner he left me at home and went off to Miss Tinning. I think he merely wanted to make a public sortie with me to fool people. During all this time I spent nights with Luigi, who was sweet to me and behaved more like a nurse than a lover. I was nearly off my head and could not sleep without drugs.

Max came every day to paint in his studio. One Sunday afternoon, while Emily was with me in the house, we had tea with Max and then he went upstairs to paint again. I asked Emily to go up and talk to him for me. For some strange reason I was terrified of living alone. I asked her to tell Max that I knew the whole thing was my fault, that I didn't want to break up our marriage, and that I would wait for him to get over his affair. She began by asking him what I thought of a new painting he was doing. He said he didn't know, as I was no longer interested in his work, and that he never saw me; that I was a destructive person who had broken up our life, and that I had been in love with Luigi for twenty years. She then gave him my message and came downstairs, saying he looked impressed by it. Earlier in the winter Max had tried to get me to go to Arizona with him, but I had refused to leave the gallery, and told Emily I would rather risk breaking my marriage than give up Art of this Century.

When Max talked about Miss Tinning he was very contradictory. Sometimes he said he was not in love with her and

that it was just a physical attraction. At other times he said he was like a cat who wanted to run away. Once he told me that we had had no luck, because, though he had been in love with me in Marseilles, as soon as he found Beatrice again it was all over with me.

At one moment he said I should wait for him to get over his love-affair, at another that it was no use because he would always want a new one. He also said I made too many scenes for him to endure our life together.

Jimmy thought I ought to be psychoanalyzed in order to straighten myself out. The only person I wanted to have for a psychoanalyst was Breton, who had been a psychiatrist in the last war. I invited him to lunch and told him all my troubles. When he heard about Luigi he said Max would never come back to me because of his pride. Breton thought I had really gone too far and had done things to Max that he himself would never endure and he wanted to know why I did not live with Luigi instead of fussing about Max. I told him Luigi was married and that we could never have a serious affair. Breton said he would do anything in the world for me, but that he couldn't analyze me as he was not qualified, and that under those circumstances it would be dangerous. He told me to go away to the country and rest my nerves.

In February, Jean Hélion, who had escaped from a German prison camp and written an excellent book about his adventures, *They shall Not Have Me*, consented to hold a retrospective show in my gallery and to come up from Virginia where he was living to give a lecture relating to some of his experiences. The show was beautiful. I bought a handsome 1934 painting and sold some others. James Johnson Sweeney wrote the preface for the catalogue and Hélion gave a very moving lecture. Over a hundred people crowded into the gallery and we turned over the proceeds to the Free French. After the opening I gave a big party in my house on the river for Hélion.

He met Deirdre who was only seventeen and immediately fell in love with her. I realized it at once but Deirdre was unaware of this fact for over a year and a half; later she married him.

It was a great strain to keep the gallery going when my private life was so horrible and causing me so much misery. I was like a little girl who had torn the house down on her head, and then sat surprised among the ruins. I couldn't sleep without drugs and felt worse each day. Every morning Max came to paint in his studio. It gave him intense joy to see how awful I looked and he taunted me for getting up so late. The worst of all was that, as a result of my fighting about *VVV* magazine, the show I was to have had of all the originals of this review was called off, and I was left at the last moment without anything to replace it. I had to think up a new show and organize it in forty-eight hours. I used a suggestion of Jimmy's and arranged an exhibition consisting of two works each of twenty well known painters showing what they had done twenty or thirty years before and what they were doing now. The contrast was extraordinary. I was very nerve-racked and longed for some peace, which I soon found.

One afternoon when I came back from the gallery to get Sindbad's new address, I found Max painting in his studio. We got into an argument about pride and he said that was all women thought about. I asked him what he would do in my place. He replied he would wait until the storm blew over, which was actually what I was trying to do. But he really took advantage of my patience as he merely used the studio to paint in, and being in the gallery all day, I never laid eyes on him. Anyhow that very afternoon I went to an opening at Julien Levy's, where I saw Miss Tinning with her hair dyed turquoise. Inserted in her blouse, which was specially cut for this purpose, were little photographs of Max. This really was too much for me. I was so disgusted that I decided I had had

enough of the whole affair and, as you will see, I finally put an end to it.

I was happy to get away from home and spend my entire day in the gallery, often not even going out for lunch. But soon I realized that I was imprisoned and that my life was no longer my own. If I stepped out for half an hour on gallery business someone would surely come in and want to see me and be annoyed by my absence, or I would fear I had lost an occasion to sell a painting. I felt as though I had given up all my personal life and become a slave to the artists, whose interests I was trying to further. The gallery soon became known as the only gallery in New York devoted to discovering and furthering unknown American Abstract and Surrealist artists.

In London Mr. Read had conceived the idea of holding a Spring Salon. I decided to try it in New York. I appointed a jury consisting of James Sweeney, James Soby, Piet Mondrian, Marcel Duchamp, Putzel and myself. The first year it worked exceedingly well. Out of the pickings we had a very fine show of about forty paintings. The stars who emerged were Jackson Pollock, Robert Motherwell and William Baziotes. They had already exhibited their work the previous month in a show of *collage* and *papier collé* I had organized. We all realized that they were the three best artists we had found. Soon after David Hare came to me. He had formerly been a commercial photographer but now he was entirely absorbed by his beautiful plaster sculptures. He had been very much influenced by the Surrealists and seemed to be the best sculptor since Giacometti, Calder and Moore. I promised to give him a show.

Funny things were always occurring in the gallery. Once when Putzel was there a man came and complained that one of the Cubist paintings did not resemble a man. Putzel was indignant and told him that if he wanted to see a man he should go and look at one.

Kiesler had installed a wonderful box into which you could

look by raising a handle that operated the eye of a camera. Inside the box was placed a magnificent Klee painted on plaster. A woman peering in said, "I do love a peep-show, even if it's on batik."

One day a girl came from a college and said, "Will you please sign a paper for me so that I can prove to my Professor Mason that I have been here? He said I was either to get the signature of Miss Guggenheim or the Duchess." I presume she was referring to the Baroness Rebay, with whom I certainly do not like to be confused. People were forever asking me what connection I had with the Museum of Non-Objective Art. I always replied, "Not the slightest, though Mr. Guggenheim is my uncle."

On another occasion we had a visit from Mrs. Roosevelt. Unfortunately this honor was not due to her desire to see modern art. She was brought by a friend and Justine Wise Polier to view a photographic exhibition of the Negro in American Life, arranged by John Becker. Mrs. Roosevelt was extremely cordial and wrote enthusiastically about the exhibit in her column, but unfortunately in print the gallery was called "Art of This Country." Before she left I did my best to make her go into the Surrealist gallery, but she retired through the door sideways, like a crab, pleading her ignorance of modern art. My English friend, Jack Barker, had come up in the elevator with the ladies. Following them into the gallery, he mimicked the gracious high falsettoes with which they greeted me. Mrs. Roosevelt, evidently amused by his behavior, turned to him smiling and bowed. The embarrassed Barker, unable to recall how well he knew this lady, whose face was so familiar, was uncertain whether to fling himself into her arms, clasp her warmly by the hand or bow back in a reserved manner. In such a dilemma he decided to ignore the whole thing and failed to return the gracious salutation.

Once when I asked Piet Mondrian to clean his no longer immaculate painting for me, he arrived with a little suitcase and

spent days in the gallery not only restoring his own, but one of Arp's and one of Ben Nicholson's. When Mondrian brought his paintings to the gallery for exhibitions they were always carefully wrapped in white paper. Mondrian greatly admired Max's paintings and Max reciprocated, though they were so far apart in their conceptions of art. One evening I went to Mondrian's studio to see his new paintings and hear his boogie-woogie records on the phonograph. He kept moving strips of paper with which he was planning a new canvas and asked me just how I thought it would look best. He kissed me and I was surprised to discover how young he still was at seventy-two. The last party he went to was in my gallery. He loved parties and never missed an opening. One day my cousin, Colonel Guggenheim, came to Art of This Century and when I asked him which painting he disliked least of those in my collection he said, if offered, he would accept a Mondrian. Needless to say, I did not give him one.

part 7

chapter 1

peace

I often wonder (and never found out) why this man was destined to cause such a commotion in my life, why he occupied my entire thoughts for a year, and why I bear him no grudge after all we have been through. To begin with he entered my consciousness as a myth—the sort of myth that only a very rich, irresponsible, vague and spoiled person can be; the sort of person who is so attractive and so much sought after that he never bothers to do anything he is supposed to do; who loses addresses, and never goes anywhere on time, or arrives on the wrong day, or sends telegrams full of lies and apologies. Finally I met him and he appeared to be just the opposite of what I had expected. He visited my house to buy some of Max's paintings. He had given Max an affidavit to come to America, when Mrs. Barr had asked him, so we were very curious to meet him and Max wanted to thank him. He was so handsome, so charming, so modest, so shy, that I was overcome with surprise.

The next time I saw him I sat next to him at Mozart's opera,

Don Giovanni, and a peculiar current seemed to pass between us. He has often referred to it since. He took me home in a taxi. Afterwards I told Putzel that if I weren't afraid he would give me a terrible run-around I would fall in love with Quentin. I was quite right to beware of him. Not that he meant to be evasive, he just couldn't help it. And when the time arrived and I did fall in love with him, my prophecy proved true, but in quite an unexpected way.

He came into my life when I most needed him and when he most needed me. I know now that it was inevitable. He came to me when I was very unhappy, and that was why he offered me his friendship and why I seized it, with no thought of the consequences. He immediately became my friend, and because he was over six feet tall he assumed a domination over me. The first thing he made me do was break with Max. It was so obvious that it had to be done; I don't know why I waited for Quentin to tell me. I couldn't go on in my ridiculous situation any longer. He merely said, "The situation is absurd. It's neither one thing nor the other." I made it the other. He didn't do this from any self-interest. He just gave me the advice any sensible friend would have given me. Then he suggested I go to a lawyer and have a legal separation drawn up. Because he was used to thinking about property in a practical way, he convinced me this was necessary, and I accepted his advice.

But I am running ahead of my story. It all started this way. Everything he did was extremely practical and kind and, because he knew I was unhappy, he invited me to his house and gave a little cocktail party for me. I had been there before to large impersonal parties, but this one was quite different. At the last minute I decided to bring Max with me, and I am sure my host must have been very surprised to see us arrive together; but he did not show it, and he showed no surprise when Max left the party to join Miss Tinning. However, that

was exactly what we all wanted him to do. When he left we felt much freer.

I don't know why, but Quentin immediately gave me a sense of peace, and when I sat with his arm around me I was perfectly happy, happier than I had been for years. It is most unfortunate that I could not have been satisfied with this. If only I had been able to accept the peace and ecstasy I felt when I lay in his arms listening to music, everything would have been different. But then I am not the kind of person to accept anything as it is. I always think I can change the situation. The incredible thing is that I never believe in failure, and no one can convince me that I cannot move mountains or stop the tide until I have proved to myself that I can't. I therefore immediately set out to achieve what I was destined never to accomplish. Of course I got many other things instead, things that I hadn't dreamed of.

We went to dinner with his sister and Putzel, and then came back to my house on the river. We spent a long time on a couch behaving like undergraduates. I seem to have covered Quentin with my lipstick, and he said he enjoyed it so much that, when his sister and Putzel returned to the room after discreetly wandering around the house, Quentin folded his legs, saying, "Oh, dear, this seems to be very necessary." I never found out whether it was or not. Before Quentin left he said he would take me to dinner very soon. I wanted to go home with him but his sister was staying with him and his flat was very small.

A few days later Joan Flarity was giving a big birthday party for her sister's friend Lila. I couldn't make up my mind whether or not to go. Max refused to come with me, saying, "*Je ne connais pas cette dame.*" Gypsy Rose Lee telephoned to ask if she could bring a friend to our house to meet Max and to see his books and paintings. I couldn't refuse her but I felt very uncomfortable and thought I ought to explain our situation to her, it was so ambiguous. I called her back and said that

I had invited Max to meet her in my house, but that we were
not living together, and that I didn't know whether or not I
would be home. However I hoped she would enjoy herself with-
out me, and excuse me for not being there if I couldn't make it.
I lay in bed dithering between the two possibilities for the even-
ing. Suddenly I remembered Quentin was a friend of Joan's.
That decided me. I leaped out of bed, and got dressed and
rushed to the party before Gypsy arrived.

I had a very wild and wonderful evening, a sort of inde-
pendence celebration. At last I felt free of Max and spent the
whole time dancing wild dances with Quentin. I embraced him
in the bathroom, where we went to wash away the smell
of pickled onions that we had secretly inserted in the birthday
cake. It was this night that Quentin told me to break with
Max. The next morning I phoned Max asking him to find him-
self a studio and not to come to the house any more. He was so
outraged that he came and took Kachina without warning me
leaving our two Persian kittens Romeo and Gypsy. Quentin
had the flu at this party and couldn't tear himself away from
me, but he should have been in bed. Finally a motherly soul,
an old English war-horse, forced him to go home. Before leaving
he invited me to dinner the following Thursday.

I was in a state of great excitement all week about my next
rencontre with Quentin, wondering whether or not he would
forget about it. Thursday afternoon he telephoned to me and
said, "Do you remember, you're having dinner with me this
evening?" It would have been impossible for me to forget, but
I merely replied, "Yes, I do." He came to fetch me at my house
very late. I was extremely perturbed about what to wear, as I
knew how much stress Quentin laid on the appearance of any
one he was seen with in public. Of course I had nothing suit-
able, but I did my best and did not feel too self-conscious. I
wore green gloves and a green scarf. "Now let me see, where
would you like to go?" Quentin began, and I chose a restau-

rant Max used to take me to. This was the only time Quentin ever took me to a place where I had been with Max. From then on he always chose where we would eat.

Getting to know somebody suddenly is an exciting, strange and alarming factor in life, but it is even more exciting when it is something one has desired for a long time. The full impact of Quentin's Englishness came upon me. It delighted me, even though at first I felt it was a rather conventional Englishness. He talked so much I realized at once I was merely supposed to listen. I liked that. It was easier, and it couldn't cause trouble. The only thing I remember saying was that I had been to Curzon Street (as he referred to the home of his parents-in-law in London) the day before Sindbad was born and well recollected the extreme solicitude of his mother-in-law. It gave me a pleasant feeling to be thus connected with Quentin even so remotely. It immediately made a sort of bridge between us and, as I knew, like all the English he was very snobbish, I felt pleased to think I had been to Curzon Street.

After dinner he took me to his flat. We lay on the sofa for hours, wrapped in each other's arms, while his automatic phonograph played Mozart, Bach and Beethoven. Later in bed he told me that he was apt to get claustrophobia as his mother had made him sleep in her bed when he was a child. Therefore I took the precaution of going home as soon as he went to sleep.

Little did I know that a few hours after I had left, all this was to give him a terrible heart-attack. I only learned it some days later, when he suddenly announced to me, in the middle of dinner, that he had been terribly ill and that the doctor had told him he must not drink or have a love-affair. "It happened a few hours after you left, and I couldn't move, not even to get to the bathroom. But it's horrible to be ill. I don't want to talk about it." I don't know whether he realized the full psychological import of what had happened, but I felt responsible and decided we must not try to make love any more.

After dinner he took my arm and walked me to his flat. We lay on the sofa in a gentle embrace for a long time, and then we went to bed and took sleeping draughts, but I lay awake all night terrified lest I disturb him. In the morning he gave me a glass of milk in just the same way he had given me the sleeping potion. He offered it the way a child offers a gift. Then he kissed me goodbye in the sweetest way. On the steps, as I went out, I met Anaminta, his little colored maid. She looked surprised to see me emerging from his flat so early in the morning.

A few days later I gave a party. Quentin came surrounded by a lot of little young men. They were charming. Quentin showed them my house and suddenly said it would be nice to share a big house like this with some one. He asked me how I would like to rent half of it to him, or suggested that we take another one and have a trap-door between our floors. Every time, even jokingly, that he dropped a word of this kind I would seize upon it and use it to build my future.

From that day on I knew I must live with him, and indeed I never rested until I had achieved my purpose. This was comparatively easy because he was very lonely. That was why he allowed me to become a part of his life. He needed to be admired and to be loved. Partially his mentality was that of a college boy; intrigues were an important pastime to him. He liked to have a lot of people in love with him. Not that this brought him any real satisfaction, because his life was fundamentally unhappy.

Quentin had a job with the British Intelligence Service but it never seemed to involve any work. In fact he seemed to spend most of his time listening to music. His phonograph played all day. He wasted a lot of time eating and drinking. He drank more than anyone I have ever known, except John Holms. Quentin belonged to the eighteenth-century. His surroundings, his background, his taste, his behavior were all

reminiscent of a great *signeur* of that epoch. He was so subtle
and sensitive that he never missed any *finesse* or *bon mot*. Noth-
ing escaped him, and it was a pleasure to converse with him. He
would not permit me to use the word fairy. In its place he
insisted on Athenian. He claimed fairy was as vulgar as the
terms wop or kike. He was civilized, therefore an oasis in the
American desert. However, he was much too good for him-
self. In a sense he never lived up to the best in him. He was
dragged down to the level of his friends, who were all inferior.
Possibly out of politeness, so as not to make them feel un-
comfortable, he aped their inferiority. He needed someone
strong to bring out his qualities. He had many friends and
among them were many women. He was an ideal friend. He
always made you feel that he belonged to you.

As he lived entirely for pleasure he was always anxiously
awaiting the opening of the opera, concert or ballet season.
He spent fortunes in the best restaurants, for he loved good
food and wine; they were an essential part of his life. He wore
the most elegant clothes. His suits were usually blue to match
his eyes, and he had dozens of them. They were always im-
maculate. He was well groomed and very much made up with
Max Factor's cosmetics, and his hair was bleached too blond.
In his bathroom, which was more like a star's dressing-room
than anything else, were every kind of makeup and the most
expensive perfumes from Paris. He showed me how to fix my
hair. He knew how to do it much better than I did.

Because of his health Quentin went away to the country and
I was miserable and lonely. Florenz came to live in my house
because he had a broken leg and could not climb the stairs to
his flat. I gave a party every night for him, so that he would
not have to rush around with his bad leg.

One day when I thought Quentin was still in the coun-
try Putzel brought him to the gallery. I was just going out to
lunch, although it was four o'clock, so Quentin took me to a

bar and fed me. He was very sweet, but his evasive and escapist manner became more and more noticeable. He made me feel as if he never wanted to be pinned down to anything, or counted on in any way. I think that the only reason I went on with this affair was the fact that John Holms's spirit encouraged me to, by promising me great peace from Quentin. John himself never promised me more. The rest was left ambiguous.

Soon after this Quentin had a thirty-ninth birthday. Jimmy Stern, not knowing I was in love with Quentin, took me to a birthday party that was given for him by a friend. Jimmy thought he was introducing me to a new world. It was funny. Quentin was extremely artificial and polite, the way I always hated him most.

A few days before, I had sent him a beautiful Cornell object, chosen by Putzel, as a birthday gift. My secretary, John, delivered it and came back thrilled by the glimpse of Quentin's real life, wafted through the door to him on an aroma of whiskey. I was jealous and felt shut out of Quentin's intimate life.

When John went into the Army, Putzel insisted on taking his job. I had resisted this catastrophe for two winters, but now I weakened, in view of the fact that this move would bring me nearer to Quentin. They were such good friends.

I was still having a vague affair with Luigi. This never meant very much to either of us; we were almost like brother and sister, having known each other so long. I used to phone him if the spirit so moved me, or he would come to the gallery and make a rendezvous with me and take me to lunch. He was at the same time my father-confessor, and he knew all about my affair with Quentin. It was often difficult to tear myself away from Quentin to join Luigi, and once I phoned from a bar excusing myself on the pretext of being drunk, which I certainly was. Luigi always pretended not to care about any-

thing. He didn't believe in emotion and certainly not in love, but he felt more than he admitted. Being with Quentin always meant one was drinking much too much. I think Luigi understood how I felt about Quentin and soon after broke up our affair saying his wife would hear about it because I was so indiscreet. I agreed as it was all getting to be dangerous and I was relieved when it ended, so as to be able to concentrate on Quentin. When I didn't go to see Luigi, Quentin asked me if I wouldn't regret it, meaning he wouldn't be able to give me what I had missed by remaining with him. But of course I didn't mind.

For the birth of the second number of *VVV* magazine Kiesler gave a big party. Of course I was not invited, as I would not let him come to my house since our trouble about the gallery bills. However, I was determined to go at any price, and when I could not get an invitation upon Florenz's suggestion, I dressed up as a boy and wore some of Sindbad's clothes which were left in my house. I found a beautiful blue suit and a cap, into which I stuffed my hair. I made myself up with burnt cork giving myself sideburns and a little goatee. Then I phoned Quentin to tell him what I had done and to ask him if he would escort me. He was amused at the idea until he saw the dirty-looking little Greek boy I turned out to be. Quentin added to my make-up, but he was ashamed to be seen with me and left me at the door and went into the party alone. He said he did not know Kiesler and therefore felt shy about bringing me. As for me, I made a great hit and no one recognized me except Max, who fled with Miss Tinning from the party the minute I arrived, as though I were the devil in person. Georges Duthuit was there and asked Joan, "*Qui est ce garçon? Il a l'air très intéressant.*" Joan said, "*C'est un Grec.*" "*Ah oui, je comprends,*" Duthuit replied. When Kiesler discovered who I was, he was so delighted that we made up then and there and

have been friendly ever since. If ever I build a house in Amer-
ica Kiesler must design it.

Soon after the party our period of house-hunting began. We
were both looking for a place to move to in October. My house
had been sold over my head and Quentin's flat was much too
small for him. It was easy for me to get lists of apartments
from my old friend the agent, Warren Mark, and then share
them with Quentin. After we had visited all the places on
the lists we retired to bars and spent the rest of the afternoon
drinking. The gallery was abandoned to Putzel who, when-
ever he saw me going off to lunch with Quentin, remarked, "I
suppose you will be back by five."

I was absolutely determined to share a place with Quentin.
He wanted to live in an accessible neighborhood, so I soon
realized I would have to give up the river, which was what
I really preferred. Every day we were given a new list. We
looked at many flats, and they were all hopeless except one
duplex apartment. This was so perfect in every respect (except
that it had only one kitchen) that we decided to take it. Every-
one was horrified at the prospect, and all our friends warned
us of the terrible dangers we would incur in the common
kitchen. But, since Quentin never ate at home except on rare
occasions, we thought our friends were silly. Putzel nearly went
off his head with jealousy. We had to tear down three walls to
make an extra room out of four servants' rooms that were
useless. When Putzel heard the conversations on the telephone
about this he got all mixed up and thought we were building a
wall to separate our different abodes. He did not realize what
we were doing, and went quite mad when he learned that we
were taking down walls instead of putting them up. He was
always pushing me into Quentin's arms and then getting fur-
ious if we became too intimate.

Our new apartment was beautiful. It consisted of two floors
in two brownstone houses, so that we had twelve windows in

front and twelve windows in the back overlooking terraces
and gardens. The top floor, which Quentin was to have, had a
big bedroom, a sitting-room, and an enormous sort of ball-
room. There was a kitchen and pantry on this floor. Below
this, to which you descended by a magnificent Regency stair-
case, I was to live in three rooms, and the extra room I was
to build out of the servants' rooms. It was inconvenient to walk
upstairs to the kitchen, but on the other hand I had four
bathrooms and Quentin had only one. I made him sign the
lease because he was so unreliable. I felt safer that way.

After the lease was signed we spent hours in bars thinking
about the *décor* of our new home. There was a large entrance
hall from which an elevator took you upstairs. There was no
staircase up to the apartment, only the Regency one between
our two floors, so we were more or less at the mercy of the
elevator. The emergency staircase was not supposed to be used,
except in case of fire when you had to break a door which
automatically set off a fire alarm. We were preoccupied for
weeks trying to think of fantastic ways of decorating the en-
trance hall. I was horrified by Quentin's ideas, which were so
frivolous and prewar that I really would have found it difficult
to agree with them. In spite of the fact that he was politically
left wing, he didn't seem to realize that a certain highly
luxurious pleasure-seeking life was over and no longer fits
in with our times. Fortunately he wasn't serious about anything
he suggested for the hall. So instead, and with his permission,
I got Jackson Pollock to paint a mural twenty feet long.

Pollock was the new genius I had just discovered and to
whom I had given a contract for a year. He was by far the
most promising of all the young painters I had exhibited in
group shows in my gallery, and I was very excited about his
work. Pollock found it difficult to settle down to anything
as big as this mural. After weeks of hesitation he began wildly
splashing on paint and finished the whole thing in three

hours. I liked the result but Quentin couldn't bear it. He never allowed me to light it, saying the light I had installed especially for it blew out all the fuses, so it could only be seen in the daytime or when I went down and put the lights on surreptitiously. Everybody wanted to see the mural. One rainy night James Soby stopped in on his way home from the Museum. He arrived absolutely drenched as he was not able to get a cab. I borrowed a shirt from Quentin, fearing Soby would get a bad cold if he remained in his wet garments. However, all he accepted was a stiff highball, which he claimed saved him. Of course he loved the mural.

One day at lunch Quentin told Putzel and me he would take a house on Long Island and invite us. The next day he forgot all about it, but I didn't. I immediately seized upon the plan of renting a house with him in the country for the summer. I tempted him with a beautiful camp in the Adirondacks, but this turned out to be impractical, though we both wanted very much to go there. Then I took a friend's camp in Maine, but we decided this was too far away and gave it up. In the end we decided to go to Connecticut to live next to Florenz on one side and Joan Flarity on the other. (This place was on a lake where Jews were not supposed to bathe.) I wanted Quentin to go to see the landlord and take the house in his name, but he rebelled and said he couldn't talk to such a man, and finally I had to send my friend, Paul Bowles, to take the house for me.

Before going to Connecticut I wired Sindbad to get a three-day pass, and I flew down to Florida to see him on the Fourth of July. He was stationed at Drew Field near Tampa. The heat was terrific but we had a wonderful time together anyway and spent most of it in Spanish restaurants and on beaches. I hadn't seen Sindbad since the winter, when he was first inducted into the Army, and it was wonderful to be with him again. We love each other very much and were happy to be together.

After his pass was over, I remained a few days longer, as he managed to get off in the evening, but he was so exhausted from the heat and his long day that it was quite a strain on him.

In the daytime I had nothing to do and a lot of time on my hands. Quentin had asked me to go and see an old friend of his in the hospital at Drew Field, who had broken his hip and was waiting for a discharge from the Army. I had met him once at a party at Quentin's but was afraid that he would not recognize me, so I sent him a message that I was coming. I got lost at Drew Field and entered the hospital by the back entrance, after wading through hot swamps. Private Larkins, the nurse told me, was in the tenth bed. I found him easily, but he looked very strange. Because of his accident he was connected to contraptions, much like Kiesler's strings in my gallery, and was half suspended from the ceiling. He was asleep when I arrived and, not wishing to disturb him, I sat down and waited for him to wake up. After a long time I poked him gently with my finger. The heat was horrible and the ward was full of the most pathetic cases of soldiers in plaster casts with broken necks and other things. One man was not allowed to move his head and he had his eyes focused on a ball that hung from the ceiling.

Larkins seemed pleased to see me, but I felt I was bringing him out of another world and I was not certain that this was a good idea. He gave me a strange feeling that he had lain there for months with the patience of Buddha and didn't mind. I told him, in the most garrulous way, all about the duplex and our summer plans, never dreaming how he was to be the instrument of evil and destruction in my life, and that I was merely playing into his hands. Unfortunately, he too was secretly in love with Quentin. He pretended he thought all our plans were wonderful, and he accepted my invitation to spend the summer with us if he got out of the Army in time. I went to see him twice and brought him books. Later I wrote to him from

Connecticut, never dreaming what harm he was about to do me.

After I got the lease of the house in Connecticut all fixed up, Quentin decided he wouldn't come up for the first ten days, and since we had taken it for a month, that meant he would only be there for three weeks. But there was no use in fussing. I was glad he was coming even for a short time. He helped me by going with me to buy food and lending me linen, mine being in storage; and he gave me some oil and other things I needed, and packed me in the car. I took with me an old friend, a Russian, who wanted to get out of New York for a few days, so when Quentin arrived ten days later the whole house was in order. Maybe that was what he anticipated.

By this time I was known in the neighborhood as Mrs. Bowles, since that was the name the house was taken in. The house was horrid, but the non-Jewish lake was nice and just in front of our door. I loved sharing my life with Quentin, and especially the feeling of sharing the responsibilities and the expenses, which made it all so domestic. He did most of the cooking, because he was so much better at it than I was. Besides being an excellent cook he was a very particular house-keeper, and fussed a lot about keeping the refrigerator clean. I washed the dishes and occasionally cooked a meal. We went shopping in my car, listened to the radio, also in the car, and did a lot of swimming and sun-bathing, entertaining our neighbors and looking after my cats. I really felt as though I were married to Quentin and was perfectly happy and peaceful for a change. Putzel came up to visit us several times as did Paul Bowles and his wife, the real Mrs. Bowles. I think Quentin was very happy, and only got restless once and insisted on going to New York. Strangely enough, he wanted me to come along. Paul was returning to town that night, so we all went together. At this time Quentin was quite jealous of my friendship with Paul.

When we arrived in New York, as Quentin had a date, I

asked Paul if he would put me up overnight in the big apartment he had borrowed for the summer from Virgil Thomson. We had a lovely evening. I lay on the floor on an air-mattress, wearing his African robes, while he played his compositions for me. He is a very good modern composer. He had dozens of bottles filled with exotic perfumes which he had mixed himself, and he gave me some amber which he put on my wrists. The next day Agnes, Marcel, Quentin, Putzel, Paul and I had lunch together. Paul came in a white suit looking like a doll. He was very dainty and immaculate.

After lunch Quentin and I went off to his flat and played the phonograph. He sat with his arm around me and, as usual under such circumstances, I was in heaven. Then we missed the train for Connecticut and spent hours drinking and eating in the bar of the Grand Central Station. We finally got home.

I lived with Quentin during these three weeks as a wife in every respect but one. I never slept with him. One night he said I should share his bed because I was so frightened. We had come across a corpse or a crouching figure of some kind in Joan's garden. It was after a party and we were walking home. By the time we went back to fetch a light the corpse had disappeared, but not its terrifying memory.

During this period we got on so well we made all sorts of wonderful plans for the future. We decided to go to Cuba in February and leave the gallery to Putzel. Quentin also promised to take me to Greece after the war, as I had never been there and he loved it so much.

part 7

chapter 2

life in the duplex

On the first of September, as previously arranged, Quentin insisted on going back to New York, although we could have remained over Labor Day. He wanted me to drive him back. It was more convenient for him, so of course I did. I then moved into the duplex alone, because Quentin had to wait for some furniture he had in another house, which he had sublet. I think in the beginning I must have been very lonely in this enormous place, for I invited the strangest people.

Soon Joan Flarity moved into my flat for a few weeks, and stayed all winter. She was in love with Florenz and would have made him a wonderful wife, and it certainly would have been more sensible if she had lived with him rather than with me. She had been in England for years, where she had been married to a leading English literary light. She was twenty years younger than Florenz, a handsome brunette and extremely intelligent, with a very sweet character. She was a great friend of Quentin's but soon, without meaning to, she caused a great deal of trouble in our *ménage*.

349

While Quentin was getting settled he spent all his free time in my flat. He liked to be able to escape from the confusion that existed upstairs. His ballroom floor was littered with every conceivable object, and looked more like a junk shop than anything else. It took days to put it in order. He had a lot of elaborate furniture, and spent a fortune redecorating his new apartment. I felt a strong contrast between his way of living and mine. In the beginning he loved the coziness of my home, but of course his own surroundings were what he wanted. In fact our tastes were so different that we never approved of each other's flats.

Once he got settled he instituted the closed door *régime*. He had his life with his friends. I was always made to feel most unwelcome when they were about.

Our domestic arrangements were very simple. We each had our own refrigerator. Quentin's was in the pantry, which he considered his domain, while he gave me the kitchen where there was a larger refrigerator. I had to walk through his pantry to get to my kitchen, and he had to cook in my kitchen. I always used the back stairs to go up there, and made a lot of noise about getting ice, hoping to draw Quentin out into the pantry. The door to his flat was sometimes mysteriously closed, or I would be invited to have a drink. He nearly always came into the pantry when he heard me there.

As he was very changeable, one never knew what to expect. Joan was very indiscreet and helped herself to everything Quentin left about. One night she even took a bottle of Scotch. It was the only one in the houe and a terrible scene followed. When Quentin came home he came rushing downstairs to find it and bawled her out. In the mornings he would ask her to have a drink with him. He called it his first, but it was more likely his third by that time, as it was round midday. Very soon she formed the habit of going upstairs when she heard the ice rattling; she thought it was an invitation. I was in the gallery

at that hour and did not partake of their little daily party.
Soon Quentin got tired of Joan's coming up uninvited every
day and complained to me about it. I warned her and she
stopped going. Then he missed her. Whatever he had always
displeased him, and he invariably preferred what he didn't
have. If a lot of people were living in my apartment he
hated it, but if he were alone in the whole building he felt
lonely. When Joan stopped coming up for drinks he was an-
noyed. He had to have a grievance of some kind in life to be
happy.

At this time I became sort of a slave to Quentin's dog, a
Boxer called Imperator. The animal, neglected by his master,
became greatly attached to me, and Joan named him Mr. Gug-
genheim. He slept on a rug next to my bed and spent all his
spare time with my Persian cats, Gypsy and Romeo, whom he
adored. Quentin was very jealous of Imperator's love for me
and my cats. This tremendous dog was perpetually rushing
downstairs, which I must say was perfectly natural, considering
how lonely and abandoned he felt upstairs, for Quentin went
out so much. I used to take Imperator to the gallery with me
every day, and as he could not go in the bus I became his slave,
walking him everywhere, and bringing him home for his dinner
every night at six. In a way he replaced my darling Kachina.
Quentin was delighted to have found a nursemaid for Im-
perator, and I was delighted to be seen in public with Quentin's
dog. Quentin certainly liked that aspect of the situation, too.
Every night when he came home he called Imperator to take
him out for his last walk. I always took this opportunity to
ask Quentin down for a drink. So we got in the habit of sitting
up till four in the morning.

Deirdre was still in Mexico in October, where she had
gone to spend her summer holiday. It was her second visit
there, as she had gone the summer before with two girl-friends
after we were sent back from the Cape—but this time she was

alone. Suddenly I got a letter of warning sent by Beatrice to Mrs. Bernard Reis, telling me that Deirdre was in the most dangerous company and that I should come at once or send some one to look after her. I tried to get a reservation on an aeroplane but couldn't manage one for a week. In the meantime Florenz and I tried to phone Deirdre. We put in calls which were constantly delayed, and when they did get through Deirdre wouldn't come to the phone. I finally got Beatrice on the phone in Mexico City and asked her if she could go to Deirdre's rescue. She said she couldn't, as it would involve too much responsibility, authority, and money to get Deirdre out of the bad hands she had fallen into. It all sounded terrifying and unreal, and we were in a state of complete hysteria. Even Quentin tried to find out from his lawyer if he could get a visa and go with me to Mexico. (Florenz having been born abroad had to wait six weeks for one.) Suddenly we got a wire and several letters from Deirdre, saying she was fine and would be back as soon as she could get a reservation, and then a letter from Beatrice apologizing for all the trouble she had made. It was just one of her mad ideas.

I cancelled my airplane reservation and was glad not to have left, as Sindbad suddenly appeared on furlough. He was surprised by my strange connection with Quentin. Though he had to admit that he was exceedingly handsome, he could not understand what pleasure I got from this peculiar situation. Being open and free with my children, I tried to explain, and managed somehow to convey what I felt, but Sindbad thought it was very silly and inappropriate. We had a nice time while Sindbad was with us, but it was all too short. I was completely absorbed by his presence and one day when the air-lines phoned me and said, "You have a reservation for Mexico City tonight" I felt as though I had fallen out of the sky, but told them it had been cancelled for days. When Sindbad left he flew back to Florida. We saw him off at seven in the morning

and he left by the same air-line Deirdre had taken to Mexico. When my children disappeared through that cavernous door before taking a bus to La Guardia Airport I always felt as though they were being swallowed up by some dreadful monster, and that I would never see them again.

I opened the gallery in October with a wonderful show of Chirico's early works. There were about sixteen in all, borrowed from museums and private collections. Quentin and I fell in love with "The Melancholy and Mystery of a Street" owned by Captain Resor, son of Mrs. Stanley Resor. We wanted to buy it, but he wouldn't part with it at any price. It is a most extraordinary painting. In it a little girl is rolling a hoop down a dark, deserted, north Italian street. The empty arcades and an abandoned circus wagon add to the peculiar poetic gloom of the scene.

Next came Jackson Pollock's show. The paintings were handsome and exciting and justified all my hopes. James Johnson Sweeney wrote a preface which gave the public confidence. Sweeney did so much to help me make Pollock known that I felt as though Pollock were our spiritual offspring. In a way Sweeney replaced Mr. Read in my life. He was forever giving me advice and helping me. I hate men who criticize me without dominating me. Sweeney dominated me without criticizing me. Therefore we were in perfect accord. Quentin came and helped us hang the show and bought the best drawing. He had an incredible eye, and always knew just what he wanted. We sold quite a few Pollocks during the year and even sold one to the Museum of Modern Art. After deliberating for six months, which is their habit, they bought it. But what is certainly an unheard-of thing on their part, they bought this one without bargaining, due to Barr and Sweeney's efforts. After the opening I gave Pollock a party and we all ended up in Quentin's apartment. He pretended to be very much annoyed, but I think he liked it.

About two in the morning I slipped on the floor and broke my ankle. I had no idea it was broken, but I would allow no one to come near me except Djuna and Quentin, who put me to bed. I couldn't walk the next day, and I thought this was merely a repetition of what had occurred so often to me in my life. Florenz insisted on taking me to his Austrian doctor, who immediately diagnosed a broken ankle. I had an X-ray taken, and then he told me I must have broken it in the same place two months before, when I was alone in the flat, and hopped around all unsuspectingly. Dr. Kraus was a wonderful little man, and he put my foot in a plaster cast with a stirrup, which took all the weight off my ankle and permitted me to hobble around. I was therefore never laid up and was able to go to the gallery every day. I wore a blue knitted sock over my foot in place of a shoe, and everyone thought I was trying to be Surrealist and admired my color scheme. The treatment and exercises which followed upon removal of the cast entirely cured my ankle. During the treatment I could no longer exercise Imperator.

Quentin and I were very domestic at this period, fussing about the two Persian cats and Imperator. Our life was not only boringly domestic, but it became distinctly unpleasant. To begin with the cats had their box in a little back room which was consecrated to them. It smelled rather like a jungle, in spite of the fact that the box was cleaned out every day. This awful smell used to permeate my whole flat, and even mount to the kitchen and to Quentin's rooms. But the worst of all was the fact that Imperator, who never was sufficiently exercised by Quentin as he was used to having lots of servants look after the dog and could no longer depend on me, became filthy. I think Imperator was demoralized by the cats' having the privilege of using the little back room instead of having to go out-of-doors; he began to dirty the floor around the box, and from there he went further and further and finally messed

up my whole apartment. In the beginning I didn't mind cleaning up after Imperator, especially as it made Quentin actually vomit if he did it himself. But Imperator got worse and worse, and what irritated me most of all was that he never made a mess upstairs—he was too terrified Quentin would beat him. I didn't dare beat him, as Quentin warned me it would be dangerous. I spent all this period rushing around with a little shovel like a man between circus acts. Every time I came home I trembled at the thought of what would greet me on my exit from the elevator.

Finally we gave Gypsy to a friend of Quentin's, and I promised Romeo to Pollock's brother. I did this partly to please Quentin and partly because the jungle odor got me down. But giving away Romeo was too much for me. I loved him. So, after deciding to send him to the country, I wired Pollock's brother at a little country post-office saying, "Cannot part with Romeo after all. Many regrets."

I then sent Romeo away to the pet-shop, hoping that if he were mated he would smell less foul. For weeks he had tried to mate with Gypsy and I had done all I could to assist him, but it never came off. There was a beautiful little Persian female in the pet-shop window next door, and when she came in heat the pet-shop sent for Romeo, as we prearranged. This however was a great fiasco, Romeo proving to be not at all what his name implied, and he came back in disgrace. Worst of all, his habits were all changed and he now messed up my bedroom three times a night. This finally decided me to give him up.

Then only Imperator remained to torment me, but this was a much more difficult problem to solve. All Quentin's friends said that I should not clean up after Imperator, but make him do it. I used to send him little notes informing him how often Imperator misbehaved and finally, long after, Quentin sent him away to the country.

Quentin wanted so much to have people think I was his mistress that he nearly convinced me of it on many occasions. When I was in his flat on Sundays (he always cooked lunch for me on that day) and my telephone rang he used to rush down and answer it for me. He wanted people not only to know that I was upstairs with him, but that he had a. proprietory right to answer my phone. He often brought his friends down to my flat and acted as though he felt as at home there, as I really longed for him to be. He wanted every one to think I belonged to him. He was very sweet to people in trouble and was always being sent for by them and going to their rescue. That was the reason he had become so friendly with me in the beginning; though I did not need his financial help, I certainly needed his spiritual aid.

Because of Quentin's very strong influence over me I suddenly completely changed my style of dress. I tried to stop looking like a slut and bought some expensive clothes, among them a little stonemarten coat that cost a fortune. He loved it and, as he always took good care of things, he made me raise it before I sat down. Once when I said it was a good idea, that I probably would never have another such coat in my life, he replied, "If you hang around long enough you may." He hated red so much that though it was my favorite color I entirely gave up wearing anything that approached it. I bought a little blue suit with buttons, which he adored, because he said I looked like a little boy in it. He loved what he called my *gamin* quality.

It was impossible to do anything secret in the flat, because of Imperator. I had to leave all the doors ajar for him and the cats. There was a complicated arrangement for them to go to their box through many open doors, and for Imperator to go upstairs to Quentin when he came home.

At this time Quentin and I were very happy together. He depended on me and would have been quite lost without me. If he ever felt he was losing me, he turned on all his charm

to get me back. Putzel called this putting another log on the fire. I really think that at this time Quentin half considered me his wife.

Joan slept in my bed, and one night I made her invite Quentin to sleep with us. The next time we tried this I realized that Joan's presence was no asset, so I asked her to sleep in the room I had had made for Deirdre. I don't think Quentin liked my having Joan there all the time. I knew I should have sent her away. One night she was in my bed when he walked in unexpectedly to talk to me. I tried to hide her. Even though he must have known that our relationship was perfectly innocent, I felt he objected to her being there.

Our wonderful Regency staircase we never used. Joan and I always went up the back staircase into the kitchen. As most of our life seemed to depend on whether or not we met in the kitchen, Quentin and I became sort of backstairs people. We often used to sit on the steps like servants. It was very funny, when we had this enormous and beautiful apartment, to find ourselves sitting on the backstairs.

One day I asked Max to come to the flat to take away his last remaining objects. There was practically nothing left; he had removed, one by one, his whole collection of primitive artifacts, leaving the house on the river as bare as a hospital. I also wanted to show him Quentin's paintings. Besides several of Max's he had bought my "Toilette de l'Air" by Tanguy, a marvelous Klee, an incredible Miro, and a Picasso and a Braque. Putzel was always urging him to buy more.

When I arrived home with Max, to my great surprise I found Luigi and Marcel Duchamp playing chess in my sitting-room and Florenz watching them. I hadn't expected any of them to be there, so I burst out laughing for more reasons than one. As usual, Marcel was the detached outsider while my past, present and future were about to be assembled. I brought down Quentin, who looked very self-conscious in the rôle of reigning

Prince, and made many excuses about his house costume. Max
never knew exactly what my connection with Quentin was.
Probably a lot of other people didn't either—I certainly was
asked enough indiscreet questions by my friends.

What Quentin really wanted from me, and what would have
made our life successful, would have been a very one-sided ar-
rangement. He really would have liked me to live alone in my
apartment and have me entirely at his disposal when it was
convenient for him, and not when it wasn't. Before I had time
to arrange it this way, it was all over. One week-end when Joan
went away I was quite convinced of this, and I should have
sent her away, but Deirdre came back from Mexico then and
that complicated our life still more.

The week-end we spent alone in the flat was a very happy
one. It began at lunch time when Quentin came to fetch me at
the gallery and gave me a wonderful new name, which he in-
scribed in the guest book. It was a combination of Max's name
and his, and by changing only one letter he used both names.
After lunch we went to buy a rug for our entrance hall. Then
he waited for me in a bar, while I went to a necesssary but
boring opening of a friend's exhibition and bought a little
sculpture which I soon gave to Quentin. After that we went
home. He had to finish a quarterly article he did for an art
paper. We had dinner together and went to see "For Whom the
Bell Tolls." Afterwards we went home and read some poetry
and I asked him to spend the night with me and to my great
surprise he did. The next day we had lunch together. That
night I went up and slept with him in his flat. The next day
Joan came back and everything was different.

One night at midnight, when I was in bed (resting my broken
ankle) and Quentin was sitting talking to me, we heard the bell
ring. Quentin was determined not to admit anyone, but finally
put his head out of the window to see who persisted so violently
in ringing. It turned out to be Deirdre, home from Mexico at

last. She wore a raincoat and a carried a little bag, having lost everything else at the frontier. She looked like such a baby, it really was pathetic. We showed her the duplex, which she had so much encouraged us to take in the spring, and the room which I had built for her. She was glad to be home but quite lost in this new setting. Complications arose at once. She was jealous of Quentin and he was jealous of her. That night when I went upstairs to sleep with him he sent me back saying, "You can't do that the first night Deirdre comes home," and when I came down, Deidre said, "You've been making love with Quentin." I was caught between two opposing forces. When I went upstairs to Quentin's apartment Deirdre used to follow me, which was quite natural as I provided no home life for her downstairs, being perpetually with Quentin in his flat at this time. When she followed me upstairs, I invited her into Quentin's flat, and he was annoyed that I should take such liberties. Poor Deirdre had accepted Quentin as a sort of step-father, and jokingly called him "father," which he liked very much. Deirdre wore high heels. They resounded mercilessly on my uncarpeted floors, and she had a very loud voice which could be heard all over the duplex. Added to Joan's presence, it was too much for Quentin to endure.

To add to the very feminine atmosphere we created, our maid, who did our laundry, insisted on drying it in the kitchen. I must say it was a revolting sight to see brassieres, panties, and blouses all hanging overhead. Now that we were three females living there, I realized it was too much for Quentin and had the laundry removed to one of my bathrooms.

Joan and I tried to make a home life for Deirdre. She was miserable in New York and wanted to go back to the Mexican family she had lived with and marry their son. Florenz and I were against this for many reasons and we thought if she were happier in New York she would change her mind.

Joan used to cook dinner for us. She was very sweet to me

when I broke my ankle and behaved like my wife. She was a good cook. Both Deirdre and Quentin liked eating home.

A very short time after this David Larkins, whom Quentin had been expecting for weeks, suddenly announced his arrival. The night before he came I went up to Quentin's apartment and tried to remain all night. He had a perfect fit and turned me out saying, "How can you think of such a thing when David is coming tomorrow?" There certainly was no connection that I could see between these two facts. However it must have been an omen of the future. The next morning when I was on my way to the gallery Quentin called me upstairs and said, "David is here. Come up. and greet him." We were all pleased to see each other or pretended to be. We talked about our various broken bones, and had a drink to celebrate his arrival, and then I went off to the gallery.

David, exhausted by his trip, got a sort of relapse and went to bed for a few days. After that we all saw a lot of each other. Quentin took us to the opera and, as usual, he and I held hands all evening. I couldn't walk very well because of the stirrup I I was still wearing, and Quentin helped me up and down the steps of the Metropolitan Opera House with great affection and care. After a few days Quentin gave a party for David.

I had bought yards of rose taffeta with which to cover an old chair. I now decided to turn it into a dress. Quentin cut it for me, and I got a dressmaker to sew it up. It made me look like some one in a Mozart opera. The party was not much fun. Quentin doesn't know how to mix people and the atmosphere of his flat was too formal. I invited Gypsy Rose Lee and spent most of the evening talking to her. She was extremely handsome and wore a wonderful John Frederick's costume, and all the women were jealous and rather nasty to her. Quentin seemed to expect me to act as hostess; he assumed a possessive attitude towards me, patting the costume he had invented for me in a most intimate way.

part 7

chapter 3

war in the duplex

A few days later we had our first quarrel. Quentin went out to dinner and David came down and told me I was to get the superintendent to take Imperator out for a walk. When Quentin returned he came to my room, where I was lying in bed and resting my ankle, surrounded by some of his friends. I asked him why he had sent me such a crazy message about the superintendent and Imperator. The superintendent had never taken the dog out in his life. Quentin got furious and said he had not sent me such a message. Then I got boring and domestic and began nagging him about blown-out fuses and other stupid things. He suddenly turned on me and, in front of his friends, said that I had made him sign the lease in order to avoid all responsibility, that he wished he had never taken the flat, and that he hated his life in it. After he went upstairs, his best friend, Polo, apologized for him, explaining that he was drunk. This was too much for me to bear. I told Polo he need not apologize for Quentin, that it was my affair and that he must understand I wouldn't be in such a situation if my intimacy and relationship with Quentin didn't warrant it.

361

I am sure Quentin never told his friends about his life with me. When they were around he always denied me. He was terribly hypocritical and it was often difficult for me to know what he meant. He wanted to please every one, so he had many sides.

The next day I was very unhappy. All my peace had vanished and I felt as though I ought to leave the duplex. I had had no apology from Quentin when I left in the morning for the gallery. Djuna came to see me and I told her what had happened and sent her to Quentin. He liked her very much and was always pleased to have her visit him. When I got home I found a note on my mantelpiece from Quentin apologizing and telling me how badly he would feel if I were to leave the duplex. I rushed upstairs and fell into Quentin's arms and we kissed and made up. Afterwards Djuna told me that he had been in a bad state of nerves. I attributed it to our row, but I think I was wrong. It was already the beginning of the end.

Quentin and I had always meant to share a big house-warming party. So far we had each given a small one. But now, suddenly, he decided to give the house-warming party on his own. I was surprised and disappointed. He said it would be compromising to put my name on the invitation because he was married. Anyhow, he wanted to give an elaborate party, not at all the kind I would have chosen, so I let it go at that. I helped him make a list of guests. We thought of all the people of importance in the art world, and of course Quentin knew lots of other people too. He had invitations printed. Unfortunately when the evening arrived he and David had the flu. In the meantime we had sworn never to fight again but to remain real friends, with emphasis on the "friends." Quentin always insisted that I must never expect more than that from him. If I got more, it was either in my imagination or because I wrung it out of him. What he most wanted was affection.

Because Quentin had the flu, and David was no good socially,

and I had nothing to do with the party, and because it was very formal, and had millions of different elements and lots of negro performers and God knows what else, it was awful. Also the elevator broke down under the strain and kept going to all the wrong floors. A lot of people came down to my flat, the Sweeneys, the Barrs, and the Sobeys and forgot, Quentin claimed, to say good-night to him, which upset him. He had a high fever and felt extremely ill.

The worst of all was that, at the end of the evening, David suddenly took it into his head to make love to me. He told me he had fallen in love with me in the hospital at Drew Field when I came to see him. I was very tight by this time and believed him, and made a scene, telling Quentin that I was sick of everything and was going off with David. I must say Quentin took it very well and merely treated me like a spoiled child. David and I didn't get very far, but we did get to bed that night and the next. After that he told me he really couldn't feel anything about a woman, that what he really liked was choir-boys. Of course what he wanted was Quentin. We were both in love with him. We knew it was that which drew us together. I am furious when I think of all the men who have slept with me while thinking of other men who have slept with me before.

It was bitchy of me to do this to Quentin, though he had always talked about it before David came and expected it to happen. I was in my favorite rôle and making the most of it, a thorn between two roses. I told David how much I loved Quentin, and that I would never leave him and that he gave me a sense of security and peace. Never dreaming how things would turn out, I told David he would get the worst of all this in the end. I think all my confidence about how I felt towards Quentin made David decide to break up our friendship. He was jealous and afraid that I was going to marry Quentin. He plotted and planned very carefully to get me out of the flat.

All this time Quentin never dreamed David was in love with him. Fate played into David's hands and, from every point of view, I was doomed. Quentin was already tired of having so many women around and did not like to have us come up so freely to his flat.

Suddenly Quentin got sick, and when I took his temperature and saw that it was 104, I sent for my doctor, who told me I had called him in the nick of time. He gave him some sulfa and saved his life. Two days later Quentin got news from England that his mother had died, while he himself had been so near death. From then on he was completely under David's control. He collapsed and wouldn't see any one else. When I finally did see him again he was very far away from me and I realized that I had lost him.

We ended with a dreadful explosion. We were in the kitchen, where I had cooked dinner for him and David, when suddenly he told me I was a dangerous woman and accused me of opening one of his letters. David had seen me open a bill from our windowcleaner which was lying on Quentin's desk, and had reported it to make trouble. I wanted to see that the horrid little man I had engaged to do all our windows hadn't cheated Quentin, so I had opened the bill to verify the price. The real catastrophe came when I complained about the closed-door attitude. I was playing straight into David's hands, because then Quentin burst out and said he could not live any other way, and that if I wanted to preserve his friendship, I should leave the duplex. David egged him on and we both got more and more furious. Of course Quentin was not in his right mind. He had been completely abnormal ever since his mother died and really had no idea what he was doing. I refused to leave the duplex and offered to take it over. David said it was more suitable for Quentin to remain, as the lease was in his name. I said that was merely chance; anyhow, I had found the flat, had urged Quentin to take half of it, and I really con-

sidered myself responsible for his being there. Then David said that the flat was too big for me, as I was not used to running a large establishment. This made me angry when I thought of my beautiful house on the river. David then suggested that I remain and buy all Quentin's funiture. The more he interfered the worse things got. Naturally neither of us wanted to leave and we both felt we had a right to remain. No one left, but from then on the whole thing was over. David ruled supreme upstairs and tried to get Putzel to help him in his further efforts to have me ousted, but of course Putzel was disgusted with him. In the end David himself left, as Quentin finally had enough of him.

Now Quentin and I are the best of friends, but that is another story. We only arrived at this, I suppose, by going through all the rest. If only we could have started where we ended, even David could not have come between us. But one lives and learns, or maybe one lives too much to learn.

The End

CPSIA information can be obtained
at www.ICGtesting.com
Printed in the USA
BVOW09s2303030817
490692BV00003B/143/P